María-José Friedlander has a degree in art history from London University. She has travelled extensively and has been a specialist tour guide in many countries around the world.

Bob Friedlander graduated in engineering from Trinity Hall, Cambridge, and was Managing Director of Ford New Holland UK Ltd.

'María-José Friedlander's *Hidden Treasures of Ethiopia* is a must-have guide for anyone interested in looking at the rock churches of northern Ethiopia. It is beautifully illustrated and the principal murals are all carefully described in skilfully drawn diagrams. An invaluable *vade mecum*.'

Richard Snailham, author of *The Blue Nile Revealed*, past Honorary Foreign Secretary of the Royal Geographical Society

María-José Friedlander
and **Bob Friedlander**

Hidden
of Treasures
Ethiopia

A Guide to the Remote
Churches of an Ancient Land

I.B. TAURIS
LONDON · NEW YORK

This edition published in 2015 by I.B.Tauris & Co Ltd
www.ibtauris.com

Distributed worldwide by I.B.Tauris & Co Ltd
Registered office: 6 Salem Road, London W2 4BU

First published in hardback in 2007 by Shama Books

ISBN: 978 1 78076 816 8
eISBN: 978 0 85773 809 7

A full CIP record for this book is available from the British Library
A full CIP record is available from the Library of Congress

Library of Congress Catalog Card Number: available

Designed by Ian Ross www.ianrossdesigner.com
Printed in China by 1010 Printing

FSC
www.fsc.org

MIX
Paper from
responsible sources
FSC® C016973

To our grandchildren: Max, Thomas, Poppy and Wilfred
who have brought so much joy into our lives.
We hope that one day they will read this book
and will be encouraged to discover the wonders of Ethiopia.

Contents

Acknowledgements

I would like to give my heartfelt thanks to the following people for the invaluable help they have given me in writing this book. First and foremost, Richard Pankhurst, for encouraging me to write the book, and for all his help with regard to its content and his suggestions as to potential publishers, and to Richard Snailham, who, together with Solomon Tekle, first introduced us to the wonders of Ethiopia. Merigeta Abbay, for his indispensable and knowledgeable translations of the Ge'ez inscriptions. Peter Brooke, for his expert and often humorous advice on biblical matters. Julia Maynard, for her 'eagle eye' in proofreading the text and the church plans. Maite Uribarri-Pegrum, for getting me started on describing the frescoes. Yassin Nur, owner of the Caravan Travel and Tour Agency, for being such a help in organising our trips to Ethiopia. Solomon Afewerk, Sales and Marketing Manager of the Caravan Travel and Tour Agency, for looking after us with great efficiency and with a lovely sense of humour. Serkalem Kebede, who has driven us all over the Ethiopian Highlands and has carried most of our equipment up many mountains, and always with a smile. Jemal Kedir and Hailu Abraha, our two excellent guides to the churches of Tigray. Solomon Gebeyaw, who in his youth was a *dabtara*, then a guide, and is now the proud owner of the excellent Jerusalem Hotel. He has always made it possible for us to see whatever we wanted to and has always accompanied us on long treks to churches on the outskirts of Lalibela. My sister-in-law, Judy Friedlander, who patiently went through hundreds of slides and helped us choose those that have been included in this book. Javier Gozálbez Esteve and Dulce Cebrián, without whose help this book would never have seen the light of day. Bantalem Tadesse and Anne Parsons for their help in translating the Ge'ez painting inscriptions in the church of Abreha Atsbeha for this second edition. And lastly, my husband, for the photographs, the maps, the church plans and for his help and encouragement.

Preface

This book is aimed at those intrepid travellers who are eager to visit the fascinating country that is Ethiopia, who enjoy walking and climbing, and who desire to visit the churches in the remote highlands with their unique architecture and paintings. Its primary purpose is to provide you (and also the general reader) with a full record of the paintings in the churches reviewed; the background information needed to understand them; and photographs of the paintings, together with plans showing where they are located within each church. The seventeen churches comprise eleven in Tigray, three near Lalibela and one each at Gondar, Gorgora and Lake Tana.

Background

It was in 1997 that I first decided to visit Ethiopia. As the starting date for the tour came closer, my family and friends asked, 'Why on earth do you want to go there?' My husband had refrained from asking this question, but his general lack of enthusiasm for the trip was more than obvious. In January 1998, we touched down on Ethiopian soil for the first time. From that moment on I was captivated by the country, and I have returned every year since – often twice in a year – and usually accompanied by a group of my extra-mural adult students.

It was through a friend that, in 1998, I met Professor Richard Pankhurst and his wife Rita. Richard recommended I write this book since he felt that a guide to the paintings of Ethiopia's remoter churches was much needed. I am sure that he has since regretted making this suggestion; for the following three years I have contacted him frequently to seek his help and advice.

During my first visit I was profoundly affected by the number of cases of blindness, due to trachoma, in both adults and children. It was in connection with this issue that I came to hear of the St Louise Eye Clinic run by the Daughters of Charity at Mekele. When I learned that twice every year

three eye surgeons from Barcelona give their time and expertise free of charge to spend a week at the clinic performing critical operations, I knew that I had to go there. And I was to find out that St Louise is not only an eye clinic but that it also does much other wonderful work for the local people in and around Mekele. As a result of my association over the past six years with the Daughters of Charity of St Louise and my absolute admiration for all the different works of charity performed by them, I have resolved that any proceeds from the sale of this book will go to them.

The Book

On our first Ethiopian tour we visited the church of Debre Berhan Selassie at Gondar, a visit that is a 'must' for any tourist to the country. The church interior is entirely covered in paintings, including its ceiling, which features on many postcards. To fully appreciate each painting, I desperately needed a detailed guide, which I did not have. By the time of my second visit I had discovered Jäger's book, *Antiquities of North Ethiopia*, in which he laid out plans for each wall of this church, listing the subject matter of each painting. What a boon this was! I now was able to fully appreciate Debre Berhan Selassie.

Jäger's book was so helpful that I realised the need for someone to take up his idea and carry it further by adding detailed descriptions of the paintings, relevant quotations from the Bible, plans showing the locations of the paintings and summaries of the legends of the many Ethiopian saints portrayed and the many miracles attributed to the Virgin Mary. I have sought to do this in this book.

The main themes associated with the Virgin and these saints, often repeated in church paintings, have been described in detail in Chapter 2, 'Ethiopian Christianity and Saints'. In addition, most Ethiopian church paintings incorporate Ge'ez inscriptions which are extremely helpful but need to be translated and put into context. Wherever appropriate I have included translations of these Ge'ez scripts.

Visiting Churches

The first thing you need to do is to obtain a document from the church authorities in Addis Ababa which states who you are and gives you permission to visit the churches, the names of which must be specified in the document. Usually your local travel agent will obtain this authorisation for you once you have indicated to him exactly which churches you wish to see. You should be prepared to be patient while the documents are presented to the local priest and the negotiations over the entrance price are completed. This can sometimes take up to an hour.

Of the churches covered in this book the most difficult to reach are those in Tigray. To begin with, they are remote from any major town with Western-style hotels, Mekele being the nearest. Consequently you are faced with either making the long drive from Mekele every day, or staying in a very basic hotel in a village such as Hawzien, or camping. Furthermore, the churches themselves are

usually on the top of an *amba* (plateau) and so involve a climb of some 300 or 400 metres. One also has to contend with the uncertainty of finding the priest with the key to the church and, when you have found him, the uncertainty of how the negotiations between him and your guide will conclude with regard to price of entry, or whether he will agree to your visit at all.

I very much wanted to visit the churches of Debre Maar and Maryam Bahera since they reputedly have some very fine paintings. We reached both of them but never managed to gain entrance, the reasons being different in each case. Debre Maar involved a climb and a very long walk of some three hours through thorny scrub and cacti during which we had to cross a somewhat treacherous landslide. On reaching the church we were told that the priest lived down in the other valley. Someone was sent for him, but after a three-hour wait he had still not arrived, and we had to make the long walk back, unrewarded.

In the case of Maryam Bahera, which is in the Sulloh Valley, north of Hawzien, we were able to get within a couple of kilometres of the church in our four-wheel-drive vehicle. The walk to the church was easy-going through small agricultural fields and did not involve a climb. But again, on reaching it, we were to find that the priest was not there and someone had to be sent for him. It was some two hours later when he arrived, looking somewhat the worse for wear. The negotiations with our guide did not go well, and we were refused entry – perhaps because it was a Sunday, a day when the priests and the male congregation tend to celebrate to excess with *tej* after mass.

You have to be patient and prepared to encounter occasional disappointments such as these. Indeed, our waits were trifling in comparison with those suffered by Thomas Pakenham and Georg Gerster. Pakenham in his book, *The Mountains of Rasselas: An Ethiopian Adventure*, tells of his four-day wait to visit the church of Bethlehem, south-west of Lalibela. In *Churches in Rock* Gerster relates the story of his unsuccessful visit to the grotto church of Jammadu Maryam. He had trekked with a heavy backpack for seven hours and, on reaching the church, was treated in a surprisingly hostile manner by the local villagers. An Ethiopian nun stationed herself on a rock and shouted to the men of the village to kill him. Luckily for Gerster, they failed to carry out her instructions. However, the church remained shut, and the next day he had to make the long return journey without having seen inside Jammadu Maryam.

In most instances you will be successful at gaining entry; however, you then have other challenges facing you. Most of these remote churches have their floors covered in hay, which is home to thousands of fleas of the most agile and athletic variety. My husband presents these church inmates with a tasty target, and he is always badly bitten regardless of the fact that he rolls his socks up over his trouser bottoms, does up his collar tightly and smothers himself in flea powder.

You should carry several strong torches, as the interiors of most churches – certainly those that are either rock-hewn or grotto churches – are dark inside. Without torches you will be unable to appreciate their paintings and their architecture. And when you can see a painting clearly and ask what it portrays, you need to be aware that you will not always be given a consistent answer. Explanations

provided by the priests are usually helpful and accurate; however, when returning to a church for a second or third time, I have occasionally been given a completely different interpretation of the same fresco on each visit!

You should also be aware that many of the paintings are covered in a thick layer of dust, which in some cases must be as old as the church itself. Often I have been tempted to take along a feather-duster attached to the end of a pole, but I have been told that the priests would never permit such irreverence; the dust being regarded as God-sent.

The Paintings

Most wall paintings up to the mid-seventeenth century appear to have been painted directly on to a thin layer of lime and are therefore considered to be frescoes. What is not known is whether they are true frescoes, where the pigment was applied to a base of wet lime plaster, or whether they are fresco secco, where it was applied when the lime plaster was dry.

The First Gondarine style paintings executed after the seventeenth century, when the court had settled in Gondar, tend to have been painted on cloth. However, there are some recent church murals – such as the nineteenth-century paintings in the church of Abreha Atsbeha – which are frescoes. In Ruth Plant's book *Architecture of the Tigre, Ethiopia*, she quotes from a Mr Coffin's *Travels of Nathaniel Pearce* (1810–9), in which he described how the cloth was applied to the walls:

> After plastering the wall and smoothing it with clay, they line it, when perfectly dry, with cotton cloth, which is stuck to the wall by means of a slimy substance made from cow's hide, or from the fruit of the Wanzatra. Over this cloth they lay a coat of whitewash, made from chalk or limestone, first burnt, and then pounded and mixed with water, adding a little of the aforesaid substance with which the cloths are stuck to the wall. They then draw the outline of the picture with charcoal and afterwards paint it with black paint, which they make by burning up hempseed nearly to a cinder.

The stories depicted in the scenes on the walls vary according to the period in which they were painted. The churches painted before the seventeenth century portray both Old Testament stories (the Sacrifice of Isaac and the Three Jews in the Fiery Furnace being very common) and New Testament scenes (involving the Virgin and Child, Christ's Crucifixion and the apostles). They also include equestrian saints as well as a large number of Ethiopian saints and holy men, some of whom are revered locally and only depicted in that specific church.

The Second Gondarine style paintings have a more extensive narrative. In the churches of this period, one wall of paintings is commonly dedicated to the Life of the Virgin Mary and to the childhood

of Jesus. Some of the scenes are immediately recognisable, such as the Annunciation and the Nativity. Others are completely alien, such as Mary drinking the Waters of Correction, an event based on the Old Testament to test if a wife is unfaithful (Numbers 5:11–31).

Other scenes relating to the lives of Mary and Jesus are described in Sir E. A. Wallis Budge's *One Hundred and Ten Miracles of Our Lady Mary* and *Legends of Our Lady Mary the Perpetual Virgin and Her Mother Hanna*. The stories told in these volumes are based on non-Canonical books such as the *Proto-Evangelium of James* and the *Gospel of Pseudo-Matthew*. Scenes related to the miracles of the Virgin Mary, such as the story of Belai Kemer, the miracles on Mount Qwesqwam and at Metmaq and the Covenant of Mercy, are purely Ethiopian stories. Another interesting characteristic of these paintings is that the Virgin's cousin, Salome, is always portrayed with the Holy Family in scenes relating to the Flight into Egypt.

The stories dealing with the saints are derived from the *gadl* (life) of each saint or from the *Synaxarium*, a detailed church calendar describing the saints celebrated for each day of the year. The latter was translated from Ge'ez into English by Sir Wallis Budge at the beginning of the twentieth century and is a four-volume work. Several saints are celebrated on each day; some are only named, whereas others are the subject of lengthy biographies. Many of their stories are highly imaginative, totally incredible and engender hilarity when read by a Westerner – so much so that I sometimes doubted whether I should include any of them in this book. It is not surprising that Pope Gelasius decreed in AD 494 that the stories of St George and other saints should not be read because they were of such a fabulous nature that they provoked ridicule. In the end I decided to include these stories because they do set the scene for many of the church paintings, and they also help the visitor appreciate the extent to which Ethiopian Christians are steeped in these saintly legends.

I trust this book will be helpful to those of you who decide to venture forth and visit these wonderful churches.

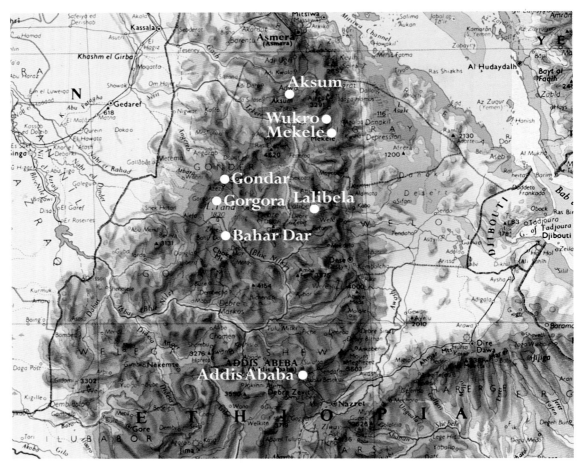

Map of the Ethiopian Highlands

Introduction

Ethiopia is a unique country of great antiquity. Described by many observers as the Cradle of Humanity, it is the land of origin of Lucy or Dinkenesh, the 3.5-million-year-old skeleton of *Australopithecus afarensis*, the world's best-known early hominid. Many other prehistoric remains are also to be found in the Ethiopian region, including important cave paintings.

This part of north-east Africa was no less renowned in historic times. It was familiar to the ancient Egyptians, who called it the Land of Punt and the Land of the Gods, the source of the life-giving Nile River and the territory to which Queen Hapshetsut and other pharaohs despatched many a naval expedition in search of incense for their temples.

The country, which they termed Ethiopia, or Land of Burnt Faces, was subsequently also known to Homer and the Greeks. They spoke of it as a far-off country visited by the gods and inhabited by the 'blameless' Ethiopians, who lived, it was believed, on the very edge of the world.

Ethiopia, to the Ptolemies, was no less renowned as a land to which they too sent important expeditions, in quest of elephants, aptly described as the tanks of ancient times.

Ethiopia was likewise well-known to the Jews of Antiquity, and to other readers of the Bible. They learnt that she was mentioned in the Holy Scriptures, which prophesied that she would 'stretch forth her hands to God'.

Traditionally Ethiopians dated their history from Adam and Eve, and from King Solomon and the Queen of Sheba. They believe that this biblical queen was a wise Ethiopian woman ruler who travelled to Jerusalem to learn of the wisdom of Solomon. Her legendary story is told in the country's national epic, the *Kebra Negast*, or 'Glory of Kings', which was written in the early fourteenth century. This text claims that Menilek, Sheba's son by Solomon, who lived around 1000 BC, presided over the acquisition of the biblical Ark of the Covenant and later founded an imperial dynasty that ruled the country until the Ethiopian Revolution of 1974.

Modern archaeological research has identified a number of ancient settlements in northern Ethiopia. The most important was at Yeha, site of an immense and remarkably fine temple erected to

the sun and moon gods. It dates back to perhaps the seventh or eighth century BC – i.e., within only a few hundred years of the believed lifetime of the legendary queen. The well-documented history of Ethiopia begins half a millennium or so later, with the founding of the Aksumite kingdom, in what is now the north of the country, around 300 BC.

The Aksumite state owed its importance to its location in fertile, well-watered land. This allowed for the emergence of extensive agriculture, most notably the cultivation of cereals. The state was also well located in that it enjoyed relatively good access to the Red Sea, at the port of Adulis, as well as to gold deposits towards the west, near the present-day Sudan frontier, and deposits of rock salt in the Afar or Dankali depression. Bars of salt were long to be used in Ethiopia instead of money.

The Aksumites developed a flourishing foreign commerce. They traded with countries as far apart as Egypt and India, as well as Arabia, and exported ivory and gold in exchange for textiles and a variety of manufactured goods. Early in the Christian era, the Aksumites also began the minting of coins. Struck in gold, silver and bronze, these bore inscriptions in both Ge'ez, the then language of the country, and Greek, the principal international language of Red Sea commerce.

The Aksumites were also renowned for their work in stone. At their capital, Aksum, they erected stone inscriptions, extensive many-roomed palaces and lofty monolithic stele. The finest such obelisks, which were designed to resemble multi-storeyed buildings, were adorned with representations of doors and windows – a decorative feature that was to reappear in rock-hewn churches a millennium later.

The kingdom of Aksum emerged as the most important Red Sea power between the Roman Empire and Persia. Aksumite armies were despatched on major expeditions, to Arabia and Nubia in the west, as well as into the Ethiopian interior, the north of which came increasingly under Aksumite rule. The kings of Aksum are believed to have exercised considerable powers. In support of this view it has been noted that whereas coins in most countries bear an effigy of the king on one side and of the state on the other, the money of Aksum has a representation of the monarch on both sides.

Aksum embraced Christianity early in its history; Ethiopian Church tradition holds that the first Aksumites were converted at the time of the Apostles. Be that as it may, it is undeniable that the Aksumite state adopted Christianity as the state religion in the early fourth century. Earlier currency bearing representations of the sun and moon were then replaced by money decorated with the Cross of Christ. This was some of the first currency of this kind to be minted anywhere in the world.

The introduction of Christianity is believed to have taken place in the Aksumite kingdom when a ship carrying Syrian Christians put in at the coast. A fracas ensued in which almost all on board were killed, but two young boys survived and were found studying – the Bible? – under a tree. They were brought to the king, who appointed them to his household. The elder, Frumentius by name, became the royal secretary and treasurer. He subsequently founded churches and converted the heir to the throne, after which he travelled in quest of a bishop to Alexandria, in Egypt, then a major centre of Christianity. He was there received in audience by the head of the Coptic Church,

Patriarch Athanasius, who, recognising the young man's achievement for the faith, appointed him the country's first bishop. This act had immense implication, for it was to become traditional, for over a millennium, that the *Abuna*, or head of the Ethiopian Church, should always be imported from the Church of Coptic Egypt.

It was not long after the country's conversion, it is believed, that the Christian Scriptures began to be translated into Ge'ez. This work may well have been completed at the time of the nine Saints, who also came to Ethiopia from Syria, around the fifth century, and founded important monasteries in the vicinity of Aksum and elsewhere.

Aksum emerged as the centre of Ethiopian Christianity which in the following centuries spread increasingly southwards into the mountainous interior. The city was the site of the great Church of St Mary. Reputed to be the resting place of the Ark of the Covenant brought from Jerusalem in Menilek's day, it was named after St Mary of Seyon, i.e. Zion. Aksum was by then part of the wider Christian world, and pilgrims from Ethiopia, then as for the next millennium and a half, travelled on pilgrimage to Jerusalem, where they communed with co-religionaries from many European, Asian and African lands.

The Aksumites, who are said to have originally spoken a Semitic language similar to that of South Arabia, at first used the Sabaean script employed there. This writing, like that of other Semitic languages, ran from right to left, or, more often, in the boustrophedon, or 'ploughwise' manner. In it, the first line ran from right to left, the second from left to right, the third from right to left, and so on. Sabaean writing, again like that of other Semitic languages, was primarily consonantal and made little use of vowels.

Aksumite writing underwent a major transformation in the early fourth century, probably on account of the coming of Christianity. To make the newly translated Ge'ez Bible legible to the newly converted, the old Sabaean alphabet, which, like that of other Semitic languages, was mainly based on consonants, was changed to make it more intelligible by indicating vowel sounds. Each consonant was thus modified to express seven different consonant plus vowel combinations. The old Sabaean alphabet was transformed into a new Ge'ez syllabary.

Another major change, which may have resulted from the translation of the Bible from Greek, was the abandonment of boustrophedic writing. It was replaced by writing that ran exclusively, like Greek, from left to right. Numerals based on the Greek letters were at this time also introduced, and several of the old letters were substantially modified, and in some cases even turned sideways.

It was this way that a writing system evolved, which is unique in Africa, and used in Ethiopia to this day. Aksum later played a notable role in the early history of Islam. This occurred, according to Muslim tradition, almost at the beginning of the teaching of the Prophet Muhammad. When his disciples were suffering from persecution in Arabia, he pointed across the Red Sea to Ethiopia (or Abyssinia as the Arabs called it), and told them to proceed there, as it was 'a land of righteousness', where 'no

one was wronged'. His words proved justified, for when an Arab embassy with costly presents arrived to demand the refugee's forcible repatriation, the Aksumite monarch turned to the envoys, and replied, 'Even if you were to offer me a mountain of gold I would not give up these people who have taken refuge with me'.

The refugees duly returned to Arabia, where two of the women married the Prophet, and told him of the beauty of the Church of St Mary at Aksum. Muhammad subsequently prayed for the soul of the Aksumite ruler who had given his disciples asylum and ordered his followers to 'leave the Abyssinians at peace', thus exempting them from Jihad, or Holy War.

Islam subsequently expanded widely into Ethiopia. Particularly strong in the lowlands that surrounded the Christian highlands to the north, south, east and west, it was also established in the walled city of Harar in the south-west. This settlement, which was ruled by its own amirs, became a major centre of Muslim piety and learning as well as an important commercial centre issuing its own currency.

Aksum, for reasons outside the scope of this Introduction, began to decline around the sixth century AD, and in the seventh the minting of its currency came to an end. The Arabs, fortified by the power of Islam, meanwhile made themselves the masters first of the Red Sea and later of the African off-shore islands. The Aksumite kingdom as a result became increasingly land-locked, and, in the early twelfth century, power shifted southwards to the province of Lasta. The latter was located much further inland than Aksum and was thus far less involved in foreign trade. The inhabitants of Lasta, unlike those of ancient Aksum, made no use of coins.

It was in Lasta that a new dynasty, known as the Zagwé, then rose to prominence. Unique among Ethiopian rulers, they were canonised by the Ethiopian Orthodox Church but were later to be condemned as usurpers. The Zagwé dynasty is renowned for maintaining the Christian traditions of Aksum and for the founding of many remarkably fine churches. Most prominent among the places of worship established during the Zagwé period were the monolithic rock-hewn churches of Lalibala, which have been classed among the wonders of the world. Situated in close proximity to each other, they made the city a major centre of pilgrimage and one which has been visited over the centuries by innumerable devout Christians from all over Ethiopia.

Though justly famous, the rock-hewn churches of Lalibala form part, as readers of these pages will see, of a much wider constellation of such structures. They stretch from Asmara in Eritrea to the vicinity of Goba in Balé, hence covering an area that extends over 1,000 kilometres from north to south. Several rock-churches have been excavated in the past decade.

Zagwé rule, which was increasingly challenged from both north and south, came to an end around 1270 when an emperor called Yekuno Amlak established himself further south in the province of Shawa. The centre of political power, which had moved south from Yeha to Aksum and from Aksum to Lalibala, thus moved further south again to Shawa. There an entirely new dynasty came into existence.

Its members, who continued the Christian traditions of their predecessors, are described as 'Solomonic', because they claimed descent from Solomon and the Queen of Sheba.

The medieval Shawan state differed from those of Aksum and Lalibala in that it had no permanent capital. The Shawan emperors, who were accompanied by huge armies, and innumerable camp followers, had no fixed residence. They travelled far and wide, to inspect their far-flung empire, to collect taxes and to fight frequent wars. They thus moved from place to place, as one chronicle observed, until the hour of their last sleep, the day of their eternal repose. Their armies were so extensive that they speedily consumed the foodstuffs, and firewood, in their vicinity, thus obliging them to continue their almost nomadic peregrinations.

Commerce, based partly on trade with the Gulf of Aden ports, to the East, was at this time conceivably somewhat more extensive than under Zagwé rule in Lasta but was still probably less important than in Aksumite days. Currency was still no longer minted, and people made do with 'primitive money': bars of salt and pieces of cloth and iron.

This period, nevertheless, witnessed an important cultural and literary revival. Many fine churches were constructed, and beautifully decorated; and many remarkable icons, such as those on display in the Museum of the Institute of Ethiopian Studies in Addis Ababa, were painted. Innumerable illuminated manuscripts were also produced: many were subsequently looted and may be seen to this day in several major world libraries.

The medieval period was also the time which witnessed the flowering of Ge'ez literature. It was the time when the *Kebra Negast*, or 'Glory of Kings', was written. Important religious and theological treatises were also composed, and not a few writings were translated from Arabic. Royal scribes also began producing detailed chronicles, which were to describe in considerable detail the reigns of their masters for well over half a millennium.

This was likewise a time when a growing number of Europeans, mainly from Italy and the Iberian Peninsula, succeeded in finding their way into Ethiopia. They included two fifteenth- to sixteenth-century Venetian artists, who rose to prominence at the Shawan court. The works of one of them, Brancaleone, can be seen in the Institute of Ethiopian Studies Museum.

The Shawan state did not face any major external threat until the early sixteenth century, when the coming of firearms in the Middle East transformed the balance of power to its disadvantage. The Christian emperors, living in the interior of the country, found it difficult to import rifles or cannons, but such weapons were relatively easily accessible to the Muslims at the coast.

Differing access to firearms led to a dramatic shift in the balance of power, which was successfully exploited by Imam Ahmad ibn Ibrahim, a charismatic Muslim leader from the Harar area, who was better known as Grañ, or the Left-Handed. After launching a series of raids into the Christian highlands in 1527, he undertook several much more substantial expeditions and soon overran almost the entire country. The then Christian monarch, Lebna Dengel, was obliged to flee from one mountain refuge to another.

Ahmad's campaigns were accompanied by the seizure of innumerable slaves, as well as by the destruction of countless churches, manuscripts and other religious, historical and cultural treasures.

The Christian Regent, Empress Eléni, had, however, by then appealed to the Portuguese, as fellow Christians, to come to the aid of their Ethiopian co-religionaries. Portugal thereupon despatched a well-equipped army of intervention, which landed at the Red Sea port of Massawa and made its way inland. Imam Ahmad was killed in battle in 1543, and Muslim rule over the Christian highlands thereupon rapidly collapsed.

Lebna Dengel's son, Galawdéwos, quickly restored the Christian empire. Encouraged by this success, he tried to capture Harar, but perished in the attempt. His son and successor, Minas, who had earlier been a prisoner of Imam Ahmad, was only too well aware of Muslim power. He realised that Harar was virtually impregnable and that there was no way of gaining access to firearms imported through the Gulf of Aden ports. He therefore immediately shifted his capital north-westwards to the Lake Tana area, a site which, it might be assumed, would provide better access to arms imported by way of either Massawa or the Sudan.

The bitter struggle between the old Christian empire and Imam Ahmad's administration based on Harar had meanwhile seriously weakened both powers. This development provided the background to the ensuing great northward migration of the Oromo people, who had previously lived in relative isolation around the south of present-day Ethiopia. As a result of their move, they came to live in many more northerly regions of the country, where they were thereafter to play an increasingly important role in state affairs.

The period after the move of capital from Shawa witnessed the expulsion of the Jesuits. Arriving as missionaries from Portugal and Spain in the late sixteenth century, they had succeeded in converting two successive emperors, Za Dengel and Susenyos, but later alienated much of the population by their insensitivity to local religious beliefs and practices, and were expelled from the country in 1632–3. Roman Catholic priests were at the same time forbidden from entering the country. Ethiopia thus closed its doors to the West, but this did not in any way imply full isolation: Ethiopian pilgrims continued to travel to Jerusalem, and there was political contact with Yemen, the Mogul Empire and the Dutch East Indies.

The emperors meanwhile made use of a succession of capitals in the Lake Tana area before establishing themselves first at Danqaz, north-east of the lake, and later, in 1636, to the north of it at Gondar. The latter settlement, the first important fixed capital since Lalibala, was the site of an impressive castle erected by Emperor Fasiladas. His practice of building fortresses was continued by his successors, with the result that an extensive imperial quarter, surrounded by a high wall, duly came into existence.

The city, because of its relative permanence and settled life, acquired a population of perhaps 60,000 inhabitants, the largest in the region, which made it a sizable metropolis. Though currency was still not

minted, considerable use was made of Maria Theresa thalers, or dollars, which were in extensive demand for their silver content and were extensively melted down into crosses and jewellery.

Gondar witnessed important developments in commerce, culture and the arts. The city became renowned for its elegant court life, as well as for its rich merchants, learned scholars and skilled craftsmen. Gondarine art also developed significantly. Many religious paintings of this period for the first time depicted specifically local features, such as Ethiopian dress, weapons, horse decorations and baskets, and are therefore invaluable not only as works of art but also as historical documents illustrating the life of the Ethiopian people of the time.

The Gondarine state fell, however, on hard times in the second half of eighteenth century when centralised power collapsed, the power of the monarchs declined and the various provinces were torn apart by frequent civil war. This period was referred to by traditional Ethiopian historians as the Era of the Masafent, or Judges, as it seemed to resemble the biblical time (Judges 21:25) when 'there was no king in Israel: every man did that which was right in his own eyes'. Some degree of cohesion was, however, provided by the Church.

This period of disunity and civil war was the more serious in that it coincided with the beginnings of the Industrial Revolution in Europe which before long had repercussions throughout the world. The impact of the new technology was soon felt in Ethiopia's northern neighbour, Egypt, which began to expand southwards into Sudan, annexing the country's borderlands, on both the west and the coast. This happened at the very time when steam-driven European gunboats were appearing in the Red Sea, and the British and French were beginning to acquire their first possessions in the area: the European Age of Imperialism was soon to dawn.

The challenge to Ethiopia, which became increasingly compelling as the nineteenth century proceeded, was to unite and to modernise: to take advantage of the new forces unleashed by modern technology, to bring hitherto undreamed of material, medical and other benefits to its inhabitants, as well as to maintain the country's age-old independence.

This was no easy task, but it was the one with which the country's three great reforming monarchs, Emperors Téwodros, Yohannes and Menilek, were to grapple. Their lives, struggles and achievements, however, lie beyond the scope of this volume.

Richard Pankhurst OBE

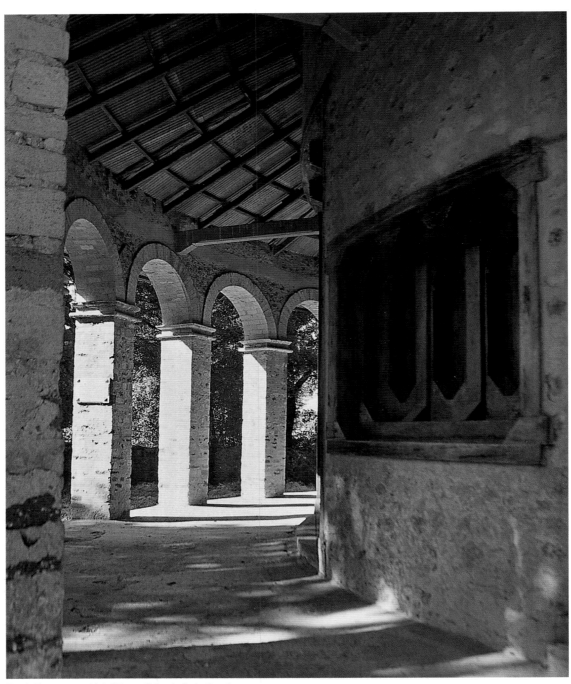

Fig. 1. The *qene mahlet* of Narga Selassie (Lake Tana)

Chapter 1

The Architecture of the Churches

Externally, Ethiopian church architecture does not bear any relation to the familiar styles evident in the Western world, which are derived from either Greek or Roman buildings, or the soaring buttresses of the Gothic style. Ethiopia was isolated from these architectural concepts. The architectural forms that we see copied in stone in the stelae fields of Aksum reflect the traditions of Ethiopian built-up structures. They represent a style and technique unique to Ethiopia, which has prevailed in most of the built-up churches of today. It is these features that have also been reproduced in many rock-hewn churches, some of which are included in this book, and, although devoid of their structural meaning, they are exceedingly decorative.

Ethiopian church plans fall into two main categories:

1. The rectangular plan which follows three main forms:
- single aisle,
- basilical with a tripartite apse,
- hypostyle. This layout was the most popular until the seventeenth century.

2. The round plan, resembling the indigenous *tucul* house, which became the preferred style from the seventeenth century onwards.

The space into which Ethiopian churches are divided appears to be derived from the threefold division of the Hebrew temple (Ullendorf, 1968, pp. 87–8). This is irrespective of whether the church is rectangular or round. These three divisions are:

• The *qene mahlet* – the outside ambulatory of a round church or the narthex of a rectangular one. This is the place where the *dabtaras* stand and the hymns are sung, sometimes for hours on end. The *qene mahlet* corresponds to the *ulam* of Solomon's Temple.

• The *qeddest* – the 'place of miracles' which is the chamber generally reserved for priests but where the congregation comes to receive communion. The *qeddest* is the equivalent of the *hekal* of Solomon's Temple.

• The *maqdas* – the sanctuary where the *tabot* rests and to which only senior priests and the king are admitted. Mass takes place here. The *maqdas* corresponds to the *debir* of Solomon's Temple. It is carefully guarded and its aura of mystery is greatly accentuated by subdued lighting or virtual darkness.

The *Tabot*

Ethiopian legend has it that the Ark of the Covenant was taken from Jerusalem to Ethiopia by Menelik, the son of Solomon and the Queen of Sheba. Ethiopians believe that they are still the keepers of the original sacred Ark – the *tabot* – containing the tablets of the law given to Moses by God, which they guard in the monastery of St Mary of Zion at Aksum. The *tabot* is the guarantor that Ethiopians are the Chosen People and therefore is their focal point of worship. Every church has a replica of the *tabot*, either in stone or hard wood, and some churches have more than one.

It is the *tabot*, and not the church building, which is consecrated by the bishop and gives sanctity to the church in which it is placed. The original Ark of the Covenant at Aksum never comes out of the monastery. However, the replicas do, and they are carried in solemn processions around their church and often, to celebrate certain holy festivities, they are carried through the village. The *tabot* is carried by priests and is covered in silks and shaded by colourful umbrellas. They are accompanied by *dabtaras*, singing, dancing, beating their prayer-sticks, rattling their sistra, and sounding other musical instruments. This recalls the biblical account of King David and the people of Israel dancing around the Ark of the Covenant:

> David and the whole house of Israel were celebrating with all their might before the Lord, with songs and with harps, lyres, tambourines, sistra and cymbals … David, wearing a linen ephod, danced before the Lord with all his might, while he and the entire house of Israel brought up the ark of the Lord with shouts and the sound of trumpets. As the ark of the Lord was entering the City of David, Michal daughter of Saul watched from a window. And when she saw King David leaping and dancing before the Lord, she despised him in her heart. (2 Samuel 6:5 and 14–6)

Rectangular Churches

The most common type of church at the beginning of Christianity was of the basilical or single nave plan. This plan was of Western origin and was certainly used in Syria and the Nile Valley, from whence it was spread to Ethiopia by such people as Frumentius, who converted King Ezana to Christianity in the fourth century, and the nine Syrian saints who introduced monasticism to Ethiopia in the fifth and sixth centuries — all of whom were citizens of the Byzantine Empire.

Most rectangular churches, whether built-up or rock-hewn, are of the basilical-type, divided lengthways by columns or piers into three or five aisles and into several bays in depth, starting from the narthex at the entrance all the way to the apse at the eastern end. They all face east–west and have at least two doors, one for men and one for women.

The nave ceiling in the basilical plan is at a higher level than that of the aisles. This can be seen in the built-up churches of Yemrahane Krestos and Makina Medhane Alem outside Lalibela. Both have a truncated saddleback roof (a roof that does not terminate in a sharp ridge but is truncated so that it flattens out at the top) over the nave but not over the sanctuary, which is domed. This is also true of the partially built-up, partially rock-hewn churches of Enda Mikael on Debre Salem near Atsbi and Petros and Paulos at Melehayzenghi, north of Wukro. The church of Ghenate Maryam outside Lalibela, even though entirely rock-hewn, has a truncated saddleback roof and the nave ceiling is therefore slightly higher than that of the rest of the church.

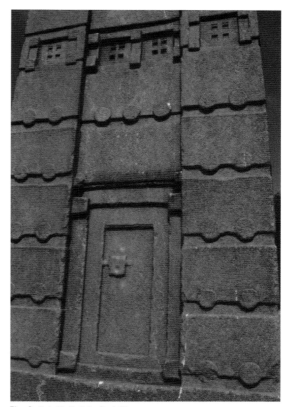

Fig. 2. Detail of stela 3 at Aksum

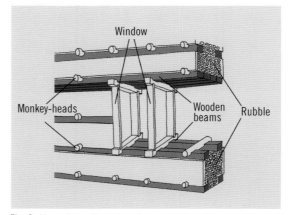

Fig. 3. Aksumite wall construction

Other rectangular churches, which are divided by columns or piers into aisles and bays but have a ceiling of the same height throughout the church, are more appropriately called hypo-style. The rock-hewn churches of Abuna Gabre Mikael at Koraro and Kidana Mehrat on Debre Tsion are prime examples.

Ethiopian rectangular-plan churches often involve the Aksumite style of construction, the origins of which are to be found in the buildings of the country's first known capital at Aksum, and which date from both before and after the arrival of Christianity in Ethiopia. This has been dramati-cally recorded on the great monolithic stelae to be found at Aksum, many of which are carved with simulations of the architectural style of the capital's palaces.

This Aksumite style, of which you will see and hear much, is distinctively decorative. The walls comprise layers of small stones sandwiched between immense, horizontal, wooden beams of a square cross-section that run the length of the wall, on both its inner and outer sides. The rubble layers are then sometimes plastered with the result that the beams become slightly recessed by the thickness of the plaster.

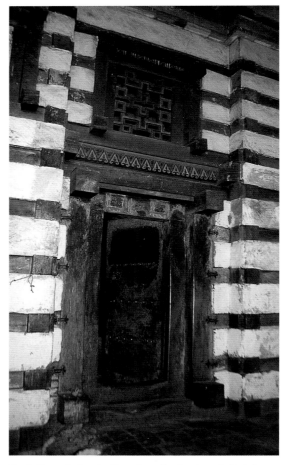

Fig. 4. Aksumite façade, Yemrahane Krestos (near Lalibela)

Short, horizontal timbers of a round cross-section are placed across the width of the wall and are grooved to slot over the longitudinal beams, thus creating a firm structure. They are allowed to project freely from the outer surface of the wall, and sometimes the inner surface, resulting in a feature that has become known as 'monkey-heads'. At the corners of doors and windows, the beams that are used to traverse the width of the wall and link the frames together are of a square cross-section and have their ends projecting both inside and outside, forming square 'monkey-heads'.

Another prominent feature of the Aksumite style is the frieze, which is an attractive decorative characteristic of nearly all built-up and rock-hewn churches. These friezes comprise rows of arcaded blind windows constructed exactly like single windows, with the usual corner 'monkey-heads'. However, the vertical frame members are shared between adjacent windows.

The Aksumite style of construction is unique to Ethiopia. It was used in many of the built-up churches dating from before the sixteenth century and has been employed in a purely decorative manner in many rock-hewn churches. Unfortunately, most of the original Aksumite built-up churches have disintegrated or have been destroyed in wars. One of the few extant examples is Debre Damo, reputedly Ethiopia's oldest built-up church dating back to the sixth century which is clearly of Aksumite construction but which has been substantially restored. The fact that the church is situated on top of a 3,000-metre-high *amba* has ensured its survival despite the ravages of war. Only men are allowed to visit this church, and to do so they have to ascend the vertical cliff face using a leather rope.

Three other excellent extant Aksumite style churches are Yemrahane Krestos and Makina Medhane Alem, both of which are just outside Lalibela, and the partially built-up, partially rock-hewn church of Enda Mikael on Debre Salem, near Atsbi.

Rock-Hewn Churches

There are two basic types of rock-hewn church in Ethiopia:

1. Those that have been created by excavating an encompassing trench downwards into a horizontal rock face to leave a monolithic block of living rock in the middle, which is then itself sculpted to imitate a built-up church. To shape the interior, entry was achieved through the upper windows which were carved out first. Most churches of this kind are to be found in or close to Lalibela, the most famous of them being Bet Giyorgis. However, there is one example just south of Addis Ababa: the church of Adadi Maryam near Tiya. Nowhere else in the world will you find rock-hewn churches created in this manner. It is these churches that most tourists will see when visiting Ethiopia on an organised tour. A few do have interior frescoes, but they are not nearly as spectacular as can be found in examples of the second type of rock-hewn church.

2. Those which are cut horizontally inwards from a more or less vertical cliff face. A substantial quantity of rock was left above the church itself so as to minimise the danger of cracks. Regardless in which direction the rock façade faced, the church plan was always rotated so that the sanctuary faced east. These churches, more often than not, have been created in remote locations. The rock-hewn churches described in this book are of this type because it is in these churches that the most impressive frescoes are to be found.

The architecture of the rock-hewn churches and their decorative motives are directly derived from Aksumite building techniques. Ethiopia is an extremely conservative country, and, as a result, this

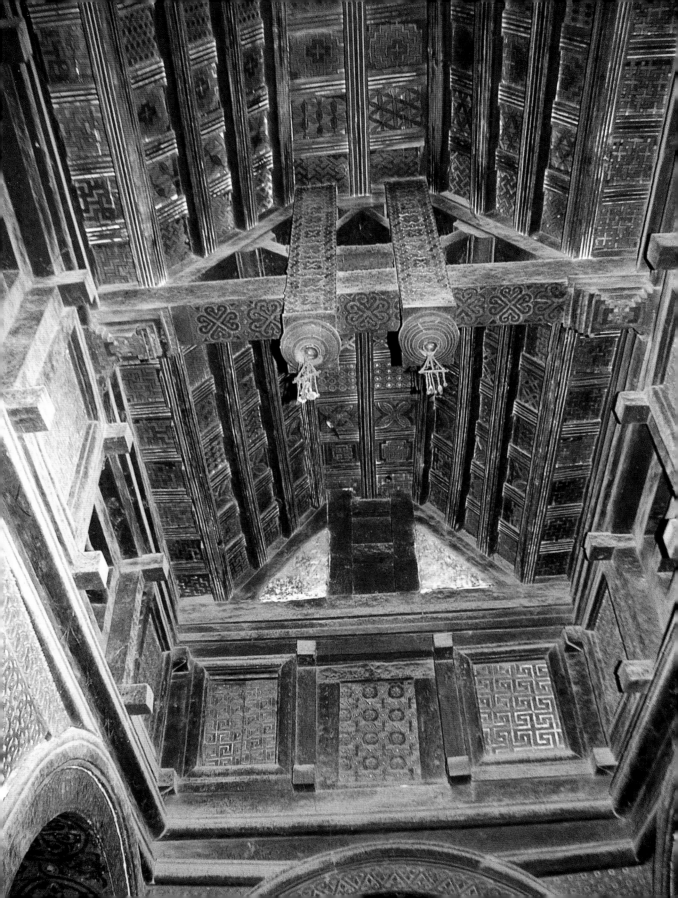

Fig. 5 (left). Truncated saddleback roof, Yemrahane Krestos (near Lalibela)

architectural style has been used from earliest time up to the present day. From the time of Frumentius in the fourth century, or with the arrival of the nine Syrian saints in the sixth century, churches were built of local materials – small stones, earth mortar and wooden horizontal beams, and cross-members – using Aksumite techniques. These churches would have had a simple thatched roof. When these built-up churches acquired their elaborately carved wooden roofs is not known. Yemrahane Krestos, which has such a roof, has been dated by David Buxton to the twelfth century. The rock-hewn churches were created at the same time as built-up churches, and many of them, especially in Tigray, reflect in their ceilings the precise and decorative incised decoration of the wooden roofs.

In many rock-hewn churches the ceilings have been carved with patterns for the most part derived from wooden prototypes. In the early built-up churches, the ceilings of the bays were constructed by placing beams across the corners forming a diamond within a square. The diamond could be reduced in size by placing more beams on the corners, thus reducing the area to be decorated, usually with a cross which had painted patterns around it.

Coffered ceilings with a multitude of paintings or designs were also common. In rock-hewn churches you will see a variety of these patterns, for the most part deeply cut into the rock, some of which are painted over while others are left unpainted to show the decoration on the stone itself.

Some of the rock-hewn church ceilings imitate the truncated saddleback roof and the upside-down boat type of roof characteristic of some built-up churches. Clearly the truncated saddleback roof of Yemrahane Krestos, or other church ceilings of a similar style, became the prototype for the rock-hewn churches of Kidana Mehrat on Debre Tsion, where the central truncated saddleback roof and arches have been painted with a variety of designs based on the cross, and of Yohannes Meaquddi in which the ceiling of the central bay has been carved in the shape of an upside-down boat and then decorated with geometrical designs and human figures.

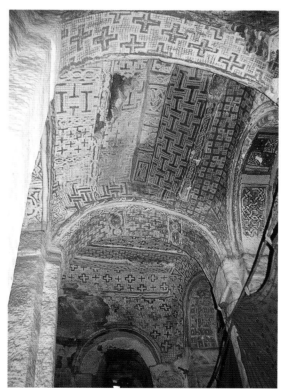

Fig. 6. Truncated saddleback roof, Kidana Mehrat (Geralta)

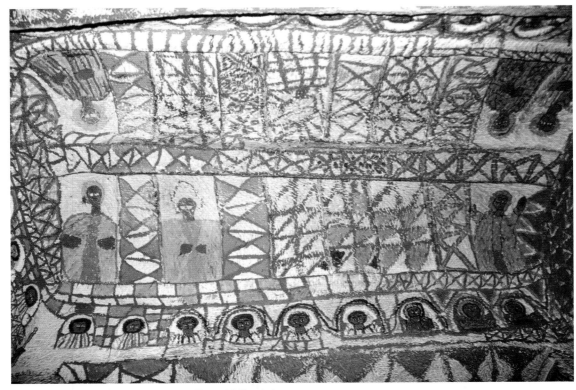

Fig. 7. Upside-down boat ceiling, Yohannes Meaquddi (Geralta)

The domes of built-up churches were either supported by pendentives or were placed onto the square of the church walls on which beams had been placed diagonally across the corners, so forming an octagon and reducing the area to be covered, thereby creating a substitute for pendentives. In rock-hewn churches, the same principle was followed, even though, of course, there was no architectural need for pendentives or beams across corners.

The rock-hewn church of Abuna Gabre Mikael at Koraro has a shallow dome resting on pseudo-pendentives which have been carved below the base of the dome. While the dome itself is painted with some of the twenty-four Elders of the Apocalypse, the pseudo-pendentives are carved triangles left unpainted. In the church of Mikael Melehayzenghi, there is a carved shallow dome surrounded by an Aksumite frieze. The dome itself has a beautiful, circular, shallow relief carved from the sandstone rock. Many bands of intricate circular patterns radiate out from an enclosed Greek cross at the centre of the relief, the whole design resembling the decorated Tigrayan circular bread loaf, the *himbasha*. The church of Maryam Korkor has a dome carved with pseudo-ribs joining in a central boss.

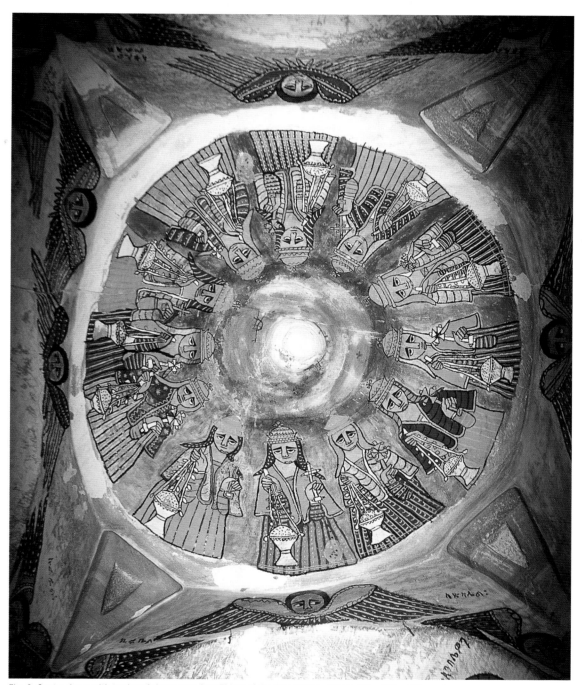

Fig. 8. Centre dome with twelve of the twenty-four Elders of the Apocalypse, Abuna Gabre Mikael (Koraro)

Round Churches

The stone-built circular church with a conical thatched roof, which has now been substituted by corrugated iron, has become the most common style of construction from the seventeenth century to the present day. The church is set on a platform, usually slightly raised, sometimes to a height of three or four steps. It resembles the *tucul*, the traditional indigenous house seen in the countryside and blends beautifully into the landscape, which is perhaps one of the reasons why it is the most widely used style today.

The round church is designed to fit the hierarchical order of the liturgical service. In the centre there is a square *maqdas* or sanctuary, topped either by a cylindrical drum or by a pole originating from the centre of the sanctuary, both of which extend up to the roof which they help support. Rafters extend laterally from the top of the sanctuary to the outer wall of the church and are often decorated with colourful designs. These rafters usually carry a crown of trusses on which the roof rests.

The *tabot* is kept within the *maqdas*, which can have up to three doors and several blind windows. Often, the walls of the *maqdas* are covered with paintings, as are the doors. Curtains are drawn around the four walls, so perpetuating the sanctuary's aura of sacred mystery.

Surrounding the *maqdas* is a circular enclosing wall which defines the *qeddest* in the form of an inner ambulatory, pierced by wooden doors and windows with wooden shutters. Occasionally the windows are filled with an intricate fretwork screen. The circular enclosing wall is itself surrounded by columns supporting the roof. Between the columns extends a low wall which creates an outer ambulatory – the *qene mahlet* – protected by the wide, overhanging roof. The roof is topped by an umbrella that tinkles in the breeze, and above it is a cross from which finials emanate ending in 'ostrich eggs'. The number of eggs can be five, seven or twelve. There are three, somewhat obscure, Ethiopian stories associated with the significance of these eggs:

1. When the female ostrich is incubating her eggs and becomes hungry, the male replaces her on the nest, and hence the eggs are never left unattended. When Jesus Christ left this world, he did not leave his church unattended. At the time of Pentecost, the Holy Spirit descended to the disciples:

> And when the day of Pentecost was now come, they were all together in one place. And suddenly there came from heaven a sound as of the rushing of a mighty wind, and it filled all the house where they were sitting. And there appeared unto them tongues parting asunder, like as of fire; and it sat upon each one of them. And they were all filled with the Holy Spirit, and began to speak with other tongues, as the Spirit gave them utterance. (Acts 2:1–4)

2. The female ostrich never takes her eyes off her eggs. When we attend church we must look up at the cross, and not take our eyes off it, remembering the sacrifice that Jesus made on our behalf.

3. In the same way that the baby ostrich breaks through and sheds its egg, through the sacrament of baptism we shed our original sin.

Ethiopian churchyards are usually surrounded by a high stone wall with an entrance which is sometimes in the form of an elaborate gatehouse. Within the church compound will be the church bell, which can be a conventional bell, but, in the case of remote churches, is often two large rocks individually suspended from a tree which can then be banged together with the resultant sound being very much like that of a cast bell. I have even seen in several churches empty shell cases of Russian manufacture (from the war to overthrow Mengistu) serving as the church bell.

Before entering an Ethiopian church it is necessary to remove your shoes:

When the Lord saw that he had gone over to look, God called to him from within the bush, 'Moses! Moses!' And Moses said, 'Here I am.' 'Do not come any closer,' God said. 'Take off your sandals, for the place where you are standing is holy ground.' (Exodus 3:4–5)

The floor of the church is usually strewn with hay, which, unfortunately for the visitor, is a paradise for fleas. In a corner will be a pile of prayer-sticks used by the priests to lean on while standing through the very lengthy services. Also evident will be the drums, sistra for the *dabtaras*, ceremonial fans and colourful umbrellas. The *qabaro* is the church ceremonial drum of the barrel-shaped, tubular design with a double membrane. The *negarit*, or military drum, found in Ethiopian churches because they have been donated by members of the congregation, is of the bowl-shaped, single-membrane type. And in another corner you will usually find an *alga,* a leather-thonged, Indian charpoy-type bed for the use of the guardian of the church.

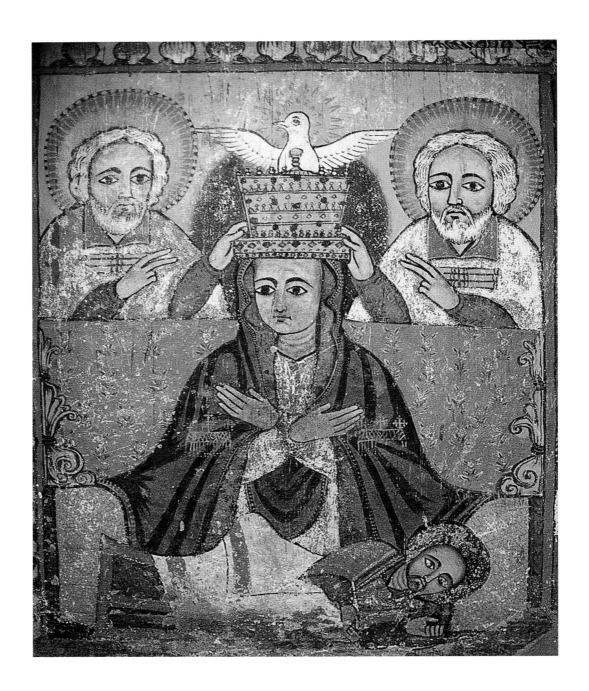

Chapter 2
Ethiopian Christianity and Saints

The Coming of Christianity

The Ethiopians believe that they are one of the earliest countries to have become aware of Christianity. They base this belief on Acts 8, where the apostle Philip converted and baptised an Ethiopian eunuch, the treasurer of Queen Candace. All the Jewish customs, such as circumcision and observance of the Sabbath, are seen as proof of the antiquity of their faith, which is reflected in this biblical episode:

> Now an angel of the Lord said to Philip, 'Go south to the road – the desert road – that goes down from Jerusalem to Gaza.' So he started out, and on his way he met an Ethiopian eunuch, an important official in charge of all the treasury of Candace, queen of the Ethiopians. This man had gone to Jerusalem to worship and on his way home was sitting in his chariot reading the book of Isaiah the prophet [...]. The eunuch asked Philip, 'Tell me, please, who is the prophet talking about, himself or someone else?' Then Philip began with that very passage of Scripture and told him the good news about Jesus. As they travelled along the road, they came to some water and the eunuch said, 'Look, here is water. Why shouldn't I be baptised?' And he gave orders to stop the chariot. Then both Philip and the eunuch went down into the water and Philip baptised him. (Acts 8:26–8 and 34–8)

The conversion of the King of Ethiopia to Christianity took place early in the fourth century, as confirmed by the contemporary Latin historian, Rufinus, who describes how a Christian merchant, Meropius of Tyre, returning from a trip to India in a trading vessel, stopped at one of the Red Sea ports for provisions, where all the passengers were killed except for two young Syrian boys, Frumentius and Aedesius. They were taken to the court of King Ella Ameda in Aksum, where they both became employed by the King. Frumentius eventually became a royal scribe and treasurer, and when the King died,

he served as regent for the young king, Ezana. Frumentius spent much of his time working to spread the Christian faith, and, as a result, both Ezana and his brother, Saizana, became Christians and are known as Abreha and Atsbeha. Their bodies are believed to have been buried in a church named after them – Abreha Atsbeha – in Tigray, just north of Wukro.

When the young King Ezana had become an adult and Frumentius had completed his regency, the two Syrians left Aksum, Aedesius for Tyre in order to see his parents, and Frumentius for Alexandria, one of the five great centres of the early Church. There, he attempted to persuade the patriarch, Athanasius, to send a bishop to Aksum, but instead Athanasius consecrated Frumentius himself, proclaiming before the assembled bishops, 'What other man shall we find in whom the Spirit of God is as in you, who can accomplish these things?' (Rufinus, *Historia Ecclesiastica* 10.9–10).

On his return to Aksum, Frumentius spread the faith throughout the kingdom. Frumentius was to become the first *abuna* of Ethiopia, the head of the Ethiopian Church, and from then onwards every *abuna* was selected and appointed by the Coptic Patriarch of Alexandria until as recently as 1959.

The Nine Syrian Saints

The nine Syrian saints of the Ethiopian Church came from various parts of the Eastern Empire. They probably arrived during the fifth and sixth centuries. At that time, the Empire was deeply divided over the controversy concerning the nature of Christ. The controversy turned on the understanding of the term 'nature' and in what way Christ could be understood to be both human and divine. The Monophysites taught that Christ had a single nature which was at once both human and divine, while their opponents taught that the divine and human natures remained distinct though united in a single 'Person'.

The debate was important because, in the eyes of all concerned, it was precisely the union of the divine and human natures in Christ that enabled the reconciliation and union between God and our own human nature, which was the whole rationale behind the Incarnation. The Council of Chalcedon in AD 451 proclaimed monophysitism a heresy, and, as a consequence, the Coptic (Egyptian), Syrian and Armenian Churches separated from the rest of the main body of what is usually called the 'Orthodox' or 'Catholic' church.

It is probable that the first Syrian monks arrived soon after these events so as to escape persecution. Indeed, their migration to Ethiopia probably continued for at least the next hundred years because Byzantine society continued to be deeply divided over this issue. Theodora (AD 500–48), the wife of Emperor Justinian (AD 482–565), was herself a Monophysite and bravely tried to protect her fellow believers, but nonetheless the persecution continued.

The nine Syrian saints were learned monks who probably found Ethiopia in a lapsed state, revitalised Christianity in the country and established important monasteries in the north. They created church schools and translated the Bible and other Christian writings into Ge'ez, the official language

of the Ethiopian Church to this day, the equivalent of Latin in European Christianity. The Syrian saints did much to strengthen the Christian faith in Ethiopia in its present Monophysite form.

The *Synaxarium* of the Coptic Church, where the stories and legends of saints are told together with their related feasts and fasts for every day of the year, was translated from Arabic to Ge'ez in the thirteenth or fourteenth century. The object of the *Synaxarium* was to instruct the believers in the doctrine of the Orthodox faith as understood by the Copts, that is to say, Christ had one nature, he was one person, and he was of one substance with the Father. The faithful were to abhor the doctrine of two quite separate natures promulgated by Nestorius and the 'abominable writings' of Arius. A further object was to inform them of the history of their religion and the lives of the saints and martyrs. It was intended to interest and amuse its hearers as well as to instruct them. The *Synaxarium* was translated by Sir E. A. Wallis Budge into English in 1922, and many of my quotations are taken from his work.

The nine Syrian saints, of whom you will hear so much during your visits to Ethiopian churches, are listed below, together with something of what is said about them in the *Synaxarium*:

Aragawi, also known as *Abba* Za-Mikael. He became a monk at the age of fourteen in the monastery founded by *Abba* Pachomius (d. AD 348) where he was given the name Za-Mikael. Legend has it that he reached the summit of the *amba* of Debre Damo (the monastery which he founded) holding the tail of a serpent, and that is how he is often represented.

Pantaleon, also known as Za-Somaet (the cell). He was the son of noble Byzantine (Roman) parents. As a child, his mother took him to a monastery, where he grew up in wisdom, praying and fasting. He went to Ethiopia at the time of King Ella Ameda II, and he lived in Bet Katin. He founded the monastery which bears his name, just outside Aksum. Later, *Abba* Pantaleon went up to the top of a small hill in Aksum and made himself a small cell where he remained standing upright in prayer for forty-five years. When King Kaleb was about to wage war in Yemen in about AD 525, he came to *Abba* Pantaleon and asked his advice. He said to the King, 'Go in peace, for God is able to do all things and He shall give thee victory over thy enemy.' Kaleb went to Saba and conquered it, and his army testified that they had seen *Abba* Pantaleon standing with them during the battle, overthrowing their enemy. When Kaleb returned, having conquered the kingdom of Yemen, he gave up his crown and became a monk with Pantaleon.

Garima, whose father was Masfeyanos, a Byzantine emperor. His mother was Sefengeya, who bore him through the intercession of the Virgin Mary after fifteen years of barrenness. He was sent to study theology at the age of twelve. Following his father's death he became king against his will. After he had ruled for seven years, he was summoned by *Abba*

Pantaleon, and, with the help of the archangel Gabriel, he reached Aksum in three hours! There he remained with Pantaleon for five years. He then went to Madara and founded a monastery, where he stayed for many years performing miracles. Emperor Gabre Maskal is reputed to have built him a church there, which he endowed liberally.

Aftse, who changed the Sabean 'Temple to the Moon' at Yeha into a Christian church and founded a monastery there which bears his name.

Guba, who reputedly came from Cilicia, now in modern Turkey. After remaining with *Abba* Pantaleon for some time, he went out into the desert of Baraka and disappeared.

Alef, who was from Caesarea. He founded the monastery at Beheza in Ahseya. A monastery named after him was founded near Adwa.

Likanos (or Libanos), also known as Mataa. He was born into a noble Byzantine family. His parents, Abraham and Negest, were very rich. On the day when they brought a wife to him, the archangel Gabriel appeared to Likanos in the night and took him from his father's house to the monastery of *Abba* Pachomius in Egypt, where he became a monk. He stayed at Baqela for seven years, translating the Gospel of St Matthew into Ge'ez until he was summoned to Aksum by the *Abuna*. When he indicated the corrupt practices of the *Abuna*, he was forced to withdraw to Darraga by the emperor. He remained in a cell in Darraga until the emperor and the *Abuna* were constrained by God to accept his criticism, and then he went to Guna-Guna. Here he was visited by Emperor Gabre Maskal, who built the church of Beta Maskal for him. He was a missionary in the pagan areas north of the Marab and Belesa rivers and became known as the 'Apostle of Eritrea'. Many churches were built for him in the district, and it is said that he was able to make sources of water spring from the ground.

Yemata, who is reputed to have come from Qusyat. He founded a monastery at Endarte in the Geralta region of Tigray.

Sehma, who fought a good fight and pleased God! He founded the monastery of Sedenya.

The *Synaxarium* states that God made a covenant of mercy with the majority of saints just before their deaths. It means that these saints can intervene in favour of sinners. These covenants have a biblical origin; in the Bible, God made covenants with Noah (Genesis 6:17–8 and 9:12–3), with Abraham (Genesis 15:18 and 17:7) and with Moses (Exodus 31:16 and 34:10).

Up to the thirteenth century, the cultural centres of Christian Ethiopia were mainly those monasteries founded by the nine Syrian saints in the northern province of Tigray. Though local churches tried to provide some elementary instruction in reading and writing, it was the old monasteries that provided serious religious and literary training.

Then, in about 1248, a young monk named Iyasus Moa (*c.* 1211–92), who had trained in the famous monastery of Debre Damo, where he distinguished himself as an outstanding calligrapher, opened a small monastic school much further south, on the island of St Stephen in Lake Hayq, just north of Addis Ababa. One of his pupils, Yekuno Amlak, became the restorer of the Solomonic Dynasty. The importance of Iyasus' monastery was that, thenceforth, students who wanted to further their religious or monastic training did not have to go north to Tigray. Tekle Haymanot was another of his disciples.

Other Saints

Tekle Haymanot

Tekle Haymanot, the son of Saga-Za-'Ab and Egzie-Haraya, was born at Zorare, in Selales, a district on the eastern edge of the Shoa plateau, at a place today known as Etisa. He descended from a family of Christian immigrants who had settled in the region over ten generations earlier. He appears to have received his early education from his father. A significant turning point in his religious career occurred when he decided to join the island monastery recently established by *Abba* Iyasus Moa at Lake Hayq, where he was to remain for the next ten years. He then left for Tigray with the intention of making a pilgrimage to Jerusalem. Apparently he failed to do this but instead settled at the monastery of Debre Damo where he stayed for more than a decade, gaining a deeper insight into the history and ecclesiastical traditions of Ethiopia that ensured his undisputed leadership of the Church. He was to return briefly to Hayq with a number of followers but was advised by Iyasus Moa to go back to his native Shoa.

Fig. 9. Tekle Haymanot, Abuna Gabre Mikael (Koraro)

Shoa was still predominantly pagan at this time, and Tekle Haymanot began to preach in this province with many disciples joining him. He finally settled at Debre Asbo, where he founded a monastery, later to be known as Debre Libanos. His followers became so widespread that most of Ethiopia's monastic centres derive their origins from his spiritual leadership and are known collectively as the 'House of Tekle Haymanot'. The *Echege* (the head) of the Ethiopian Church was always elected from the abbots of this monastery – not to be confused with the *Abuna* (the patriarch), who was appointed by Alexandria.

In 1270, according to tradition, it was Tekle Haymanot who was instrumental in obtaining the abdication of the last Zagwe ruler in favour of the Solomonic Yekuno Amlak, an accomplishment that was financially very beneficial to the Ethiopian Church.

Legend has it that Tekle Haymanot eventually withdrew from the monastery to a cave at the foot of the gorge of Asbo, where he prayed, night and day, standing upright, for twenty-two years. To prevent him succumbing to sleep and falling down, he had vertical wooden spikes placed around him in his tiny cave. Not surprisingly, after twenty-two years, his right leg withered and fell off!

Another legend describes how an angel appeared to Tekle Haymanot while he was living in the monastery of Debre Damo. The angel ordered him to visit all the monasteries in Tigray. Tekle Haymanot went to see Abbot Yohanni and told him of the order he had been given. Debre Damo is an exceedingly precipitous mountain from which it was only possible to descend with the use of a rope (as it still is today). Abbot Yohanni and his monks watched as Tekle Haymanot began his descent when the rope suddenly gave way under his weight. To their amazement, six wings immediately sprouted from the saint, enabling him to fly away.

The paintings of Tekle Haymanot, which are to be seen in most of Ethiopia's churches, depict him in two ways:

1. As the ecclesiastical leader, enveloped in a shawl, which is usually decorated around its edges with what appears to be little bells. Very frequently he appears in the company of *Abba* Ewostatewos, the other great leader of the Ethiopian Church.

2. As a saint who has lost his right leg, as described by legend, and with the angels' wings which he acquired when the rope snapped at Debre Damo.

Abba Ewostatewos (*c.* 1273–1352)

Abba Ewostatewos was born in Geralta in central Tigray and became a student under his uncle, *Abba* Daniel, who was the abbot of Debre Maryam. When he left Geralta, he established his own community in Sarai, in what is today southern Eritrea. Later, he was to be persecuted by his colleagues, primarily for insisting on the Old Testament custom of celebrating the Sabbath on a Saturday, a strong belief he inherited no doubt from his teacher, *Abba* Daniel, whose nickname was 'Rock of the Sabbath'. He fled

Fig. 10. Tekle Haymanot and *Abba* Ewostatewos, Debre Sina Maryam (Gorgora)

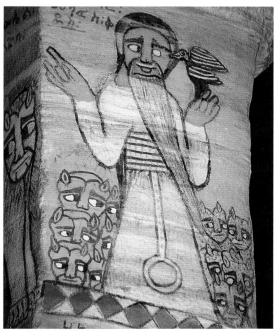

Fig. 11. Gabre Manfas Kiddus, Abuna Gabre Mikael (Koraro)

to Egypt in about 1338, apparently to plead his case before the Patriarch, and then went on to Palestine, Cyprus and Armenia, where he died in 1352 after fourteen years of self-imposed exile.

After his death, some of his disciples returned to Ethiopia to join up with those of his followers who had remained behind. Together they organised themselves into a major monastic group which founded a series of settlements that were to become known as the 'House of Ewostatewos', as distinct from the followers of Tekle Haymanot. Both 'houses' were to emerge as powerful forces in Ethiopia's monastic life, that of Ewostatewos being based in the north and that of Tekle Haymanot in the south.

In 1449, Emperor Zara Yakob convened a church council at Debre Metmaq in Shoa at which the orthodoxy of observing the two Sabbaths was recognised, and the followers of Ewostatewos were formally admitted into the Orthodox Ethiopian Church.

Gabre Manfas Kiddus and *Abba* Samuel

There are a number of anchorite saints depicted on the walls of many Ethiopian churches. They all have two things in common. They lived in harmony with the animal kingdom, curing the creatures and extracting thorns from their paws. In turn, the animals became their trusted servants, complying with the prophecy in Isaiah 11:6–9:

The wolf will live with the lamb, the leopard will lie down with the goat, the calf and the lion and the yearling together; and a little child will lead them. The cow will feed with the bear, their young will lie down together, and the lion will eat straw like the ox. The infant will play near the hole of the cobra, and the young child put his hand into the viper's nest. They will neither harm nor destroy on all my holy mountain, for the earth will be full of the knowledge of the Lord as the waters cover the sea.

These animals are sometimes depicted as carrying pots of water for the saints or transporting the saints on their backs. The most famous of the anchorite saints are the Egyptian, Gabre Manfas Kiddus and the Ethiopian, *Abba* Samuel. *Abba* Samuel is always depicted riding his lion, and sometimes his two disciples, *Abba* Zarufael and *Abba* Gabre Maskal, are portrayed nearby. Gabre Manfas Kiddus is usually surrounded by panthers and lions and sometimes with a bird pecking at his eye. This represents an episode in his legend when he allowed a thirsty bird to drink his tears in the desert.

Gabre Manfas Kiddus means the 'servant of the Holy Spirit'. His feast is on the 30th of Magabit. According to the *Synaxarium*, he was born in the city of Nahisa in Egypt. As a child, the archangel Gabriel carried him on his wings to the seventh heaven to be presented to Mary and other saints. When he was a young man, God commanded him to withdraw into the inner desert where he lived with sixty lions and sixty leopards. When he asked God what the animals would eat, the answer was, 'When you treadest on the ground with thy foot, they will lick the dust of thy feet, and they will be satisfied' (*Synaxarium*, Magabit 30). He himself survived by only eating fruit, roots and herbs.

The Lord ordered him to go to Ethiopia, where he was taken by the archangel Gabriel, who brought him down in the desert. His hair grew thick all over his limbs. His beard was one cubit long, and his hair seven cubits long. He devoted himself to prayer, not eating till his body dried up and his skin became stretched tightly over his bones. He lived like that for a hundred years. He stood upright like a pillar for six months and gazed into Heaven, neither dropping his eyelids nor bowing his head and with his hands stretched out towards Heaven.

Abba Samuel of Waldebba, together with his parents Stephen and Ammata Maryam, moved to Aksum when he was young, and there he was taught the Books of the Church. When his parents died, he became a monk in the monastery of Debre Bankol where the abbot Medhani Egzio became his spiritual father. He devoted himself to fasting and praying, standing up and prostrating himself so strenuously that he became flat-footed.

From Debre Bankol, he went into the desert, where he ate no food and drank no water for forty days. Lions, leopards and all sorts of terrifying beasts came to him, bowed down before him and licked the dust off his feet. One day he arrived at a river, holding a book and a torch of twigs.

Fig. 12. *Abba* Samuel, Abreha Atsbeha (Geralta)

Making a prayer, he entered the water, and, even though it engulfed him and the strength of the current dragged him down, through the power of God he found himself on the opposite bank, the torch still alight and his book intact.

Satan tempted him with all kinds of wild beasts, but he feared none because he had faith in God. One day as he prayed, Jesus Christ filled him with power. From that day on he bound his feet with fetters and wore a sackcloth; he recited the psalms of David five times a day; and he scourged his back with innumerable lashes. The lions came to his care like sheep, and he used to stroke their bodies and dress their wounds and pluck out thorns from within their paws.

Many disciples attached themselves to him, the first being *Abba* Zarufael. One day *Abba* Samuel met *Abba* Gabre Maskal of Debre Leggaso. They had never met each other before. They spent the day discussing the great works of God. When it was time for supper and they were praying, a table came down from Heaven, and they ate and gave thanks to God. He was in the desert for twelve years.

One day when he was consecrating the offering, there came down to him bread and a chalice from Heaven, and when he was reading the praises of Our Lady Mary, he was lifted up a cubit from the ground, and the Virgin Mary came and gave him a radiant stone and pure incense. When his time of departure came, the archangel Michael came to him, caught him on his wings and lifted him up to heavenly Jerusalem. There he showed him its delights and brought him to the throne of God, who promised *Abba* Samuel that the man who should invoke his name or celebrate his commemoration would be saved. He returned to his bed, told his disciples everything he had seen, and then he died in peace.

St Raphael

Feast Day: 3rd of Pagwemen. According to the *Synaxarium*, a church was built on an island outside Alexandria and dedicated to the archangel Raphael. On the day of the saint's commemoration, the church began to shake and was in danger of being carried into the depths of the ocean together with its congregation. It transpired that it had been built on the back of a sea monster (usually depicted as a

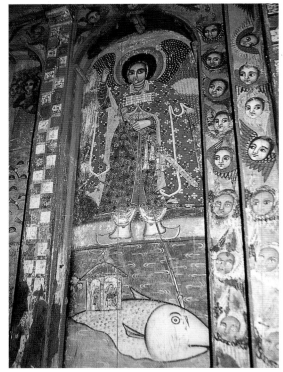

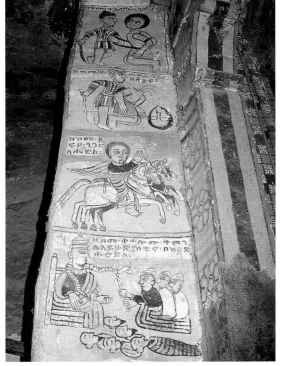

Fig. 13. St Raphael with the whale, Narga Selassie (Lake Tana)

Fig. 14. The story of Gigar, Abreha Atsbeha (Geralta)

huge fish, resembling a whale), which Satan shook in order to have it destroy the church. The Patriarch and his congregation cried out and prayed to Our Lord Jesus Christ, who intervened by despatching the archangel Raphael to the scene. Raphael impaled the monster on his spear and commanded that it should not move from that time henceforth.

St Raphael frontally depicted with his archangel's wings, usually appears on one of the doors of the sanctuary as a guardian saint, with one hand grasping his sword hilt and the other holding a spear with which he is piercing a whale below him. On the whale's back is the church within which one can see the figures of the frightened congregation.

Gigar

The story of Gigar is depicted in most of Ethiopia's churches. It is a legend that appears in the book *Legends of Our Lady Mary the Perpetual Virgin and Her Mother Hanna*. According to the Ethiopian Church, he is the first martyr for Jesus' sake and was slain by Herod. The legend is set against the background of Herod's persecution and his attempt to find the Holy Family in Lebanon during their flight into Egypt. This is why paintings of Gigar's story are usually positioned next to murals of the Flight into Egypt.

The Holy Family had found refuge in the desert of Lebanon, but Herod became aware of where they were and went with his soldiers to find them. However, the Holy Family was helped by Gigar, who was the governor of Syria, and by Emperor Domitianus. Because of this, Herod had Gigar imprisoned and tortured. While in prison, certain strange happenings occurred, which were attributed to Gigar, and he attained the reputation of being a magician. He would have a serpent slither into Herod's throne room and kill those near the King.

One day, the serpent wrapped itself around Herod's neck and could not be removed. An ironsmith had attempted to free it with a pair of pincers but was then bitten by the snake and died immediately. Herod had Gigar brought before him and ordered him to remove the serpent, which Gigar did – once, twice, three times – but each time the serpent returned to Herod's neck. And so Herod commanded that Gigar be beheaded.

Gigar was taken to an olive grove where, while he prayed to the Lord, he heard a voice say, 'Come, let us go up into Heaven that thou mayest see what I have prepared for thee, a crown, and a habitation, and thrones, which cannot be gazed upon with polluted eyes' (*Legends of Our Lady Mary*, p.228). And suddenly Elijah caught him up into his chariot to Heaven, and he saw everything that had been promised him in the abode of the faithful. And he saw Herod in Hell, as black as a raven, the angels smiting him with a sword of fire, and he also saw his Father and the King of Kings. Then the angel brought him back to the olive grove.

Where Gigar's head fell after his execution, a large flowering tree sprung up which could be neither felled, burned nor smothered. Herod heard of this miracle, and when he came to see it for himself, an apparition of a mounted Gigar appeared before him and startled his horse so that it shied and threw the King. Herod was then borne away by his soldiers to his palace.

The paintings illustrating the story of Gigar in Ethiopian churches depict different episodes of his legend but not in any logical sequence. The most commonly portrayed scenes are those of the serpent around Herod's neck; the ironsmith with his pincers attempting to remove it, with the bodies of those already poisoned by the serpent lying before the King; Gigar being decapitated; and the apparition of Gigar riding a horse next to Herod and Herod falling from his mount. The scenes that are shown less frequently, as in Debre Berhan Selassie in Gondar, are those of Gigar being beheaded with a large flowering tree appearing where his head falls and Herod's rearing horse with the King prostrated on the ground having been thrown.

St Yared

St Yared was the inventor of Ethiopian church music. He is occasionally depicted in church frescoes (Abuna Gabre Mikael at Koraro being one of them), dancing and shaking the sistrum, holding the prayer-stick (*makwamiya*) in front of Emperor Gabre Maskal. His life story has been told in the *Kebra Negast* (Glory of the Kings). He was born on 25 April AD 505 in the city of Aksum. His father was named Adam and his mother Taklia, and he was descended from a line of Aksum priests.

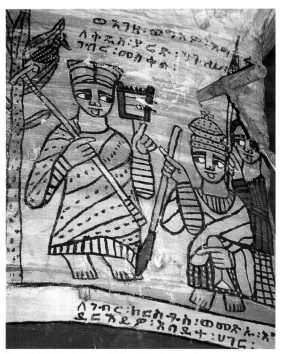

Fig. 15. St Yared, Abuna Gabre Mikael (Koraro)

When he was six years old, his parents sent him to Yishaq, a teacher in Aksum. He learned the alphabet and he began to study the psalms. However, he had great difficulty learning his lessons and was sent back to his parents. His mother sent him to her brother, *Abba* Gedeon, who was a parish priest, so that he should raise and educate Yared. *Abba* Gedeon taught at the monastery of St Mary of Zion in Aksum. For years Yared lagged behind the others in his studies and was constantly reprimanded and punished by his new teacher.

Yared was not a bright student, and however much he studied he could not grasp his lessons. Because of his slow-mindedness, he became an object of derision and mockery to his classmates. One day, his uncle whipped him severely, and he fled from school. He became caught up in a heavy shower and was obliged to take cover under a tree near a spring called Maikerah, four kilometres outside the city of Aksum. While sheltering under the tree, brooding about his academic failure, he witnessed an event that was to change his whole life. His attention was caught by a caterpillar, struggling time and again despite repeated failures, to climb up the trunk of the tree to eat its leaves (reminiscent of Robert the Bruce and his spider). Watching the perseverance of the caterpillar, Yared wept, comparing his weakness with the strength of the grub.

After seeing the stamina of this tiny creature, he decided to return and take up his studies again. He reasoned that man was a creature superior to a caterpillar, and, as the caterpillar, with repeated effort, had reached its goal and eaten the leaves of the tree, he too should put up with the whipping, study diligently and succeed. He went back to his teacher. Now he went to church every day to pray to God to give him wisdom. God heard his prayers and endowed him with insight and intelligence. His teacher was amazed. He quickly completed the study of the Old and New Testaments, he learned Hebrew and Greek, and became as knowledgeable as his teacher. When his uncle died, even though he was only fourteen years old, he took over his teaching duties.

In the *Synaxarium*, we are told how Yared created the chant, inspired and guided by the Holy Spirit. At this time there was no set of rules for the liturgical chant. Three angels were sent from Paradise in the form of three birds to teach Yared heavenly songs in his own language. The birds circled

in front of Yared and sang sweet and captivating new songs to him. Then they carried him off to heavenly Jerusalem, where twenty-four angels were singing. While he was in Heaven, he heard the angels praising God with musical instruments such as the *inzira* (large flute), the *masingquo* (one-stringed violin), the *tsenatsil* (type of sistrum), the *qabaro* (church drum) and the *begena* (great harp). He thus had these instruments made and used them to accompany his hymns. Yared composed a large number of chants, which are called *zema*, and these are written in a book called *Deggua*. He introduced the *makwamiya* (prayer-stick) to provide support during the long services.

All the hymns composed by Yared continue to be sung by the priests and *dabtaras*, accompanied by the various musical instruments introduced by him. As Ullendorff states in his book *The Ethiopians* (1973):

> The entire spectacle, the carrying of the *tabot* in solemn procession, accompanied by singing, dancing, beating of staffs or prayer-sticks, rattling of the sistra and the sounding of drums, has caused all who have witnessed it to feel transported.

St Yared taught the nine Syrian saints the hymns found in the *Deggua*. Yared, apart from composing hymns, went from place to place teaching. One of the places was the monastery on Lake Tana, St Qirqos, where he stayed for two years. This is where he wrote his *Deggua*. The original of this book, the bowl in which he is said to have mixed the ink, and his sistrum and prayer-stick are preserved to this day in this monastery (where men only are allowed to visit). Yared died at the age of sixty-six on 20 May AD 571 in a cave below the Simien Mountains.

Abba Bula, also known as Abib

Feast day: 25th of Teqemt. *Abba* Bula came from Rome. His life story is related in the *Synaxarium* and is summarised below:

> His Christian parents, Abraham and Harik, had to flee from city to city during the reign of Emperor Maximianus II (305–11), who was renowned for his pitiless persecution of Christians. They had no son, and so they entreated God with fasting and prayers to give them one. An angel appeared to them in a dream and gave them a vine full of grapes, and when Harik conceived, a large tree near their home blossomed and on its leaves was the name 'Bula' meaning servant of God.
>
> Bula was ten years old when a villainous governor arrived and ordered the people to worship idols. Bula went to the governor and cursed his idols. When the governor saw the small stature of the boy, he marvelled greatly but nevertheless commanded his soldiers to drive nails into him, scrape his body, strip off his skin, saw off his hands and feet, beat his back with whips, cast him on a wheel and drag him along the roads of the city. St Michael arrived at the scene to save and heal Bula.

Bula went to another villainous governor and reviled him; as a result he was beheaded. St Michael raised him up unharmed and took him to the desert and gave him the clothes of a monk. Bula went into a withered tree to live, and whenever he remembered the crucifixion of Jesus, he threw himself down from the top of the tree. One day he did this and died [not surprisingly!], but Jesus raised him up and said to him, 'Bula, your name shall be Abibha and you will become many fathers' [meaning he would be the spiritual father to many people]. Bula lived in the desert of Scete for forty-two years without eating or drinking and died when he was sixty-six years old [even less surprisingly!].

The Equestrian Saints

In the stratified society of highland Christian Ethiopia, where only noblemen were trained in the art of horsemanship and war, victorious equestrian saints had a specific appeal.

St George of Lydda (as King of Martyrs)

Feast Day: 23rd of Miyazya. He is the soldier saint *par excellence*, the horseman of Christ. As King of Martyrs, he is depicted sitting astride a magnificent stallion with splendid trappings, covered with a richly embroidered saddle-cloth. He is not portrayed spearing a dragon. In Ethiopia, as in many countries, he is regarded as a national hero. The story of his life is told in the *Synaxarium* which I have summarised as follows:

George was the son of Anastasius, a native of Cappadocia, and his wife Theobaste, a native of Palestine. At the age of twenty he went to the court of King Dodyanos, King of Persia, to be appointed to the office previously held by his father. He found the King setting up idols and making men worship them. George dismissed his slaves, gave all his goods to the poor and went before the King, proclaimed himself a Christian and refused to worship the idols. He was tortured many times in different ways, but Christ always healed him and told him that he would die four times, and after the fourth death he would receive the crown of martyrdom. Athanasius, a magician, attempted to poison him, and when he failed to do so, he himself embraced Christianity and suffered martyrdom. George was sawn asunder and died, and Christ raised him up to life again.

Having experienced enormous cruelty, he was finally brought to the King, who was in the company of seventy other kings, seated on their seventy thrones. They ordered him to make the thrones blossom and produce fruits. George prayed to Christ, and immediately the thrones blossomed and put forth fruits. As a result he was boiled to death, and his remains were cast out into the desert. Christ restored his soul to his body and raised him up to life for

a second time. Then George raised to life those who were dead in a certain tomb, and he was beaten to death by a soldier, and Christ raised him up a third time.

Later, George was to explain the Incarnation to Queen Alexandra, and it appealed to her, and she became a believer. On the following day, the Queen confessed to the King that she was a Christian, and he had her sawn asunder. She died and received the crown of martyrdom. The King, full of fury, ordered George to be beheaded, and the saint rejoiced. George took it with joy and prayed to the Lord that fire would come down from Heaven to destroy the seventy kings and that the persecutions against the Christians would cease.

Immediately fire descended from Heaven and burnt the seventy kings. The saint was taken outside the city and beheaded. He received three everlasting crowns. His servants took his body to Lydda and built a beautiful church over it.

In converting Queen Alexandra to Christianity, George rescued her, not from a fire-breathing scaly beasts, but from Dodyanos – the serpent/dragon who, through the eyes of Christian writers, was a fair equivalent for the Devil.

St George as Dragon-Slayer

St George is also depicted slaying the dragon and/or rescuing the princess Birutawit (Beirut) while riding a white horse at full gallop. The tradition of the white horse originated in Coptic Egypt. The theme of St George saving the daughter of the King of Beirut was unknown in Ethiopia till late in the fifteenth century and does not appear in the *Synaxarium*. It is probable that the Italian painter Brancaleone, who worked in Ethiopia from 1480 to 1526, introduced it to Ethiopian art. It has become one of the most popular ways of depicting the saint. In this guise, he embodies the fight of good against evil; he is the deliverer of the oppressed, the champion of widows, orphans, the helpless, the poor and the needy. Very often he is portrayed on a wall near the Trinity (as can be seen in the church of Maryam Papasetti)

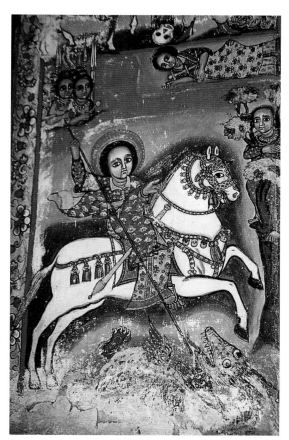

Fig. 16. St George rescuing the princess Birutawit, Narga Selassie (Lake Tana)

because it is believed that he enjoyed a close relationship with God and thus is the intercessor *par excellence* with the Trinity.

Pope Gelasius and his council of seventy-two bishops decreed in AD 494 that St George, Cherkos (Cyriacus) and Julitta's stories must not be read because they were of such a fabulous nature that they provoked ridicule. Their martyrdom had become overlaid with fabulous and impossible additions. But, despite this edict, St George remains one of the most painted saints.

St George Rescues Bifan's Son

This story is the twelfth miracle of St George as told in the Ethiopian book *George of Lydda* (translated by Budge). The story concerns a man called Befamon in Ge'ez but translated by Budge as Bifan.

Bifan and his wife built a church to St George in the city of Bilakonya. They were very rich but had no children. St George sent them a son, and they called him George. Arabs made war on the city, and the King asked Bifan to send his son to fight. Bifan took the young man to the shrine of St George and committed him to his care. George went to the war and was taken prisoner.

On the night of the festival of St George, Bifan and his wife called upon the saint to give them back their son, and, at the same time, George was praying to the saint for deliverance. Suddenly a horseman appeared in the camp, and he seized George just as he was about to drink wine from a cup and swung him up behind him, in sight of all the men, and in the twinkling of an eye George found himself in the church which his father had built. The verger,

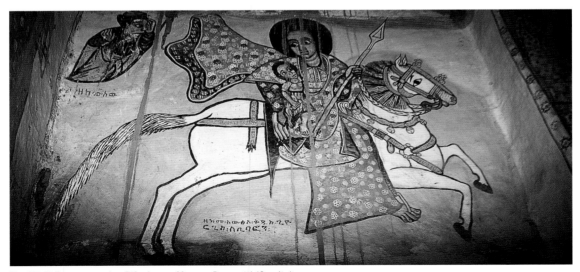

Fig. 17. St George rescuing Bifan's son, Maryam Papasetti (Geralta)

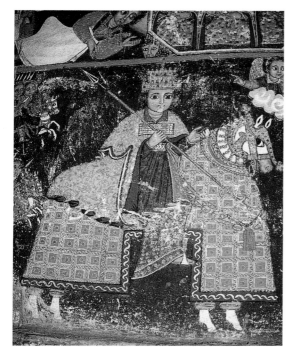

Fig. 18. St Fasilidas, Selassie Chelekot (near Mekele)

judging by George's garb, thought he was an Arab and raised a cry for help. The congregation rushed from their places and, thinking he was a spy, threw him out of the church. At length George found his tongue and explained the matter and held out the wine cup from which he was about to drink when the horseman seized him. The cup was still full of wine. The horseman was, of course, St George.

Representations of this story usually show a mounted St George holding a spear with Bifan's son seated behind him.

St Fasilidas

St Fasilidas was Emperor of Ethiopia from 1632 to 1667. He was instrumental in expelling the Roman Catholic missionaries, burning the Ge'ez translations of their books and re-establishing the Ethiopian Orthodox Church. He represents civil and religious authority. He reissued the book *Faith of the Fathers,* a collection of excerpts from the writings of the Eastern Church, thus symbolising the triumph of the Ethiopian Orthodox Church over Roman Catholicism. Emperor Fasilidas founded his capital at Gondar where he built seven churches.

Basilides, Theodore the Oriental, Claudius and Victor

The equestrian saints Basilides, Theodore the Oriental, Claudius (Gelawdewos), and Victor (Fikitor) were members of the Roman aristocracy and related by blood. Others were high-ranking officers in the Roman army. They are usually portrayed on horseback and at full gallop.

St Basilides (*Qeddus* Fasilidas)

Feast Day: 11th of Meskerem. He was the general in charge of the Roman troops in the city of Antioch. His sister was married to Emperor Numerian (AD 283–4). Rather than become part of a plot to oust Emperor Diocletian (AD 284–305) for his idolatry, Basilides announced his own belief in Jesus Christ for which he underwent torture and death. St Basilides was the father of Eusebius and Macarius, who also were to be sanctified.

He is usually represented with his spear slanted upwards, and in Gondarine style portraits he is depicted in much the same manner as St George, King of Martyrs – resplendent astride a majestic horse.

St Theodore the Oriental (Masraqawi, aka Banadlewos)

Feast Day: 12th of Terr. He was born in Antioch and was related to the royal family. He became a soldier and fought against the Persians. Christ appeared to him in a dream and said that Theodore would shed blood for his sake. On his return to Antioch, Emperor Diocletian ordered him to worship Apollo, which he refused to do and was put to death. He is normally shown riding a red horse.

St Theodore the Roman (Tewodros Romawi)

Feast Day: 28th of Yakatit. He was born in Amasya in Turkey. He was a senior military commander in the Roman army. The story is that he set fire to the idols in the temple of Cybele in Amasya and that the governor of the town violently struck him but God sent the archangel Gabriel to his aid and the archangel killed the governor. Gabriel then gave Theodore a white horse on which he rode through Asia converting many people. When the Emperor heard of this, he sent soldiers to put the converts to death. When the soldiers approached Theodore, his horse breathed fire and burned them to ashes. Theodore was finally burned alive by Emperor Maximianus II (AD 305–11) in AD 306.

He is usually portrayed riding a white horse breathing spiritual fire and setting alight the evil ones which it is trampling.

St Theodore the Egyptian (Tewodros liqa serawit)

Feast Day: 20th of Hamle. His father John was from Upper Egypt. John went with his regiment to the city of Antioch, where he married the daughter of a pagan nobleman, who gave birth to Theodore. When his mother wanted to have him brought up in the house of idols, his father refused. She became angry and drove him out of the house but kept the child with her. John prayed ceaselessly and entreated God to guide his son Theodore to Christianity. The child grew up and learned philosophy, wisdom and literature. Jesus Christ illuminated his heart, and Theodore was baptised. He joined the Roman army and became a general.

The people of the city of Eukitos worshipped a great serpent and offered it a human sacrifice every year. While Theodore was passing through this district, he saw a woman in distress and asked her why she was crying. She answered that she was a widow and that they had taken her two sons to offer them as a sacrifice to the serpent. He dismounted and turned his face towards the east and prayed and then drew near the serpent. The serpent was fourteen cubits long, but God gave him power over it, and he speared it and killed it, and saved the widow's two sons.

When Theodore returned to Antioch he found that Emperor Diocletian was persecuting Christians. He came before him and announced that he himself believed in Jesus Christ. The Emperor

ordered him tortured and cast into the fire, but the Lord saved his soul. Churches were built in his name in many cities.

St Theodore the Egyptian is usually mounted on a grey and white horse and slaying a serpent.

St Victor (Fikitor)

Feast Day: 27th of Miyazya. The *Synaxarium* tells us that his father, Romanus, was a captain and close advisor to Emperor Diocletian (AD 284–305). His mother, Martha, was a Christian. Victor himself became a Christian and an officer in the palace. His close friend was Claudius. He had St Theodora, the mother of Cosmos and Damian, decently buried when others were afraid to do so. As a result, his father denounced him to the Emperor, who sent him to Alexandria to be chastised by Governor Herminius. Before departing he threw his military girdle into the face of Diocletian.

In Alexandria he was severely tortured; his tongue was torn out; he was hung upside-down; thrown into a hot oven; boiling oil and pitch were thrown over him; and salt rubbed into his eyes. While he was enduring these horrific tortures, an angel took his soul to Heaven and showed him around and then returned his soul to his body. From then on, every time he was tortured, God gave him strength.

A girl witnessed his torture from her window and observed that he was attended by angels, who were crowning him. As a result she became a Christian, and the governor had her tortured as well. Herminius then ordered that Victor be beheaded. Martha made the journey to Egypt to find her son's body, which she then wrapped and removed to Antioch, where she had a beautiful church built for him.

St Claudius (Gelawdewos)

Feast Day: 11th of Sene. Claudius was of noble family; his father Ptolemy was the brother of Emperor Numerian (AD 283–4). According to the *Synaxarium*, he was hero-worshipped by all in Antioch because of his righteousness and his courage in battle. When war broke out with Armenia, Claudius marched against the enemy and won. He then returned to Antioch where he found that Emperor Diocletian (who had succeeded Numerian) had reverted to worshipping idols.

He and his friend Victor made a pact to shed their own blood for Jesus' sake. However, because of his popularity with the people, Diocletian dared not harm Claudius in Antioch. Eventually, Victor's father Romanus persuaded him to send Claudius to Egypt to be tortured and killed as had been done with his son. In Antioch, the governor tried to convert Claudius but did not succeed and, in a fit of anger, ran him through with a spear. It was his friend Victor's mother who made the journey to Egypt to find both her son's body and that of Claudius. She took both away with her for burial in Antioch.

St Claudius is usually astride a brown horse and portrayed killing the *seba'at*, a sort of centaur with a lion's body and a tail that forks into two serpents.

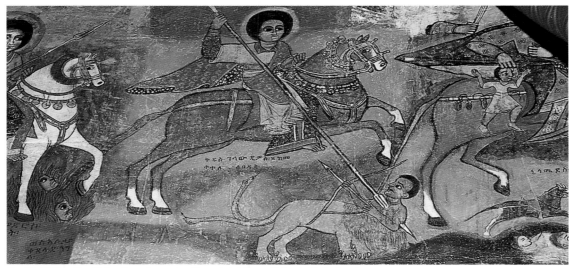

Fig. 19. St Claudius (Gelawdewos) spearing the *seba'at*, Narga Selassie (Lake Tana)

St Mercurius

Feast Day: 25th of Hedar. St Mercurius, Julian the Apostate (AD 361–6) and St Basil (d. AD 379) are all part of a story that is related in the *Synaxarium*:

> And some of his miracles took place when Julian, who denied our Lord Jesus Christ, was reigning, and in the days of St Basil, Bishop of the country of Caesarea and Cappadocia, even as it is written in one of the works of St Basil. Now Julian the infidel had inflicted very great tribulation upon those who believed in our Lord Jesus Christ, and he was wroth with St Basil and shut him up in prison, and he multiplied his works against the believers. And St Basil gathered together the believers and he prayed and made entreaty unto God concerning Julian the infidel, and he made intercession with St Mercurius. And God heard his prayer and sent His great and holy martyr Mercurius, and he came riding upon a horse and he speared Julian the infidel with his spear in his head, and the emperor died an evil death during the war in the land of Persia.

St Mercurius is usually portrayed as being mounted on a black horse (a tradition that originated in Coptic Egypt) with his spear held horizontally, its tip covered in blood, and with Julian the Apostate lying under the feet of his horse. St Mercurius is usually accompanied by St Basil and his brother St Gregory who was bishop of Nyssa from 372 to 376 and from 378 until his death *c.* 395. The two brothers are collectively referred to as the Cappadocian Fathers.

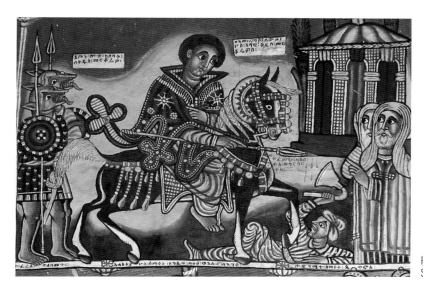

Fig. 20. St Mercurius, St Basil and
St Gregory, Agamna Giyorgis (Gojjam)

St Philoteus (Filotewos)

Feast Day: 16th of Terr. St Philoteus was from Antioch, and his ancestors were the worshippers of a bull called Maragd. When still a boy, his parents tried to make him worship the bull, but he refused, and the Lord sent him an angel to inform him of the mysteries of God. At a later date, his parents again asked that he make offerings to the bull, but instead Philoteus had the bull killed. Emperor Diocletian came to hear of this incident and had Philoteus brought to his court where he demanded that the young man worship Apollo. He had an idol of Apollo brought before him together with other idols and their priests, and immediately the earth opened up and swallowed up the idols and the priests. Diocletian then had Philoteus beheaded.

St Philoteus is usually depicted riding a dark horse and spearing a bull.

St Aboli

Feast Day: 1st of Nehase. As related in the *Synaxarium*, St Aboli was a Roman. He fought in the war, and when he returned to Antioch he found that Emperor Diocletian (AD 284–305) had denied Christ and had set up the worship of idols. Diocletian urged him to sacrifice to these idols but he refused. The Emperor then ordered that he, his father, Justus, and his wife, Theoklera, should be sent to Egypt, to the city of Alexandria. Alexandria's governor, Herminius, was ordered to separate them should they refuse to accept the idols. That night, Jesus appeared to them and warned them of what was about to happen, and he promised to receive them in Heaven.

When they arrived in Alexandria, the governor wondered why they had forsaken their royal position and tried to persuade them to return to their honourable estate. But they would not recant. So Justus was sent to the city of Antinoos, his wife to Sa and Aboli to Basta, where he was tortured severely, put on the wheel, his limbs cut off and thrown to the lions. God gave him strength and raised him up whole and uninjured from the tortures. And many of the men who witnessed this believed in Jesus Christ and became martyrs.

The governor was infuriated with him and commanded his soldiers to flay off his skin and dip rags of sackcloth in vinegar and salt and rub them into his wounds. All through this torture Aboli praised the Lord and the archangel Michael healed his wounds.

There was a certain rich man, Abskiron, who had two sons, and he brought workmen to his house to demolish a wall and rebuild it. But the wall fell on his workmen and his two sons and killed them all. Abskiron went to Aboli and cried at his feet, 'Have compassion upon me for my two sons are dead, if you raise them, I will believe in your God.'

Aboli prayed to God and then took his cloak and spread it over the dead saying, 'In the name of my Lord Jesus Christ, the Son of the Living God, do you all rise up alive', and he took them by their hands and raised them up while all the people watched. They all cried out, 'The God of the Christians, Jesus Christ, the God of Aboli, is One.' Abskiron bowed down saying, 'Now I know that Jesus Christ is a great God; I believe in Him.' All the people in his house believed with him and the governor was put to shame.

Jesus Christ appeared to the saint and made him a promise saying, 'My chosen one, Aboli, whoever shall ask me for help in thy name I will hear his prayer and will fulfil all his petitions and desires. And whoever builds a church in thy name shall have a place in My Kingdom.' And when the governor tired of torturing him, he had his head cut off, and his body was buried in his monastery of Hadak outside the city of Cairo, where he performs many miracles.

St Susenyos

Feast Day: 26th of Miyazya. St Susenyos was sent by Emperor Diocletian from Antioch to Nicodemia, where he decided to be baptised. On his return to Antioch he found that his sister had given birth to a grotesque child because she had become possessed by the Devil. He killed the child, his sister, her husband and the husband's father with his spear. When he was later in a temple of idols he commanded that they descend to Hell, and immediately the earth opened up and devoured them. He was denounced to the Emperor, and Diocletian had him tortured and put to death. St Susenyos is often portrayed spearing a female demon.

Other Equestrian Saints

Less seldomly depicted are Sts Marmehnam, Minas, Abader and Lianos, to name a few.

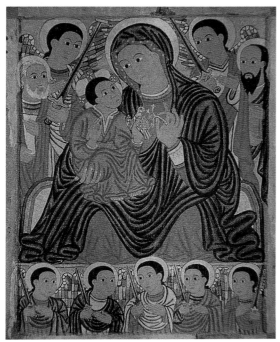

Fig. 21. Virgin and Child by Fere Seyon (Courtesy of the Institute of Ethiopian Studies)

Iconography of the Virgin Mary

The life of the Virgin Mary is one of the most popular subjects in the Ethiopian Church and has its own cycle of festivals. Many of the stories can be found in the Apocrypha texts, the *Proto-Evangelium of James* (an account of the life of Mary) and the *Pseudo-Matthew Gospel* (an account of the life of Christ). Another text, the *One Hundred and Ten Miracles of Our Lady Mary* (in which Mary relates these miracles to Theophilus and Timothy of Alexandria) exercised an enormous influence after it had been translated from Arabic into Ge'ez during the reign of Emperor Dawit (1382–1413).

The first Ethiopian depictions of the Virgin seem to have been based on the Byzantine icons of the 'Mother of God of Tenderness'. In this painting, Mary holds the infant Jesus close to her in one arm, bending her head towards him. Jesus tenderly presses his face to his mother's cheek, seemingly to try to calm her hidden grief. Her face is stern and full of sorrow. No mural paintings showing Mary and the Child have survived from this early period, only a few manuscripts. These paintings are linear and flat; no attempt has been made to give the illusion of volume or perspective; colour range is limited, and the figures show little recognisable anatomy. They are somewhat rigid, but powerful.

Marian iconography underwent a tremendous transformation during the reign of Emperor Zara Yakob (1434–68). Zara Yakob was the son of Emperor Dawit's third wife, Queen Egzi Kebra. He had received Our Lady Mary's intercession *in utero*, when a miscarriage was avoided through prayers in her name. On the day of his birth in 1399, his mother marked the sign of the cross upon his right hand in the Virgin's name. He seems to have been reared in a monastery, which accounts for his literary ability. When he became emperor, he chose 'Constantine' as his regal name. He had a residence built for himself in the monastery of Debre Berhan in Shoa where he lived permanently after 1454.

Zara Yakob was devoted to the Virgin Mary and he wrote several homilies to her. He commissioned translations of accounts of her miracles from most of the Christian world, including Spain, France, Palestine and, above all, Egypt. He encouraged the recording of her local miracles, and more than 600 accounts of these have survived.

Zara Yakob introduced thirty-two festivals commemorating Our Lady and made them obligatory celebrations throughout his empire. The *One Hundred and Ten Miracles of Our Lady Mary* was now incorporated into the Ethiopian *Synaxarium*. He encouraged his people to wear icons of Mary, and her images appeared not only on panels but incised on processional crosses which are carried on long poles before the congregation. He also encouraged the development of iconography which expressed the message of his teachings concerning the central position of Mary in the Christian scheme of salvation.

The new Marian rituals created an urgent demand for images of Mary. Fere Seyon (Fruit of Zion) was the most renowned artist at the court of Zara Yakob. He was a monk from Debre Gew Gweben in Lake Tana. He worked as the Emperor's painter and created a new symbolic vocabulary for the Marian cult. Zara Yakob and his successors built churches which were lavishly decorated with murals. However, now we only have their descriptions since all were destroyed during the Muslim occupation of the Christian highlands which lasted from 1527 till 1543 when the Muslim leader Ahmad Gragn ('the left-handed') was killed and his army defeated with the help of the Portuguese. Even though there are few remaining murals and paintings from this period, the new iconography introduced by Fere Seyon has endured to the present day.

To the Virgin holding the infant Jesus, Fere Seyon introduced the motif of a grey dove held in the hands of the Child. The dove was a well-known literary metaphor of Our Lady but had never been used as a visual symbol until this moment. There are many hymns that honour Mary, one of which is a hymn that praises her 'who gave birth to our salvation'; henceforward, the veneration accorded to her virtually elevates her to the status of her son.

Fere Seyon was probably the first to depict the two archangels surrounding the Virgin and Child with raised swords, realistically represented, with one of their wings at right angles to their body, a feature that first appears in the Spanish *Beatus* of Liebana of the tenth century. The Virgin now appears wearing a blue *maphorion* (the name given to the type of veil she wears). Before, as can be seen in the frescoes of Maryam Korkor and Kidana Mehrat in Geralta, the Virgin was covered in an ochre-coloured patterned cloak. This blue *maphorion* has very distinctive undulating folds and a rippled hem.

Sometimes Jesus is depicted caressing his mother's chin, a motif Fere Seyon borrowed from European devotional images. And sometimes Mary is shown offering a sprig of flowers to the Child. This refers to a verse for Sundays in the 'Praise of Mary' hymn: 'Mary, you are the flower of delicious perfume which has blossomed from the tree of Jesse.' It refers to Isaiah 11:1, 'A shoot will come up from the stump of Jesse; from his roots a branch will bear fruit.'

In the late fifteenth century, two Venetian artists, Nicolo Brancaleone and a certain Bicini, arrived at the Ethiopian court. Bicini not only served as a painter but also as a secretary to Emperor Lebna Dengel (1508–40) and reportedly spent many hours playing chess with him. Brancaleone, who was active in Ethiopia from 1480 to 1526, painted the murals of the royal church of Emperor Lebna Dengel and also produced illuminated manuscripts and devotional images. He painted not only for the church but

also for the royal court and for the nobility. He used a simple drawing style for the portrayal of figures together with decorative colours set against a neutral background. It was Brancaleone who introduced the young princess Birutawit (of Beirut) into the narrative paintings of St George and the dragon.

The Covenant of Mercy

The Covenant of Mercy (*Kidana Mehrat*) is a Marian feast introduced by Emperor Zara Yakob which is celebrated on the 16th of Yakatit. It commemorates the promise Christ made to Mary to accept her intercession on behalf of anyone devoted to her; any sinner who celebrates the feast of Mary or does a good deed in her name, even if it be providing no more than a drop of water to a thirsty man (as the wicked Belai Kemer did), will be forgiven. According to the *One Hundred and Ten Miracles of Our Lady Mary*:

> Our Lord said to her, 'Whoever shall keep in remembrance the sorrows and sufferings which have come upon thee for my sake [...]. I will remit his sins. And whoever shall give an offering in your name's sake, I will remit his sins. I will come unto him with thee, who gave birth to me, and I will appear to him three days before his death.'

The *Synaxarium* reading for this day relates how 'the angels brought Mary to her Beloved Son on his Throne, where he took her hand and kissed her mouth.' This line is an allusion to the Song of Songs (1:2), 'Let him kiss me with the kisses of his mouth – for your love is more delightful than wine.' The gesture symbolises the role of Christ as the bridegroom and that of Mary as the bride. In depictions of the Covenant of Mercy, Mary and Jesus are shown seated on a throne with their hands raised and joined, a visual confirmation of the promise made by Christ to his mother.

The Story of Belai Kemer

The story of Belai Kemer is an example of the Covenant of Mercy. The story, which is told in the *One Hundred and Ten Miracles of Our Lady Mary*, and is one of the legends depicted in most of Ethiopia's churches, is summarised below:

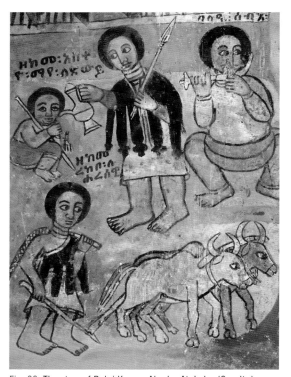

Fig. 22. The story of Belai Kemer, Abreha Atsbeha (Geralta)

Belai was a man in the city of Kemer, a Christian, but his sin was great. He did not eat ordinary food but lived on human flesh. After he had devoured seventy-eight of his friends, men fled from him, and he ran out of victims and eventually ate his wife and two children! One day he was walking along a road when he met a farmer. He lay in wait for him and then followed him, but when he realised that the man was too strong for him he decided to leave him alone. As he was turning away, he said to the farmer, 'Sell me an ox and I will give you my bow which is plated with gold. Take it'. The farmer said, 'I do not need it, for money and food are more useful to me, and so I will not give you my ox.' The cannibal spoke a second time, 'I will also give you three arrows with my bow', but still the farmer refused to take them. The cannibal spoke yet again, 'Show me the cave where you live.' The farmer said, 'Here, look, it is close by. Do you not live amongst men?' But he refused to show him the cave, and, as he was turning away, he said to the cannibal, 'You are of noble family, but your heart is depraved and full of guile even though you appear to be a rich man who has his home in the village of Kemer.' The cannibal took some water in a drinking vessel, and, as he was going along the road, he met a beggar whose body was covered with the sores and scabs of leprosy.

He thought of eating the poor man, but the sores stank and put him off! The beggar was thirsty and pleaded, 'Give me some water to drink for God's sake.' But the cannibal became enraged and abused the beggar. Again the beggar asked for water, for Heaven's sake and for the sake of the martyrs, but again the cannibal refused him. Finally the beggar asked for water for Mary's sake, to which the cannibal agreed and said to him, 'Verily, from the days of my youth I have heard that the Virgin Mary saves by her prayers and therefore I myself will take refuge in her. Take the water and drink for Mary's sake.' But when only a little of the water had gone down the beggar's throat, the cannibal seized hold of him, and, before he was able to satisfy his thirst, stopped him from drinking any more. Then the cannibal died, and the angels of darkness took his soul to Hell. And the Virgin Mary went to her son and said to him, 'Have compassion on me, my son.' Jesus said, 'What can I do for you?' And Mary replied, 'He gave a thirsty man water to drink in my name.' And Jesus said, 'Bring forth the scales and weigh the souls that he had devoured against the water that he gave to the thirsty man to drink.' Angels came and weighed the souls against the water and the little drop of water outweighed the seventy-eight souls that the cannibal had devoured during his life.

The story of Belai Kemer is usually depicted in several episodes showing Belai brandishing a knife in one hand and inserting a limb of one of his victims into his mouth; the farmer tilling the ground; Belai holding a gourd of water; St Michael holding the scales, since the archangel is the one who weighs the good versus the bad deeds of those who have died; and the Virgin Mary placing her hand on the scales and tilting them in Belai's favour.

The Miracle at Metmaq

The Miracle at Metmaq commemorates the appearance of the Virgin Mary in the church of Deir al-Magtas (the Monastery of the Baptistery) in the Nile Delta. This miracle, which occurred every year for five days and which is celebrated on the 21st of Genbot, is described in the *One Hundred and Ten Miracles of Our Lady Mary*. She appeared seated, surrounded by light, in the cupola of the church together with archangels and martyrs. The three equestrian saints – Mercurius, Theodore the Oriental (Banadlewos) and George – descended from their horses, and all three bowed before her.

In 1437/8, the church of Deir al-Magtas in Egypt was destroyed by a group of Muslim holy men who had become angered by the large crowds of Christian pilgrims visiting the church. This occurred at exactly the same time that the feast of Debre Metmaq had been introduced into the Ethiopian Church calendar. Because of the destruction of the Egyptian church, Emperor Zara Yakob had a church built to Our Lady Mary at a site he named Debre Metmaq in the province of Shoa. Unfortunately this church was also destroyed, by the Muslim conqueror Ahmad Gragn, early in the sixteenth century. The feast of Debre Metmaq remains a major festival, celebrated with great solemnity, especially by women.

According to the story of the miracle, it was the custom of the faithful at the moment the vision appeared to remove their hats and headscarves and throw them high up into the cupola. One year, a servant threw up her handkerchief, and Mary caught it in her hands to prove the reality of the miracle.

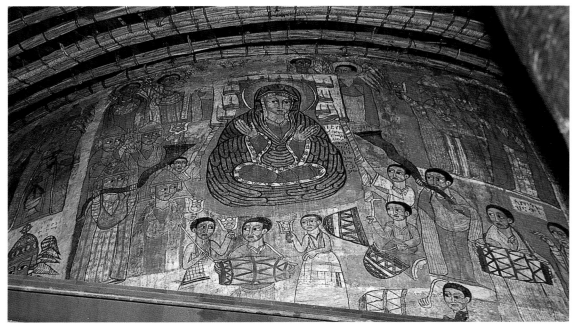

Fig. 23. The Miracle at Metmaq, Debre Sina Maryam (Gorgora)

Though no murals portraying this miracle remain from this period, it became a popular theme from the seventeenth century onwards. In these paintings Mary is depicted under a canopy held by angels. She is surrounded by archangels, angels, Elders of the Church, noblemen, sometimes *dabtaras* playing drums and sistra, King David playing the lyre, all of whom are singing hymns to her. Usually in the lower right-hand side the three equestrian saints – Mercurius, Theodore the Oriental (Banadlewos) and George – appear bowing before her with their horses – which are black, red and white – behind them. The Virgin always holds a white handkerchief.

Our Lady Mary at Mount Qwesqwam

This story is related in the *One Hundred and Ten Miracles of Our Lady Mary*. It is a homily attributed to Theophilus of Alexandria in which Mary herself describes the difficulties encountered by the

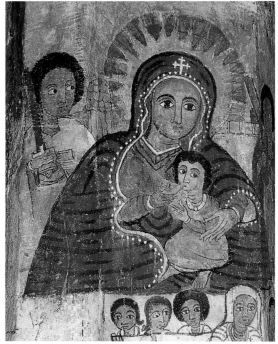

Fig. 24. The Virgin Mary suckling Jesus, Abreha Atsbeha (Geralta)

Holy Family during their exile in Egypt, as well as tales of miracles of the infant Jesus during that time. Qwesqwam is the name of a village in a mountainous region of Upper Egypt where the Holy Family were reputed to have stayed.

To commemorate their sojourn in this part of Egypt, a monastery and a church were built, and both are still standing. By the twelfth century this had become a celebrated pilgrimage site. A community of Ethiopian monks flourished here during the fourteenth and fifteenth centuries. On the 6th of Hedar, the Ethiopian Church celebrates the appearance of Jesus and his disciples on Mount Qwesqwam to consecrate the church.

Till the eighteenth century, the paintings depicting Our Lady of Qwesqwam were always associated with tender representations of the Virgin and Child, with Mary resting her cheek on the Child's face or suckling him. This is a rare pictorial representation; however, the theme is evident in the hymn 'Praise of Mary':

O Mary, the God-bearer, the spiritual city wherein dwelt God the Most High. For you carried in your hand the One who sits upon the cherubim and seraphim; and He who feeds all of flesh by His plenteous goodness took your breasts and suckled milk.

There is a beautiful fresco of this scene in the church of Abreha Atsbeha, just north of Wukro, where Mary is seated on her throne, attended by the archangels Gabriel and Michael with their swords held high, saluting her and the Child, thus emphasising the royal dignity due them. The Child is sucking the breast of his mother while holding it with his hand.

The First Gondarine Style

Emperor Fasilidas (1632–67) founded a new capital at Gondar which became the religious, artistic and political centre of the empire for over two centuries. Painters from Gondar decorated the new churches of the city as well as the nearby churches of Lake Tana. Luxurious manuscripts of the *One Hundred and Ten Miracles of Our Lady Mary,* with a large number of illustrations, were produced not only for the Emperor's monasteries but also for the nobility and churches. Stylistically, this period is divided into the First and the Second Gondarine styles during which all church murals were painted on cloth and consequently are not true frescoes.

The First Gondarine style was fully developed by 1665 and continued into the early eighteenth century. Even though new elements both in style and subject matter seem to have been inspired by European engravings, they were entirely transmuted in accordance with local taste.

Realistic details of clothing, furniture, hairstyles and even genre scenes became popular. Despite the realism of the accessories, there is no indication of a light source, or of shadow, or of three-dimensional spatial relationships. Scenes are portrayed against a delicately shaded background. There is an attempt to model the faces by inserting rouge below the cheekbone, and most of the women are portrayed with their hair falling over their shoulders in a more naturalistic trait. The faces are long and narrow, the line of the pointed nose continues uninterrupted to form the eyebrows; all the figures have large black eyes with a very expressive gaze. The clothes are depicted by lines that follow the contour of the body and are filled with geometrical patterns. The figures who sit cross-legged wear cloaks enveloping their whole body, giving the impression they are seated on a cushion.

The best extant example of the First Gondarine style is found in the church of Debre Sina Maryam in Gorgora, beside Lake Tana. The church of St Anthony at Gondar was also covered with paintings of equal quality, but they were bought by Marcel Griaule in the 1930s and today are in the Musée de l'Homme in the Trocadero in Paris. Apparently the church was to be renovated, and the original paintings would have disappeared. A French painter made copies of the murals, which were then donated to the church.

Two political events influenced the paintings of this period. The first was the widespread destruction of churches and manuscripts during the Muslim invasion of the Christian highlands, which only ended in 1543, and the second was the arrival of the Jesuit missionaries from the mid-sixteenth century to their expulsion by Emperor Fasilidas in the early 1630s. The Jesuits brought with them religious prints and engravings, which coincided with the need for new devotional images due to the devastation caused by the Muslims, and these provided ready-made models.

One of the most important influences was the print of the Virgin holding the infant Jesus from the church of Santa Maria Maggiore in Rome to which the Jesuit founder, St Ignatius of Loyola, was devoted and which the missionaries widely disseminated. In this painting, the Virgin is enveloped in a blue *maphorion*, trimmed in gold, pleated around her head, with an embroidered cross at the height of her forehead. Her hands are crossed over the infant Jesus' legs, her right hand, with very long elongated middle and index fingers, pointing downwards. The hand gesture, the *maphorion* and the pleated cap under her mantle were all incorporated into paintings of the Virgin.

The expanded narrative included scenes from the Passion of Christ, the Crucifixion and the Raising of Adam and Eve, all of which are depicted in nearly every church from this time on.

The Raising of Adam and Eve

Christ's descent into Hell and his raising of Adam and Eve, the 'Harrowing of Hell' as it is known in medieval Christian theology, is rarely seen in visual form in Roman Catholic or Protestant churches, whereas it is a commonly portrayed in Ethiopian churches. The event is partially described in the Apostles' Creed: 'He suffered under Pontius Pilate, crucified, dead and buried. He descended into Hell. And the third day he rose again from the dead.'

In the *Synaxarium*, the reading for the Feast of the Resurrection, *Tensae*, is even more directly related to the depiction of Christ raising Adam and Eve: 'Salutation to Thy Resurrection, the day of which became the day of Adam's salvation.' Adam and Eve are the parents of all mankind, and their redemption is the hope of eternal life for all humanity.

But Christ has indeed been raised from the dead, the firstfruits of those have fallen asleep. For since death came through a man, the resurrection of the dead comes also through a man. For as in Adam all die, so in Christ all will be made alive. But each in his own turn: Christ, the firstfruits; then, when he comes, those who belong to him. Then the end will come, when he hands over the kingdom of God the Father after he has destroyed all dominion,

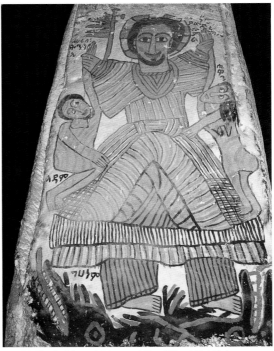

Fig. 25. The Raising of Adam and Eve, Mikael Biet Mahar (Tsaeda Amba)

authority and power. For he must reign until he has put all his enemies under his feet. (1 Corinthians 15:20–5)

The pictorial image of this theme is said to have been introduced to Ethiopia by the Italian painter Brancaleone in the fifteenth century. In his version, Adam and Eve and the righteous of the Old Testament are fully clothed, but Christ is clothed in a white garment that leaves his right arm and shoulder exposed.

In this fresco from the church of Mikael Biet Mahar in Tigray, Christ, who is raising Adam and Eve, is clothed in an Indian princely costume with an outer garment worn over pants and an overskirt. This is a further indication that Ethiopian painters had been introduced to religious paintings produced by Indian artists and brought by the Jesuits from Goa. Here, we can see Christ trampling on the representation of his enemies – the devils in Hell. He is also bearing the flag of the Resurrection, symbol of his triumph over death. This way of representing the theme became the standard Ethiopian version.

The Second Gondarine Style

It has lasted from the mid-eighteenth century up to the present day. It is associated with the patronage of the regent Empress Mentewab and her son Emperor Iyasu II (1730–55). Its most conspicuous characteristic is the attention given to fabrics, which are meticulously depicted, showing off the usually imported colourful, flowered silks and brocades that were fashionable at the time.

The faces are round with heavy, indiscriminate modelling of the flesh. There is still no visible source of light and no shadow; this is reflected in the representations of the neck, where heavy, dark lines are painted across it to indicate shadow. The figures wear a round and full hairstyle reflecting the fashion at the imperial court. Where before only the Emperor or his family were depicted as donors, it now became fashionable for the nobility to appear in churches as donors, usually prostrate, next to portrayals of saints, or in illustrated manuscripts commissioned by them. An overtunic of sheer fabric is depicted around the waist of noblemen allowing the scabbard of their richly decorated sword, a status symbol, to be seen bulging sideways from the body. The background of all these paintings is now shaded in strong colour changing from yellow to red to green.

The Trinity

The Trinity was seldom seen in European paintings because its depiction had been proscribed by the Council of Trent (1545–63). However, in Ethiopia, the Trinity had been depicted as three identical figures, frontally portrayed, seated, holding a book in their left hand, one or two fingers of the right hand raised, wearing a cruciform halo and their beard obscuring their neck. They had not appeared during the First Gondarine style due to strong objections of the Jesuits to any anthropomorphic representation of God but now made a strong comeback.

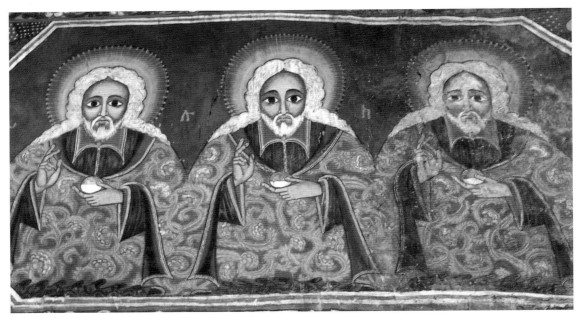

Fig. 26. The Trinity, Narga Selassie (Lake Tana)

The representation of the Trinity that emerged in the eighteenth century has a strong visual impact. The three identical figures are again frontally depicted but now wearing colourful red robes embroidered with a rosette pattern in black with a tunic having a pointed collar resembling the chasuble worn by European priests. They appear to be seated, though they are only shown three-quarter-length, with their beautiful garments spread around them. Their haloes are not cruciform but are either plain gold against an orange background, or have an elaborate filigree pattern. In the left hand they hold an egg or an orb. Their right hand is lifted in a gesture of blessing with their first two fingers pointing upwards.

They are painted within a rectangular frame, the corners of which have been diagonally cut away, leaving space for the Tetramorph. While in previous centuries the figures of the Tetramorph had their heads turned towards the Trinity, they now look outwards towards the viewer with their backs turned on the Trinity; they have become ornamental rather than respectful beings. The Trinity are surrounded by the twenty-four Elders of the Apocalypse, depicted as young men wearing crowns and the colourful garments of Ethiopian priests and holding censers and hand-crosses. They have wings, because the Ethiopians believe they are angelic beings.

The Tetramorph

Images of the Tetramorph, the four apocalyptic beasts and symbols of the four evangelists, are based on the text in Revelation 4:6–8:

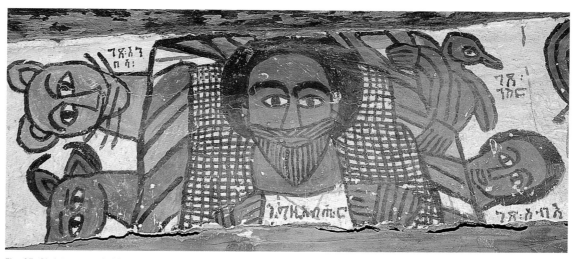

Fig. 27. Christ surrounded by the Tetramorph, Petros and Paulos (Tsaeda Amba)

Also before the throne there was what looked like a sea of glass, clear as crystal. In the centre, around the throne, were four living creatures, and they were covered with eyes, in front and behind. The first living creature was like a lion, the second was like an ox, the third had a face like a man, the fourth was like a flying eagle. Each of the four living creatures had six wings and was covered with eyes all around, even under his wings. Day and night they never stopped saying: 'Holy, holy, holy is the Lord God Almighty, who was, and is, and is to come.'

Each evangelist was given the symbol most appropriate to the content of their writing. To St Matthew was given the human face because in his gospel he traces the human ancestry of Christ. To St Mark was given the lion because his gospel begins with a description of John the Baptist as a 'voice of one crying out in the desert' (Mark 1:3), which was interpreted to be that of a roaring lion. To St Luke was given the ox because, in his gospel, he writes especially of the priesthood and of the sacrifice of Christ – the ox being a sacrificial animal. To St John was given the eagle because his inspiration soared to the loftiest heights.

The creatures of the Tetramorph are usually depicted with wings to denote the divine mission of the four evangelists.

Expanded Cycle of Marian Iconography

Marian iconography now becomes expanded to include scenes from the life of Mary, for example, Mary's Entrance into the Temple, the Waters of Correction, the Flight into Egypt and the Coronation of the Virgin.

Fig. 28. The Waters of Correction, Narga Selassie (Lake Tana)

Mary's ***Entrance into the Temple*** is not an event that appears in the Gospels, but it is a feast of the Ethiopian Church, celebrated on the 3rd of Tahsas. According to apocryphal tradition and the account in the *Synaxarium*, Mary's parents took her to live in the Temple of Jerusalem when she was three years old, to fulfil a vow they had made to the Lord when they were childless. Mary remained in the Temple for twelve years and was cared for by an angel who brought her food and clothing.

Paintings of this theme appear from the late eighteenth century onwards and depict Anne carrying Mary on her back, the customary way for Ethiopian women to carry their babies, with Joachim following on behind. In a sequential scene, Mary appears seated in front of an Ethiopian round church, which symbolises the Temple in Jerusalem, with an angel offering her a jug and sometimes an *injira* basket. This basket is where the Ethiopians keep their staple bread, *injira*, which they eat at every meal.

In the ***Waters of Correction*** Mary is depicted holding a cup of water in her hands, facing a group of Elders, with Joseph sometimes shown standing behind her. The precedent for this story relates to the test for an unfaithful wife as told in Numbers 5:11–31: the Lord tells Moses that if a husband suspects a wife of having been unfaithful, he must take her to a priest who will make her drink the bitter water. If she is guilty, her abdomen will swell, and she will be caused bitter suffering.

The tale of Joseph and Mary being asked to go before the high priest because the scribe Annas denounced Mary as being pregnant before her marriage, and of Mary being made to drink the Waters of Correction, is told in the *Synaxarium*.

In the ***Flight into Egypt*** Mary is always shown accompanied by Salome. According to apocryphal sources, Salome was the Virgin's cousin. Anne, the Virgin's mother had two sisters, one, Sophia, who gave birth to Elizabeth, and the other, Mary, who gave birth to Salome. Salome was brought up in the

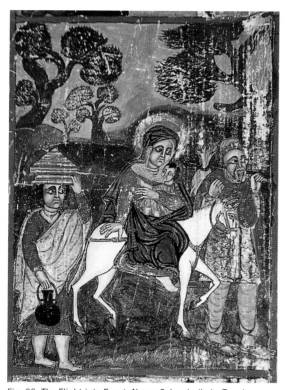

Fig. 29. The Flight into Egypt, Narga Selassie (Lake Tana)

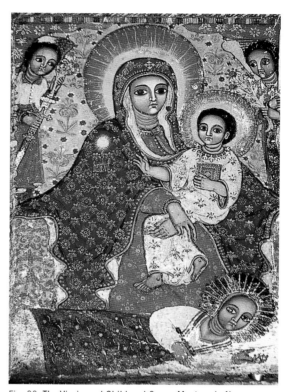

Fig. 30. The Virgin and Child and Queen Mentewab, Narga Selassie (Lake Tana)

house of Joseph with the Virgin Mary and looked after her and was present when Jesus was born. She accompanied the Holy Family to Egypt, sometimes carried Jesus in her arms, sometimes washed him, and she looked after him for thirty-three years. On the Day of the Passion, she was there with him, and she wept and lamented. On the Day of the Resurrection, she saw him before the apostles did. In the *One Hundred and Ten Miracles of Our Lady Mary,* Mary herself is quoted as saying that, because she was weak, she needed Salome's help.

Virgin and Child

Queen Mentewab had a palace and a church built for her use in the hills north-west of the city of Gondar, which came to be known as Qwesqwam. It was named after the place in Egypt where the Holy Family supposedly lived for a few years. Iconographically, the most influential painting of this period was of the Virgin and Child, a painting that Queen Mentewab had executed for Qwesqwam since she was particularly and deeply devoted to the subject.

The chronicler relates how she had advised the painter who made the painting as follows: 'Do not make the Virgin's dresses using colours but silk material on gold, silver, and blue – put on her breast a red brocade woven with gold. Make the dress of the Child with the brocade mentioned above and St Michael on her right, St Gabriel on her left must hold a shining curtain'. Apparently she loaded the picture with pieces of silver-work, and the bracelets and brooches pinned on the picture were made of pure gold – to make it as attractive as possible. On Jesus she placed a small chain made of gold as was customary with regal children. (Chojnacki, 1983, p. 241)

The nearest representation we have of this vanished painting is that of the Virgin and Child from the church of Narga Selassie with Queen Mentewab prostrate at her feet. Mary is sumptuously clothed in a royal blue silk *maphorion* embroidered with gold rosettes and bunches of red grapes, trimmed in gold braid. On her right shoulder is embroidered a large gold star with a pendant below it. Henceforth this became a permanent fixture in paintings of the Virgin. She wears a red tunic with gold brocade and with the cuffs and round neck braided in gold. The edging of the folds is arranged in a zigzag pattern. The front of this garment has a row of gold buttons. This is another feature that becomes incorporated, not only in the Virgin but in other saintly figures. Her hands are crossed over the Child with two elongated fingers of her right hand pointing downwards.

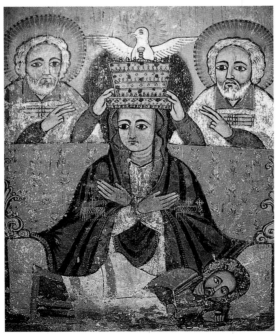

Fig. 31. The Coronation of the Virgin, Selassie Chelekot (near Mekele). Also see page 12

We read that Mentewab requested that the archangels Gabriel and Michael hold a shining curtain. This curtain, usually in red brocade with rosettes, appears in all paintings of the Virgin done at this time. In the Narga Selassie version they hold a sword in one hand and flowers in the other. The archangels are no longer the vigilant defenders of the Mother and Child but have been reduced to a mere decorative function.

Depictions of the **Coronation of the Virgin** began to appear from the eighteenth century on. These were based on the painting of the Virgin and Child executed for Mentewab in her Qwesqwam palace, a painting that set a precedent for the lavishly robed manner in which the Virgin was to be portrayed from now on. She is shown seated with her hands reverently crossed

over her chest, covered by a silk *maphorion* edged in gold, embroidered with a cross with pendants below it, also in gold. She wears a crown, always in yellow, with coloured details indicating it was made of gold with inset precious stones. The crown is constructed of several superimposed rings topped by a finial motif. It is held by two Persons of the Trinity, Father and Son, depicted as two old men with the Holy Spirit represented by a white dove with outspread wings hovering on top of the crown. She is seated on a large throne consisting of a seat with high arms covered with an ornate carpet or cloth. Behind her is a richly patterned, brocaded screen from which the two Persons of the Trinity emerge. At her feet is the prostrate donor. If he is a man he is shown with his sword scabbard, a symbol of nobility, bulging sideways from his body, encased by an overtunic with the hilt clearly visible.

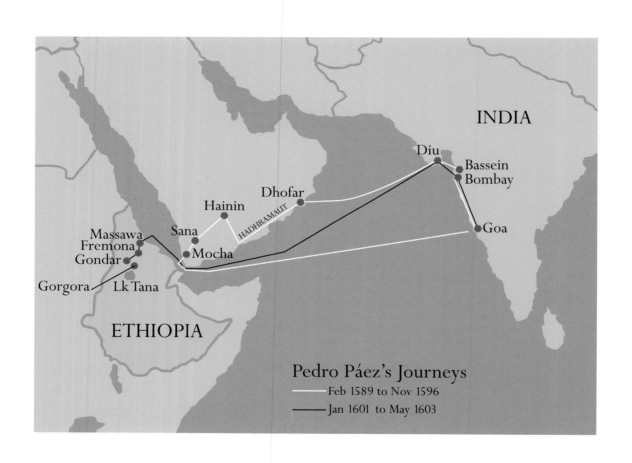

INDIA

Diu

Bassein
Bombay

Dhofar

Goa

Hainin

Sana

HADHRAMAUT

Massawa
Fremona
Gondar

Mocha

Gorgora Lk Tana

ETHIOPIA

Pedro Páez's Journeys

Feb 1589 to Nov 1596

Jan 1601 to May 1603

Chapter 3

The Jesuit Interlude

The First Legation

Goa was the headquarters of the Jesuits in India, and it was from Goa that their missionaries were sent out to proselytise in Japan, China and Africa. Between the years 1546 and 1554, St Ignatius, the founder of the Jesuits, had been working with John III of Portugal and the Holy See to arrange for a large number of Jesuits to enter Ethiopia as part of a Portuguese embassy. He drew up precise instructions on which practices should be allowed to be retained by the Ethiopian Church and which unacceptable customs should be replaced. He was very specific that the Jesuits should not start challenging minor doctrinal issues. He placed great importance on the Jesuits being seen to care for the secular as well as the spiritual well-being of the Ethiopian people. He advised that it was necessary to obtain a reputation as wise and virtuous men and thus gain the love and submission of the people, practise charity, build hospitals, organise fraternities for the redemption of prisoners and take care of abandoned children. For this purpose he advised that bridge-builders, construction workers, agricultural experts and doctors should be part of the first mission. The whole objective would be to bring the Ethiopian people, with their different customs and traditions, into the Latin fold with gentleness and without major upheavals.

The most important task was to convert the Emperor. Because of the volatile situation in Ethiopia at that time due to its constant warfare with the Muslims, it was never known for sure who would be in power when an embassy from Goa reached the country. Consequently, Ignatius, who was an extremely astute man, advised that they should take letters written by the Viceroy of India addressed to no one in particular so that the most opportune name could be added once they were in Ethiopia. He stressed the need for many schools and the education of the young who would always remember with affection the faith of those who taught them in their youth. Furthermore, he urged that the most intelligent amongst them should be sent to study in the Jesuit universities of Goa, Coimbra, Rome and Cyprus with the

consent of the Emperor, so that when they returned home they would be instrumental in recruiting more people for the Latin Church.

In February 1555, the special envoy, Diego Diaz, with two Jesuits, Gonzalo Rodrigues and his brother, left Goa and arrived at the court of Gelawdewos (Yohannes Claudius, 1540–59). Rodrigues discovered that Judaic practices were deeply ingrained and had been derived from the presence in Ethiopia of the *Falashas*, a Semitic people who had settled in the country before the arrival of Christianity, who lived in the Simien Mountains near Gondar and who followed the ancient rituals of the Israelites. It was their presence that explains the incorporation of the title 'King of Zion' into the title of the emperors.

The Emperor was polite but decidedly against the Roman Catholic Church. In 1557, the Viceroy of Goa decided to send a small legation, which included a bishop, the Spaniard Andres de Oviedo, and Francisco Lopes, to assist him, together with a few Jesuits. Meanwhile, the Turks had gained control over the Red Sea and the Jesuits were cut off from their base in Goa. In 1559, Oviedo left the court aware that there was nothing to be gained. In the same year Gelawdewos marched against the Muslims only to be killed by the Turks who had him beheaded.

Gelawdewos was succeeded by his brother, Minas, who had been a prisoner of the Turks in Arabia for eight years, as a result of which, according to the Jesuits, he had become perverse and cruel. He persecuted the few Portuguese in the country, and eventually Oviedo was forced to settle in a remote and barren part of the mountains, north-east of Aksum, which he named Fremona in honour of Frumentius, the first *abuna* of Ethiopia.

Minas died in 1563, and the new emperor, Sarsa Dengel (1563–97), spent his reign fighting the Muslims. He tolerated the Jesuits without showing any favours. He was desperately short of guns and had petitioned Portugal for workmen who could cast cannons and make gunpowder and muskets. Thus, for political reasons, he did not want to antagonise the Portuguese by persecuting the 800 or so of them left in the country. Oviedo, who had been very undiplomatic, died in 1577 having ordained his companion Brother Francisco Lopes a priest so that he could continue to minister to the Portuguese community. In 1583, at the age of eighty, Lopes was the only remaining Jesuit in Ethiopia. He remained cut off from any communication with Goa and died in 1596. The Jesuit mission begun in 1556 had failed completely.

Pedro Páez

In March 1596, the Jesuit Provincial General in Goa decided to send the Jesuit, Belchior da Sylva, to Ethiopia. It was hoped that, because of his dark skin, he may be able to pass himself off as a Muslim through the territory controlled by the Turks and reach Ethiopia safely, which he did, eventually arriving in Fremona, where he remained as the only Jesuit in the country till the arrival of Pedro Páez in 1603.

The story of the Jesuits in Ethiopia during the first quarter of the seventeenth century is really the story of the remarkable Spaniard, Pedro Páez, and his epic journey which deserves to be told, if only to better appreciate the trials and tribulations all missionaries were exposed to which, in the case of Páez, included seven years as a slave of the Muslims.

Pedro Páez was born at the height of Spanish colonial expansion during the time of the Habsburgs. In 1580, Philip II had inherited Portugal and was urging the Portuguese viceroys in India to send missionaries to Ethiopia. He needed an ally to the south of the Ottoman Empire for strategic reasons. The Portuguese viceroy suggested to the Jesuit Provincial General in Goa, Pedro Martínez, that he comply with the desires of the King.

Pedro Páez Jaramillo (1564–1622) was born in Olmeda de la Cebolla, a small village, some 40 kilometres east of Madrid. Its population was the butt of many jokes since its name means 'Olmeda of the Onions' – so much so that in 1954 the inhabitants had it changed to Olmeda de las Fuentes, 'Olmeda of the Fountains'.

Early in his life Páez became aware of his religious calling. He first went to university in Alcalá de Henares, near Madrid, and then on to the Jesuit university of Coimbra in Portugal, where, after two years, he returned to study at the Jesuit seminary in the small town of Belmonte, south of Madrid. It was there that he established a long-standing friendship with Tomás de Iturén, a Jesuit priest seven years older than himself. They were to maintain a correspondence over the years despite the thousands of kilometres that separated them and it is through these letters that we know of the hardships that Páez was to encounter on his missions.

When Páez was twenty-three, in 1587, he wrote to the Jesuit General in Rome asking to be sent to China or Japan, and it was in April 1588, without having finished his studies in Belmonte, he was sent to Goa. In January 1589, the provincial Jesuit General in Goa suggested to Páez that he should travel to Ethiopia with the Jesuit Catalan priest, Antonio Monserrate, who was then fifty-eight years old, an experienced missionary who spoke fluent Arabic. The journey (see map, p. 50) was to last eight years.

At this time, it was very hazardous for Portuguese to travel around the Indian Ocean since they were thoroughly hated due to the pillaging by Portuguese navigators during the early sixteenth century. Added to this, there was the new threat: the Turks, who, since 1557, had conquered the Red Sea coast and blockaded the Arabian ports. Since their defeat at the Battle of Lepanto in 1571, Turkey and the Hispano-Portuguese Empire had been deadly rivals, and any Portuguese or Spaniard found in their territory was either decapitated or enslaved. The two Jesuits disguised themselves as Armenian merchants, which did not help much because the Armenians were hated by the Portuguese and were persecuted by them while in Portuguese ports. The chances of reaching their Ethiopian mission at Fremona were very slight indeed.

Early in February 1589, they made their way to Bassein, north of Bombay, and from there on to Diu on the peninsula of Kutch, from where they hoped to sail to Massawa on the Eritrean coast.

It would only be at Christmas, eleven months after having left Goa, that finally they were accepted by a Moor who was on his way to Somalia. On New Year's Day their ship was accosted by pirates who took them all to Dhofar on the coast of Shihr. There, it was assumed that the two priests were spies on their way to Ethiopia to persuade the Emperor to make war on the Turks, and they were stripped naked and put in jail for five days with little to eat. It was then decided to transfer them to the ruler of Hadhramaut, a journey which they made barefoot and which was to take almost a month.

From Hadhramaut, Páez was to write to his friend Iturén and so became the first European traveller to describe a region which was to remain unknown to the West until the nineteenth century. He is also the first European to mention coffee! From Hadhramaut they walked on to Hainin, 270 miles north-east of Aden, where the Sultan of Oman resided and where they were to remain for four months. Although the Sultan was anxious to free them, he felt obligated to hand over any 'Portuguese' prisoners to his overlord, the Turkish pasha of Sana in Yemen.

The Sultan provided camels and horses for their journey to Sana, but, nonetheless, the travelling was hard. Again, Páez was to describe it in his letters, and these are the earliest known accounts of the Yemeni interior by any European until well into the twentieth century. Páez and Monserrate were to remain captive at Sana for five years, after which the Pasha decided to send them to the slave market at Mocha on the Red Sea coast. When no trader offered the price the Pasha had demanded for his captives, they were turned into galley slaves, and later, when Monserrate fell ill, they were transferred to work in a quarry.

After a year had passed since their enslavement, a Syrian youth, whom they had befriended at Sana, was instrumental in securing their ransom. He made his way to Goa and informed the Viceroy of their fate. Immediately, an Indian merchant was despatched to Mocha with instructions that the two priests were to be ransomed at any price – Philip II had instructed that the ransom would be paid by the state treasury. They were finally returned to Goa on 27 November 1596, almost eight years after they had left.

Shortly after returning, Páez fell ill, and it was not to be till January 1601 that he was fit enough to set out again for Ethiopia, this time alone. In Diu he befriended Razuam Aga, a servant of the Pasha of Suakin, an island north of Massawa. Calling himself Abedula and dressed as an Armenian, he told him he was anxious to get back to his country but was fearful of falling into the hands of the Turks. Razuam Aga agreed to carry him safely to Suakin from where he could join a caravan to Cairo, Jerusalem and then on to Armenia.

On reaching Massawa on 26 April 1603, he asked if he could be allowed to go upcountry to collect goods belonging to a friend who had recently died, and that is how, at last, his journey into Ethiopia began. He reached Fremona on 15 May. While the captain of the Portuguese settlers went to inform Emperor Yakob of his arrival, Páez began learning both Amharic and Ge'ez, the ancient liturgical language of Ethiopia. Yakob was only thirteen years old, even though he had succeeded Emperor Sarsa Dengel six years before.

Páez noticed that the churches constructed after the Muslim invasion were architecturally much more modest than their predecessors. In future church construction he was to play a key role in reinstating the splendour of previous times, and, indeed, his architectural interest was to be the stimulus behind the first palaces to be built at Gondar, which was to become the first permanent Ethiopian capital since the thirteenth century.

Emperor Yakob did not last much longer as emperor. Before Páez could visit his court, Yakob was deposed by his uncle Za Dengel, an educated man who had a keen religious interest. Za Dengel was much charmed by Páez and soon disclosed to him his desire to become a Roman Catholic. Páez, wisely, as events turned out, tried to dissuade him on the grounds of potential political repercussions. Za Dengel wrote to Philip III of Spain asking for craftsmen, soldiers and missionaries, and he also wrote to Pope Clement VIII to acknowledge the Pope's ecclesiastical authority. It was not long before it leaked out to the Ethiopian monks that the Emperor was intent on becoming a Catholic and taking the country with him. They sought the help of the power behind the throne, Za Selassie, who immediately waged war against his emperor and brought about his defeat and personally drove a spear through him.

Five more Jesuits succeeded in reaching Fremona between 1603 and 1605 before the route was closed, and no further priests arrived before Páez's death in 1622. After a short civil war, yet another emperor was to come to power: Susenyos, who was crowned in March 1608. He assumed the name of Seltan Sagad I. Three days after his coronation, the Emperor moved against the rebels, and on his way he visited Páez in Fremona. Páez wrote to Iturén that Susenyos behaved more like a friend than an emperor. On his return from the campaign, Susenyos left *Abuna* Simon, the Patriarch of the Ethiopian Church, in Fremona and advised him to study the religion of the Jesuits and be friendly to them.

Before his coronation, Susenyos had given the Jesuits land for a church and a mission in Gorgora by Lake Tana. There were many points of dissension between the Ethiopian and the Roman Catholic Church, but Páez soon found out that the key factor was the pride of the people in their old religion, which they had preserved without change for 1,100 years. He knew that little was to be gained by direct confrontation with their old customs. His approach was different to that of Oviedo before him and was much more akin to the policy of Ignatius, which was to influence the Emperor and the people around him in the hope that they would abandon their orthodox practices. He was an admirer of the lack of complexity in their belief in God, in their strong devotion to the Virgin Mary and the reverence shown by the faithful who entered their churches barefoot and moved around silently as a sign of respect.

In 1610, Susenyos asked Páez to come from Gorgora to his court at Coga, close to where the Blue Nile leaves Lake Tana. He was to navigate the lake in a *tankwa*, a papyrus reed boat bound together by strips of fig tree bark, a craft still used to this day, and which he found alarming because of the presence of hippopotami, one of which made for his *tankwa*.

Regarding Susenyos' court at Coga, which was no more than a tented camp, Páez gives an interesting account of the Emperor's way of life and customs. Susenyos ate behind a curtain since none

of his courtiers were allowed to see him eat. The table was covered with their staple bread, *injira*, which functioned both as a plate and as food – just as it does today – and raw beef was served.

During his stay at court, Páez took part in theological discussions with the Emperor and his brother Cella Krestos, the Viceroy of Tigray, and the Emperor's half-brother Bella Krestos, a keen and well-read theologian, as well as a number of nobles. During these years, the Emperor so enjoyed the company of Páez that he insisted he remain with him most of the time, even to the point of accompanying him on his campaigns. Susenyos was interested in Roman Catholicism, not only because he admired Páez but because he hoped to gain military assistance from the Pope and Catholic Europe in his wars against the infidels within his empire known as the Galla. Both the Emperor and Páez, however, were only too well aware of what followed Za Dengel's hurried conversion to Catholicism and so agreed to proceed with caution. It was the monks who represented the most formidable opposition to Catholicism, and, because of their closeness to the people, they were in a strong position to manipulate the feelings and actions of the populace.

At court, *Abuna* Simon was becoming increasingly frustrated with Susenyos' tolerance of the Jesuits whom he believed should be expelled, especially since the Emperor's two brothers, Bella Krestos and Cella Krestos, had openly adopted the Roman Catholic faith and *Abuna* Simon was threatening their excommunication from the Ethiopian Church.

In March 1613, the Emperor sent one of the Jesuits, Fernandes, as leader of a legation to carry three letters: one to the Pope, one to Philip III of Spain and the third to the Viceroy of the Indies. In his letter to the Pope he proclaimed himself ready to accept a patriarch sent by Rome to Ethiopia. In his letter to Philip III he reiterated his obedience to the Pope and his willingness to receive a patriarch from Rome and also asked for at least 1,000 troops to be sent from Portugal to help him occupy the Red Sea coast together with armourers and construction workers.

Abuna Simon and the monks were well aware that Susenyos was considering becoming a Catholic, and they resented the amount of time the Emperor spent in the company of Páez at court, so much so that Susenyos was concerned for Páez's life. To make sure he himself was not poisoned, he kept Páez at court to supervise the preparation of his food. *Abuna* Simon declared his hatred of the Emperor and publicly excommunicated him. Matters were going from bad to worse, and the monks were preparing for a holy war. Already *Abuna* Simon had approached a *Falasha* to replace Susenyos as emperor, and Susenyos was forced to march against him. Fortunately, one of the *Falashas* betrayed the pretender, who was then beheaded by the Emperor.

For a short period, things were quiet again, but *Abuna* Simon found an ally in Susenyos' son-in-law, the Viceroy of Tigray. At the *Abuna's* urging, the Viceroy ordered that the Portuguese settlers should forfeit their land and that their Ethiopian wives should have their ears and noses cut off if they did not renounce Catholicism. During these difficulties Páez continued to follow Ignatius' original cautious policy – he never requested that any additional Jesuits be sent out to Ethiopia and throughout this

period he only had six other Jesuits in the country. Furthermore, the Jesuits were not actively pursuing converts amongst the people but concentrated their attention on the court and the nobility. For example, at Gorgora there were only fourteen converts in 1614 in spite of the mission's proximity to the court. And only three missions had been established: at Fremona, where they worked amongst the Portuguese settlers; at Collela, where they were translating Catholic texts into Ge'ez with the assistance of converted monks provided by Cella Krestos, the Emperor's brother; and at Gorgora where there was a seminary.

At Susenyos' request, Páez built a small palace for him at Danqaz, near Gorgora. Work began in May 1614. Even though the Ethiopians in earlier times, at Aksum and at Lalibela, had constructed excellent buildings, for the preceding 300 years the court had moved from tented camp to tented camp, and the ability to build in stone had regressed. Páez had to train his own work crews, instruct them on how to make the required tools and teach them the principles of masonry and carpentry. The end result was a small, two-storied, handsome palace with an internal staircase that led to a flat roof surrounded by a parapet from where the Emperor could view the surrounding mountainous countryside. Many people came to see it, and what they most admired was the fact that it had a second storey. Danqaz now became the equivalent of a capital for Susenyos.

In April 1618, Páez accompanied Susenyos and his army to the source of the Blue Nile at Ghish, some 110 kilometres south of Lake Tana and so became the first European to describe it in his *History of Ethiopia*. The first Europeans to have seen the source were the Portuguese, who had been sent to Ethiopia with Christopher da Gama (son of Vasco) in 1541 and had remained behind in the country, eventually to be settled at Nanina, only 50 kilometres from the Blue Nile's source. Páez, more importantly, also described the course followed by the river into Lake Tana (this river is called the 'Little Abbay' by the Ethiopians) and out again (as the 'Great Abbay') to the Tissisat Falls, 25 kilometres downstream. Ten years later, Jerónimo Lobo, another Jesuit, followed in Páez's footsteps. In the early 1770s, the Scot, James Bruce, was to falsely claim that he was the first European to discover the source of this famous river.

In 1617, Cella Krestos, who much admired the chapel the Jesuits had built at Gorgora, suggested to Páez that a new church should be built. Páez had already begun preparations when the Emperor informed him that he needed his expertise for a grander mission, that of building a permanent capital. The site for this new capital was chosen, not by Susenyos, but by Páez who picked out a spot that was cool in summer and mild in winter. The new capital, which was finally completed by Susenyos' son Fasilidas, was at Gondar. And at a location just a few kilometres west of Gorgora, Páez built the new church. The foundation stone was laid in December 1617 and the cornerstone was placed in position in November 1620 by Susenyos himself, accompanied by Fasilidas, who was then eighteen years old. It was dedicated to the Virgin and named Maryam Gimb ('Mary's stone building') in January 1622. Apparently, one wall of the nave is still standing. During the period of

construction of this church, Páez was busy writing his *History of Ethiopia*, the first in-depth account of the country in which he also gave exact descriptions of animals and plants centuries before any work of classification existed.

In May 1622, only four months after the dedication of Maryam-Gimb, Páez succumbed to malaria and died. He was buried in the mission church at Gorgora but his remains were later moved to the new church he had built. But before his death, in March, Susenyos visited him and told Páez that he had publicly declared himself a Roman Catholic and had dismissed all his wives except the first. He took confession and received the sacraments from Páez.

After Páez

However, all that Páez had achieved was soon to be annulled by the arrival of his Portuguese successor, Alfonso Mendes, who was appointed by Philip IV of Spain without consultation with Rome. Mendes proved to be a bad choice: he was proud, arrogant, narrow-minded and tactless. He insisted that all the clergy had to be reordained, the people rebaptised, Ethiopian feasts and festivals abolished, together with circumcision, which St Ignatius had listed among the practices to be allowed temporarily. Not surprisingly, between 1628 and 1632 there were uprisings throughout the country which Emperor Susenyos had to quell. Finally, a battle took place where 8,000 Ethiopians were to die on both sides, and Fasilidas pointed out to his father that these were all his own subjects, his own people.

Susenyos abdicated shortly after, in June 1632, and died only three months later, a death that was heralded with joy by most of his subjects. Fasilidas, immediately upon becoming emperor, dismissed all Jesuits from his court and ordered them back to Fremona where Mendes remained for nine months until Fasilidas had him forcibly removed to the coast from where he returned to Goa where he died in 1656.

Jesuit Influence on Ethiopian Art

Those extant representations from the middle of the fifteenth century onwards reflect an interest in imported visual models which are mainly derived from two sources: the first being the foreign paint-ers who were active at the Ethiopian court – Brancaleone and Ricci – and the second being the Jesuits. The Jesuits brought with them religious paintings and prints which were disseminated through their missions and at court where, as we have seen, they concentrated their proselytising effort, and it was the Emperor and the nobility who, as patrons, were instrumental in spreading this artistic influence.

Two of these illustrated books were to have a major influence – *Evangelicae Historiae Imagines* devised by the Spanish Jesuit Jerome Nadal and printed in Antwerp at the end of the sixteenth century and *Evangelicum Arabicum*, which was printed in Rome in 1590–1. The Jesuit annual letter of 1611 from Goa states that a close relative of King Susenyos (1607–32) had all 153 gospel illustrations of the

Imagines copy-painted for him. The *Evangelicum Arabicum* was copied in the 1660s at the time of Fasilidas (1632–67) and his son, Yohannes I (1667–82).

The similarities between Nadal's *Imagines* and the Narga Selassie paintings show that this book was definitely used as a model and was a significant influence in the development of the First Gondarine style. Two marked characteristics of Gondarine art – the use of a halo of clouds and of small winged angel heads, especially in scenes of the Transfiguration and Ascension – can be traced to both these books.

The Jesuits introduced illustrated theological books, prints and paintings not only from Europe but also from India. Some of these prints and paintings were executed by Indian artists in the Jesuit headquarters in Goa, and this is how some Indian artistic details became incorporated in Ethiopian paintings.

Indian garments and poses can be seen in most of the depictions of Jesus raising Adam and Eve. A couple of examples are the fresco in Mikael Biet Mahar and another in Petros and Paulos, where the angels surrounding the Virgin wear long-sleeved cloaks called *caftans* tied at the waist with a wide cummerbund from where they then spread out like a hooped skirt. The guardian archangels of the First Gondarine style, who are usually depicted at the entrance door to the sanctuary, wear wide trousers gathered at the ankle which are entirely un-Ethiopian. Two of their other garments – a long-sleeved tunic reaching to just above the ankles and a robe ending at knee-height – reflect Indian-style clothing. It is the position of their feet which is most remarkable, squarely set with the toes pointing outwards. Their shoes, resembling pointed slippers, are typically Indian. The preciousness of the fabrics depicted in paintings dating from the late fifteenth century onwards is typical of those seen in Mughal miniatures. Marilyn Heldman writes in *African Zion* (p. 194) that 'the *Chronicle of Emperor Sarza Dengel* (1563–97) indicates that Indian fabrics and entire garments were imported and worn by the Ethiopian aristocracy. Specifically named is the *qaftan* (caftan), a long-sleeve outer garment very much like the costume worn by Christ in depictions of the Resurrection.'

The tunics, which end in square or pointed collars and which are worn by the three figures of the Trinity and the twenty-four Elders of the Apocalypse in First Gondarine style paintings dating from the seventeenth century onwards, reflect the clothes worn by Europeans at that time. This is not to say that Ethiopian painters copied foreign works blindly but that certain details, gestures, poses and an expanded cycle of narrative subject matter entered the artistic vocabulary and, though transformed by Ethiopian taste, had an enduring presence.

Sources

This chapter has been based on Philip Caraman, *The Lost Empire: The Story of the Jesuits in Ethiopia* (London, 1985).

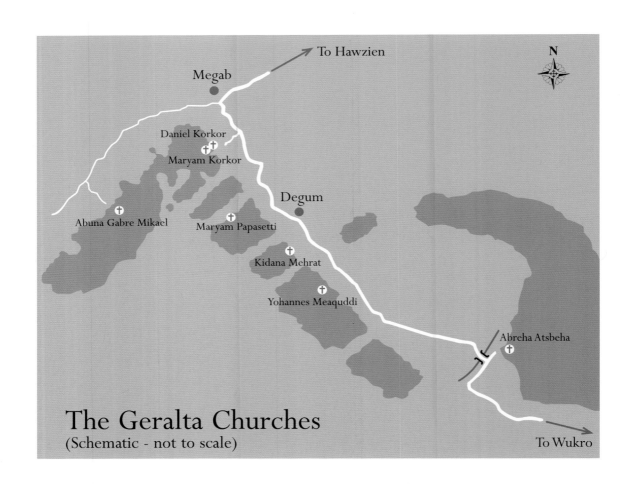

To Hawzien

N

Megab

Daniel Korkor

Maryam Korkor

Degum

Abuna Gabre Mikael

Maryam Papasetti

Kidana Mehrat

Yohannes Meaquddi

Abreha Atsbeha

The Geralta Churches
(Schematic - not to scale)

To Wukro

Chapter 4
The Churches of Tigray

The Rock-Hewn Churches of Geralta

The Geralta mountains lie north-west of Mekele. This range, which rises abruptly and almost perpendicularly above the Hawzien plain, offers some of the most spectacular views in Tigray. Its steep escarpment extends for many kilometres and the churches, situated on its various summits, are very remote. To reach them you have to climb through fairly difficult terrain on paths that are often not easily seen. It is therefore imperative that you are accompanied by a guide from the tourist office in Mekele; he will also be needed to track down the key-holders of the churches you wish to visit and to negotiate with the priests to obtain their permission for your visit.

The majority of these churches have been hewn out of the sandstone but not cut free from the rock so that, when you look up from the plain, in most cases they are not visible. Each of the churches is separated from the next by a wide ravine or plain. Only two – Maryam Korkor and Daniel Korkor – are situated on the same peak, albeit on different sides of it, but you can easily walk from one to the other.

History of the Churches

In the Geralta region, both the priests and the people maintain that the churches were hewn out either during the joint reigns of Saizana and Ezana, the first Christian kings of Ethiopia (c. AD 330–56), or at the time when the nine Syrian saints spread monasticism in Ethiopia during the sixth century. However, it is much more likely that they were excavated and decorated by monks who originated from eastern Tigray during the thirteenth and fourteenth centuries. Indeed, in the case of one of the churches – Kidana Mehrat on the summit of Debre Tsion – there exists a manuscript which clearly indicates that it was built at the end of the fourteenth century.

These monks were searching for the solitude and Christian discipline of monastic life, and that is the most probable reason for Geralta's churches being perched on top of the mountains. The churches

Yohannes Meaquddi

WEST WALL, NORTH BAY: Top left corner, page holding a fly-whisk over King Herod Antipas who is seated on a throne; Salome and her mother, Herodias; below them, the decapitated John the Baptist. Top right, the figure of Christ surrounded by the Tetramorph. Below Christ is *Abba* Gabre Maskal, one of *Abba* Samuel's disciples, riding a lion and with one of his disciples behind him. The two figures on the left, below the decapitated John the Baptist, are *Abba* Samuel of the monastery of Waldebba and *Abba* Zarufael, his disciple. At the bottom of the fresco is the mounted King Fasilidas killing his enemies; he has two servants and a mounted courtier with him.

PILASTER: Two archangels.

WEST WALL, NAVE: Top, left to right, the Temptation of Christ, the Baptism, and Adam and Eve with the serpent. Below, left to right, the mounted St Victor killing a lion which is attacking a hyena; and two 'angels of death' beating a man hanging upside-down between them.

PILASTER: St Michael with his sword.

COLUMN: Crucified Christ with two centurions. Below, an angel holding a sword.

NORTH WALL: Top, left to right, the mounted St George rescuing Birutawit; the Virgin and Child with the archangels Michael, on the left, and Gabriel on the right. The figure on the far right is the monk, *Abba* Likanos. Below, left to right, *Abuna* Gabre Manfas Kiddus; St John the Evangelist; *Abba* Gabre Iyasus, the donor of the frescoes; Gabre Maskal, founder of the monastery of Debre Maar; and *Abba* Yemata, one of the nine Syrian saints. At the bottom, part of the army of King Fasilidas.

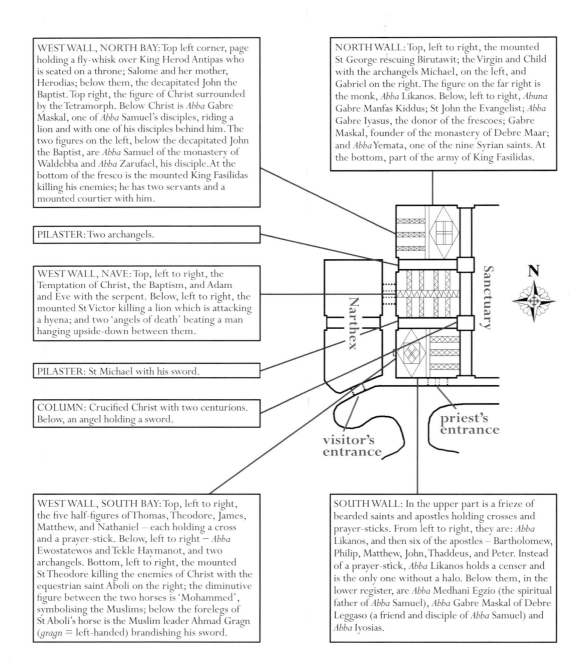

N

Sanctuary

Narthex

priest's entrance

visitor's entrance

WEST WALL, SOUTH BAY: Top, left to right, the five half-figures of Thomas, Theodore, James, Matthew, and Nathaniel – each holding a cross and a prayer-stick. Below, left to right – *Abba* Ewostatewos and Tekle Haymanot, and two archangels. Bottom, left to right, the mounted St Theodore killing the enemies of Christ with the equestrian saint Aboli on the right; the diminutive figure between the two horses is 'Mohammed', symbolising the Muslims; below the forelegs of St Aboli's horse is the Muslim leader Ahmad Gragn (*gragn* = left-handed) brandishing his sword.

SOUTH WALL: In the upper part is a frieze of bearded saints and apostles holding crosses and prayer-sticks. From left to right, they are: *Abba* Likanos, and then six of the apostles – Bartholomew, Philip, Matthew, John, Thaddeus, and Peter. Instead of a prayer-stick, *Abba* Likanos holds a censer and is the only one without a halo. Below them, in the lower register, are *Abba* Medhani Egzio (the spiritual father of *Abba* Samuel), *Abba* Gabre Maskal of Debre Leggaso (a friend and disciple of *Abba* Samuel) and *Abba* Iyosias.

are roughly hewn and hence were not constructed by professional craftsmen — as in the case of the church complexes at Lalibela — but by the dedicated monks themselves who were probably also the painters of the frescoes.

Regarding the time needed to excavate these churches, the Kidana Mehrat manuscript states that this church was completed in a year and nine months. One's initial reaction is of disbelief but, recognising that the rock is soft sandstone and that recently a church was hewn out in two months, this may be true.

The Geralta churches are my favourites because of the incredible scenery of this mountain range and the feeling I have on each visit that these churches are a significant part of the long and honourable architectural tradition of Ethiopia, stretching back to the palaces and obelisks at Aksum which date between the first century BC and the fourth century AD.

Yohannes Meaquddi

This church, dedicated to St John the Evangelist, is situated 25 kilometres from Wukro via a dirt road and is best approached in a four-wheel-drive vehicle. It is the first of the summit churches reached when approaching from Wukro. The church is situated 230 metres above the valley floor, at an altitude of 2,365 metres. There are two routes up to it. The shorter route, which I prefer, leads directly from the small

Fig. 32. María-José with our guide, Jemal Kedir, on the walk to Yohannes Meaquddi

hamlet immediately below the church. This narrow goat path is the one used by the locals and goes more or less straight up; it takes no more than one hour to climb. You really need to be accompanied by a local person, even if you have a guide, since his help will be invaluable in ensuring you use the correct path. Once the church is reached, he will probably be needed to fetch the priest who lives in the valley behind the church.

The alternative path, which is longer but less steep, starts well to the south-east of Yohannes Meaquddi. It climbs diagonally across the mountain and goes past the church of Abi Addi (which has no paintings) situated about twenty minutes walk up from the valley floor. By this path it will take about one and a half hours to reach Yohannes Meaquddi.

The church is hewn from a great outcrop of white sandstone on top of the mountain. It is not visible from the valley floor. There is a large church compound; on entering it you will see a building to the left which is used by the priests and the congregation on Sundays and feast days. In front of you is an opening in the rock that gives access to the church.

The church has two entrances: one, used by the priests, leads directly into the nave; the other, to the left of the first, is used by the congregation and by tourists and leads into the narthex, a room with a ceiling divided into two. The first part has a carved cross within a shallow dome, and the second has a plain, shallow dome. At the end of the narthex, two steps take you through an Aksumite doorway giving access to the church itself.

The entire wall surface is covered in colourful paintings of scenes from the Bible and of Ethiopian saints. In Yohannes Meaquddi, there is an inscription below one painting naming the donor of the frescoes which, unusually, allows us to date them precisely. It states that it was painted 'twenty-five years after the coronation of our King Fasilidas', that is, in 1657. However, since the style of these paintings is different from those of any other church in the surrounding area, it does not help us to date the others.

The figures are frontally depicted and seem to be angelical beings, whose voluminous cloaks, painted in terracotta, mustard-yellow, and grey, may conceal wings. This might explain why they are drawn with square shoulders. A few of their robes are of a patchwork pattern whereas the majority are striped or have a simple herringbone

Fig. 33. The entrance to Yohannes Meaquddi

design. The figures are depicted with round faces, painted in terracotta or grey, with almond-shaped eyes. Their haloes, most of which resemble turbans, are outlined in black, and most are filled in with yellow and are cross-hatched in black. King Fasilidas, his attendants and a few of the saints have their hair elaborately plaited so that it stands up on end.

On entering the church you will see directly in front of you, in the east, the *maqdas* hidden by curtains. The church is divided into three bays by two pairs of columns joined by false beams.

North Bay Ceiling

This has a flat ceiling divided into two by a false beam running north–south. The western section is further divided by three false beams. The eastern section has two sunken squares, one within the other, but rotated through 45 degrees with respect to each other, creating a lantern pattern. Within the smaller square is a carved, painted cross. The whole ceiling is decorated with a number of patterns in terracotta and grey on a white base.

Nave Ceiling

The ceiling is concave, in the shape of an upside-down boat, with the keel of the boat being an east–west false beam separating the ceiling into two sections (see Fig. 7, p. 8). These two sections in turn are separated into five panels, each by four north–south false beams forming the hull of the boat. Within panels on each side of the ceiling are three robed figures, six in all, the remaining panels being decorated with criss-cross patterns. On the north, west and south, there is a frieze of twenty-three figures (nine each on the south and north sides and five on the west side) – head and torsos only – set within arches.

South Bay Ceiling

The ceiling here is the same as that over the north bay except that it is a mirror image – the section with the cross inside the two sunken squares is on the western rather than the eastern end.

The Paintings

North Wall

This is the wall opposite the priest's entrance. Starting on the left-hand side of the top register, we see St George mounted on a horse trampling a dragon and rescuing Birutawit. She is the small figure holding the dragon's leash. To the right of Birutawit are the Virgin and Child followed by the archangels Michael and Gabriel. The figure on the far right is *Abba* Likanos, a monk who came to Ethiopia from the monastery of *Abba* Pachomius in Upper Egypt.

In the second register, left to right, are Gabre Manfas Kiddus, the famous hermit whose sanctity tamed wild beasts. Then comes St John the Evangelist holding a quill in the act of writing his gospel;

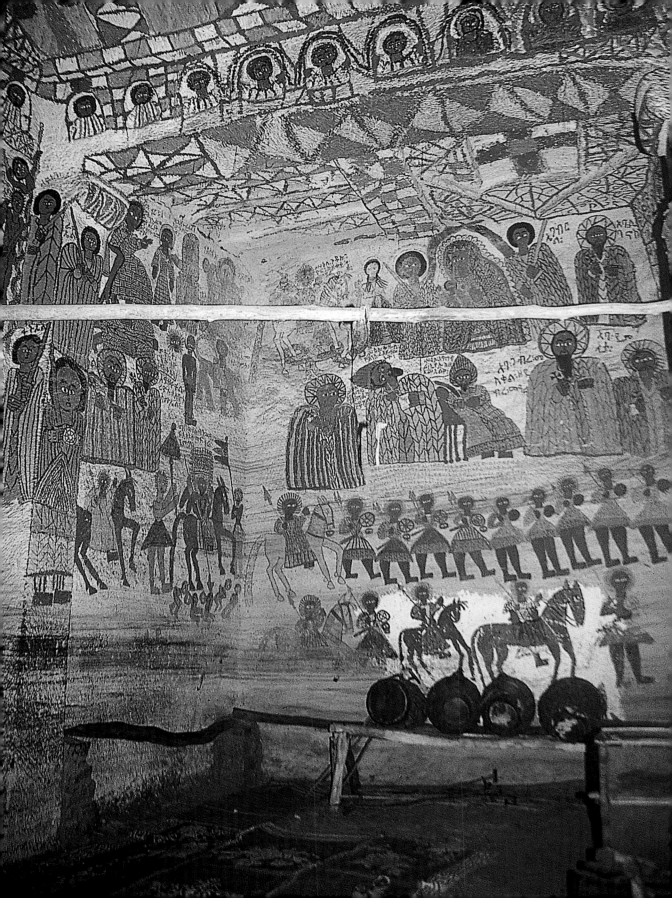

Fig. 34 (left). The frescoes on the ceiling and west and north walls

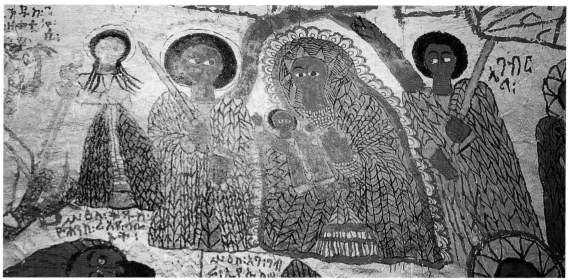

Fig. 35. North wall. Birutawit, St Michael, the Virgin and Child, and St Gabriel

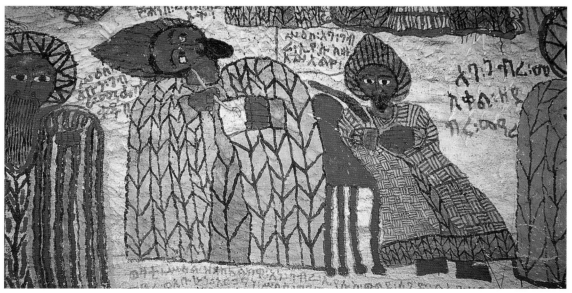

Fig. 36. North wall. St John the Evangelist and the painter of the church's frescoes

he is looking up towards the Virgin and Child. The smaller, seated figure next to him is the person who paid for, and who may have been the painter of, the frescoes in the church because the caption above his head reads, '*Abba* Gabre Iyasus, the artist'. He is seated in an armchair and is holding a fly-whisk. Next we see Gabre Maskal, founder of the monastery of Debre Maar, followed by *Abba* Yemata, one of the nine Syrian saints and the founder of Guh.

In the lower register of the fresco are four mounted figures, holding spears, together with a row of soldiers dressed in short skirts, holding shields and spears, all of whom are part of the army of King Fasilidas. Attached to the shields of some of the soldiers, and to the collar of the horse behind the soldiers, are trophies which appear to be the heads of the defeated enemy.

The remarkable piece of information which allows accurate dating of these paintings is the inscription located just above the line of soldiers which reads as follows: '*Abba* Gabra Iyasus Walda Segid La'ab from Dabra Ma'ara and his father from Agana Sellase, during the time of *Abba* Asfe Memhir (teacher) twenty-five years after the coronation of our *Negus* (king) Fasilidas, the lover of God. This was painted in memory of Yohannes, Son of Thunder. The love of Yohannes, Son of Thunder, please remember me who enjoys the love of the Saints' (translated by Richard Pankhurst). King Fasilidas reigned from 1632 to 1667 and consequently these frescoes date from 1657.

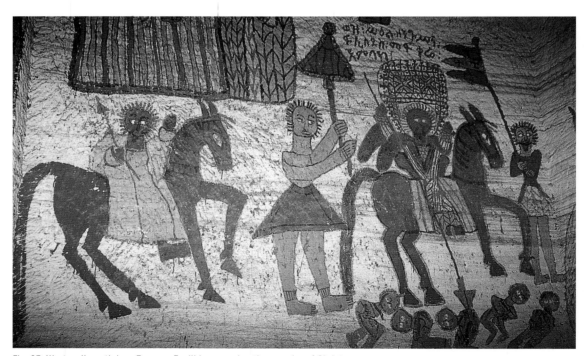

Fig. 37. West wall, north bay. Emperor Fasilidas spearing the enemies of Christ

West Wall, North Bay

In the top left corner is a scene representing a page holding a fly-whisk and umbrella over King Herod Antipas, who is seated on his throne and facing Salome, who is being presented to the King by her mother Herodias. Below them is the decapitated figure of John the Baptist.

At the top right is the figure of Christ surrounded by symbols of the evangelists, the Tetramorph. On the top left is the head of a man, symbol of Matthew; below it is a lion, symbol of Mark; on the top right is an eagle, symbol of John; and below it is a bull, symbol of Luke. Below Christ is *Abba* Gabre Maskal, one of *Abba* Samuel's disciples, riding a lion (usually *Abba* Samuel himself is shown on the lion but the text above clearly states that it is *Abba* Gabre Maskal) with one of his disciples behind him. The disciple's name is no longer legible; all that is legible is the word '*Abba*' meaning 'father'.

The two figures on the left, below the decapitated John the Baptist, are *Abba* Samuel of the monastery of Waldebba and *Abba* Zarufael, his disciple. At the bottom of the fresco is the mounted King Fasilidas (1632–67) killing his enemies with a long, sharp spear as they wriggle on the ground beneath him. The caption reads, 'This is a picture of King Fasilidas who loved his God.' Two servants wearing short skirts stand on either side of the King; the one behind holds an umbrella and the one in front holds a banner. The mounted figure behind the King is one of his courtiers. The King and all his attendants have plaited hair.

West Wall, Nave

In the lower part of this wall is the door leading into the narthex. In the top left of the fresco we have the Temptation of Christ by the Devil (clearly male!) who is holding a stone.

> The devil said to him, 'If you are the Son of God, tell this stone to become bread.' Jesus answered, 'It is written: Man does not live on bread alone.' (Luke 4:3–4)

This is followed by the Baptism of Christ by John with Jesus shown immersed in a river full of fish. In the top right-hand corner of the fresco are Adam and Eve. Eve is tempting a rather coy Adam, whose hair is standing on end and whose hands are covering his genitals. Behind Adam is the serpent wrapped around a tree trunk. The head of the

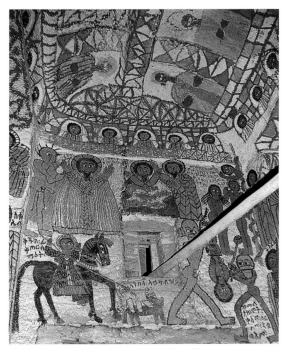

Fig. 38. The west wall of the nave and its ceiling

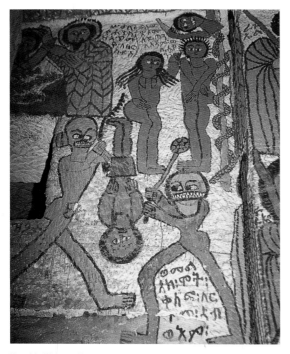

Fig. 39. West wall, nave. Above: Adam and Eve with the serpent. Below: 'angels of death' beating a man

serpent is represented by a human bust, whose arms hold the trunk and a branch of the tree, and who is leering down on the couple.

Below this scene are two delightful, naked, grey, 'angels of death' with toothy smiles and elongated heads and legs. They are beating an unfortunate man who is hanging upside-down between them. The weapons being used appear to be a mace and something resembling a rake. The caption between the legs of the demon reads, 'The angels of death tortured him because of the curse of his mother and father.'

On the left, below the Temptation, is the mounted figure of St Victor (Fikitor), his hair plaited, holding a long spear with which he has run through a ferocious lion which, according to the inscription, is attacking a hyena. St Victor, who was martyred in Egypt, is one of the Ethiopian equestrian saints.

West Wall, South Bay

At the top of this wall are the five half-figures of Thomas, Theodore, James, Matthew and Nathaniel, each holding a cross and a prayer-stick. They are separated from the scenes below by a band of geometrical patterns. Below them, on the left-hand side, there are the two figures of *Abba* Ewostatewos and Tekle Haymanot, the two early fourteenth-century spiritual leaders of the Ethiopian Church who were responsible for founding two distinct monastic centres. On the right side, are two archangels.

At the bottom, the mounted figure on the left is Theodore the Roman killing the enemies of Christ with the equestrian saint Aboli depicted on the right. The diminutive figure between the two horses is named as 'Mohammed', symbolising Muslims in general. And the figure below the forelegs of St Aboli's horse, who is brandishing a sword in his left hand, is the Muslim leader Ahmad Gragn, *gragn* meaning left-handed.

His full name was Ahmad ibn Ibrahim al-Ghazi. He was from the Danakil Desert near the Red Sea, and it was he, supported by men and firearms supplied by the Turks, who began the Muslim conquest of Ethiopia in 1527. The Ethiopian emperor at that time was Lebna Dengel, whose army was hardly aware of the existence of firearms and certainly did not possess them. By 1535, after having been driven by

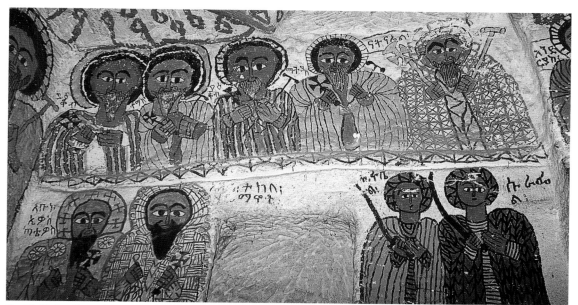

Fig. 40. West wall, south bay. Above: Thomas, Theodore, James, Matthew, and Nathaniel. Below: *Abba* Ewostatewos, Tekle Haymanot, and two archangels

Gragn from province to province, the Emperor sought the assistance of the King of Portugal, in return for which he promised to acknowledge the supremacy of the Pope.

The King of Portugal had sent 400 to 500 Portuguese soldiers to Ethiopia under the leadership of Christopher da Gama, the son of Vasco da Gama. They landed at Massawa in 1541 and found that the Emperor had died and most of the country overrun by Gragn. Christopher da Gama was killed in battle, together with half his Portuguese army, but the rest, together with the new emperor, Gelawdewos, fought and killed Gragn near Lake Tana in 1543. This whole series of events opened the door to the Jesuits who were to try to convert the country to Roman Catholicism. This led to much conflict within the Ethiopian kingdom, before the Jesuits were finally expelled in 1633.

South Wall

This wall incorporates both the priest's entrance and a small window above it which is surrounded by a cross-hatch pattern. In the upper part of the wall there is a frieze of bearded saints and apostles holding crosses and prayer-sticks.

From left to right they are *Abba* Likanos and then six of the apostles – Bartholomew, Philip, Matthew, John, Thaddeus and Peter. Instead of a prayer-stick, *Abba* Likanos holds a censer and is the only one without a halo. Below them, in the lower register, are *Abba* Medhani Egzio (the spiritual father of *Abba* Samuel), *Abba* Gabre Maskal of Debre Leggaso (a friend and disciple of *Abba* Samuel) and *Abba* Iyosias.

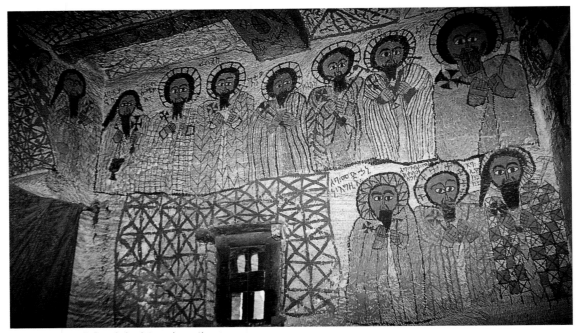

Fig. 41. South wall. Bearded saints and apostles

Columns and Pilasters

On the north-east column separating the nave from the sanctuary is a depiction of the crucified figure of Christ with two centurions, one of whom, Longinus, is spearing his side. It is interesting to note that the Cross itself is not shown. Above the Crucifixion are the sun and the moon while below is the figure of an angel holding a sword. Opposite, on the north-west pilaster are two archangels, and on the south-west pilaster is St Michael with his sword.

Manuscript

Yohannes Meaquddi has a beautiful manuscript with ten illuminated pages. The first two pages are of portraits of the twelve apostles. These are followed by portraits of Christ in Majesty, the Virgin and Child, the four evangelists and, at the end, two illustrations of saints.

The first eight illustrations date to between 1470 and 1540 and were most probably executed in the Stephanite scriptorium of the monastery of Gunda Gunde. What dates them to this period is the use of lapis lazuli which came from Egypt; it was never used before 1470, and it disappeared from use in Ethiopia after 1540. The style of Gunda Gunde of the fifteenth–sixteenth centuries is recognised by the elongated but squat faces. The last two illustrations, one of which is of St Euphemia and the other of an unidentified male saint, date to the first half of the fourteenth century.

The figures of the four evangelists are two-dimensional and sit in a three-quarter view but are imbued with a wonderful sense of volume due to the artful arrangement of their garments. Each layer of the garment is differentiated by a band of colour and a network of parallel lines drawn vertically, horizontally and diagonally within the figure of the saint. The colours used are different shades of blues, yellow ochres and greens.

Christ in Majesty Surrounded by the Tetramorph

The inscription within the triangle at the top says, 'This is a picture of God the Father with the four Evangelists.'

The four beasts are illustrated exactly as they are described in Ezekiel 1:5–11: 'And in the fire was what looked like four living creatures. In appearance their form was that of a man, but each of them had four faces and four wings. Their legs were straight; their feet were like those of a calf and gleamed like burnished bronze. Under their wings on their four sides they had the hands of a man. All four of them had faces and wings, and their wings touched one another. Each one went straight ahead; they did not turn as they moved. Their faces looked like this: Each of the four had the face of a man, and on the right side each had the face of a lion, and on the left the face of an ox; each also had the face of an eagle. Such were their faces. Their wings were spread out upwards; each had two wings, one touching the wing of another creature on either side, and two wings covering its body.'

Fig. 42. Manuscript. Christ in Majesty

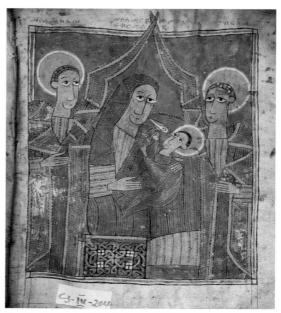

Fig. 43. Manuscript. The Virgin and Child

This illustration is of exceptional interest. I have never come across a similar depiction. I believe it to be a copy of a miniature that probably hung on a wall – the twine has been depicted at both the top and bottom. However, there is another school of thought that believes the roundels to be the wheels mentioned in Ezekiel 1:15–9.

Virgin and Child

The Virgin and Child are set within an orange frame. Like all the others in this manuscript, the figures are strictly two-dimensional. All the figures wear striped garments, a characteristic often seen in works of the early sixteenth century.

Two archangels, Gabriel on the left and Michael on the right, stand full length on either side of Mary and Jesus. Their wings, which have triangular shapes of different colours within them, are arched above her head defining a sacred canopy above Mary who sits holding the baby Jesus with her left arm. Each archangel wears a chequered headband, reminiscent of Byzantine portrayals of angels. Mary sits on a stool of abstract design which consists of a yellow Gondarine cross with entwined arabesques in whites, greens and blues.

Above the Virgin is written 'The Virgin Mary with her beloved son'. Jesus grasps a bird in his right hand in the same naturalistic way that all babies grasp at their toys. With his left hand he points to his mother. The Virgin wears a green veil which is decorated with triangles, the arms of which are in red with white dots sprinkled across them. This characteristic of placing dots along many of the lines in the painting is often found in the sixteenth-century works of the Stephanite scriptorium.

The whole miniature is aesthetically beautiful. The brilliant colours complement each other, and the work has a profound religious feeling. Jacques Mercier in *Vierges d'Éthiopie* (2004) points out that he believes this to be the work of a scribe rather than a painter because of the beautiful interlace design on the stool compared to the awkward depiction of the Virgin's body. I fell in love with this manuscript precisely because the figures' sense of volume has been wonderfully achieved by a network of parallel lines placed horizontally, vertically and diagonally in bands of different colours around each figure. A copy of this illumination appears on page 125 in Jacques Mercier's *Vierges d'Éthiopie* (2004).

St Mark

This is one of the most beautifully laid out figures in this manuscript. Set within a yellow frame, his reflective and imposing figure covers the entire space. An abstract design, entwined with crosses and arabesques in white, yellow and ochre, surrounds the figure on three sides and serves as his seat on the fourth. A dove, symbol of the Holy Spirit who inspired him to write his gospel, appears at the top right.

His long face is intent; it is outlined in black, as are his eyebrows, eyes and nose. He has a round head with a full head of hair. He has full round lips and wears a short square-cut beard.

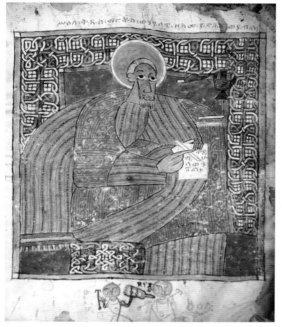

Fig. 44. Manuscript. St Mark

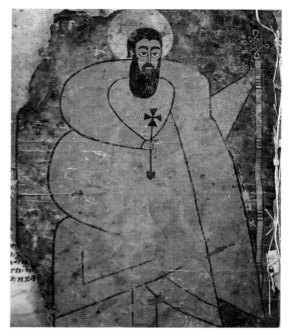

Fig. 45. Unidentified saint

The white lower margin of the page has been spoiled by two schematic figures. When I asked the priest why this had been allowed to happen, he told me that the congregation had no paper on which to draw!

Portrait of an Unidentified Saint

This is one of two badly torn pages which come from an older manuscript than the previous illustrations – from a *Gadla Samaetat*, a book devoted to the life of saints. Several of the biographies (*gadls*) were introduced by a portrait of that saint. These portraits are types and are only recognised by their inscriptions.

There is a presence about this saint that goes beyond the bulk of his ample body, which is clad in a voluminous cape: his commanding facial features, the intense blackness of his beard, moustache, hair and eyebrows make this portrait one of the most impressive depictions of a saint that I have seen in any Ethiopian illustration. The folds of his cape are highlighted by black curved lines. His tiny hands serve to exaggerate the enormity of his body. With his right hand he holds a hand-cross in front of his chest, and with his left he holds a staff that ends in a multicoloured interlaced cross.

In Jules Leroy's *Ethiopian Painting* (1967), in Plate XIV, St John has a similar stance, and in Plate XV, the diminutive St Cyriacus wears a cape, the folds of which are depicted in the same manner as with this saint. But neither of these can compare with the commanding presence of this particular portrait.

Kidana Mehrat

BAY K, EAST WALL: Below, three rows of three shallow niches in each of which is an angel holding a chalice. Above, the Virgin and Child between two angels. CEILING: a dome within which is a carved cross in low relief. The centre of the cross and the spaces between the beams are decorated with ribbon knotwork.

BAY L, EAST WALL: A series of niches above which is Christ painted within a green *mandorla* and held by the figures of the Tetramorph. CEILING: The most elaborately painted vaulted ceiling in the church. The dome has a carved cross.

BAY G, NORTH WALL: Three rows of three arched niches. Upper row, left to right, a barely discernible Crucifixion; a much-damaged Christ carrying the Cross; and a single figure, with a bowed head. CEILING: Carved to simulate the truncated saddleback roof of a built-up church (running east –west) and decorated with Greek and Jerusalem crosses.

BAY M, EAST WALL: Three rows of three niches with the figure of a saint within each. Above is a window opening on to the ambulatory. On either side of the window there is a cross.

BAY H, CEILING: Truncated saddleback running in north–south direction.

BAY J, SOUTH WALL: Three rows of three niches with the figure of a saint within each.

BAY D, NORTH WALL: Above, the two equestrian saints – St Theodore the Egyptian, whose horse is trampling a rearing snake, and St Claudius behind him. Between them is the archangel Michael. Below, an Aksumite frieze of metopes and, below that, shallow niches with frescoes of saints.

BAY F, SOUTH WALL: At the top, the archangel Gabriel. Below are shallow niches with frescoes of martyrs. Left to right, top row, Gabre Krestos and Arkalewos; lower row, Awsanyos, Ewostatewos, and Yostos.

PILASTER: In the middle panel, *Abba* Lukas and *Abba* Aragawi, one of the nine Syrian saints.

COLUMN, NORTH SIDE: In the lowest row are a pair of monks; each holds a book. The one on the left is *Abba* Fikitor, a saint from Tenben in Tigray; the one on the right is unidentified. SOUTH SIDE: Lowest panel, *Abba* Besoy from Egypt (left) and *Abba* Tewolde Medhin from Tigray (right).

BAY A, NORTH WALL: Above the door there were originally two scenes, only one of which remains in its entirety – this is of the builder of this church, *Abuna* Abraham, holding a cross. In front of him is his lion 'servant' carrying four pots of water on his back for his master.

BAY A, WEST WALL: *Abuna* Abraham parting the waters of the river Giba to allow safe passage for his four disciples. The fresco depicts the river full of fish. CEILING: a painted cross with the four evangelists, of which only two remain.

PILASTER: Three rows of patriarchs, a pair in each row. Middle row, *Abba* Abib (known as 'Bula') on the left and, on the right, *Abba* Latsun.

BAY B, WEST WALL: Between door and window, a lioness with her two cubs, one suckling while the other is held by *Abba* Samuel. Above the arched window, a partially visible man and woman and two mounted figures, St Claudius on the larger horse, and St Alianus riding the smaller one.

N

Abuna Abraham's cell

2m high

7m high

rock face

K L M

G H J

D E F

A B C

Narthex

6m high

Ambulatory 4m high

Kidana Mehrat

The church of Kidana Mehrat is 2 kilometres beyond Yohannes Meaquddi, a total of 27 kilometres from Wukro. It is situated in the same mountain range as Yohannes Meaquddi but on an escarpment of its own – that of Debre Tsion – at an altitude of 2,290 metres, some 200 metres above the valley floor. Your four-wheel-drive vehicle should be left just outside a small hamlet a short distance south-east of the village of Degum. There is only one route to this church. Begin by walking through the hamlet and along the southern flank of Debre Tsion. The climb starts south of the church and involves passing through a relatively narrow chimney, strewn with large boulders which may require sideways negotiation. About halfway up is the spot where, legend has it, *Abuna* Abraham had a vision that he should build a church on Debre Tsion.

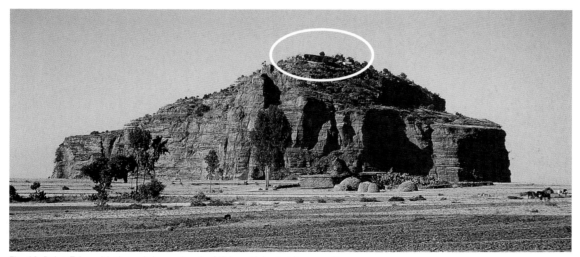

Fig. 46. Debre Tsion with the rock-hewn church of Kidana Mehrat at its summit

Just before reaching the compound of Kidana Mehrat, to the left of the path and well hidden below ground level, is the cave-like entrance to the first church to have been built on Debre Tsion, called Abuna Abraham. It is no longer used and is very easily missed. You need to make a specific request to your guide if you want to see it. It is not clear whether this church had already been built before *Abuna* Abraham had his vision or whether it is the first of two that he built on this escarpment. It is roughly hewn from the sandstone and is small – only some 3 metres wide, 5 metres long and 2 metres high – with a flat roof and carved beams that continue down into pilasters in the walls. It has four rough columns that divide the church into three aisles. Beyond an arch is a small grotto that is the sanctuary.

Some 50 metres further along, the path brings you to the compound of Kidana Mehrat ('Covenant of Mercy'). Roger Schneider, who went to Ethiopia in 1956, discovered a sixteenth-century manuscript in this church dedicated to the life of *Abuna* Abraham (Gerster, 1970, p. 81). According to this document, Abraham's father came from Sawa to Tigray in the third year of the reign of King Sayfa Arad (1344–72). Therefore, Kidana Mehrat was probably built at the end of the fourteenth century. The manuscript also states that the church took one year and nine months to build. The church is dedicated to the Virgin Mary. It celebrates the promise Christ made to Mary to accept her intercession on behalf of anyone devoted to her. According to the Ethiopic *Synaxarium*, anybody who performs a good deed in her name will be forgiven all his sins.

A monk has been living in the compound for the past twenty-five years. He has the key to the church. His mother, and a woman who comes up every day to bring him food, live in the hamlet below. Before you attempt to reach the church, you should have your guide make inquiries in the hamlet as to who has the key and whether the monk is in residence.

Kidana Mehrat has an extensive, exposed, north-facing rock façade bearing faint traces of attempts to carve it in the style of an Aksumite structure of wood beams and stonework with monkey-heads. When we visited it in 1998, the exterior roofline was constructed of loose stones. Between that visit and our visit in 2001, a proper cornice of cemented stones had been constructed to help prevent the ingress of rainwater into the church. The façade has three entrances. The two at either end lead

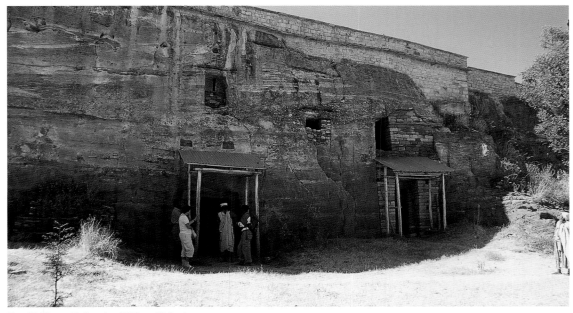

Fig. 47. The north façade of Kidana Mehrat

to the ambulatory that surrounds the church, and the third leads into the church itself. The ambulatory entrances are as high as the ambulatory itself, about 7 metres, but have been partially bricked up to protect the interior. The church entrance is much lower, perhaps only 2 metres high. Since 1998, all three entrances have had a timber porch added on to them with a corrugated metal roof, again to provide some protection from the elements. The façade also contains five window openings located at differing heights.

The church interior resembles that of Makina Medhane Alem in Lalibela. Kidana Mehrat is splendidly hewn from the sandstone. It has a hypostyle plan, 14 metres long by 10 metres wide, divided into three aisles and four bays with six columns. It has a narthex extending two-thirds of the full width of the church.

The Frescoes

Abuna Abraham had the name Abraham bestowed upon him by *Abba* Besoy, a disciple of Gabre Manfas Kiddus, when he accepted him as a monk (a fresco of *Abba* Besoy is to be seen on the south side of the closest column to the entrance). *Abuna* Abraham's true name was Berhana Maskal, and he came to Besoy after the death of his wife who had born him seven children.

Abuna Abraham (*c.* 1350–1425) was to become a prodigious church-builder, so much so that he came to the notice of King Dawit (1382–1411), and it was Dawit's son, Yeshak (1414–29) who funded the decoration of the church of Kidana Mehrat. According to a colophon to a manuscript dating to the reign of another of Dawit's sons, Zara Yakob (1434–68), Kidana Mehrat's frescoes were completed at this time – and so we can safely say that they were executed in the mid-fifteenth century.

All the ceilings, walls and columns of the church are lavishly painted. All the domes and soffits of the arches of the bays in the north, south and east walls are covered in a white background on which have been painted ribbon-interlaced crosses of different styles in viridian green. The space between the crosses has been decorated with geometrical entwined patterns in viridian green with details in red.

The architecture of some of the bays in the north, east and west walls consists of three rows of shallow niches, each under a round arch. They resemble the architectural frames of book illustrations. They have been deliberately carved from the rock and are a prominent feature of this church. The walls have been plastered in white, and the niche arches have been framed with two running bands of geometrical interlacing patterns painted in viridian green. In contrast, the columns separating the niches have a viridian green background with interlaced designs and intricately woven ribbon-crosses in white. Arabesque designs decorate the spandrels. Figures of saints and monks have been painted within each niche.

The lower part of the walls was also originally painted but now there are few traces of this work remaining. Each scene is contained within a frame filled with knotwork in greens and browns.

Bay A

The ceiling over the entrance door has a painted cross with the four evangelists, of which only two remain. The figures are rectangular-shaped, dressed in brown garments with white *shammas*; both have elongated necks; their beards and hair and beautifully expressive large eyes are black; both have haloes. Arabesques in viridian green form the background. Each holds a book in his right hand and the index finger of the left hand points towards the book. Although the figures are stylised and flat, they have a sense of purpose because of their animated gaze. The sense of remoteness that is typical of Byzantine art is lacking here – the figures seem human.

Above the door there were originally two scenes, only one of which remains in its entirety. This is a wonderful depiction of the builder of this church, *Abuna* Abraham, holding a cross. His rounded figure is covered by a green cloak through which part of a brown undergarment is visible. His very expressive face is framed by a

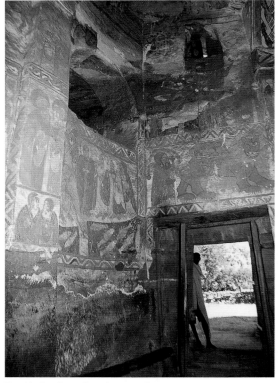

Fig. 48. Bay A, north and west walls

square-cut black beard and the brown cowl on his head. He seems to be uttering some words. In front of him is his 'servant', an oversized lion in brown with its full mane depicted in a partially transparent grey. The lion is carrying four pots of water on his back for his master, three of which still have remains of green paint. The text reads, '*Abuna* Abraham with his servant, the lion, who carries pots of water on his back for his master.' Such harmony between man and beast, of which we have two examples in this church – here in the case of *Abuna* Abraham and with *Abba* Samuel in Bay B – was the goal of anchorite life and was prophesied in Isaiah 11:6–9:

> The wolf will live with the lamb, the leopard will lie down with the goat, the calf and the lion and the yearling together; and a little child will lead them. The cow will feed with the bear, their young will lie down together, and the lion will eat straw like the ox. The infant will play near the hole of the cobra, and the young child put his hand into the viper's nest. They will neither harm nor destroy on all my holy mountain, for the earth will be full of the knowledge of the Lord as the waters cover the sea.

On the west wall of this bay there is a pan-elled scene, which, when I first saw it I thought was Moses parting the waters of the Red Sea. However, it turned out to be another painting of *Abuna* Abraham. He was returning from a visit to another church with four of his disciples. His monumental figure on the left of the scene is clad in a white *shamma* over a brown robe. In his left hand *Abuna* Abraham holds a hand-cross (the kind all priests carry with them and which you often see the people being allowed to kiss). With his right hand he is parting the waters of the river Giba, which you will have crossed on the drive to the church, with a cross at the end of a long pole which purposefully touches the water. This was to allow safe passage for his four disciples. The fresco depicts the river full of fish. His four disciples witness the event; one of whom is shown in a frontal pose while the other three are shown partially turned towards *Abuna* Abraham. They are all two-dimensional but have a sense of volume. Although their robes envelope them, the

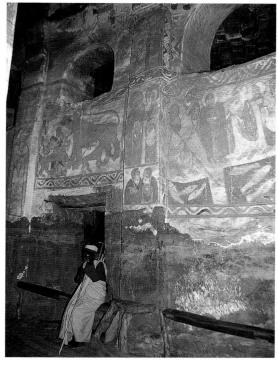

Fig. 49. Bays A and B, west wall. Left: *Abba* Samuel with a lioness and her cubs. Right: *Abuna* Abraham parting the waters of the River Giba

lines are complementary to the form below. The folds terminate in sinuous lines, suggesting that the men are walking. The caption reads, 'May the prayer of all saints, our fathers, be with us all. Amen.'

Above this scene is an arched opening through which you can see the elaborately carved ceiling of the narthex.

Bay B

The stucco, together with its frescoes, on the lower part of the west wall has fallen away exposing the brown sandstone rock surface of the church. A doorway cut in Aksumite style connects the church with the narthex, and high above it is an arched opening. Between door and window there is a painting of a lioness with her two cubs, one of which is suckling while the other is held by the very determined-looking figure of *Abba* Samuel, with his sleeves rolled up revealing his strong arms, standing in front of the mother. Legend has it that Samuel rescued the cub and brought it back to the lioness. The text reads, 'The Virgin covers *Abba* Samuel with her grace like a cloak and sanctifies him with blessed doves (saints) in the Sanctuary of Zion. Amen.'

Above the arched window is a scene depicting a now only partially visible man and woman and two mounted figures, St Claudius (Gelawdewos) on the larger horse, and the diminutive figure of St Alianus riding the smaller one.

Bay C

No frescoes remain on the walls of this bay. The brown sandstone is clearly visible. The south wall has an Aksumite-type door providing access to the ambulatory, with a square window above it.

Columns and Pilasters

The pilasters by the entrance on the north wall and by the entrance to the narthex on the west wall, and the four columns in the centre of the church, are painted in a very different style from the walls with the niches. Here we see figures of monks and holy men, each holding a book. The significance of the book is that, as monks, one of their duties was to spread the gospel. Each side of the columns has three registers separated by colourful bands filled with geometric decoration, each different from the others, both in colour and design.

The monks either wear cowls on their heads, or have haloes. The figures are monumental and occupy the entire surface of the column. They are depicted in pairs, standing close to one another, in frontal or three-quarter pose. Their colourful cloaks, in viridian green, mustard yellow and white, merge into one another. Although their attitudes are static they lack the sense of remoteness so typical of Byzantine art. The figures are stylised and flat but they are imbued with a sense of purpose because of their animated gaze. They appear realistic. Their mouths are portrayed in such a way that they appear to be whispering to one another, an impression which is enhanced by the rapt expression of the listeners who are gazing into space. Thus, despite a certain degree of awkwardness, the figures of these monks are strangely impressive.

Above some of these holy men are inscriptions with their names written in Ge'ez. On the west wall, between the paintings of *Abba* Samuel with the lioness on the left and *Abuna* Abraham parting the waters of the river Giba on the right, is a pilaster. In the middle row of monks on this pilaster are *Abba* Abib (also known as 'Bula') on the left and, on the right, *Abba* Latsun. *Abba* Abib was a saintly monk who was born in Rome during the period of Emperor Maximianus II (AD 305–11). He repeatedly challenged governors who worshipped idols and, as a consequence, was tortured and put to death several times, always to be rescued by St Michael. The hair of both monks is white, and they both have a kind of mustard halo.

To the side of the entrance to the church is a pilaster on which, in the middle panel, are *Abba* Lukas and *Abba* Aragawi, one of the nine Syrian saints.

On the north side of the first column inside the entrance, in the lowest row are a pair of monks or holy men who are depicted face sideways, frontal figure. Each holds a book. The one on the left is *Abba*

Fikitor, a saint from Tenben in Tigray; the name of the one on the right is not clear but he is a monk and a saint. They are both discussing the Holy Bible. On its south side, in the lowest panel, are *Abba* Besoy from Egypt on the left and *Abba* Tewolde Medhin from Tigray on the right. *Abba* Besoy was born in the city of Sanasa. An angel chose him out of all his brothers to serve God. He went to the desert of Scete where he became a monk. He had great faith in the Holy Trinity which helped him interpret the Old and New Testaments, and, in turn, this enabled him to guide people away from the error of their ways and lead them to the true faith. He was a devoted monk. One of the stories told of him in the *Synaxarium* goes as follows:

> One day a disciple heard Besoy talking to someone but when he entered the room there was no one there and he asked Besoy, 'Who were you talking to?' Besoy replied, 'I had a vision of Emperor Constantine who said to me, "Had I known how great was the glory which attended monks, I should have abandoned my kingdom and become a monk."' Besoy reminded the Emperor that God had given him many mercies and the Emperor said, 'But none of them is like the glory which surrounds the monks, for I have seen among them a wing of fire as they were flying into the heavenly Jerusalem.' Besoy replied, 'You have a wife, sons, and riches and gain consolation from them while monks are poor and hungry and thirsty and afflicted and it is for this reason that God has given them the glory they have.'

Bay D

Each of the niches in the lower row of the north wall has lost its plaster, and consequently its fresco, but this allows us to see how these niches have been carved out from the rock face. In the middle row a single figure has been depicted within each niche, each wearing a viridian green *shamma* over a white garment. Their right hands are pointing to the book they hold in their left hand. Each has a halo.

In the upper row, each figure within a niche is outlined in black and appears to be a monk

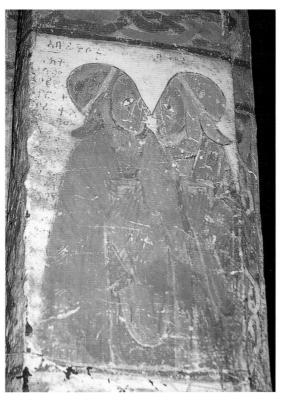

Fig. 50. North side of column near entrance. A pair of monks (*Abba* Fikitor on the left), each holding a book

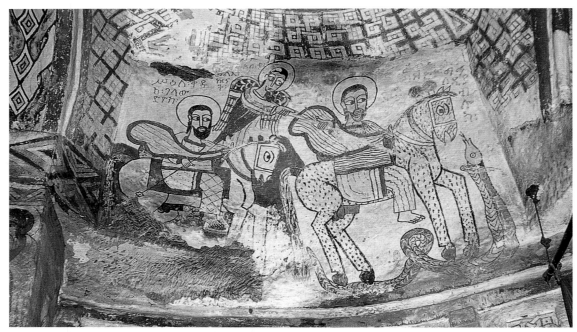

Fig. 51. Bay D, north wall. St Theodore the Egyptian with St Claudius behind him

holding a cross, his head covered by a cowl. But for the black beard and hair, there are no other traces of colour. None of these figures has a halo.

Above them is a frieze of metopes, simulating Aksumite monkey-heads, but here purely decorative and unrelated to their original structural function. The bay is surmounted by a shallow dome and pendentives. There is a painted cross within a sphere, scarcely visible, surrounded by a circle of decorative, interlaced, white pattern on a viridian green background. The pendentives are painted with regularly spaced ribbon looped interlaced crosses in white which in turn define a multitude of green 'Tigrayan' crosses, which are similar to the Jerusalem cross but lack the interstitial crosslets.

Above the frieze there is a scene of two mounted figures, St Theodore the Egyptian with St Claudius (Gelawdewos) behind him, both with haloes. Notice the crude attempt to depict that their robes are being blown by the wind – their *shammas* have the appearance of inflated balloons. In between them, the archangel Michael points towards the rearing snake which St Theodore's horse is trampling. All the figures are delineated in green, geometrically drawn in a two-dimensional way. The caption above St Theodore's head reads, 'The angel gives a spear to the Martyr', and that above the head of St Theodore's horse reads, 'The Martyr killed the snake that is the Devil.' The script above the halo of Claudius says, 'Gelawdewos was from Rome.'

All of the figures painted on this wall face towards the east where the sacred *tabot* is kept.

Bay G

This bay's north wall has three rows of three arched niches. In the upper row is a barely discernible Crucifixion on the left, followed by a much damaged Christ carrying the Cross. The last niche has a single figure, with a bowed head, looking towards the previous scenes. There are traces of interlacing above.

The ceiling has been carved to simulate the truncated saddleback roof of a built-up church, similar to the cave churches near Lalibela – Yemrahane Krestos and the Church of the Redeemer, Makina Medhane Alem. The lines of this ceiling run east–west and it has an overall surface decoration of Greek crosses elaborately painted with green Jerusalem crosses of two types against an overall surface decoration of red squares.

East Wall

The three bays against the east wall of the church (Bays M, L, K) form the *maqdas*, which is separated from the rest of the church by curtains. This is where the *tabot* is kept. In this church there is only one *tabot* and it is to be found in the central bay (L).

Bay K

The east wall of this bay has a whitewashed background with figures painted in viridian green. It has three rows of three shallow niches each of which contains an angel, depicted holding a chalice with his left hand and having his right arm outstretched and pointing downwards. Each angel has wings and a halo.

Above the niches is a scene of the Virgin and Child painted between two angels, who stand full-length, on either side of the holy couple, their feet clearly visible resting on the arch below them. Their wings are arched above Mary's head, forming a sacred space within which the Mother and Child stand. Mary is clad in a voluminous white robe which is decorated with a dotted patchwork pattern in black. Her head is covered with a viridian green *maphorion*. In her left arm she holds Jesus who is dressed in pure white, the only evident colour being that of his green undergarment which is visible around his arms and neck and hangs down beneath him. His hair is black. All the figures have haloes drawn with a black line.

The expression in the gaze of the figures in this scene conveys a deep sense of tenderness. Mother and Child appear to be looking lovingly at one another. The archangels' large communicative eyes look towards Mary and Jesus; moreover, their hands point towards them as if to say here is the Holy Family which we proudly present to you and whom we are fondly guarding. On either side of the scene, on a viridian green background, there is a ribbon-interlaced cross.

The ceiling consists of a dome within which there is a carved cross in low relief that has been whitewashed. The centre of the cross and the spaces between the beams are decorated with ribbon knotwork on a viridian green background. The dome rests on unsupported pendentives as if they were suspended in mid-air. One must remind oneself that, since this is a rock-hewn church, all the architectural details are purely ornamental and serve no structural purpose.

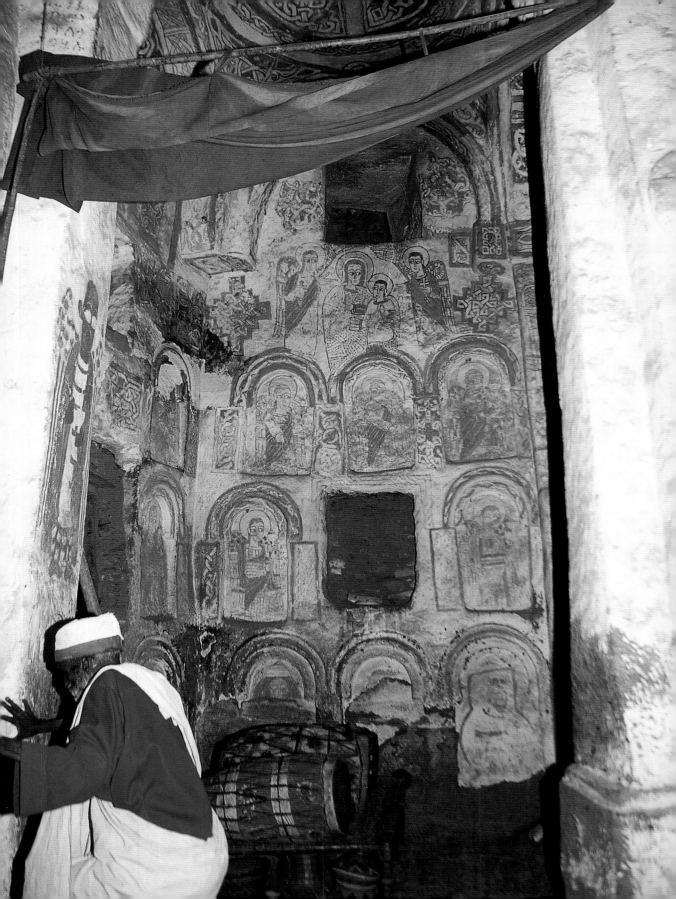

Fig. 52 (left). Bay K, east wall. Three rows of niches with the Virgin and Child and two angels above

Bay L

This bay is the sanctuary where the holy *tabot* is kept, behind a drawn curtain. If you ask him, the priest may lift the curtain slightly for you enabling you to see that here again the wall has a series of niches. Above them, in a recessed rectangular space, the seated figure of Christ in Majesty has been painted within a green *mandorla* and held by the figures of the Tetramorph. All the figures are portrayed as angels with their corresponding attributes: at the top left is the bull of St Luke; below it is the lion of St Mark; at the top right is the eagle of St John; and below it is the face of a man, symbol of St Matthew.

Since bay L is the sanctuary where the holy *tabot* is kept and is therefore the most important space in the church, its vaulted ceiling is the most elaborately painted of all the bays, with ribbon knotwork in a combination of white and viridian green. The dome has a carved cross combined with the Sacred Monogram: the Greek letter 'chi' (X), which is the first letter of the Greek word Xristos. At first an esoteric monogram for Christ, it became a universally accepted sign of the Christian faith in religious art. Later the cross was introduced to the 'X', and, very frequently, the combination of both was enclosed within a circle or wreath, as is the case in this dome.

This bay is separated from the other two on the east wall by columns which have no paintings but which have a carved processional cross with a long handle.

Bay H

This is the bay just in front of the sanctuary. It has a ceiling similar to that in Bay G but with its truncated saddleback running in a north–south direction.

Bay M

Again, the south wall of this bay has three rows of three niches, with the figure of a saint depicted within each. High up on the wall, within a blind arch, there is a window opening on to the ambulatory which allows one to observe that the wall separating the church from the ambulatory is about one metre thick. On either side of the window there is a cross delineated and painted in grey. Within it, in viridian green, there is a looped cross entwined with a white ribbon design. The space above each cross is covered with arabesques.

Bay J

This bay's south wall is also carved with three rows of three niches, but, since most of the plaster has collapsed, the painted saintly figures wearing haloes are only discernible in the upper register. One of the saints holds a cross at the end of a pole and, in the next niche, is a saint, holding a chalice, who has his mouth open as if talking. The only legible word, to his left, is 'martyr'.

Bay F

The south wall of this bay is divided into three rows of three arched niches. The paintings of the figures in the lower row are very faint. In the middle row all three figures are visible. Within each of the two outer niches in the upper row there is a figure, the middle arch being taken up with arabesques and knotwork. The names of all the figures are written to one side of them. The Ge'ez writing states that they are, from left to right: in the top row – 'Gabre Krestos' and 'Arkalewos'; in the lower row – 'Awsanyos the Martyr', 'Ewostatewos' (an important monk born in the thirteenth century in the Geralta region), and 'Yostos the Martyr'. In fact, all are Ethiopian martyrs. Over the niches there is an Aksumite-type frieze. Most of the plaster has disappeared. Above the frieze, only the figure of the archangel Gabriel is still visible.

It is of note that the paintings in this church are of two contrasting styles and obviously carried out by different artists. The saints are frontally depicted, very geometrical, and all have haloes. On the other hand, the monks do not have haloes and are depicted in profile. All have rectangular-shaped bodies, elongated, tube-like necks and oblong faces delineated by thick black lines. The line of their noses continues uninterrupted to form the eyebrows. Their neatly trimmed black beards, hair and large expressive eyes are all painted in black. Some are wearing *shammas* draped across one shoulder, most of which have been painted in viridian green in contrast to their white robes. Also in the same style are the scene of the Virgin and Child, the Crucifixion and Christ in Majesty.

I believe that these frescoes were executed at the same time as the church was built because the architecture of the niches seems to have been designed with the preconceived idea of what would be painted within their space.

The more colourful patriarchs and the scenes depicting *Abuna* Abraham portray monumental figures. They are two-dimensional, and their cloaks obscure their bodies, but they are imbued with a tremendous sense of volume by enhanced lines and brushwork that are complementary to the form of the body. Darker lines of local colour delineate the folds of the drapery,

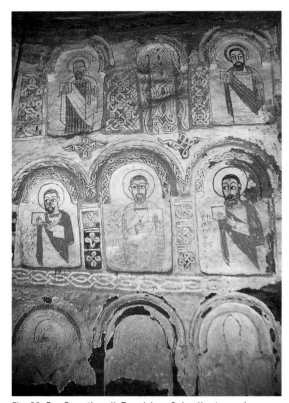

Fig. 53. Bay F, south wall. Top niches: Gabre Krestos and Arkalewos. Lower niches: Awsaynyos, Ewostatewos and Yostos

and, in the case of those figures which appear to be wearing *shammas*, the lines are in the colour of their undergarments. They may have been painted at a later date, but there is no evidence to support this theory.

Ambulatory

The ambulatory is excavated from the rock and completely surrounds three sides of the church. There are two cells leading off from the ambulatory, both near its eastern entrance, one being on the east side and one on the west side of the ambulatory corridor. The east cell is said to have been the residence of *Abuna* Abraham. It is round and entered through a very low opening. Its rounded wall and domed ceiling are carved from the sandstone in low relief. It has been plastered and whitewashed, but the lower part of the plaster has collapsed.

The figures on the wall have the same geometrical form as those within the niches in the church. There is a seated Virgin and Child surrounded on either side by archangels *orans* (their hands lifted over their heads in a prayer position). Next we see a robed figure holding, with his right arm, a cross at the end of a long

Fig. 54. Priest in the ambulatory

pole over his shoulder. His left hand is held up in the air. Next to him there is a panel with a series of different incised crosses, all geometrically carved. This is continued by Aksumite metopes and below them, geometrical decoration.

The dome is divided into eight sections and on its base it has a running frieze incised with crosses of different styles. The smaller west cell has no decoration.

Ceremonial Fan

One of the treasures of Kidana Mehrat is its ceremonial fan, which is not kept in the church. The fan is a parchment book that has been folded into thirty-six sections. It has wooden board covers and is mounted on a wooden pole. When it is opened up it resembles a fan. Each panel has a framed figure

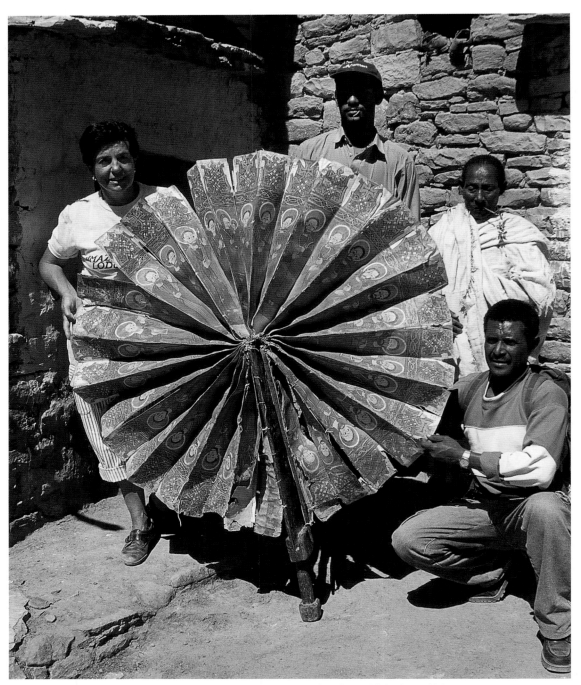

Fig. 55. Ceremonial fan. María-José, Serkalem (our driver), the guardian of the fan and Hailu (our guide)

above and below with bands of a continuous pattern known in Ge'ez as *harag* (the tendril of a climbing plant). *Harag* has been used in Ethiopia to frame the pages of manuscripts since the second half of the fourteenth century.

The interlacing of this fan is made up of six ribbons in three colours – yellow, blue and red – and each ribbon is enclosed by a black line. Each panel ends in a further angular decoration, this time with stylised tendrils that sprout from the band below and cross over each other to form a rhomboid, within which is a foliated cross.

The Virgin holds Jesus in the centre. She is flanked by two archangels. Apostles, prophets and saints appear on either side. All the figures are shown full-length and stand looking towards the centre. Most have their left hand raised, with their right placed across their chest. All have haloes, and, with the exception of the Virgin and Child and the archangels, all have black beards.

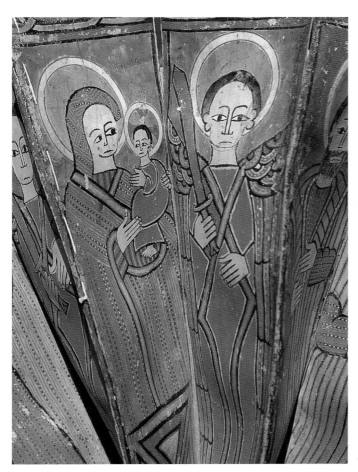

Fig. 56. Ceremonial fan, detail. The Virgin and Child with an archangel

Maryam Korkor

NORTH WALL, THIRD BAY: At the top is Christ in Majesty, holding the Gospels in his left hand, seated within a green *mandorla* with the orb of the earth at his feet, and surrounded by the Tetramorph. In the register below is the Entry into Jerusalem: on the left are ten of the twelve apostles and on the right, Christ riding a mule.

NORTH WALL, SECOND BAY: At the top are 'sea monsters' – creatures with human heads and camels' bodies. They hold a fish in their front paws and their tails end in serpents' heads. Below them is an opening in the rock wall. Further below, on the left, is the Visitation of the Virgin Mary to her cousin Elizabeth.

NORTH WALL, FOURTH BAY: Just under a blind arch is a bas-relief carving of two birds. In the centre of the arch is a fresco of St Raphael, depicted with angel's wings, with St Anthony to the right of him. On the pilaster to the right of St Anthony is a Nubian eparch with a horned crown.

NORTH WALL, NARTHEX: At the top, to the left and right of a carved blind arch are ostriches. Within the arch, at the top are two confronting birds. Below them are an antelope looking over its shoulder, and a pair of antelopes facing each other with a Tree of Life between them. Below the arch, on the right, are Adam and Eve and, below Eve, is a hairless man identified in the script as the 'False Witness'. On the left are scenes with men, snakes, and what appears to be a Secretarybird.

cell

Sanctuary

Narthex

N

FIRST NORTH COLUMN FROM NARTHEX: South Side, St Stephen holding a chalice. West Side, probably a church patriarch.

SECOND NORTH COLUMN FROM NARTHEX: West Side, an archangel wearing a patterned tunic.

FIRST SOUTH COLUMN FROM NARTHEX: North Side, St Onuphrius, naked except for his beard.

SOUTH WALL, THIRD BAY: Top register, the Virgin and Child flanked by the archangels Michael on the left and Gabriel, holding his sword, on the right. Below St Michael, two small figures carry a footstool for the Virgin Mary – a unique depiction in Christian art. At Gabriel's feet are a cockerel and a peacock. A peacock can also be seen below the Virgin. Lower register, left to right, an angel; Shadrach, Meshach, and Abednego in the fiery furnace; and King Nebuchadnezzar.

SOUTH WALL, SECOND BAY: At the top, on the left, is the equestrian saint Theodore the Egyptian spearing a serpent, symbol of evil; on the right is the Sacrifice of Isaac with Abraham, who is wielding a knife, holding his bound son by his hair. At the bottom of the panel are people riding camels (in the background) and horses (in the foreground).

Maryam Korkor

Both Maryam and Daniel Korkor are on the same peak which is a few kilometres further north-west along the Geralta range from Debre Tsion. You need to drive to the village of Megab, which is situated just where the road turns north-east towards Hawzien, from where it is possible to drive a bit closer to the mountain before starting your climb. The ascent will take about one to one and a quarter hours, first up through a steep chimney of boulders and then across and up over rocks where you do need a good head for heights. At the top the views, both over the Hawzien plain and over towards Guh, are exhilarating. Maryam Korkor is reached first and is on the west face of the mountain at an altitude of 2,300 metres. Daniel Korkor is only a ten-minute walk beyond and is on the east face with its entrance reached by walking along a one-metre wide ledge above a steep drop down to the Hawzien plain below.

Local tradition has it that Frumentius, the Syrian who became the first *abuna* in the fourth century, inspired *Abba* Daniel of Geralta to establish a monastery and church here. *Abba* Daniel was a priest and a member of the local aristocracy who lived during the second half of the thirteenth century. He was the uncle and teacher of *Abba* Ewostatewos (see Chapter 2).

Fig. 57. Part of the Geralta range. Maryam and Daniel Korkor are just below the highest peak. Candelabra tree (*Euphorbia ingens*) in the foreground

It is conceivable that the first monks lived in the two cave chambers of Daniel Korkor. At the present time, three monks and a nun live in the vicinity of Maryam Korkor.

Maryam Korkor's façade faces west. It is the largest of the Geralta churches, measuring approximately 17 by 11 metres with a height of 5 metres and has been totally excavated from the rock. Two-thirds of the narthex collapsed a long time ago, and a whitewashed, built-up façade containing the entrance door and three windows has been constructed at a later date. The church is situated just below the top of the mountain; from the north-western side of the range, it is visible from the plain below. It is very dark, and its paintings have been badly damaged due to water seepage through the rock. It also needs a good clean – the frescoes are covered by such thick layers of dust they are difficult to see.

The narthex runs across the full width of the church. The church plan is of the basilical-type, with a nave and two aisles. It is four bays deep and has a sanctuary at its eastern end. Three pairs of columns are connected with each other,

Fig. 58. The façade of Maryam Korkor

and their corresponding pilasters on the side walls by arches. The columns are cruciform and very crudely carved. The angles are rounded rather than meeting at right angles as are those of their bracket capitals. The shafts, which have been much worn away in places, are unevenly carved; and some of them are wider at ground level than the rest of the shaft.

The arches in the nave are of diminishing span, finishing with what is almost a horseshoe arch over the sanctuary. The second bay of the nave has a deeply carved dome divided by a cross with a boss at its centre. Its arms are wide and incised with crosses. In each of the quadrants created by the arms are the head and shoulders of a figure against a brown background with his hands held up in an *orans* position. These are probably the four evangelists.

The ceilings of the third and fourth bays of the nave have been combined into one with only a beam providing any division. The section corresponding to the second bay has been carved with a deep cupola containing only a central boss, around which there are the remains of painted bands in ochre colours.

The section above the first bay has a deeply carved *croix pattée* inside two sets of squares set at an angle of 45 degrees to one another. Below is a double frieze of Aksumite windows, and under this is the 'almost' horseshoe arch in front of the sanctuary. The arch is decorated with a band of entwined ribbons, the colours of which have faded. The sun and moon are painted above the arch.

The murals in this church are true frescoes, the paint having been applied onto a thin layer of gesso. Part of an inscription in the church tells us that the frescoes were executed at the time of *Abba Daniel* – so they date from sometime between the end of the thirteenth and beginning of the fourteenth century. The colours are different shades of ochre, from reds to yellows, which come from locally available pigments. Some aquamarine appears on some of the panels; this could have originally been a green with a high content of copper which has oxidised. Most of the figures are frontally depicted and two-dimensional. It is a characteristic of this church that all the heads are rounded and the eyes have large black pupils painted in the upper part of the eye leaving a great portion of white iris visible. The patterns of the garments have been carefully rendered.

The Narthex

Only the north wall of the narthex is painted. It has a carved blind arch with interlaced decoration in ochres (brown and yellow) and aquamarine. To the left and right of the arch are ostriches. Within the

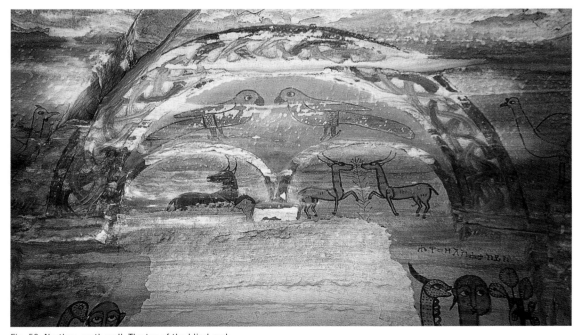

Fig. 59. Narthex, north wall. The top of the blind arch

blind arch, at the top, there are two confronting birds with red beaks and aquamarine bodies, and below them, each within its own recessed arch, are an antelope looking backwards and a pair of antelopes facing each other with a Tree of Life between them. Originally the entire wall below the arch was painted. Now, only the frescoes on the left and right sides remain. On the right, Eve covers her nudity with a leaf and is about to pick an apple from a much-stylised tree. The serpent, naively depicted with horns and the legs of a centipede, is murmuring in her ear. To the right of Eve is Adam, covering his genitals with a leaf. Below Eve is a hairless man identified in the inscription as 'The False Witness'. Two serpents, with the heads of birds, are whispering in his ears. You could take this to be a representation of 'Hear no evil, speak no evil'.

On the left-hand side, below the arch, and on the column on the right there are more scenes involving men, snakes and what appears to be a secretarybird. The presence of such a variety of creatures on this wall can be seen as a representation of earthly paradise. The architectural setting of these scenes has been inspired by the cannon tables of many Ethiopian manuscripts.

North Wall, Fourth Bay

Here there is a blind arch with unpainted, incised, interlaced decoration on the arch itself. Just under the arch is one of the rare instances of a bas-relief carving, this one being of two birds. The frescoed figure in the centre of the blind arch is St Raphael, depicted with angel's wings, with St Anthony, a disciple of St Paul of Thebes and the founder of monasticism, to the right of him. Further to the right, on the pilaster, is a dignified figure who the priest told us was King David. However, according to Lepage and Mercier, he is a Nubian eparch because of the strange horned crown that he wears.

The three are painted in red and brown ochres against the unpainted sandstone wall. Their clothes and their decorative details have been carefully drawn. None of them have the big black eyes characteristic of Ethiopian painting. These figures can be said to be Byzantine.

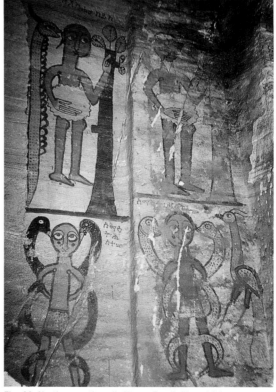

Fig. 60. Narthex, north wall. Above: Eve (left) and Adam (right). Below: the 'False Witness'

North Wall, Third Bay

Above is Christ in Majesty, holding the Gospels in his left hand, seated within a green *mandorla* with the orb of the earth at his feet, and surrounded by the Tetramorph, symbols of the four evangelists. The caption on the left reads, 'Jesus and the Four Living Creatures holding the Wheel.'

Revelation 4:3 and 4:7 state: 'And the one who sat here had the appearance of jasper and carnelian. A rainbow, resembling an emerald, encircled the throne. […] In the centre, around the throne, were four living creatures, and they were covered with eyes, in front and behind. The first living creature was like a lion, the second was like an ox, the third had a face like a man, the fourth was like a flying eagle.'

Here we have Christ painted in exactly the colours described in the Book of Revelation. His tunic is jasper yellow, his outer garment is carnelian red, and he is surrounded by the emerald green *mandorla* and the Tetramorph.

In the register below is a painting of the

Fig. 61. North wall, third bay. Christ in Majesty within a green *mandorla*

Entry into Jerusalem. On the left are ten of the twelve apostles following Christ, who is depicted on the right, riding a horse or mule with full trappings rather than a humble donkey. There are additional figures on the right of this fresco, but they are no longer identifiable. Neither is the scene below, most of which has fallen away.

The much-faded paintings on the left and right columns are of St John and St Stephen respectively.

North Wall, Second Bay

At the top of this wall there is a painting of creatures with human heads and camels' bodies in heraldic juxtaposition. These crowned hybrids are holding a fish in their front paws and their tails end in serpents' heads. The caption below reads, 'Sea Monsters'. Below them is an opening in the wall which serves to ventilate a cell behind it.

Below and on the left is the Visitation of the Virgin to her cousin Elizabeth; the caption reads, 'Maryam and Elisabet'. These two figures are geometrically depicted in brown and aquamarine. On the right is written 'The Virgin Enbamerena', the pregnant Mary. Both Mary and Elizabeth have golden

haloes edged with dangling pearls. Because of the dissimilarities in both technique and colours between this scene and the previous ones, it is clear that they have been painted by different artists.

South Wall, Third Bay

The wall is divided into two registers. In the top one is the Virgin Mary and the Child Jesus flanked by the archangel Michael on the left and the archangel Gabriel, holding his sword, on the right. Below St Michael two small figures carry a footstool for the Virgin Mary – a unique depiction in Christian art.

At the feet of Gabriel there is a cockerel, perhaps the symbol of Peter (and, by implication the entire Christian Church) and a peacock, perhaps symbolising the Resurrection. A few animals are depicted below the Virgin but only a peacock is clearly visible.

Mary is surrounded by a halo in yellow and ochre over her turquoise *maphorion* and is wearing a mantle in red ochre over a tunic in jasper yellow. She is austere and remote, possibly a reflection of Byzantine influence. She stands in front of an ornate and colourful screen which serves to accentuate the simplicity of her clothes. The screen is divided into square panels in ochres, yellows and greens in its lower section. The upper section has, on a white background, rhomboids in green with red dots within. The screen is supported by four wooden legs and has two finials on which two birds, painted in aquamarine, are perched picking at the dangling pearls surrounding the Virgin's halo with their red beaks.

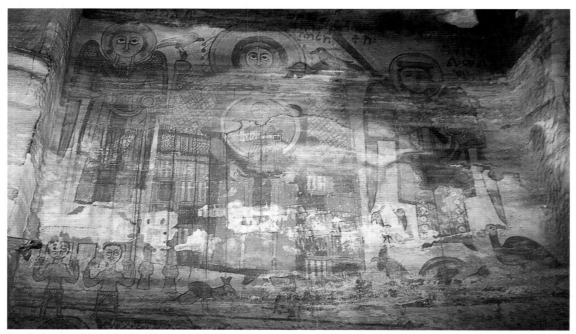

Fig. 62. South wall, third bay. The Virgin and Child flanked by the archangels Michael and Gabriel

Mary holds out her Divine Child to be worshipped. Jesus stands almost totally encircled by a blue *mandorla*. He is portrayed not as a baby but as a small boy with his right hand over his heart as if pledging to save the world.

Ivy Pierce, who saw this picture in the early 1970s, thought that because Jesus is placed in a *mandorla* around the Virgin's abdomen that it indicated the depiction of Christ *in utero*. However, I think the picture clearly resembles the Byzantine/Slavonic icon of Our Lady of the Sign, which also shows the Mother of God with the Child Jesus as a young boy in a circular *mandorla* on her breast. The icon's name is derived from the prophecy in Isaiah 7:14:

> Therefore the Lord himself will give you a sign: The virgin will be with child and will give birth to a son, and will call him Immanuel.

An example of this image is found as early as the fourth century in the Roman catacomb of Cimitero Majore.

In the icon of the Sign, however, the Virgin's hands are raised in prayer, while here they are lowered as if she is holding the Child though she is not actually touching Him or the *mandorla* that encloses Him. There is at least one other example of this, in a Syriac Bible (late sixth or early seventh century) at the Bibliothèque Nationale in Paris. An illustration appears, under the title 'The Virgin as the Source of Wisdom', in John Beckwith's *Early Christian and Byzantine Art* (1970, Illustration 115).

In the lower register is the scene of the three Jewish men who were thrown into the fiery furnace as described in Daniel 3:19–25. King Nebuchadnezzar is seated on the right. With his extended right arm, he points at the condemned Jews, and with his left hand he holds the hilt of his sword. His tunic is yellow with red ochre bands above his elbows and forming his collar. He is wearing a strange yellow hat. Above his extended arm is an imaginary beast – half bird, half animal – about to devour a man whose head is visible but whose body has faded. Below the arm is an evil 'one-eyed' man grasping at another man. This part of the fresco has deteriorated badly.

Next we have the three Jewish men – Shadrach, Meshach and Abednego – standing in the fire, the flames of which have been painted in red ochre and form a flat background. They wear long clothes with close-fitting trousers. Their hands are in the *orans* position praying for their deliverance. The three have haloes, are frontally depicted, and are looking upwards. To the left is an angel standing sideways, his left wing arched protectively over the three men in the furnace and his right hand points towards them.

This painting depicts the event after the three had said to Nebuchadnezzar that the God they served was able to deliver them from the fiery furnace and the King saw that they were unharmed and unbound (in the painting their hands are not bound). Daniel 3:25 says that the King saw four figures walking in the midst of the fire and that the fourth looked like the son of the gods, which is usually taken to mean that the fourth figure was the preincarnated Christ, symbolised here by an angel.

The event is also described in the following quotation from the apocryphal Old Testament:

> But the angel of the Lord came down into the furnace to be with Azariah and his companions, and drove the fiery flame out of the furnace, and made the inside of the furnace as though a moist wind were whistling through it. The fire did not touch them at all and caused them no pain or distress. (The Prayer of Azariah 26–7)

South Wall, Second Bay

On the left is the equestrian St Theodore the Egyptian who is holding a spear in his right hand with which he is killing the serpent, symbol of evil. The spear's handle ends in a cross. The saint's barrel-chested horse is red ochre and has a head that is disproportionately small. St Theodore sits astride his horse but has turned so that his head and torso are frontally depicted. He wears a light brown tunic decorated with black roundels

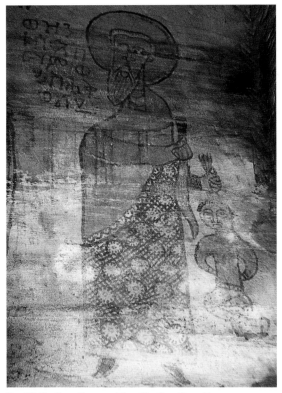

Fig. 63. South wall, second bay. The Sacrifice of Isaac

having a dot at their centre, and there is hatching in the space between the roundels. Both hatching and dots are in red ochre. His short cloak is decorated with half circles and lines, all in shades of red ochre. Below the serpent is a wild animal devouring a smaller one.

On the right is the Sacrifice of Isaac, the story of which is told Genesis:

> When they reached the place God had told him about, Abraham built an altar there and arranged the wood on it. He bound his son Isaac and laid him on the altar, on top of the wood. Then he reached out his hand and took the knife to slay his son. But the angel of the Lord called out to him from heaven, 'Abraham! Abraham!' 'Here I am,' he replied. 'Do not lay a hand on the boy,' he said. 'Do not do anything to him. Now I know that you fear God, because you have not withheld from me your son, your only son.' Abraham looked up and there in a thicket he saw a ram caught by its horns. He went over and took the ram and sacrificed it as a burnt offering instead of his son. (Genesis 22:9–13)

A bearded Abraham stands front face holding, with his left hand, a startled, naked and bound Isaac by his hair. With his right hand Abraham wields a long knife. He turns to his right, as if he has just heard God's voice telling him 'Do not lay a hand on the boy.' To the left, above Abraham's head, is the sacrificial ram, depicted here rather like a zebra with horns! Abraham wears a tunic similar to that of St Theodore except that it is all in red ochres including the roundels. His short cloak is jasper yellow.

In the bottom half of the panel there are a number of people, in the background, riding, camels and in the foreground, horses. They are travelling in both directions as if coming and going to market. The mounted figure on the far right is hardly visible.

The Columns

Tall, elegant, beautifully dressed figures are painted on the columns. They are saints and one archangel, all of whom have haloes. They do not have any identifying captions. I will describe the two that appealed to me the most.

One is St Onuphrius, who is depicted as he usually is: naked except for the fact that his light blue and white striped beard covers the front of his thin body, leaving only his legs, knobbly knees and feet exposed. St Onuphrius was a hermit for seventy years in the desert near Thebes in Upper Egypt where he lived only on the fruits of a date tree that grew near his cell.

The other is the archangel who wears a patterned tunic in ochre colours. The upper part of his body is wrapped in what appears to be his wings, which are also visible behind his tunic. They are painted in aquamarine and brown ochre contained within segments that give the impression of separate layers of feathers.

At least three artists with different styles have worked on the paintings of this church. It is likely that Maryam Korkor's murals date from the time of *Abba* Daniel, that is, from the late thirteenth century. As for the architecture, Gerster

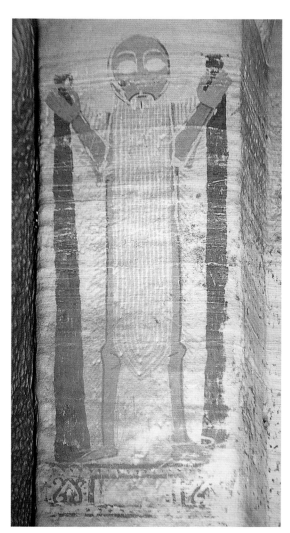

Fig. 64. Column. St Onuphrius

states in his *Churches in Rock* (1970, p. 80) that the dating of Maryam Korkor is unanswerable, at least for the present, and continues, 'One cannot help stressing that considerations of architectural history allow the adoption of any date between the seventh and fourteenth centuries – give or take a century – bearing in mind the resistance to change of architectural forms in rock.'

Maryam Korkor has several beautiful crosses and some manuscripts, one of which is bound in a wood cover and is kept in its original leather pouch.

Fig. 65. Priest and boy with processional crosses. Guh in the distance

Fig. 66. Manuscript being returned to its leather pouch

Daniel Korkor

NORTH WALL: Left to right, the standing figures of Moses and Aaron; St Mercurius on a brown horse and, at one time, below him, the diminutive figure of Julian the Apostate (all that now remains is his name written in Ge'ez); the half-size figures of St Basil and St Gregory; Thomas; and a saint whose name has disappeared.

WEST WALL: Left to right, the standing figures of Abraham and Isaac; the equestrian saint Banadlewos (Theodore the Oriental) riding a light blue horse and killing a snake; the standing figures of Stephen and Melchizedek.

EAST WALL: Left to right, the standing figure of a saint (whose name has disappeared); the Baptism of Christ; over the entrance, the Presentation of the Virgin and Child with St Paul on the left and St Peter on the right; and the standing figure of Zechariah.

ledge

entrance

niche

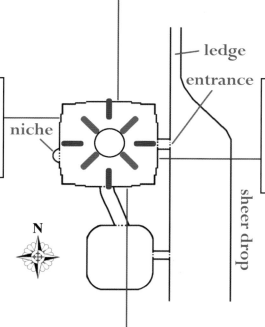

N

sheer drop

SOUTH WALL: Left to right, the standing figures of Peter, supreme head of bishops, and James, the son of Zebedee; King David seated on a stool, playing his lyre; the equestrian saint George riding a white horse; and the standing figures of Joseph and Jacob.

CEILING: Carved with a shallow dome. There are paintings of four archangels (indicated by the green lines) and the four evangelists (indicated by the blue lines). John the Evangelist is on the east side, above the entrance.

Daniel Korkor

Daniel Korkor is not a church. It comprises two small chambers connected by a passage and perhaps was a monk's dwelling. The larger chamber is about 5 metres square and has a niche in one of its walls. We were told that this was where the monk who lived here rested during his long hours of prayer. The ceiling and the upper part of the walls are whitewashed and covered with paintings. The smaller room has no paintings.

The paintings in Daniel Korkor are colourful, primitive and naive. The figures they depict are Old and New Testament characters as well as three equestrian saints. The colours are restricted to brown, mustard yellow and a few touches of viridian green. The figures and the haloes are not outlined in black, as in most other churches. The eyes are more European in appearance than Ethiopian; they have small pupils in contrast to the large, black-pupilled eyes that are associated with Ethiopian paintings. Their hair and beards are in grey and they have not been delineated. Their cheeks are indicated solely by a brown spot.

All of the figures wear a long robe with a cloak, or what appears to be a *shamma*, over it. This outer garment has sinuous folds depicted in contrasting colours and following the shape of the body it covers. The *shammas* of the three large equestrian saints are painted across their torsos and billow out behind them in an attempt to show them being blown in the wind. However, as at Kidana Mehrat on Debre Tsion, they have the appearance of an inflated balloon.

The ceiling has been carved with a shallow dome extending to the edge of the square room with flat triangles in the corners simulating pendentives. These 'pendentives', of which only one is in a good

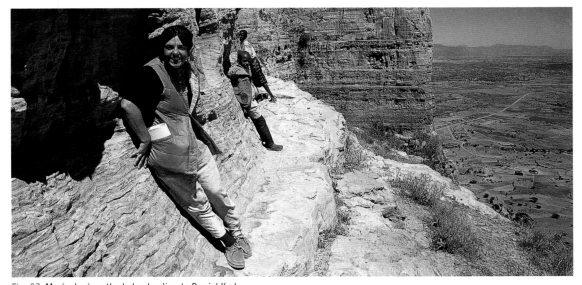

Fig. 67. María-José on the ledge leading to Daniel Korkor

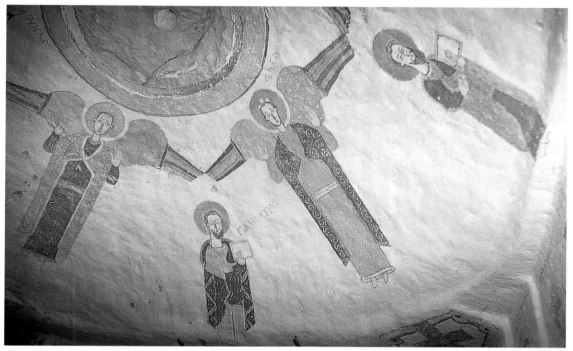

Fig. 68. The ceiling. Two of four archangels in the *orans* position and two of the four evangelists

state, have been outlined in green and yellow and have a cross depicted within. On the ceiling there are four archangels *orans* with their wings extended to form a square around the central dome, which is outlined in a wide yellow band which probably had Christ in Majesty at its centre. The archangels are placed diagonally, with their feet pointing towards the corners of the ceiling. Between each archangel are the figures of the four evangelists of whom only one is identified. He is John the Evangelist who is on the eastern side of the ceiling above the entrance doorway.

East Wall

It is through a narrow entrance in this wall that you enter the chamber from the ledge outside. On the inside the entrance has been carved to resemble an Aksumite doorway. Over this is the Virgin holding the baby Jesus surrounded by St Paul and St Peter. To the left of them is the Baptism of Christ, with both John and Jesus half-immersed in water that has been painted as a square block resembling a fish tank. The fish within it have an amusing appearance and seem to be related to penguins! Above the scene, the Holy Spirit descends in the form of a dove. Both John and Jesus are wearing striped garments in green and brown. In the left corner of the wall there is a standing saint whose name has been obliterated and, in the right corner, is the standing figure of Zechariah.

South Wall

From left to right across this wall are the standing figures of Peter, supreme head of bishops, and James, the son of Zebedee (believed to be the cousin of Jesus and the son of Salome, he was the first apostle to suffer martyrdom in AD 44); King David seated on a stool and playing his lyre with a plectrum in his right hand; the equestrian St George painted against a brown square background and riding a white horse; and Joseph and Jacob.

West Wall

From left to right are the standing figures of Abraham and Isaac; the figure of Theodore the Oriental (Banadlewos) riding a horse painted in the unlikely colour of light blue, and killing a snake; Stephen; and Melchizedek.

North Wall

From left to right are the standing figures of Moses and Aaron; St Mercurius on a dark brown horse and, at one time, below him, the diminutive mounted figure of Julian the Apostate (of whom all that remains is his name written in Ge'ez); the half-size figures of St Basil and St Gregory, who are facing St Mercurius; Thomas; and a saint whose name has been obliterated.

St Mercurius, Julian the Apostate (AD 361–6), and St Basil (d. AD 379) are all part of a story that is related in the *Synaxarium* (see Chapter 3).

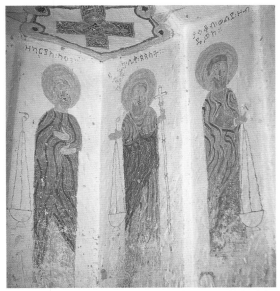

Fig. 69. Corner of east and south walls. Left to right: Zechariah, Peter, and James, the son of Zebedee

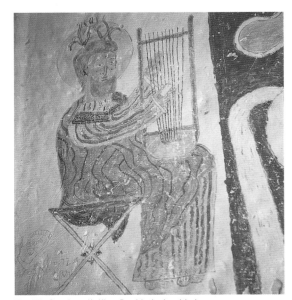

Fig. 70. South wall. King David playing his lyre

Maryam Papasetti

East Wall

1	St Raphael.
2	The Trinity.
3–26	Twenty-four Elders of the Apocalypse.
27	Tekle Haymanot.
28	*Abba* Samuel.
29	The Virgin and Child.
30	Coronation of the Virgin.
31	Jesus washing Peter's feet.
32	St George on horseback, rescuing Birutawit.
33	The soldiers of St George, armed with spears & rifles.
34	*Abba* Ewostatewos.
35	Gabre Manfas Kiddus.
36	Teckle Haymanot.

North Wall

1	Creation of Eve from Adam.
2	Adam and Eve in the Garden of Eden.
3	Temptation of Adam by Eve.
4	Adam and Eve expelled from the Garden of Eden.
5	The archangel Michael.
6	Jesus Christ.
7	*Abba* Samuel of Waldebba.
8	St George, on horseback, with the child George in his arms.

West Wall

1	Emperor Constantine listening to Arius.
2	Eleven virgins, the donors.
3	*Abba* Sehma, one of the nine Syrian saints.
4	*Abba* Mataa, one of the nine Syrian saints.
5	*Abba* Alef, one of the nine Syrian saints.
6	Unknown.
7	Unknown.

South Wall

1	*Abba* Garima, one of the nine Syrian saints.
2	*Abba* Guba, one of the nine Syrian saints.
3	*Abba* Aftse, one of the nine Syrian saints.
4	*Abba* Aragawi, one of the nine Syrian saints.
5	Tekle Haymanot.
6	*Abba* Alef, one of the nine Syrian saints.
7	*Abba* Pantaleon, one of the nine Syrian saints.
8	The Annunciation
9	The Nativity – the Virgin, Child, Joseph and Salome.
10	The Adoration of the Magi.
11	The Baptism of Christ.
12	Christ sends out the Twelve.

Maryam Papasetti

Maryam Papasetti is situated to the west of Degum. It nestles under an overhanging cliff face at much the same level as the Hawzien plain and therefore does not involve a climb to reach it. However, it does involve a tedious one-hour walk through rough fields to a palm oasis which surrounds the church.

The exterior is by no means an impressive structure. The church sanctuary is rock-hewn and is not open to visitors. The narthex is built against the rock, and it is here that the paintings, which have been executed on cloth, are located. The main attraction of this church is its graphic murals which tell both Old and New Testament stories most vividly. They can be dated because of the donors – *Basa* Dengyes and his wife Emabet Harit – who are depicted below two paintings of the Virgin. *Basa* Dengyes was the governor of the district during the time of *Ras* Walda Selassie (1788–1816), who encouraged commerce and was to receive the first British Mission to Ethiopia in 1804.

The Paintings

The murals have been painted on cloth (they are not frescoes) and in two different styles. Half of them are characteristic of the Second Gondarine Period, very colourful, the clothing meticulously portrayed, and with shaded backgrounds changing from yellow to reddish orange. However, unlike other paintings of this style in which there is a heavy modelling of the faces, here they are evenly and subtly executed. All the faces have the most expressive eyes.

The other half, which includes the nine Syrian saints, a confrontation between Constantine and Arius and the eleven virgins (the donors of the church), has been painted in monochromatic greys and blacks, and these paintings were clearly carried out by a different artist. However, I suspect that even the colourful Second Gondarine Period panels have been executed by at least two artists since the two large paintings of the Virgin are of higher quality than the others.

East Wall
The wall is equally divided by the door to the sanctuary.

1. A striking depiction of the archangel Raphael is to be seen on the door itself, holding a sword in his right hand and spearing a sea monster, on whose back rests a church, with his left hand. The story relates to the miraculous deliverance of a church in Alexandria dedicated to him but built by mistake on the back of a sea monster. The monster moved, and the church and its congregation were about to be carried into the depths of the ocean when the archangel came to their rescue.

St Raphael is wearing Indian-style orange trousers gathered at his ankles, a black gown and a brocaded orange cloak. His wing feathers are portrayed in bands of orange and black. The faces of two cherubs appear at the corners of the door frame, their small wings ending in acute triangular points.

2. Above the door is the Trinity. Each has their left hand placed over their heart and their right hand held up in a gesture of blessing. Each is surrounded by a yellow and orange halo which makes a startling contrast with the black background. This is accentuated by their richly and meticulously depicted orange brocade cloaks ornamented with a black rosette and yellow tendrils. Their long, wavy, white hair rests on their shoulders. Each has a neatly trimmed, pointed white beard and wears a black gown with a yellow pointed collar.

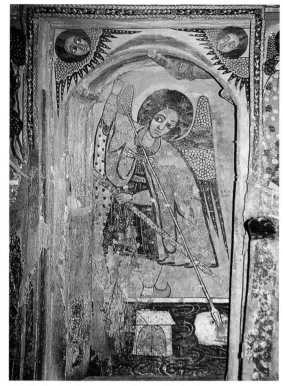

Fig. 71. East wall, sanctuary door. St Raphael

3–26. On either side of the Trinity, the upper part of the wall has two registers in which appear the twenty-four Elders of the Apocalypse. Each has been painted within a frame, depicted as heavenly priests wearing an assortment of crowns, holding censers in their right hands and crosses in their left hands which are placed across their chests in a gesture of respect.

On the left side of the wall there are fourteen frames, twelve for the Elders with the remaining two – those nearest the Trinity – being:

27. Tekle Haymanot, one of the most revered of the monastic saints.

28. *Abba* Samuel, one of the most famous anchorites.

29. To the right of the door, the Virgin holds the Child. She is portrayed in the typical manner made fashionable by Queen Mentewab in the eighteenth century. She is resplendent in her dark

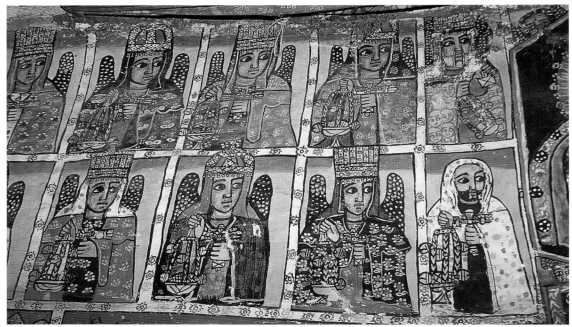

Fig. 72. East wall. Some of the twenty-four Elders of the Apocalypse and, in the two panels on the right, Tekle Haymanot (above) and *Abba* Samuel (below)

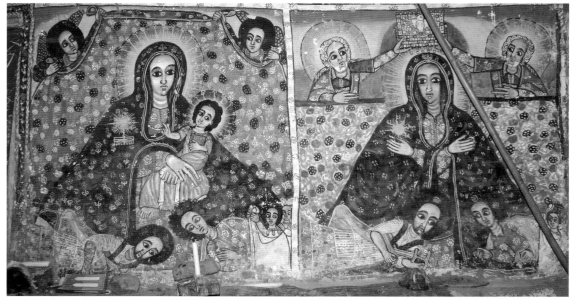

Fig. 73. East wall. Below: the Virgin and Child (left) and the Coronation of the Virgin (right)

silk embroidered *maphorion* and elaborate golden halo portrayed against an orange background, the perfect foil. She has an embroidered gold star on her right shoulder with a series of pendants below it, in this case a row of bells. She holds Jesus in her left arm and with her left hand holds a white handkerchief. Her right hand is crossed over her left, and two elongated fingers point down to the donors beneath her. Her precious, blue, embroidered *maphorion* is spread over her seat and has a cross embroidered on it, above her forehead. The archangels Michael and Gabriel support a richly decorated, red cloth screen behind her. Prostrated at the Virgin's feet lie the donor *Basa* Dengyes, who was the governor of the district, and his wife Emabet Harit.

30. The painting to the right is the Coronation of the Virgin. She is seated on her throne enveloped in a sumptuous, dark blue *maphorion* which is brocaded with yellow rosettes and trimmed in gold. There is an embroidered cross over her head and a gold star on her right shoulder. Appropriately, her hands are crossed over her chest. A halo of yellow rays of different lengths radiates from her head. The background is divided in two by a screen of yellow cloth brocaded with flowers in black and red ochre.

Over the screen, on either side of Mary, are two of the three Persons of the Trinity, the Father and the Son, represented in the Ethiopian manner as two old men with white hair and beards. They hold a large bejewelled crown over her head, and are both looking at the Holy Spirit, depicted as a white dove hovering in front of the crown. Again, the donors are prostrated at the Virgin's feet.

31. On the left side of the wall, Jesus washes Peter's feet. Peter is seated on a high-backed chair, blessing Jesus with his right hand, two fingers of which are extended – he seems to have lost the tips of the other three. He is wearing a black brocaded robe with the same style of collar as that of the Trinity – a yellow painted triangle – through which his neck appears. He is portrayed as an old, bald man with white curly hair at the back of his head, a white trimmed beard and a

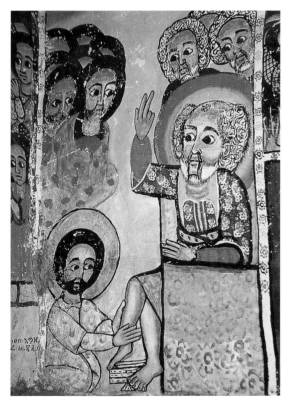

Fig. 74. East wall. Jesus washes Peter's feet

moustache. The heads of the other apostles, some with black hair and some with white curly hair, are lined up behind Peter and Jesus. Jesus himself has been portrayed as a small kneeling figure with black hair surrounded by a plain yellow halo. He has obviously taken off his outer clothing, though he has not stripped to the waist, and just wears a long tunic:

> After that, he poured water into a basin and began to wash his disciples' feet, drying them with the towel that was wrapped around him. He came to Simon Peter, who said to him, 'Lord, are you going to wash my feet?' Jesus replied, 'You do not realise now what I am doing, but later you will understand.' 'No,' said Peter, 'you shall never wash my feet.' Jesus answered, 'Unless I wash you, you have no part with me.' 'Then, Lord,' Simon Peter replied, 'not just my feet but my hands and my head as well!' (John 13:5–9)

32. Between the 'Washing of the Feet' and the door is St George mounted on a white horse, spearing a dragon in the form of a crocodile and rescuing the daughter of the King of Beirut, the princess Birutawit, who is coiled up in a tree to the right. Here St George is regarded as the soldier of God and deliverer of the helpless.

33. In a small scene to the right of St George are a group of his soldiers. Their faces are the same as those of the angels on the doorway, but, curiously, they are wearing the skirts and carrying the shields of the wild tribes of Ethiopia. Above their heads are rifles. This scene, which appears to be so innocent, is a vivid portrayal of the political situation in the country at that time. Although firearms had long been known in Ethiopia, the government in Gondar lacked rifles, and its military strength was still reliant on horseman who fought, armed with lances and shields, whereas the tribes, especially those Muslim inhabitants along the Red Sea coast, were well supplied with guns by the Turkish government, their co-religionists.

In the lowest register are:

34. *Abba* Ewostatewos, the founder of one of the two most powerful monastic orders in Ethiopia, whose observance of Saturday as the Sabbath as well as Sunday caused a great religious controversy in the country.

35. Gabre Manfas Kiddus, the famous hermit whose reputed sanctity tamed wild beasts. He is portrayed with his lions and leopards around him. His arms are opened up in prayer, his head slightly tilted back, and his eyes turned towards Heaven. A bird swoops down to his left eye, which relates to an episode in his legend when he allowed a thirsty bird to drink his tears in the desert.

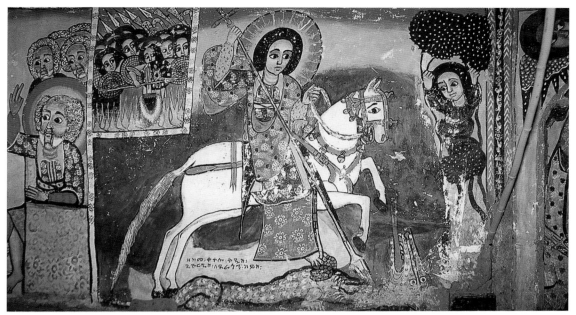

Fig. 75. East wall. St George spearing the dragon and rescuing the princess Birutawit

36. Tekle Haymanot, who lived at the same time as *Abba* Ewostatewos and founded the first of the main monastic orders. Here he is depicted with only one leg and with wings in accordance with his legends. One leg withered and fell off as a result of him standing upright to pray night and day for twenty-two years. He acquired wings when, while descending from Debre Damo, the rope snapped and six wings immediately sprouted from him.

This east wall depicts the most important and honoured religious patrons: the Trinity; the Virgin Mary and Jesus; St George; the two most important of Ethiopia's religious leaders, *Abba* Ewostatewos and Tekle Haymanot; and the three most loved saints, *Abba* Samuel, Gabre Manfas Kiddus, and Tekle Haymanot in his guise of an anchorite.

North Wall

This wall is divided in two by a pilaster and has a door on the left side. Starting on the right-hand side, at the top, the story of Adam and Eve is told in four separate scenes against a background which goes from yellow to orange:

1. The Creation of Eve. Adam is lying down with the lower part of his body covered in a yellow and orange mantle and with the torso of Eve emerging from his left side.

So the Lord God caused the man to fall into a deep sleep; and while he was sleeping, he took one of the man's ribs and closed up the place with flesh. Then the Lord God made a woman from the rib he had taken out of the man, and he brought her to the man. (Genesis 2:21–2)

2. Adam and Eve in the Garden of Eden. They are shown lavishly clothed, seated on either side of a central tree with the faces of angels behind them.

And the Lord God commanded the man, 'You are free to eat from any tree in the garden; but you must not eat from the tree of the knowledge of good and evil, for when you eat of it you will surely die.' (Genesis 2:16–7)

Traditionally, in European paintings, Adam and Eve are represented as naked in the Garden of Eden since the Bible does not mention that they were clothed until after 'The Fall'. However, Ethiopian custom is to show them clothed.

3. The Temptation and God's Curse:

Now the serpent was more crafty than any of the wild animals the Lord God had made. He said to the woman, 'Did God really say, "You must not eat from any tree in the garden"?' (Genesis 3:1)

But the Lord God called to the man, 'Where are you?' He answered, 'I heard you in the garden, and I was afraid because I was naked; so I hid.' And he said, 'Who told you that you were naked? Have you eaten from the tree from which I commanded you not to eat?' The man said, 'The woman you put here with me – she gave me some fruit from the tree, and I ate it.' Then the Lord God said to the woman, 'What is this you have done?' The woman said, 'The serpent deceived me, and I ate.' So the Lord God said to the serpent, 'Because you have done this, cursed are you above all the livestock and all the wild animals! You will crawl on your belly and you will eat dust all the days of your life.' (Genesis 3:9–14)

It is an old Ethiopian legend that the Devil assumed the body of a beautiful four-legged animal and then tempted Eve. And here the painter has followed that legend. The animal is depicted in the centre, below the tree, and from its mouth appears the black head of the Devil. The Lord God is shown floating above the ground, making his curse, and is pointing to Adam with his right hand, who listens, ashamed.

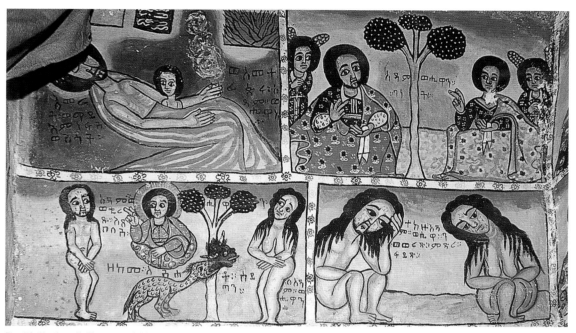

Fig. 76. North wall. The story of Adam and Eve

To Adam he said, 'Because you listened to your wife and ate from the tree about which I commanded you, "You must not eat of it," cursed is the ground because of you; through painful toil you will eat of it all the days of your life. It will produce thorns and thistles for you, and you will eat the plants of the field. By the sweat of your brow you will eat your food until you return to the ground, since from it you were taken; for dust you are and to dust you will return.' (Genesis 3:17–9)

4. Adam and Eve in disgrace, seated naked on the ground.

5. Below the paintings of the story of Adam and Eve is one of the archangel Michael as leader of the heavenly army. He cast out from Heaven one of the archangels, Lucifer, together with his followers.

> How art thou fallen from heaven, O Lucifer, son of the morning! how art thou cut down to the ground, which didst weaken the nations! (Isaiah 14:12, King James Version)

> And there was war in heaven. Michael and his angels fought against the dragon, and the dragon and his angels fought back. (Revelation 12:7)

Fig. 77. North wall. The archangel Michael

This is an unusual depiction of St Michael resembling the iconography of Mary crowned as Queen of Heaven. The lower part of the crown has a row of bells that hang all around St Michael's head; another row of bells tops the crown and at its centre there is an ornament. The archangel is seated on a throne with his lavishly brocaded cloak spread around him. This cloak much resembles those worn by priests during major religious ceremonies. He wears a blue tunic embroidered in yellow which has a square, pointed, yellow collar similar to that worn by the Trinity on the east wall. The folds of his neck, outlined in darker lines, are clearly visible. His short wings are spread out at right angles to his body and end in acute triangular points. The feathers are simulated by white dots against an orange and dark blue background. The appearance of the saint is quite startling with the overall orange colour of his clothing contrasting with the yellow background. His right hand holds a white handkerchief, and with his left hand he is giving a blessing. His gold, bejewelled crown sparkles against an orange background.

Fig. 78. North wall pilaster. Jesus blessing *Abba* Samuel

On the pilaster there are two paintings:

6. The caption in the one at the top reads, 'God, Jesus Christ, blessing *Abba* Samuel who takes care of the land of the monastery.' Jesus stands on a cloud with his right hand blessing Samuel below.

7. In the second, Samuel is looking upwards with his hands outstretched to receive the blessing. Separating the two paintings is a row of trees symbolising the monastery's lands. *Abba* Samuel is dressed in a very simple off-white garment, the folds simulated by straight brown strokes. The saint and his garment are delineated in black.

8. The entire left-hand side of the wall, from the pilaster to the corner and from the top down to the door, is taken up by a portrayal of the twelfth miracle of St George as told in the Ethiopian book *George of Lydda* (translated by Budge). The story concerns a man called Befamon in Ge'ez but translated by Budge as Bifan (see Fig. 17, p. 28). The painting shows St George riding a galloping, white horse and clad in a brocaded orange and white gown and cape, which is trailing out behind him giving the impression that the saint's horse is indeed galloping. With his left hand he holds a spear, and with his right he holds the diminutive George, son of Bifan. The caption below reads, 'St George returns the boy, carrying him on the back of his horse.' At the top left, Bifan is portrayed looking down on the scene, half-length and sideways, his arms held high in a gesture of incredulity. The caption reads, 'Befamon had a son named after St George.' The background of muted greys and pale yellow increases the monumentality of the scene.

West Wall

1. Over the double doorway, there is an unusual portrayal of Emperor Constantine seated on his throne listening to the 'one-eyed' Arius propounding his heresy. Behind him are the members of the Council of Nicaea.

Arius (*c*. AD 250–336), a Libyan theologian, was a presbyter in the church of Alexandria. He was the founder of the heresy known as Arianism, which maintained that the Son was not co-equal or co-eternal with the Father but only the first and highest of all human beings, created from nothing by an act of God's free will. Many of the clergy and laity in Egypt, Syria and Asia Minor followed his thesis.

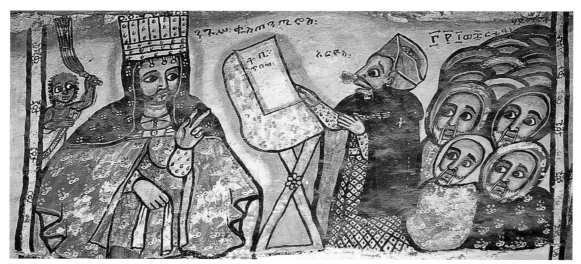

Fig. 79. West wall. Emperor Constantine listening to Arius at the Council of Nicaea

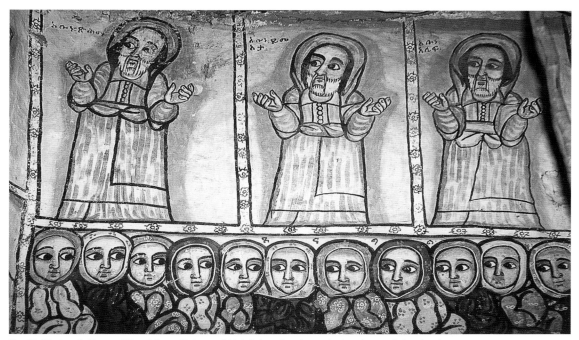

Fig. 80. West wall. Above: *Abba*s Sehma, Mataa and Alef. Below: the eleven virgins, donors of the church

The controversy became fierce, and, to settle it, Emperor Constantine convoked the Council of Nicaea (today's Iznik in Turkey) in AD 325 at which 380 bishops were present. Arius boldly expounded and defended his opinions, but the Council defined the consubstantiality of the Father and the Son. Arius was excommunicated by a synod of bishops in Alexandria and banished.

2. In a large scene to the left of the double doorway is a row of eleven virgins who, according to the priest, donated the money for the construction of this church. Their round heads are encircled by, and their bodies hidden by, what appears to be a nun's habit. Some wear black and others brown or light yellow. The lower part of the wall has been damaged by water and has now been rendered in grey.

The three paintings above the eleven virgins are of three of the nine Syrian saints who introduced monasticism to Ethiopia during the fifth and sixth centuries. They are:

3. *Abba* Sehma.
4. *Abba* Mataa.
5. *Abba* Alef.

Each of the three saints is separated by a band of flowers in red and black, and the figure of each saint is delineated in black and clad in a grey garment tied at the waist; the folds are marked by a dark grey line. Each gown has a triangular collar, showing part of the neck. The saints all wear a cowl, their eyes look heavenwards, and their arms are raised in prayer. The colours of this painting, and indeed of the entire wall, are very subdued and make a strong contrast to the other walls.

South Wall

The frieze of Syrian saints continues on the right-hand side of this wall, in the top register over the doorway. They wear the same clothing as described for those on the west wall. From left to right they are:

1. *Abba* Garima.
2. *Abba* Guba.
3. *Abba* Aftse.
4. *Abba* Aragawi.
5. Tekle Haymanot.

Tekle Haymanot is wearing the same clothes as the Syrian saints and is depicted with wings in accordance with his legend. Again, the lower part of this painting has been damaged so that not only has his withered leg disappeared but so has his good one.

On the pilaster that divides the wall into two, the remaining two of the nine Syrian saints are to be found:

6. *Abba* Alef at the top.
7. *Abba* Pantaleon below.

The wall to the left of the pilaster has paintings that are again very colourful with each panel separated by a band of flowers in red, yellow and black.

8. The first scene at the left of the top register is that of the Annunciation. The archangel

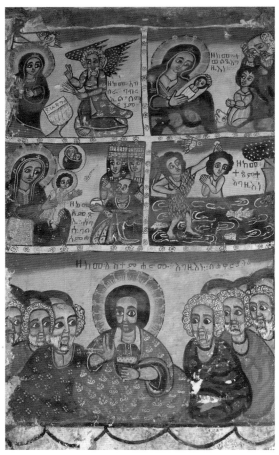

Fig. 81. South wall. Left to right from the top: the Annunciation, the Nativity, the Adoration, the Baptism, and Jesus sends out the Twelve Apostles

Gabriel is dressed in courtly garments: a richly brocaded cloak over a blue gown. He is depicted with the face of an old man with white, curly hair and a beard. The startled Mary is less colourful; she is wearing a plain blue *maphorion* over her red dress. Her halo is yellow with rays of varying length which give the appearance of filigree work.

9. The next scene is that of the Nativity. Joseph, an old, bald, white-haired man, rests his head on his right hand. Salome kneels in front of him. The ox and the ass look expectantly at the Child. Mary holds the baby Jesus, who is encased in swaddling clothes. She wears a simple blue *maphorion* embroidered with a shining gold star on her right shoulder. Her radiant halo is the most accomplished in this church. Its gold rays end in intricate circles and rosettes and is delicately placed against a muted rose-coloured background.

10. The following scene is the Adoration of the Magi:

> After they had heard the king, they went on their way, and the star they had seen in the east went ahead of them until it stopped over the place where the child was. When they saw the star, they were overjoyed. On coming to the house, they saw the child with his mother Mary, and they bowed down and worshipped him. Then they opened their treasures and presented him with gifts of gold and of incense and of myrrh. (Matthew 2:9–11)

Two of the three magi are young and are shown standing; they wear bejewelled crowns. The third magus is kneeling and offers his gift to the Child; he is old and bald and wears no crown. Mary is dressed in a blue *maphorion* sparsely embroidered with white flowers. Her head is surrounded by an intricate halo. This scene has an unusual detail: the star that guided the magi is depicted as radiant light in the form of a woman embracing an infant. This miraculous star is described in the *Synaxarium* and ultimately derives from Syriac apocryphal literature.

11. Next is a charming scene of the Baptism of Christ where John the Baptist stands at the edge of the stream and pours water over the head of the half-immersed Jesus. Jesus' head is turned and stares at the viewer with an engaging expression. The dove of the Holy Spirit swoops down towards him.

12. Below is a large painting of Jesus sending out the Twelve.

> He called his twelve disciples to him and gave them authority to drive out evil spirits and to heal every disease and sickness. (Matthew 10:1)

These twelve Jesus sent out with the following instructions: 'Do not go among the Gentiles or enter any town of the Samaritans. Go rather to the lost sheep of Israel. As you go, preach this message: 'The kingdom of heaven is near.' Heal the sick, raise the dead, cleanse those who have leprosy, drive out demons. Freely you have received, freely give. Do not take along any gold or silver or copper in your belts; take no bag for the journey, or extra tunic, or sandals or a staff; for the worker is worth his keep.' (Matthew 10:5–10)

Befittingly for this momentous occasion, Jesus is at the centre of the composition, surrounded by his disciples who seem awed by the task ahead of them. They are all seated, their astounded faces turned towards Jesus. All the visible faces are those of mature men, some bald and the others white-haired; all have moustaches and neatly trimmed beards. Jesus' golden halo is an intricate composition of short and long rays ending in a variety of rosettes placed against an orange background. His eyes stare out at the viewer; his right hand is raised in a gesture of blessing.

In conclusion, do not be put off by the unprepossessing outside appearance of Maryam Papasetti, because inside you will see two of the most beautiful and accomplished paintings of the Virgin Mary to be seen in Ethiopia.

Abuna Gabre Mikael at Koraro

The church of Abuna Gabre Mikael is situated on the north-west arm of the Geralta range. Where the Degum to Hawzien dirt road bears right (north-east) at the village of Megab, a track goes left (south-west) towards Guh and Koraro. It makes its way through rough countryside and in several spots is liable to subsidence; it was in bad shape the last time we used it. It took us over an hour from Megab to reach Koraro, which is a substantial village with its own newly built school, a clinic and its own resident nurse. Koraro also has its own small church, Giyorgis, which is located within the village itself and which has been crudely excavated from the rock. The priest will most likely insist that you pay to see Giyorgis before he allows you to proceed on to Abuna Gabre Mikael.

Reaching Abuna Gabre Mikael involves a steep, but not difficult, climb up a chimney strewn with large boulders which should take about twenty minutes. This is followed by a further easier climb of forty minutes. Even though the church is some 450 metres above the plain, the steep climb through the chimney makes for a rapid ascent.

The church's west-facing façade looks across a flat patch of land and so cannot be seen from below the mountain. The rock face, which is at an angle of some 75 degrees, has been extensively excavated to provide for a vertical façade. There are two entrances, both of which lead into the narthex, with a large, heavy, wood-framed window in between them.

Fig. 82. The chimney leading to the church

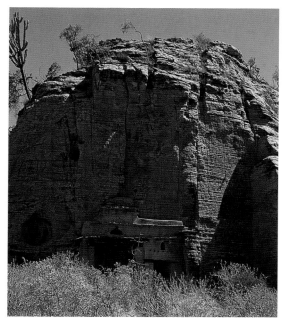

Fig. 83. Abuna Gabre Mikael

The narthex is roughly hewn and is undecorated. The church interior is of the basilical-type. Six columns create two aisles and a nave and a depth of three bays. At the eastern end there are three small apses. The columns support arches on their rounded capitals. The ceilings of two bays of the nave – the west bay and the centre bay – have frescoed domes.

The Paintings

The immediate and striking impression you have on entering Abuna Gabre Mikael is of the vivid colours of the paintings – contrasting blues and yellows against whitewashed walls – and the fact that almost all the figures appear to be wearing striped robes. On closer examination you will see that the blues go through the entire gamut of shades from the lightest 'Cambridge blue' to the purest midnight blues. Grey, orange and purple are also evident.

The rounded figures are frontally depicted and delineated by thick black lines, which are also used to define their nostrils, continuing uninterrupted to form thick triangular eyebrows, below which there are large black eyes, often looking upwards and giving the impression that they are concerned only with heavenly matters. Most of the faces have a small protruding tongue under which a black wavy line is used to indicate the chin. A crude attempt has been made to model the face to depict a frown by using white lines on a brown face and brown lines on those faces painted in white. The figures are

Abuna Gabre Mikael

WEST DOME & ARCHES

THE DOME: St Claudius, wearing an elaborate crown, and mounted on a horse with a richly embroidered covering; bowing down in front of him are the three servants of St George – Lukios, Herfas and Pasikrates. St George, holding a lance, and mounted on a horse at full gallop. The archangel Michael banishing the condemned to Hell.

NORTH ARCH LEFT: The Virgin Mary. TOP: the Banishment of Adam and Eve from the Garden of Eden. Dividing the scene in two is a tree with a serpent entwined around it; on the left, an angel with a sword grabs Adam; on the right Jesus points at Eve. RIGHT: Below Jesus, is a standing angel. SOFFIT: On the left, a *dabtara* swinging a censer; on the right, a 'one-eyed' soldier holding a spear.

WEST ARCH LEFT: At the bottom is one of Herod's soldiers holding Gigar's decapitated body; above is Herod, seated on his throne with a snake around his neck; and at the top of the arch Gigar's followers on horseback ride away with his decapitated head. RIGHT: The Dormition of the Virgin Mary with King David playing his lyre, and one of the apostles swinging a censer; below, some of the apostles mourning the death of the Virgin Mary. SOFFIT: On the left, *Abuna* Gabre Nazrawi; on the right, Jesus wearing the Crown of Thorns.

EAST ARCH LEFT: An angel with, above, Jesus holding the Tree of Life. TOP: Left panel, Adam and Eve; right panel, Joachim and Anne. RIGHT: The Virgin Mary reading a book and resting her right side on the edge of the arch; behind her head is the Holy Spirit depicted as a white dove; next to her is the archangel Gabriel. Below Gabriel is *Abba* Yemata. SOFFIT: On the left *Abba* Alef; on the right, the prophet Zechariah with *Abba* Aragawi below him.

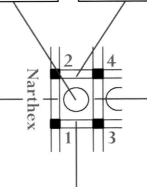

SOUTH ARCH TOP: The Nativity with Joseph and Salome on either side, holding up a cloth, in front which are a bull and an ass. RIGHT: John the Baptist baptising a child with, below, one of Herod's soldiers. SOFFIT: *Abba* Dimianos on the left and *Abuna* Fekadeamlak on the right.

CENTRE DOME & ARCHES

NORTH ARCH SOFFIT: On the left is *Abba* Garima and on the right, *Abba* Sehma. They were two of the nine Syrian saints.

SOUTH ARCH SOFFIT: On the left is *Abba* Aftse and on the right, St Pantaleon, founder of the monastery in Aksum which bears his name. They were two of the nine Syrian saints.

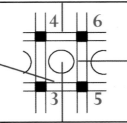

EAST ARCH SOFFIT: On the left is *Abba* Likanos and on the right, *Abba* Guba. They were two of the nine Syrian saints.

THE DOME: Twelve figures, more likely to be twelve of the twenty-four Elders of the Apocalypse than the twelve apostles because of the way they are dressed, and the fact that they are wearing crowns and holding censers and hand-crosses.

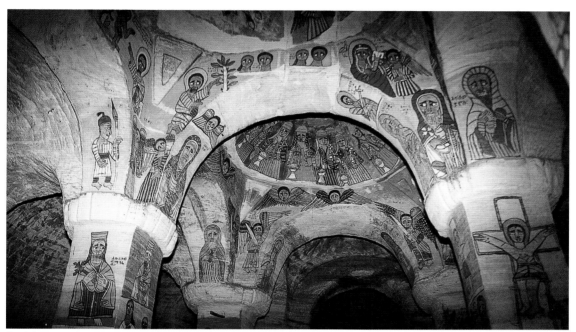

Fig. 84. Domes, arches and columns, looking from west to east

two-dimensional, and their garments obscure their bodies, but a sense of volume is achieved by linear schemes which predominate in their robes in an attempt to render the plasticity of the human form. Black lines are used to define the folds in their clothes.

Your eyes are immediately drawn to the figures in the first two domes which are visible as soon as you enter the church. The west and centre domes are covered in paintings, as indeed are all the columns. On the first dome – the west dome – you see two splendidly clothed equestrian saints and the archangel Michael in the act of consigning sinners to the abyss of Hell. The condemned are charmingly portrayed as 'one-eyed' and grey-faced and wearing what appears to be a blue-and-white-striped outfit with a blue cap reminiscent of a convict's uniform.

It is a characteristic of this church that all the evil-doers are depicted as 'one-eyed' and wearing striped, snugly fitting leggings. With the exception of the figures on the dome, they all wear what seems to be a turban with a tassel, a loose tunic reaching to their knees and tied around their waists, together with a wide cummerbund which completes their outfit. They are shown sideways in the act of torturing their victims. They look at one another with a sneering grin that conveys a true sense of wickedness.

On the second dome – the centre dome – there are twelve three-quarter-length figures. The fact that there are twelve would lead one to believe they could be the apostles; however, because they are clothed in ancient robes, wear crowns and hold censers and hand-crosses, they are more likely to

be twelve of the twenty-four Elders of the Apocalypse. Despite their colourful robes, their faces are imbued with sorrow.

The nine Syrian saints are portrayed on the haunches of the arches. Their costumes differ from those in the rest of the church. They wear ancient robes; under a striped cloak a striped tunic is visible. A shawl, also striped, covers their heads and shoulders, frames their faces and is drawn under their beards. They hold prayer beads and hand-crosses.

Because of the close resemblance of the twelve figures in the second dome, and of the winged angels, to those in the church of Debre Berhan Selassie in Gondar (*c*. 1818), I believe that Abuna Gabre Mikael's paintings could date from the early nineteenth century. The vivid blues together with the occasional use of purple indicate that the frescoes probably were retouched in the twentieth century, perhaps as recently as 1961 when the new wooden window was installed (the year has been imprinted into the plaster). It must be remembered that Ethiopian villages, however poor, take great pride in their churches and will make great financial sacrifices to ensure their upkeep.

West Dome
Against a whitewashed background are painted the equestrian saints, George and Claudius (Gelawdewos), and the archangel Michael banishing the condemned to Hell, all of whom are depicted in profile, 'one-eyed' and wearing flat caps. St Claudius' horse has very rich trappings; it has a very extravagant set of coverings painted in vivid yellows with dark blue trimmings. The saint himself is wearing an elaborate crown, and he is surrounded by the heads and wings of two angels. In front of him are three figures bowing down to him, wearing striped tight trousers and long striped shirts; these are the three servants of St George: Lukios, Herfas and Pasikrates. St George, who is holding a lance, has a powerful steed, which has been depicted at the gallop.

South Arch
At the top, against a yellow background, is the Nativity, with Joseph and Salome on either side, both of whom are holding up a cloth. In front of the cloth are a bull and an ass. On the right spandrel, John the Baptist is baptising a child. Below is a 'one-eyed' soldier of Herod's who is holding a spear. The soffit has two figures painted above the capital on either side: *Abba* Dimianos on the left, and *Abuna* Fekadeamlak on the right.

West Arch
On the left spandrel is the story of Gigar. He was the first martyr for Jesus' sake and was slain by Herod. Gigar's bonds were transformed into a snake which then began to choke Herod. Gigar is painted at the bottom of the scene; he is being held by one of Herod's soldiers and has been decapitated. Above is Herod, seated on his throne with the snake, painted in dark blue, around his neck. The Ge'ez script

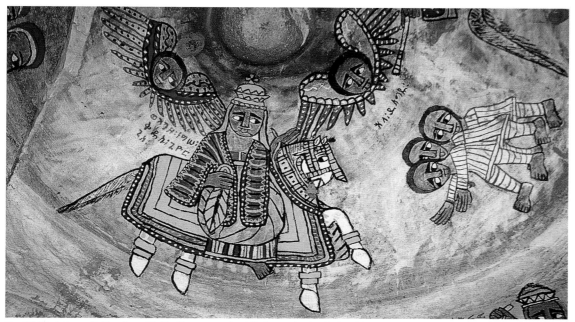

Fig. 85. West dome. St Claudius with the three servants of St George bowing before him

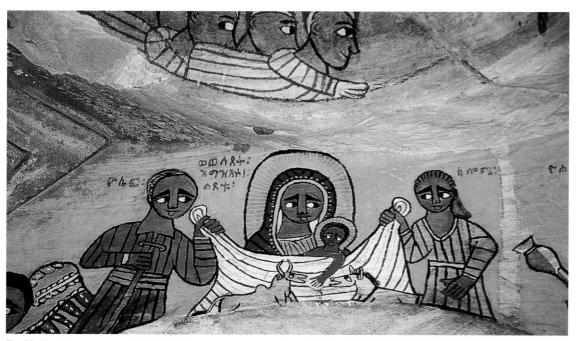

Fig. 86. West dome, south arch. The Nativity

by the tip of Herod's soldier's spear reads, 'Herod the King around whose neck is a serpent.' The script by the soldier's hands reads, 'Gigar was executed.' Above this scene, at the top of the arch, are Gigar's followers on horseback riding away with his decapitated head.

On the right spandrel is the Dormition of Mary with King David playing the lyre and one of the apostles swinging a censer, with, below, some of the twelve apostles mourning the death of the Virgin Mary.

On the left side of the soffit is *Abuna* Gabre Nazrawi, and on the right is 'Our Lord Jesus Christ wearing the crown of thorns'.

East Arch

The paintings are set against a yellow background. Beginning at the bottom of the left side of the arch, we have an angel with, above, Jesus holding the Tree of Life and ordering Adam and Eve not to eat its fruit. In the first of two central panels are a woeful Adam and Eve with, in the second panel, Joachim and Anne looking anxiously at the Annunciation scene on the spandrel next to them. This is a charming portrayal of the Virgin reading a book and resting on her right side on the edge of the arch. She appears to be listening with some concern to what the archangel Gabriel is saying to her. Behind her head is the Holy Spirit, amusingly depicted as a white dove. Below the archangel Gabriel is *Abba* Yemata.

The higher figure on the right side of the soffit is the prophet Zechariah holding a cross and looking towards the Annunciation. He is here because he foresaw the coming of Christ. He had a vision about the Messiah, the King-Priest, and prophesied that someone worthy of a crown would come to rule as both king and priest:

> He will sit and rule on his throne and he will be priest on his throne. And there will be harmony between the two. (Zechariah 6:14)

> Rejoice greatly, O daughter of Zion! Shout, daughter of Jerusalem! See, your king comes to you righteous and having salvation, gentle and riding on a donkey, on a colt, the foal of a donkey. (Zechariah 9:9)

He also predicted Jesus' triumphal Entry into Jerusalem 500 years before it happened.

The figure below Zechariah is *Abba* Aragawi, the founder of Debre Damo. He holds yellow prayer beads in his left hand and a white prayer-stick in his right. He wears a light grey tunic with black and yellow vertical stripes; a light purple coat with the folds delineated in black lines and white dots; and a shawl the same colour as the tunic, edged in yellow and black. There is a definite attempt to show volume underneath the clothes.

On the left (north) side of the soffit is *Abba* Alef, one of the nine Syrian saints. He holds a white hand-cross in his left hand and a white prayer-stick in his right. He is wearing a mauve-grey tunic with black vertical stripes, an off-white cloak with black stripes which has been turned at the corners and a royal blue shawl with black lines and yellow dots which is edged in white.

North Arch

The background to the frescoes is again yellow. On the left spandrel is the standing Virgin Mary. Above her, in the centre, is the Banishment of Adam and Eve from Paradise. Dividing the scene in two is a tree with the serpent entwined around it. On the left, an angel with a drawn sword grabs the shoulder of an ashamed Adam, who hides his face behind a hand. On the right, Jesus points accusingly at Eve, who covers her genitals with what appears to be an oversized leaf. She looks defiantly at Jesus and in turn points at him. Below Jesus, a standing angel completes the painting.

On the right side of the soffit, a 'one-eyed' soldier, holding a spear, stands in profile. On the left side of the soffit a *dabtara* swings a censer. A church is painted above him.

South-West Column (1)

This is the first column you see as you enter. On its south side, a semi-naked man wearing a loincloth is being held by two 'one-eyed' guards, one of whom wields a club. Below is an enchanting, chained devil in grey, with horns on his head, seated cross-legged and looking rather sorry for himself. On the west side, at the top, is a woman carrying wood on her head and, next to her, an evil 'one-eyed' man. Below is a young man carrying a lamb. On the east side, Philip, the apostle, is being hung upside-down by two 'one-eyed' men wearing pointed hats. His crucifixion took place in Hierapolis in Turkey. In the panel below, two 'one-eyed' men are decapitating John the Apostle. On the north side, there are two 'one-eyed' men decapitating St Paul and, below, another two 'one-eyed' men spearing Celestianus with arrows. These 'one-eyed' men also wear pointed hats.

North-West Column (2)

At the top of its west side, this column has a painting of Gabre Manfas Kiddus, the hermit whose sanctity tamed wild beasts (see Fig. 11, p. 19). A bird is perched on his left hand. Legend has it that when this saint crossed the desert with his beasts of prey he found a bird dying of thirst, and he allowed it to drink a tear from his eye to survive. At his feet are lions and leopards. Below is St Peter hanging upside-down by his ankles with two 'one-eyed' men tying him to a horizontal stake.

On the south side, at the top, is Tekle Haymanot holding a yellow hand-cross in his left hand and white prayer beads in his right. At the bottom is the stoning of Jacob, the apostle. We know him by his Latin name, James the Less, who was sentenced by the high priest, Ananias, to be stoned to death.

Abuna Gabre Mikael

THE COLUMNS

COLUMN 4 SOUTH: Top, *Abuna* Kefletsion; middle, local lady with her attendant; bottom, two boys holding books. WEST: Top, *Abuna* Gabre Mikael; below, Kidana Maryam, a donor, reading a book and accompanied by two boys carrying guns. EAST: Top, *Abba* Os; below, Tekle Haymanot. NORTH: Top, *Abuna* Etsfe Krestos; below, a local lord on horseback with his army carrying guns.

COLUMN 6 WEST: Top, Belai Kemer devouring people; bottom, the Roman Caesar celebrating the death of Christ. NORTH and SOUTH: A carved cross. EAST: Blank.

COLUMN 2 WEST: Top, Gabre Manfas Kiddus, a bird near his head and lions and leopards at his feet; below, St Peter hanging upside-down by his ankles with two 'one-eyed' men tying him to a stake. SOUTH: Top, Tekle Haymanot holding a hand-cross and prayer beads; below, the stoning of Jacob (James the Less, one of the apostles). EAST: St Paul hanging upside-down; below, the decapitation of St Matthew. NORTH: Top, *Abba* Samuel riding a lion; below, the stoning of St Stephen.

COLUMN 1 SOUTH: Top, a semi-naked man wearing a loin cloth is being held by two 'one-eyed' guards, one of whom wields a club; below, a chained devil. WEST: Top, woman carrying wood on her head and, next to her, an evil 'one-eyed' man; below, a man carrying a lamb. EAST: Top, the apostle Philip being hung upside-down by two 'one-eyed' men wearing pointed hats; below, two 'one-eyed' men are decapitating John the Apostle. NORTH: Top, two 'one-eyed' men decapitating St Paul; below, Celestianus being speared with arrows by another two 'one-eyed' men wearing pointed hats.

cell

cell

Narthex

Sanctuary

2 4 6

1 3 5

N

COLUMN 3 WEST: The Crucifixion of Christ with two centurions in attendance. SOUTH: Top, Gestas, one of the crucified thieves (one-eyed); below, a nude woman hanging by her neck with an angel on one side of her and a man wielding a club on the other side. NORTH: The crucified repentant thief (two-eyed), Dysmas, with, beneath him, women crying; below, the Burial of Christ. EAST: The Resurrection of Christ; below is his tomb with two 'one-eyed' guards.

COLUMN 5 WEST: St Yared talking with Emperor Gabre Maskal; below, Gabre Kirstos on a mat. OTHER SIDES: Blank.

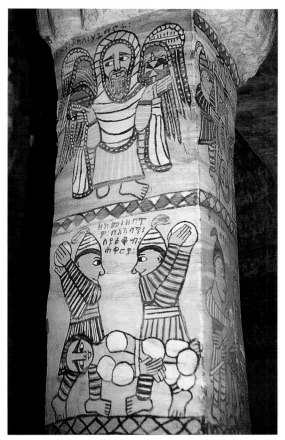

Fig. 87. North-west column (2), south side. Top: Tekle Haymanot. Below: the stoning of Jacob

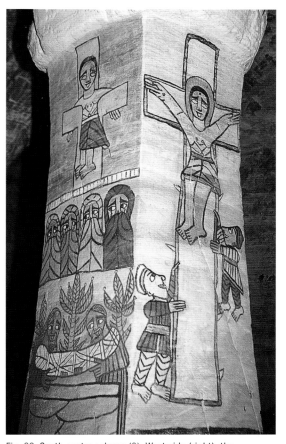

Fig. 88. South centre column (3). West side (right): the Crucifixion. North side (left), top to bottom: the crucified thief Dysmas, women crying and the Burial of Christ

On the east side is the apostle Peter, hanging upside-down with, below, the decapitation of Matthew. He is the apostle and evangelist who preached the gospel in Ethiopia and also became a martyr at the hands of the high priest, Ananias. On the north side of this column is *Abba* Samuel riding his lion and, below, the stoning of St Stephen.

South Centre Column (3)

On the west side is the Crucifixion with two 'one-eyed' guards in attendance. On the south side is the 'one-eyed' thief, Gestas, on the cross and, below, a nude woman hanging by her neck with an angel in attendance and an evil 'one-eyed' person wielding a club on the other side of her. On the north side is the repentant (he is two-eyed) thief, Dysmas, on the cross with women crying below him and,

under them, the Burial of Christ. On the east side is the Resurrection of Christ; he is resplendent in an orange gown and halo and is holding a victory standard. His tomb is shown below together with two 'one-eyed' guards.

Gestas said, 'If you are the Christ, save yourself and us.' Dysmas reproved him, 'Do you not fear God, we have been punished for our deeds, but this man has done no evil.' And he said to Jesus, 'Remember me, Lord, in your kingdom.' Jesus said, 'Amen, Amen. I say to you, today you will be with me in Paradise.' (Apocryphal New Testament, Gospel of Nicodemus or Acts of Pilate, Part 1, 10:2)

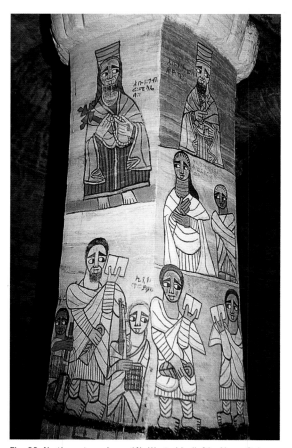

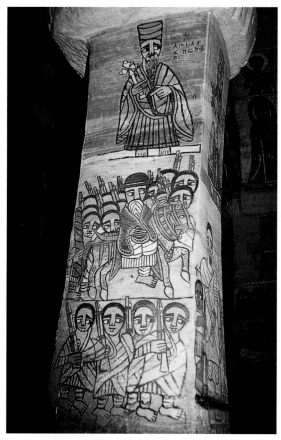

Fig. 89. North centre column (4). West side (left): *Abuna* Gabre Mikael with, below, Kidana Maryam. South side (right), top to bottom: *Abuna* Kefletsion, a lady donor and her attendant, and two boys holding books

Fig. 90. North centre column (4). North side: *Abuna* Etsfe Kirstor with, below, a local lord on horseback

North Centre Column (4)

On the south is *Abuna* Kefletsion (who lived at the same time as *Abuna* Gabre Mikael). *Abuna* Kefletsion, who was a monk and a saint, is depicted with rounded shoulders wearing the tall hat normally worn by priests. His tunic is green with black and red lines, and his coat is a light red with black lines. He holds yellow prayer beads in his left hand and a yellow hand-cross in his right. In the middle panel there is a local lady with her attendant. She is one of the donors of the paintings in this church and is making a supplication to the Virgin; the text near her head reads, 'Mary, do not forsake me.' She has tattooed horizontal dotted lines on her neck, which is still the custom for Tigrayan women today. In the bottom panel two boys are holding books.

On the west, in the top panel, is *Abuna* Gabre Mikael wearing the yellow, tall hat of a priest with his hair wrapped in a royal blue cloth. He holds a royal blue cross in his right hand and aquamarine prayer beads in his left. His tunic is royal blue, trimmed in aquamarine. Below is Kidana Maryam, a donor, reading a book and accompanied by two boys carrying guns.

On the east side there is *Abba* Os with Tekle Haymanot below him, depicted as a priest and founder of Debre Libanos. *Abba* Os holds a blue prayer-stick, and Tekle Haymanot holds a yellow hand-cross in his left hand and blue prayer beads in his right.

On the north side is *Abuna* Etsfe Krestos, who was a monk and a saint with, below, a local lord on horseback together with his followers, who carry guns. Etsfe Krestos holds a white hand-cross in his right hand and blue prayer beads in his left. There is no Ge'ez identification regarding the local lord.

South-East Column (5)

On the west side is St Yared, holding a prayer-stick, talking with the seated Emperor Gabre Maskal, who has an attendant behind him holding an umbrella (see Fig. 15, p. 24). Below is Gabre Krestos on a mat with two dogs either side of him and two men on his left. All the figures have extended tongues. The other three sides of the column are blank.

North-East Column (6)

The top panel on the west side shows Belai Kemer surrounded by the bones of the people he has already devoured and three unfortunate men who are awaiting their fate. In the lower panel, the script says, 'King Caesar'. It is referring to the Roman Caesar supposedly celebrating the death of Christ. The north and south sides of the column have a carved cross; the east side is blank.

Centre Dome

On the dome itself are the twelve figures which I believe to be twelve of the twenty-four Elders of the Apocalypse. The soffits of the arches below this dome are painted with some of the nine Syrian saints.

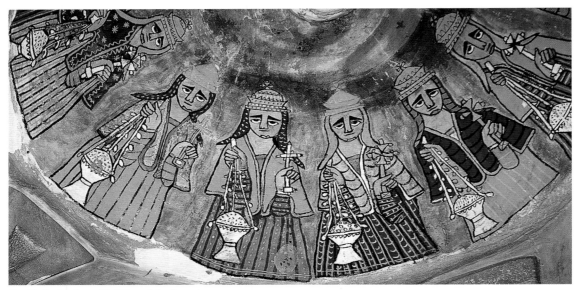

Fig. 91. Centre dome. Six Elders of the Apocalypse

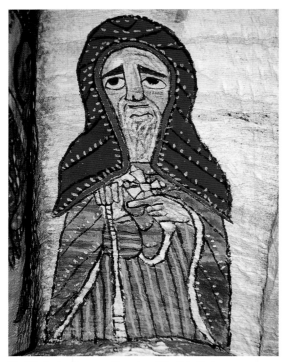

Fig. 92. Centre dome, north arch soffit. *Abba* Garima

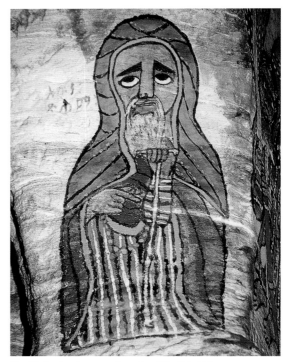

Fig. 93. Centre dome, north arch soffit. *Abba* Sehma

East Arch Soffit

On the left is *Abba* Likanos wearing a royal blue-and-white-striped tunic, a white cloak trimmed in yellow and a white shawl trimmed in blue. Both his tunic and shawl have lines in black which attempt to outline the human form. He holds prayer beads in his left hand and a prayer-stick in his right. On the right is *Abba* Guba dressed in a royal blue tunic and shawl highlighted with splashes of white. His cloak is off-white. The folds of both garments have been outlined in black. He holds a yellow cross in his left hand and a prayer-stick with his right.

South Arch Soffit

On the left is *Abba* Aftse wearing a pale mauve tunic which is trimmed in bright-yellow and a pink-ish cloak edged in white. The folds are delineated in black. He holds yellow prayer beads in his right hand and a yellow prayer-stick in his left. On the right is *Abba* Pantaleon, the founder of a monastery in Aksum which bears his name. He wears a dark-grey tunic, a light brown cloak edged in white and an ultramarine shawl trimmed in white. He holds a white hand-cross in his right hand and a white prayer-stick in his left.

North Arch Soffit

On the left is *Abba* Garima, one of the nine Syrian saints, wearing a colourful tunic striped in brown, yellow and black, a mauve cloak edged and dotted in white. A royal blue shawl covers his head; it is trimmed in brown and its folds are delineated with black lines and yellow dots.

On the right is *Abba* Sehma, one of the nine Syrian saints. His mauve tunic is striped in white and black; his brown shawl is trimmed in yellow; his head is covered with a mauve shawl edged in yellow with folds delineated in black and accentuated with yellow dots. He holds a white prayer-stick in his left hand and yellow beads in his right hand.

Abreha Atsbeha

NARTHEX

PORCH TO NARTHEX ENTRANCE, NORTH JAMB: Two portrayals of *Abba* Samuel riding his lion, one above the other.

West Wall

North Wall

1	St Theodore the Egyptian (Tewodros liqa serawit) on a light tan horse killing the serpent.
2	St Mercurius on a black horse which is trampling Julian the Apostate.
3	St Philoteus on a light grey horse spearing the bull Maragd.
4	St Basilides on a black horse.
5	St Claudius (Gelawdewos) on a brown horse spearing the *seba'at*.
6	St George as King of Martyrs; *Abuna* Habib in front of him; the Trinity within a roundel on the left.
7	Three riders, the one on the right is identified as *Abeto* Wolde Maryam.
8	Archangel Michael.
9	Archangel Raphael with, below him, the sea-monster with the church on its back.
10	Unknown *neburae'd* riding a brown horse.
11	*Nebura'ed* Tedla on a yellow horse.
12	*Abeto* Gabre Haywat riding a white horse.
13	*Ledj* Araya riding a brown horse.
14	Unknown rider on a white horse.

1	St Victor (Fikitor) riding a light tan horse.
2	St Aboli riding a black horse.
3	The Holy Family walking – Joseph and Mary who is carrying the child Jesus on her back.
4	St Theodore the Oriental (Masraqawi, aka Banadlewos) riding a brown horse and killing the King of Quz and his people.
5	St George, riding a white horse, with his three servants – Lukios, Herfas, and Pasikrates – behind him, holding spears and shields. Above his horse's head are three of his attendants, also armed. Below the horse is the donor, *Waizero* Jenbere (aka Amet-Selassie) with her family, celebrating the completion of the paintings with the priests of the church. She and her family members are holding *berelles* filled with *tej*.

Abreha Atsbeha

The church of Abreha Atsbeha is some 20 kilometres west of Wukro and is easily reached on a good dirt road in about thirty minutes. You can drive right up to just below the church compound. It can be visited either before or after you visit one of the Geralta churches. I would recommend you see it after since it is open at all times and easily viewed even when you are tired from the day's walk.

Abreha Atsbeha is one of the most revered churches in this area because it was supposedly ordered to be built in the fourth century by the two royal brothers, Abreha and Atsbeha (known in the West as the kings, Ezana and Saizana), who were responsible for converting Ethiopia to Christianity. Ezana's remains are said to be kept in this church, but since the Ethiopians do not particularly venerate relics, nobody seems to know where they are.

The church is also important because, according to its clergy, it was founded by Frumentius, also known as *Abba* Salama ('Father of Peace'), who was the first *abuna* of the Ethiopian Church and responsible for the conversion of Abreha and Atsbeha. The church has a wonderful gold cross which is said to have belonged to Frumentius. Thousands of pilgrims make the journey to Abreha Atsbeha every year.

Fig. 94. The church of Abreha Atsbeha in its mountain setting

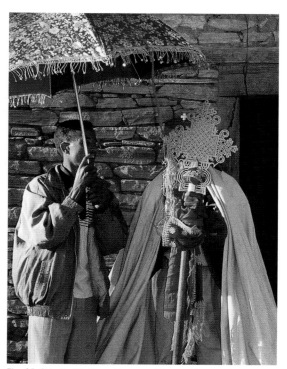

Fig. 95. Priest with the gold cross of Frumentius

The church is semi-monolithic. It has been excavated horizontally into the mountain, but, strangely, the rock on three of its sides has been cut away to leave it almost free-standing. Its two squared-off sides are very noticeable, especially from a distance. The front, the west façade, now has a large, built-up portico, installed by the Italians in the 1930s. It has been whitewashed and contrasts with the dark-red rock of the church.

The interior is of the basilical-type plan with a nave and four aisles. It is four bays deep with three sanctuaries; the two outer ones have domes whereas the central one has a semi-dome. The transept is formed by the second bay; it has a barrel-vaulted ceiling which is carried on flat pseudo-beams above which is an Aksumite frieze. The nave has a flat ceiling which is higher than those of the aisles. The ceiling of the central bay formed by the intersection of the nave and the transept has a carved Greek cross; this bay has four cruciform columns with pseudo-corbels and has arches between the columns. All the other columns in the church are of a square cross-section with bevelled corners.

The remaining ceilings in the church are flat, and all are decorated with a variety of interlacing crosses, carved in relief, and are painted in black and white. According to both the sixteenth-century Jesuit chaplain Alvares and the Imam of Adal in his chronicle *Arab Fakih*, the ceilings were partially covered in gold but were burned during the Muslim invasion of Ahmad Gragn; indeed, all the ceilings do show signs of having been blackened by fire.

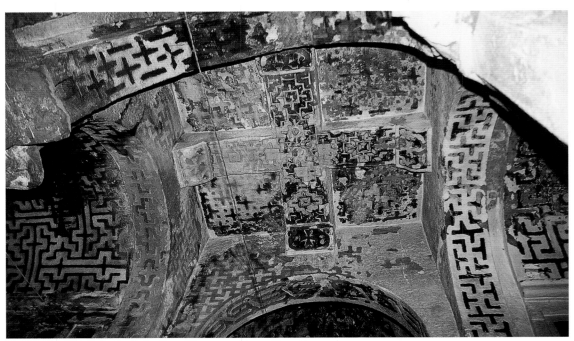

Fig. 96. Transept with the vaulted ceiling of the cross-aisle on either side

Beatrice Playne has the following to say about the ceilings of Abreha Atsbeha: 'I was told this amazing decoration had been cut from the rock surface, but when Gerster's photos appeared and in subsequent visits, I could see this work had been carved in stucco – a craft perfected by the Copts and passed on by them to their Muslim conquerors. This would account for the pieces of decoration which have fallen from the vaults' (1986).

The original narthex, hewn from the rock, is now behind the Italian portico. It has an elaborate wooden screen.

The Paintings

The paintings are of a much later date than the church itself; they are from the period of Yohannes IV (1870–89), and he is depicted in one of the scenes. They are all frescoes except for those in the narthex around the massive wooden screen separating the narthex from the church; these have been painted on canvas and glued to the wall and are in a sorry state with the canvas peeling away. On the south wall of the church itself the paintings have completely disappeared.

The wooden screen separating the narthex from the church has two doors; it is framed by a band of angels' faces. Over the doors is a painting of the Trinity portrayed in the Ethiopian fashion of three old men within a rectangular frame supported by the Tetramorph. At either side are the twenty-four Elders of the Apocalypse, wearing Ethiopian priestly robes. The entire wall has suffered badly from water seepage. The canvas on the right side is in shreds. Two guardian archangels appear on the inside of the two doors, the one on the north leaf being St Raphael saving the church that was threatened by a sea monster.

Porch to Narthex Entrance, North Jamb

Here there are two portrayals, one above the other, of *Abba* Samuel riding his lion (see Fig. 12, p. 21). Below the lower one is a long inscription that reads, 'By the grace of the Father, Son, and Holy Spirit, we have now written this text concerning the paintings, remembering the year of the world and the circulation of night and day. These paintings were carried out with contributions from Amet-Selassie, also known as Lady Jenbere. Her father's name is Kinfe-Mikael (the wings of St Michael) and her mother's, Hirute-Selassie (the kindness of the Holy Trinity). Her children are Gebre-Kidan, Tewede-Medhin, Wolde-Mikael, and Weletmaryam.'

The Narthex Paintings

The location of the equestrian saints in this church is unusual because they are painted in the narthex and not in the church itself and because they are to be found on both the north and west walls rather than on just the north wall, which is the accepted convention. The reason for this convention is that

the equestrian saints, who are regarded as God's militia, have an apotropaic function since the evil powers are believed to reside in the north. They serve as an example of fortitude and righteousness to the men, who usually stand on the north side during church services.

Yohannes IV and his commanders are depicted on several walls of both the narthex and the church. The equestrian saints may have been painted on the narthex west wall during the period when the Emperor was involved in fighting the infidel army of the Egyptians, which had overrun the north and west of the country. It is likely that he and his commanders attended services in this important church before departing to battle. They would have left through the narthex door, and the equestrian saints would have wished them luck and courage, assuring them that the Church was fully supportive of the Emperor.

These saints all ride at the gallop, barefoot with their big toe gripping the stirrup, and holding a spear in each hand ready to attack the enemies of the church. They wear a tight shirt under a striped, buttoned-up tunic with wide sleeves and a pointed collar. Their trousers are wide-legged. Each has a colourful cape that billows out behind with its edge being scallop-shaped. They all have a bouffant hairstyle, and those on the north wall have a halo whereas those on the west do not. Their horses have ornamental trappings reflecting those of the nobility; around their necks hangs a string of bells. Pommels are evident fore and aft on their saddles.

Narthex: West Wall

Five equestrian saints are portrayed on the upper part of the wall.

1. St Theodore the Egyptian (Tewodros liqa serawit), on a light tan horse, in process of killing the serpent which was fed a human sacrifice on a daily basis in the city of Eukitos. He is wearing a green tunic with black stripes and a dark cloak. He is the only equestrian holding a sword, which he has thrust deep into the snake's throat. But the beast fights back vigorously; it has wrapped its tail around the horse's hindquarters and its jaws are perilously close to the animal's legs.

2. St Mercurius on a black horse killing Julian the Apostate, who had renounced Christianity. The saint is about to spear the Emperor, who is lying on the ground. Julian wears a yellow tunic with flowery stripes, a green cloak and a yellow cape.

3. St Philoteus on a light grey horse spearing the bull Maragd. He wears a black-striped green tunic and a brown ochre flowery cape. The brown beast is adorned with gold; it was the idol worshipped by his family. The saint holds two spears but a third one has already entered the side of the bull, whose legs have buckled under him.

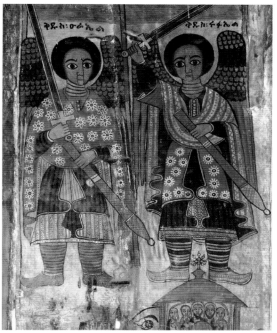

Fig. 97. Narthex west wall wooden door

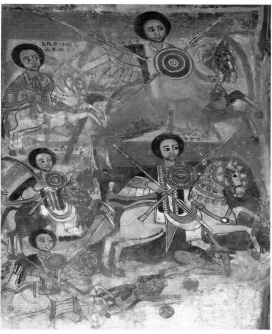

Fig. 98. Narthex west wall. Five galloping nobles

4. St Basilides rides a black horse and holds only one spear in his right hand. Under his horse is a group of five people engulfed in flames representing the enemies of Christ. He wears a black-striped light brown tunic, a green cloak and a bright yellow cape with orange stripes.

5. St Claudius (Gelawdewos) rides a brown horse and holds a spear in his right hand. His other spear has already been used to injure the *seba'at* below. Claudius wears a green tunic, blue cloak and a brown cape adorned with white daisies. The monster has a human head, the body of a lion and a forked tail – at the end of each fork is a snake's head. The *seba'at* holds a bow and is aiming an arrow at the saint.

6. St George as King of Martyrs appears on the left side of the wall. He is mounted on a white horse covered with a beautiful, quilted saddlecloth ornamented with squares of sunflowers and stylised petals. He wears a shallow domed crown surmounted by a cross with side-pieces over his ears. He is clad in a brown ochre cloak and *lamd*. With his left hand he holds the reins and a hand-cross and in his right he has a spear pointing upwards and touching the head of the diminutive figure of a priest, who, as stated in the text, is *Abuna* Habib. There is a row of heads on the far right of the panel bowing to St George. The text above them says 'how the people prostrated themselves to

St George'. Behind St George, within a roundel, is the Trinity. To the left of the roundel is part of the galloping army. Behind St George's horse is an unidentified rider.

7. On the right there are paintings of the nobility and churchmen who accompanied Yohannes IV to war against the Egyptian forces. The one on the right is identified as *Abeto* Wolde Maryam. Though *abeto* was the title normally conferred on a prince, it became an honorary title meaning 'Lord'. The left-hand horseman has been badly damaged by water leakage.

The wooden door on the right has paintings of:

8. The archangel Michael on the left.

9. The archangel Raphael on the right – the wooden door on the left has no paintings. Their heads are encircled by their wings, which are painted in horizontal bands of feathers painted in either brown ochre or dark blue. They both brandish drawn swords. They stand erect with their feet pointing outwards, wearing Indian-style trousers gathered at the ankle and shoes that have pointed, turned-up toes. They wear cloaks, tunics and gowns painted in stunning, contrasting colours – brown ochre and dark blue. St Michael's cloak and St Raphael's tunic are brocaded with white flowers. Below St Raphael is the Alexandria church dedicated to him which was built by mistake on the back of the sea-monster. Inside the church are five people together with the church's *tabot*.

Five galloping nobles are depicted on the right side of the wall, riding barefoot and holding round leather shields decorated with white circles. Each carries two weapons, either two spears with one pointing upwards and the other downwards, or a spear and a sword. They wear a *lamd* over their shoulder which identifies them as members of the nobility. Their hair is jet black and bouffant-styled; each has a neatly trimmed, pointed beard; they have the determined look of men going into battle. Their enemies' bodies are strewn underneath the horses. On the right are the two most important commanders indicated by their larger size; they are both *nebura'eds*, an ecclesiastical title given by the Emperor to the senior administrator of the church of St Mary of Zion in Aksum and the church of St Mary in Addis Alem, Shoa Province. This title originated in the fourteenth century when *Abuna* Yakob sent twelve missionaries to southern Ethiopia to proselytise and found new monasteries. Since he had no power to consecrate them as bishops, he placed his hands on them and made them each a *nebura'ed* in charge of both ecclesiastical and lay matters. The riders are:

10. An unknown *nebura'ed*; his name has disappeared. He rides a brown horse.

11. *Nebura'ed* Tedla mounted on a yellow horse. He is depicted several times in the church.

12. *Abeto* Gabre Haywat holding a spear and a sword and riding a white horse.

13. *Ledj* Araya riding a brown horse and holding a spear in one hand and brandishing a sword over his right shoulder with the other. Though the text only names him as *Ledj* Araya, he could be *Ledj* Araya Selassie Yohannes, the son and heir of Emperor Yohannes IV and his wife Mestira Selassie. He was born in 1869 and died of smallpox in June 1888.

14. Unknown rider on a white horse.

Narthex: North Wall

This wall is dedicated to equestrian saints, all of whom are riding at the gallop, barefoot with their big toe gripping the stirrup and holding a spear in each hand ready to attack the enemies of the church. Each wears a colourful cape that billows out behind with its edge being scallop-shaped. They are:

1. St Victor (Fikitor the Martyr) riding a light tan horse.

2. St Aboli riding a black horse.

3. The Holy Family walking – Joseph on the left and Mary, who is carrying the child Jesus on her back, on the right.

4. St Theodore the Oriental (Masraqawi, aka Banadlewos) riding a brown horse, killing the King of Quz and his people.

5. St George, riding a white horse, with three servants behind him who hold spears and shields; they are Lukios, Herfas, and Pasikrates. Above his horse's head are three of his attendants, also armed. Below the horse is the donor, Amet-Selassie, together with her family, celebrating the completion of the paintings with the priests of the church. She and her family members are holding *berelles* (vessels used specifically for drinking *tej*) filled with *tej*.

Narthex: East Wall

1. The Trinity is portrayed in the Ethiopian fashion of three old men within a rectangular frame supported by the Tetramorph. At either side are the twenty-four Elders of the Apocalypse, wearing Ethiopian priestly robes.

Fig. 99. Narthex north wall

2. Angels' heads and wings.

3. The Annunciation. Mary is spinning wool while the archangel Gabriel, hovering horizontally above her, brings the good news that she will give birth to Jesus.

4. The Nativity. The scene is enclosed within an arch. Mary sits cross-legged; her clothes envelop her entire body including her legs. The Child is wrapped in an orange-striped yellow cloth and is held snugly in his mother's lap. A donkey and a bull hold their heads up towards the Child in

adoration. Behind the Virgin Mary, on the left, is the head of Joseph and, on the right, Salome with her hands clasped in prayer; she wears a striped tunic in yellow, orange and white. Below, on the left, are the three magi presenting their gifts to the Child. They wear gold domed crowns surmounted by a cross; the crowns have ear-pieces. They wear *lamds* over their colourful tunics. The four children on the right hold sticks and are playing the game of *ganna*.

5. St George, spearing the dragon and rescuing the princess Birutawit. The saint rides a galloping white horse; he wears a green tunic, a dark blue cloak and an orange cape decorated with large yellow and green rosettes. A halo of golden rays radiate from his head and shine against a green background. In his left hand he holds the reins, a hand-cross and a spear with the tip pointing upwards. In his right hand he has another spear ready to strike the dragon which has already had a spear through its neck. The beast is writhing below St George's horse in its death throes with its head turned up towards the saint. It seems to be gasping for breath with its mouth open and its tongue hanging out. Its body is painted in a steely blue, and its legs are clearly visible; they resemble human feet and are outlined in black and not coloured. The princess Birutawit, whom the saint is rescuing from the monster, sits in a tree and hangs on to its branches. Her dress, which is badly discoloured, was dark blue.

6. Three mounted noblemen, recognised because they wear *lamds*, ride towards the right with their spears held high. Only the middle one has a Ge'ez text to identify him; he is *Ledj* Haile Selassie.

7. The Baptism of Jesus. On the left of the panel Jesus stands in the blue water clad in a dark green cloth draped over his left shoulder. On the right John wears a yellow camel skin over one shoulder and holds what appears to be a long-handled cross in his left hand. With his right hand he baptises Jesus. At top left there is a speckled dove, symbol of the Holy Spirit. As soon as Jesus was baptised, he went up out of the water. At that moment Heaven was opened, and he saw the Spirit of God descending like a dove and lighting on him. And a voice from Heaven said, 'This is my Son, whom I love; with him I am well pleased' (Matthew 3:16–7).

8. Pontius Pilate washing his hands. Pilate is on the right dressed in a brown ochre cloak. He holds his hands out over a bowl while a servant pours water into them. On the left are two one-eyed men; each wears a white cap on his head, has a goatee beard and holds his left hand held against his face. When Pilate saw that he was getting nowhere but that instead an uproar was starting, he took water and washed his hands in front of the crowd. 'I am innocent of this man's blood,' he said. 'It is your responsibility!' (Matthew 27:24).

Abreha Atsbeha

NARTHEX

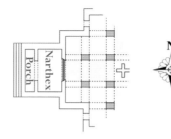

East Wall

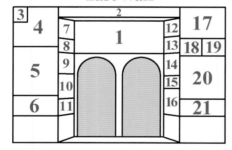

South Wall

1	The Trinity surrounded by the twenty-four Elders.
2	Angels heads and wings.
3	The Annunciation.
4	The Nativity with, below, the three magi and children playing *ganna*.
5	St George spearing the dragon and rescuing the princess Birutawit.
6	Three riders; the middle one is *Ledj* Haile Selassie.
7	The Baptism.
8	Pontius Pilate washing his hands.
9	The Flagellation.
10	Abreha and Atsbeha.
11	*Abuna* Salama.
12	Abreha and Atsbeha behind an *alga*.
13	*Nebura'ed* Tedla praying.
14	Descent from the Cross and wrapping of Christ's body.
15	Joseph of Arimathea and Nicodemus hold Christ's body while the Virgin Mary laments.
16	Placing Christ's body in the tomb.
17	The Crucifixion.
18	The Crown of Thorns.
19	Jesus carries the Cross.
20	The Virgin and Child.
21	The donor, *Waizero* Jenbere (Amet-Selassie) in a dark blue cloak.

1	Unidentified *negus* in a blue shawl (only the letters T and z remain in the text).
2	Queen Sofia who went to Rome and became a martyr with her two sons.
3	Abreha and Atsbeha as babies being held by their mother.
4	Abreha and Atsbeha being baptised by John the Baptist. Top centre: Jesus blesses the event. Below: *Abba* Salama (Frumentius).
5	The priests of the church of Abreha Atsbeha praising the Lord.
6	The beheading of John the Baptist. Top: Salome and her mother Herodias. Below: King Herod (left) and Salome (right).
7	Moses receiving the Ten Commandments.
8	Moses' brother Aaron.
9	Abraham, Isaac, and Jacob.
10	Two mounted figures – damaged.
11	King David playing the harp.
12	Prophet Ezra with his tambourine.
13	The Raising of Adam and Eve by Christ.
14	Hell with a chained, blue Satan surrounded by the heads of the condemned.
15	Gabre Manfas Kiddus.
16	Tekle Haymanot as a hermit.
17	*Abba* Ewostatewos.

9. The Flagellation. Jesus is tied to a large stake with his hands behind his back. On either side of him two one-eyed men are beating him with clubs; the one on the left also holds a whip.

10. The two brothers Abreha and Atsbeha are depicted wearing identical clothes and shallow domed crowns with ear-pieces. Each is clad in a blue tunic over which is a brocaded brown ochre *lamd* decorated with flowers.

11. *Abba* Salama. He wears a green head-cloth and shirt and a royal blue cloak decorated with white and red spots. He holds a golden hand-cross in his right hand and prayer beads in his left. He has a long, pointed, white beard. Four priests wearing white turbans stand behind him; they are wrapped in striped *shamas* in orange, blue, and white.

12. The two brothers Abreha and Atsbeha are depicted wearing identical clothes and shallow domed crowns with ear-pieces. Each is clad in a blue tunic over which is a brocaded brown ochre *lamd* decorated with flowers. They stand behind a decorated *alga* which here represents the throne.

13. Prostrated beneath the *alga* is *Nebura'ed* Tedla; he wears a shallow domed gold crown and a red ochre *lamd* over a white tunic. He lies below the *alga* to signify his close connection to the emperors. He is also depicted on the narthex west wall as an army commander.

14. The Descent from the Cross and the wrapping of Christ's body. The panel is divided into three parts. On the left, Joseph of Arimathea and Nicodemus stand on ladders placed against the Cross, in process of lowering Christ's inert body to the ground. Christ's arms hang limply around their heads.

> Later, Joseph of Arimathea asked Pilate for the body of Jesus. Now Joseph was a disciple of Jesus, but secretly because he feared the Jews. With Pilate's permission, he came and took the body away. He was accompanied by Nicodemus, the man who earlier had visited Jesus at night. Nicodemus brought a mixture of myrrh and aloes, about seventy-five pounds. Taking Jesus' body, the two of them wrapped it, with the spices, in strips of linen. This was in accordance with Jewish burial customs. (John 19:38–40)

At top right, Joseph of Arimathea, Nicodemus, and the Virgin Mary are in wrapping Christ's body, which is being supported in a sitting position by the three of them. Below this scene are five women seen from the back, completely wrapped up in alternating orange and dark blue gowns.

15. The body of Christ is lovingly held horizontal by Joseph of Arimathea and Nicodemus. His body is wrapped in a white shroud and criss-cross-bound with orange ribbon producing diamond shapes. The Virgin Mary is at the centre with her hands covering her face.

16. The body of Christ is lowered into the tomb which is in the form of a dark brown oval pit. Joseph of Arimathea and Nicodemus are in the tomb while outside it (depicted below) there are seven one-eyed men, who are obviously mourning the death of Christ. The tomb has a very prominent lock.

17. The Crucifixion. The heavy wooden cross is placed at the centre of the composition. It has a footrest which Jesus stands on with his body turned to the left. The two thieves are portrayed as diminutive figures on either side of the Cross. The repentant thief is on the left; he faces Jesus with open eyes and with his feet firmly placed on the footrest of his cross. The condemned thief is on the right; he looks away from Jesus with one of his legs kicking backwards. The Virgin Mary and John stand on either side of the bottom of the Cross; both have their hands crossed piously over their chests. Mary is on the left, enveloped in a dark blue cloak embroidered with white flowers which she wears over a brown gown decorated with large white rosettes with a prominent green centre. John, on the right, wears a dark blue tunic under a wide-sleeved gown, which has the same colour and decoration as that of the Virgin. Below the Cross is a white skull, a reference to the belief that Christ was crucified on the exact spot where Adam was buried. At bottom left, the centurion Longinus, mounted on a grey mule, spears Jesus' side while nearby an angel is ready to catch the blood. On the right, a man stands below the Cross and offers Jesus a sponge filled with vinegar to quench his thirst.

> Immediately one of them ran and got a sponge. He filled it with wine vinegar, put it on a stick, and offered it to Jesus to drink. (Matthew 27:48)

18. The Crown of Thorns. Jesus faces forward with his eyes lowered and his enlarged hands held upwards, palms forward, in a gesture of prayer. Two soldiers place the Crown of Thorns on his head; they wear dark brown shirts. Above them, another two soldiers strike Jesus' head again and again; they wear blue shirts. All the soldiers are depicted in profile and one-eyed.

> And then twisted together a crown of thorns and set it on his head. They put a staff in his right hand and knelt in front of him and mocked him. 'Hail, king of the Jews!' they said. They spit on him, and took the staff and struck him on the head again and again. (Matthew 27:29–30)

19. Jesus carries the Cross. Jesus is bent over under the weight of the heavy cross; at the right, Simon of Cyrene helps to lift it. One-eyed centurions surround them both.

> As they were going out, they met a man from Cyrene, named Simon, and they forced him to carry the cross. (Matthew 27:32)

20. A very colourful painting of the Virgin and Child. The contrast in colours between the Virgin's dark blue *maphorion* and the red ochre cloth behind her, which is framed in an assortment of green, blue, white, yellow and red geometrical designs, is stunning. She sits on an *alga* with turned legs; her *maphorion*, trimmed in gold, spreads over it. It has an embroidered gold cross at the height of her forehead and a gold star over her right shoulder. Her hands are crossed over the infant Jesus' legs, and her right hand, with elongated middle and index fingers, points downwards. She holds the Child with her left arm. Jesus holds a book in his left hand and points to the star with his right. He wears a cowrie necklace. A halo of golden rays radiates from each of their heads.

21. The donor of these paintings, *Waizero* Jenbere, stands praying with her arms piously crossed over her chest. She wears a dark blue cloak edged in gold and orange and looks at a holy book on a stand. She is surrounded by her servants, the faces and hands of two of them are painted in blue. Servants often belonged to a different race, and they were called *shanqella* which means dark complexion. The Ethiopians did not consider themselves as black people but red. The two prostrate men are probably members of her family.

Narthex: South Wall

1. An unidentified *negus* in a blue shawl (only the letters T and z remain in the text).

2. A woman dressed in a red patterned garment. Her hands are folded piously across her chest; her eyes gaze up towards the face of an angel which appears above and to her right. The Ge'ez script says she was 'Queen Sophia who went to Rome and became a martyr with her two sons'.

3. Within a roundel are Abreha and Atsbeha as babies being held by their mother, who is accompanied by two servants. Below her is the face of an angel whose red wings spread out on either side.

4. This panel depicts the baptism of Abreha and Atsbeha who are seen naked in the lower left side. They are seated against a blue background. Standing over them is John the Baptist, holding a jug of water with which he is going to baptise the two boys. The importance of this event, through which Ethiopia was converted to Christianity, is emphasised by showing Jesus in the top

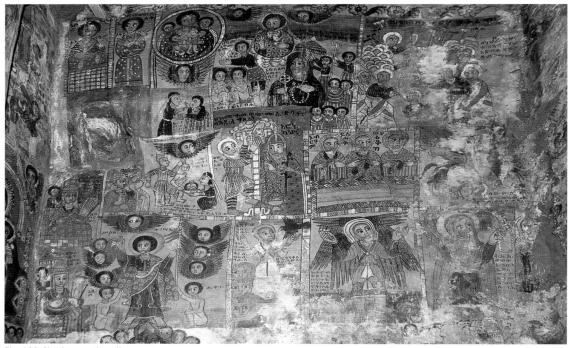

Fig. 100. Narthex south wall

centre of the composition. With his right hand Jesus blesses the baptism. Below Jesus is *Abba* Salama (Frumentius), who became the first *Abuna* of Ethiopia and was responsible for the conversion of Abreha and Atsbeha to Christianity. He is covered by a black *shamma*; he holds an elaborate hand-cross in his right hand and prayer beads in his left. Behind him one of his attendants holds an umbrella, a symbol of status, over his head.

5. The script reads, 'The priests of the church of Abreha Atsbeha praising the Lord.' A large group of priests are portrayed, all of whom wear white turbans and hold prayer-sticks and sistra. Each wears a *shamma* twisted around his waist as an expression of submission to the Lord.

6. This panel, which comprises three episodes, depicts the beheading of John the Baptist. At the top, from left to right, are Salome and her mother Herodias. Salome wears a dark blue garment tied at her waist with a white band; across her forehead is another white band which is knotted and flows out behind her head; she holds Herodias' hand. Herodias wears a striped red and white tunic. Both figures are portrayed in profile and 'one-eyed', symbolical of evil-doers. The script between them says, 'The daughter of Herodias consulting her mother about what she should

request from King Herod.' Immediately below Salome and Herodias is the executioner, who has already decapitated John the Baptist; he is holding John's head. On the right, wearing a dark blue gown, is Salome with John's head on a platter. Above this scene is a winged angel's head. The script over it reads, 'The head of St John the Baptist when he was beheaded; his head was given wings and flew away.' At the bottom left of the scene is the crowned King Herod, wearing a patterned red cloak, giving the order for John's execution to one his attendants.

7. Moses receiving the Ten Commandments. Moses is clad in a striped tunic in red, white and yellow; he is reaching up for the tablet which is being presented to him by the hand of God, depicted within a white cloud. The script at his side identifies him as 'The Prophet Moses' while that above the hand of God says, 'When Moses received the Ten Commandments.'

8. Moses' brother, Aaron, who assumed the leadership of the Israelites after Moses' death. He is depicted here as a high priest of the Ethiopian Church. He has a crown which terminates in a cross, and he holds a censer in his right hand and a staff in his left.

9. Three figures from the Old Testament: Abraham, Isaac and Jacob. Their faces are ringed by white turbans and white beards. They each hold a handkerchief, a symbol of their status. Abraham wears a yellow, red and green striped cloak. Isaac, in the centre, wears a red tunic decorated with yellow rosettes. Jacob, on the right, wears a striped red and yellow cloak.

10. A badly damaged panel with two mounted figures. All that can be seen is the rump of one horse and the forelegs of the other.

11. King David. He wears a crown and is seated in a straight-backed chair decorated below the seat with white and ochre squares. He has a red cloak embroidered with yellow and green rosettes. The Ge'ez text reads, 'King David praising the Lord with a harp.' Behind the King is one of his attendants holding an umbrella over him.

12. The Prophet Ezra. The text reads, 'The Prophet Ezra praising the Lord with his tambourine'; however, I believe he has been depicted playing a lyre. He is seated on a straight-backed chair which has been decorated with diamond shapes beneath the seat. He wears the crown of a high priest and a striped, red, green and yellow gown; a page holds an umbrella over him. Ezra in his Old Testament book recounts the return to Jerusalem of the Jews, who had been held in captivity in Babylon. They were allowed to return by King Cyrus of Persia in 539 BC. Upon their arrival in Jerusalem they began the rebuilding of the Temple.

13. The Raising of Adam and Eve. The script reads, 'The Resurrection of Our Lord.' The scene portrays Christ raising Adam and Eve, the parents of all mankind, from Hell, which is depicted below them as a black-horned devil surrounded by the heads of the condemned. Christ stands in the centre of the scene dressed in colourful robes embroidered in green and blue together with a red cloak decorated with yellow and green rosettes draped over one shoulder. He holds the banner of the Resurrection in his left hand. The naked figures of Adam and Eve are seated below him, holding on to his cloak. The faces of winged angels surround the scene.

14. Enclosed in a red rimmed circle is a representation of Hell with a chained and horned blue Satan surrounded by the heads of the condemned.

The next three panels are depictions of three famous saints, all of whom are shown in an *orans* position with their arms outstretched:

15. Gabre Manfas Kiddus, the famous hermit whose sanctity tamed wild beasts. He is clad in a white robe and wears a leather *scapular* across his chest. His head is turned towards a black bird, which, according to legend, he allowed to quench its thirst by drinking a tear from his eye. On either side are depicted the lions and panthers which had befriended him.

16. Tekle Haymanot, portrayed as a hermit. One of his legs is missing its foot; this relates to the legend that, after twenty-two years of praying in a standing position, his right leg withered and fell off. He has three pairs of wings which were given to him by God to allow him to save himself when his rope snapped while descending from Debre Damo. He also wears a leather *scapular* across his chest.

17. *Abba* Ewostatewos, who was born in Geralta only a few kilometres from this church. He was the founder of an important monastic 'house' in Ethiopia which was named after him. He is holding a cross in his right hand and prayer beads in his left.

Church: West Wall

The inner sides of the rectangular opening framing the wooden screen have the following paintings:

1. On the south side is the story of Gigar, told in four episodes (see Fig. 14, p. 22). Starting at the top, we see Gigar kneeling in front of his 'one-eyed' executioner. Gigar is naked except for a loin cloth, and his arms are tied behind his back. Gigar was the governor of Syria, who, having aided the Holy Family to flee from Herod's soldiers, was condemned to death by Herod. Below, the

executioner has beheaded Gigar, whose head is lying on the ground. The third episode shows the apparition of Gigar mounted on a white horse riding beside the crowned Herod on a black horse. The last episode depicts the 'one-eyed' Herod, seated on his throne with a snake wrapped around his neck. In front of him kneel three of his subjects, the first being an ironsmith who is attempting to remove the serpent with a pair of pincers. On the ground are the remains of those who had tried to free the snake from their king's neck but have been bitten by it and have died immediately.

2. On the north side is the story of Adam and Eve told in three episodes. They are depicted at the top, fully clothed, standing on either side of a euphorbia candelabra tree, of which you see so many in this area. A serpent is wrapped around the tree, its head close to Eve's ear. Below are Adam and Eve naked, seated on the ground, each trying to cover their nudity by wrapping their arms around their chests. In the last episode they are shown standing, covering their genitals with large green leaves.

The paintings on the left-hand side of the wall are set against a yellow background. They are all separate stories:

3. The Virgin Mary holding the baby Jesus. Joseph stands behind them and Salome is standing to the left of Mary, while a shepherd and his dog face the Holy Family.

4. Domitianus' hunter is turned to salt-stone. Mary is holding Jesus, now portrayed as a small boy, with Salome next to them. To the right is a figure of salt. The legend is that the hunter was turned into salt-stone when, after finding the Holy Family, he disobeyed Mary's command to keep their presence secret.

5. The Dormition of the Virgin. Mary, enveloped in a dark blue *maphorion*, lies on a bier carried by three of the apostles. On the left, King David is playing his lyre. The rest of the apostles are in the lower part, completely enveloped in their *shammas*, some of which are dark green while others are off-white. Their *shammas* resemble the wrappings of Egyptian mummies, a series of parallel bands criss-crossing their bodies.

6. St Michael weighs the deeds of the soul of Belai Kemer. The Virgin tilts the scales with her left hand. This scene is the culmination of Kemer's story, which is portrayed at the bottom left of the wall.

7. The story of Belai Kemer, which begins on the upper right of the panel. The cannibal Kemer is dressed in a loincloth, seated on the ground, eating a human limb. The story continues below

Abreha Atsbeha

CHURCH

CENTRAL BAY, SOUTH-EAST COLUMN: The Virgin and Child. Below is the donor, Amet-Selassie.

CENTRAL BAY, SOUTH WEST COLUMN: Our Lady Mary on her journey to Qwesqwam. Below, the donor *Waizero* Jenbere, also known as Amet-Selassie.

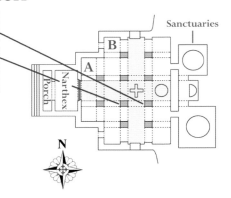

Sanctuaries

West Wall

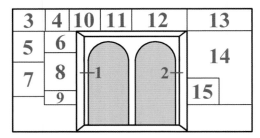

N

Bay A North Wall

1	Story of Gigar in four episodes.
2	Story of Adam and Eve in three episodes.
3	Virgin Mary holding the baby Jesus with Joseph and Salome either side of her; on the left is a shepherd and his dog.
4	Domitianus' hunter is turned to salt-stone.
5	The Dormition of the Virgin.
6	St Michael weighs the deeds of the soul of Belai Kemer. The Virgin tilts the scales.
7	The story of Belai Kemer.
8	The donor Amet-Selassie celebrating the completion of the paintings by drinking *tej* from *berelles* with her family.
9	The story of Gabre Krestos.
10	The Holy Family's encounter with Tamar.
11	The Holy Family and Salome resting in Tamar's house after the ordeal.
12	The Flight into Egypt.
13	The Covenant of Mercy.
14	The Ethiopians going into battle against the Egyptians. Top: Yohannes IV's uncle, *Ras* Araya Demsu, on a brown horse. In front of him is *Dejazmach* Gebru on a white horse. Immediately below *Dejazmach* Gebru is *Ledj* Tesfa on a black horse. In the centre there are four riders who are the lieutenants of *Ras* Alula who appears at bottom right (damaged).
15	*Waizero* Kassa, within a group of her lady attendants. She was either the wife or daughter of *Ras* Kassa who became Yohannes IV.

1	The Virgin Mary.
2	God the Father within a mandorla.
3	The archangel Michael.
4	The Ethiopians going into battle against the Egyptians. Just to the left of centre, Emperor Yohannes IV. Next mounted figure, the *Etege* and, in front of him, *Abuna* Atnatewos.
5	The Virgin Mary portrayed as the symbol of the Ethiopian Church.
6	The Ethiopians going into battle against the Egyptians. On the left, the mounted *Nebura'ed* Tedla. In front of him, Emperor Yohannes IV. On the right, Emperor Yohannes IV's brother, *Dejazmach* Maru.
7	Priests celebrating.
8	The stoning of Stephen.
9	Peter being hung upside down.
10	The beheading of Paul.
11	The stoning of James.

where a peasant is working his fields with a pair of bullocks. Kemer thought about devouring him but decided he was so emaciated that it was not worth his while. The next sequence is to the left and above: the poor man is shown crouching in front of Kemer who is pouring some water into the peasant's hands from a jug. The man had asked for a drop of water in the name of Mary, and this is why, when Kemer died, Mary interceded on his behalf to save his soul.

8. The Ge'ez text in the centre of the composition reads, 'The paintings of the church of Abreha Atsbeha were funded by Lady Amet-Selassie, who is to be remembered in the Kingdom of Heaven.' At the top centre of the painting is the donor, Amet-Selassie, celebrating the completion of the paintings by drinking *tej* from *berelles* with her family and relatives. One of her attendants holds a fly-whisk, a symbol of her status, over her head. All the figures are clad in white robes and *shammas* and, at the top, for some strange reason, several have bright blue faces. Below the inscription there is a figure pouring *tej* from a large receptacle into the *berelles* being brought by the servants.

9. This is Gabre Krestos. His story is told in the *Synaxarium*, Teqemt 14, which states that he was the only-son of 'Theodosius, Emperor of Constantine'. His parents married him to a Roman princess but on the night of their marriage he told her that he intended to dedicate his life to God and left her. After many years as an ascetic he returned to his father's city where he lived as a beggar. Here he is shown on the left, covered in sores, being welcomed by two of his father's dogs. In the middle is his red-wrapped corpse with the crowned figure of his sobbing father portrayed on the right.

Above the doorway there are three scenes painted against a yellow background with a thick band of red ochre running through it. The two on the right tell the story of Tamar:

10. The story of Tamar, which is told in the *Nagere Maryam*. When the Holy Family, accompanied by Salome, fled to Egypt, they arrived in a town where they went to the house of a woman called Tamar. Joseph asked her for some food and drink for his family, but, instead of being hospitable, Tamar struck Joseph's face and then wrenched Jesus from Salome's back and threw him to the ground. Mary began to cry, 'My Son! My Son! What have they done to you?' Joseph said to Mary, 'Let him show them who he is.' Then Tamar was swallowed up by the earth, and all her family were turned into monkeys and fled to the desert. At the bottom left of the painting there are three figures clad in white representing Tamar, on the extreme left, and her family. The script above them says, 'As Tamar cursed Our Lady Mary.' Jesus is shown lying on the ground, after having been thrown there by Tamar. The Virgin Mary is wearing a red tunic covered with a greenish-blue *maphorion* embroidered with a white cross above her forehead. Both Mary and Joseph

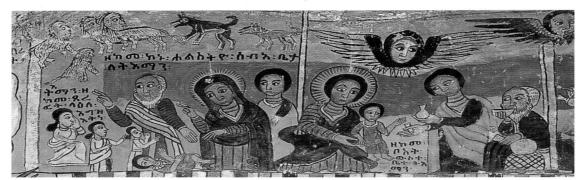

Fig. 101. Church west wall. The story of Tamar

are pointing with one hand at their child Jesus lying on the ground and at Tamar with the other. Salome is the figure dressed in yellow standing behind Mary. Above Tamar are two monkeys being pursued by various wild animals. The script below them says, 'As the family of Tamar turned into monkeys.'

11. In this panel the Holy Family, together with Salome, are portrayed in Tamar's house after the ordeal. Mary holds Jesus while Salome is offering them drink. Behind her, Joseph sits on a high chair drinking from a bowl.

12. The Flight into Egypt. The scene is painted against a striped background of green, yellow and red ochre. Mary is in the centre, riding a donkey and dressed in a blue *maphorion* which again has a white cross embroidered on it above her forehead. She is surrounded by a golden halo. Mary holds the baby Jesus in her arms. The full figure of an angel appears behind them, pointing the way with his hand. The head of another angel is shown above them, holding a sword, ready to protect them. Salome walks in front of the donkey carrying an *injira* basket on her head which she holds steady with one hand. In her other hand, she carries a jug of water. Joseph trails the group, walking behind another donkey.

13. The Covenant of Mercy. The half-length figures of Mary and Jesus, with joined hands, represent the promise of Christ to answer the prayers of those who make supplication in the name of his mother.

14. The Ethiopians going into battle against the Egyptians who had taken advantage of Yohannes' internal difficulties at the beginning of his reign and had captured the Bogos area in northern

Fig. 102 (right). Church west wall, left side.

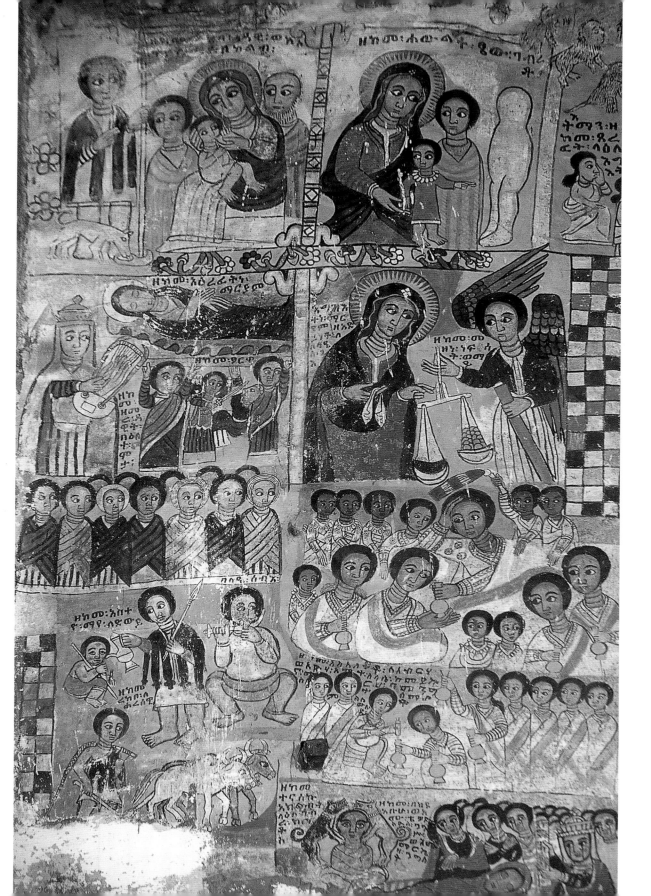

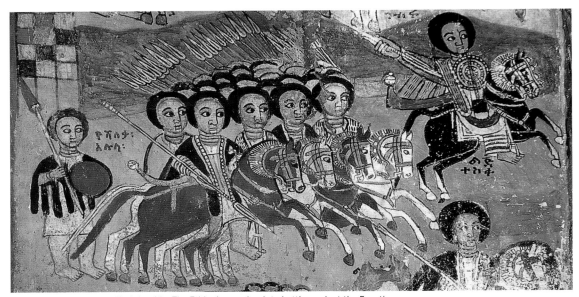

Fig. 103. Church west wall, right side. The Ethiopians going into battle against the Egyptians

Ethiopia and had also occupied the interior to the west of Massawa. This scene is a continuous narrative (which resumes on the north wall) with eight horsemen, all with jet-black hair, their foot-soldiers following on behind. The scabbard of each horseman's sword protrudes behind him. At the top left is *Ras* Araya Demsu, riding a brown horse while holding a spear. He was Yohannes IV's uncle, the most prominent of the Tigrayan chiefs who served the Emperor faithfully and who died, along with Yohannes, in the Battle of Qallabat in 1889. In front of *Ras* Araya Demsu is *Dejazmach* Gebru on a white horse, the ruler of the region of Hamasen (now Eritrea). He was a military leader who had supported Yohannes in his rise to power. He was probably killed at the Battle of Gundat (16 November 1875). Immediately below *Dejazmach* Gebru is *Ledj* Tesfa, a young nobleman, on his black horse and armed with a shield and a lance.

In the centre there are four riders. The caption beside the head of the foot-soldier on the far left reads, 'The lieutenants of Alula'. At the bottom right (in a part of the scene which has been damaged), according to the priest of Abreha Atsbeha, is *Ras* Alula, the Emperor Yohannes' chief commander. *Ras* Alula was the son of an impoverished farmer in the region of Tamben in Tigray. He became one of *Ras* Araya's followers, and it was with Araya's cooperation that he went into the service of Kassa, the future Yohannes IV. It was at the Battle of Gundat that, as a result of *Ras* Alula's military prowess, the Egyptian force was routed, enabling the Ethiopians to capture all the Egyptian modern weaponry including cannon and thousands of Remington rifles. Alula was

rewarded with the position of 'Leader of the Emperor's Fusiliers'. He became the governor of Tigray (not today's Tigray but the region of Adwa and Aksum) and was appointed supervisor of Yohannes' only son, *Ras* Araya Selassie (1868–88). *Ras* Alula also became related to the royal family by marriage; he divorced his first wife, by whom he had three daughters, and married the nineteen-year-old daughter of *Ras* Araya Demsu.

The battles of Gundat in November 1875 and of Gura, which took place a few months later, between 7 and 9 March 1876, were of immense importance to Yohannes IV because they helped to consolidate his position as emperor and because the Egyptians abandoned their expansionist ambitions in this part of Africa.

15. *Waizero* Kassa, within a group of her lady attendants, one of whom is holding a fly-whisk over her head. She was either the wife or daughter of *Ras* Kassa who became Yohannes IV.

Church: Bay A, North Wall
1. The Virgin Mary.
2. God the Father within a *mandorla*.
3. The archangel Michael.

4 and **5** are the continuation of panel 14 on the west wall portraying the Ethiopians going into battle against the Egyptians.

4. The mounted figure just to the left of centre is Emperor Yohannes IV with a crown on his head. Behind him, one of his attendants holds an umbrella, a symbol of rank, over him. The next mounted figure is the *Etege*, the highest-ranking Ethiopian cleric after the *Abuna* in the Ethiopian Church. In front of the *Etege* is the mounted *Abuna* Atnatewos (1870–6), holding a hand-cross in his right hand. He was to die as a result of a stray bullet at the Battle of Gura. One of his attendants holds an umbrella over him.

5. At the far right of the scene is a depiction of the Virgin Mary clad in a striped blue, brown and white robe, holding a *tabot* above her head. Here she symbolises the Ethiopian Church on whose behalf Yohannes IV was preparing to battle against the infidel.

6. On the left is the mounted *Nebura'ed* Tedla, one of the commanders. In front of him is Emperor Yohannes IV, galloping into action and, on the right is Emperor Yohannes IV's brother, *Dejazmach* Maru, who occasionally commanded one of his armies.

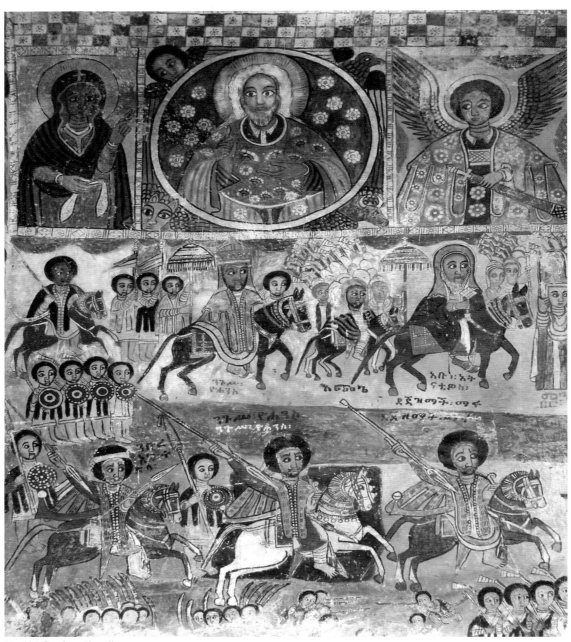

Fig. 104. Bay A, north wall

7. Priests celebrating. They are holding prayer-sticks and rattling their sistra; the one at the bottom is playing the *qabaro*.

8. The stoning of Stephen.

9. Peter being hung upside-down.

10. The beheading of Paul.

11. The stoning of James.

Church: Bay B, West Wall

1 and **2.** A martyr being hung by his neck from a horizontal pole.

3. A martyr being hung by his feet from a horizontal pole.

4. St Matthias being beheaded. According to the Acts of the Apostles, Matthias was the apostle chosen by the remaining eleven apostles to replace Judas Iscariot following Judas' betrayal of Jesus and his suicide. Matthias first preached the Gospel in Judaea and then in Ethiopia. Tradition maintains that he was stoned and then beheaded in Jerusalem.

5. Thaddeus puts a camel through the eye of a needle. The story is told in the *Synaxarium* for the 2nd of Hamle. A young rich man came to provoke the apostle Thaddeus when he was preaching in Syria. He asked how he could attain eternal life and Thaddeus told him that he should give all his money to the poor. This enraged the young man, and so Thaddeus said to him, 'Our Lord saith, "It is as easy for a camel to go through the eye of a needle as for a rich man to go into the kingdom of heaven."' At that moment a man with a camel was passing by and Thaddeus stopped him and then obtained a needle from a nearby tailor. He prayed to God and was able to have both the camel and its owner go through the needle's eye.

6. St Thomas being skinned alive. Tradition has it that Thomas preached in India. He converted the wife and household of his master Lukios to Christianity. The King had him tortured and had his skin cut off and his body rubbed with salt and lime.

7. St Thomas carrying his own skin.

8. The Assumption (*Felsata*) of the Virgin. This is one of the two main paintings in this bay, the other being the Covenant of Mercy (panel 1 on the north wall). Both are very different from the other paintings in this church, and they are perhaps the oldest. They are both painted on to the wall rather than on to cloth. Marilyn Heldman dates them to the seventeenth century in the *Encyclopaedia*

Abreha Atsbeha

CHURCH

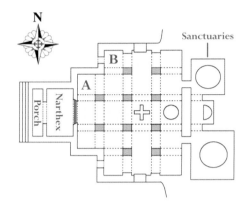

Bay B, West Wall

Bay B, North Wall

1	Martyr being hung by his neck from a horizontal pole.
2	Martyr being hung by his neck from a horizontal pole.
3	Martyr being hung by his neck from a horizontal pole.
4	St Matthias being beheaded.
5	St Thaddeus made a camel go through the eye of a needle.
6	St Thomas being skinned alive.
7	St Thomas carrying his own skin.
8	Assumption of the Virgin. Bottom left to right: Thomas witnesses the Assumption; martyrs are rewarded with heavenly crowns.

1	Covenant of Mercy. Text at left: 'Come to me to be in Heaven. The thirsty will be given drink. The hungry will be given food. The naked will be clothed. When you ask that I give to the poor, I will give.' Text at right: 'The people will praise his mercy.'
2	Angel playing the drums.

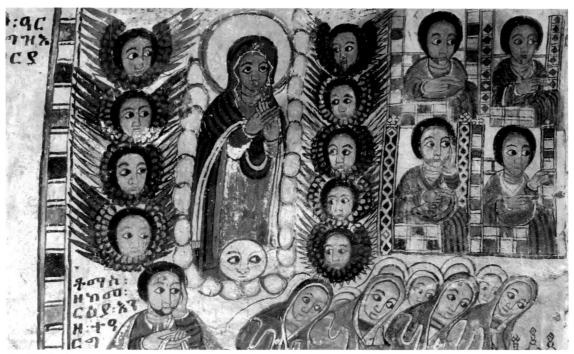

Fig. 105. Bay B, west wall. The Assumption of the Virgin

Aetheopica (Vol. II, p. 519). Their colours are more subdued than the other paintings: blues and light browns predominate; the figures are outlined in black. Above the paintings there is a chequered frieze, approximately 50 centimetres wide, of brown, black, and dark blue squares separated by white ones.

Mary is represented being taken up to Heaven in bodily form. She stands within a cloud, framed by angels' faces; her head is surrounded by a plain white halo bordered in light brown. Her hands are piously crossed over her chest, and she glances upwards. An anthropomorphic full moon rests at her feet. Crouching at bottom left is the apostle Thomas. He holds his left hand up to his troubled face and holds Mary's girdle in his right hand. The text near his head says, 'When Thomas saw the Assumption of Mary'. The story is related in *Legends of Our Lady Mary the Perpetual Virgin and Her Mother Hanna*:

And Thomas, one of the Twelve Disciples, whose name was 'Didmos' (Didymus), was not with the disciples when the soul of our Lady Mary went forth [from her body]. And he came from India riding upon a cloud, and he saw the body of St Mary and angels carrying it along on a cloud and taking it up to heaven. And then when Thomas arrived Peter and all the disciples said unto him, 'The body of St Mary hath departed from this world; why didst thou tarry in coming

to her burial?' And Thomas said, 'The Mother of our Lord is not dead; unless I see her dead body I will not believe [it].' And the disciples said unto him, 'Behold, before this thou didst say, "I will not believe that Christ is risen unless I can thrust my hand into His side, and my fingers into the nail marks," and in the abundance of the mercy of Christ He showed thee these things, and thou didst cry out and say, "My Lord and my God."' And Thomas answered and said unto them, 'I will not believe unless I see where ye have buried the body of the holy woman.'

Below the Virgin is a group of kneeling women facing right towards three crowns placed on the ground. The caption tells us that these are Mary's faithful who have been rewarded with heavenly crowns: 'They became martyrs and the gates of Heaven are opened to them.' At top right are four seated men – they are four of Christ's disciples, the other eight are to be found on the adjacent wall in the painting of the Covenant of Mercy. According to Marilyn Heldman, the Assumption of Mary does not appear in Ethiopian art till the seventeenth century; hence this painting must be one of the earliest representations of this theme in Ethiopia.

Church: Bay B, North Wall

1. The Covenant of Mercy, which represents the promise Christ made to Mary that she would be the intercessor on behalf of humanity. Christ is seated at the centre of the composition wearing a blue robe and a brocaded light brown *lamd*, which is draped over his left shoulder. A diminutive Mary stands at her son's right side with her head bowed and with her hands outstretched under his

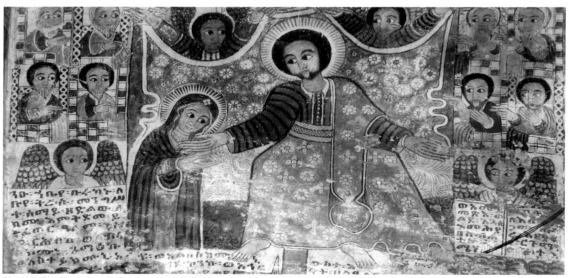

Fig. 106. Bay B, north wall. The Covenant of Mercy

right hand to catch the blood from his crucifixion wound. A light brown brocaded cloth decorated with blue and white flowers, held by two angels, forms the background to the scene. On each side are four men – eight of the apostles (the other four being on the adjacent painting of the Assumption of Mary) – who sit facing Christ and Mary. Below each group of four is an angel. Under the angel on the left the text is a summary of that in the Beatitudes (Matthew 5:3–11): 'Come to me to be in Heaven. The thirsty will be given drink. The hungry will be given food. The naked will be clothed. When you ask that I give to the poor, I will give.' Below the angel on the right the text reads, 'The people will praise his mercy.' The rest of the painting at the bottom is badly damaged. Still visible is a crowd of people on the left and two prostrated figures at bottom centre in front of the Cross; only a few heads remain at bottom right.

2. An angel playing the drums.

Cruciform Columns of the Central Bay

Two of the central bay's cruciform columns have frescoes on their west sides. They are:

South-West Column: Our Lady Mary on her journey to Qwesqwam (see Chapter 2). The Virgin wears a muted-pink tunic and is enveloped in a blue *maphorion* edged in white with a large white cross embroidered on it above Mary's forehead. With her left hand she holds the baby Jesus, who is suckling the breast she is offering him with her right hand. He wears the same colour tunic as his mother. Both Mother and Child look at the viewer. Two archangels, with their swords held upright, stand on either side of the Virgin. Below lies the donor, *Waizero* Jenbere, also known as Amet-Selassie. Behind her there are three half-figures who may be her children. The painting must have originally included a dedicatory inscription but unfortunately this has now disappeared.

South-East Column: The Virgin and Child. The Virgin wears a yellow tunic buttoned up at the front. She is enveloped in a blue *maphorion* trimmed in gold with a gold star embroidered on its right shoulder. She holds Jesus in her left arm; he wears a striped yellow and white tunic and a cowrie shell necklace, protection against the evil eye. With the two elongated fingers of his right hand he points towards the star on his mother's *maphorion*. Both the Virgin and Child have very elongated necks, with a row of parallel black lines to indicate the folds of the flesh. Two archangels stand on either side, their swords held upright, with one of their wings arched over Mother and Child in a gesture of protection. Lying prostrated below is the donor, Amet-Selassie. Her name is no longer readable, but she is surrounded by the same blue-faced attendants holding a fly-whisk over her as depicted on the west wall of the church.

The Rock-Hewn Churches of Tsaeda Amba

The white sandstone escarpment that runs north–south between Senkata and Wukro, and parallel to the road, is called the Tsaeda Amba, meaning 'White Mountain'. There are several rock-hewn churches in this area, and you can spend a pleasant day walking to four of them: Mikael Biet Mahar, Petros and Paulos, Mikael Melehayzenghi and Medhane Alem.

If you are staying in Mekele, the distances involved in driving to the start of your walk are as follows: from Mekele to Wukro is 47 kilometres, and from Wukro to your start-point just south of Senkata is a further 27 kilometres – 74 kilometres in all. The linear walk of some 12 kilometres is relatively easy and does not involve any strenuous climbs. This is provided your driver moves his vehicle along the road to meet you; otherwise the distance would increase to some 18 kilometres if you were to do a circular walk back to your start-point. I would recommend that you begin with the northernmost church of Mikael Biet Mahar and end at Medhane Alem, simply because you would then begin with the least interesting.

Mikael Biet Mahar

Mikael Biet Mahar is a thirty-minute walk across fields from the Wukro–Senkata road ending with a very short climb up to the church. The church is at the base of a 200-metre perpendicular cliff face (inhabited by many Mocking Chats) and is set back under an overhang in what was probably a cave. A large narthex has been built up in front of the church. Both the narthex and the church compound's substantial gate are easily seen from the road. The nearby stream is meant to be holy and have healing powers, and you may well see people being immersed in it and a priest blessing them.

Discounting the narthex, Mikael Biet Mahar measures some 12 metres from east to west and 10 metres north to south. On entering the church through a wooden screen you will see directly in front of you two of the four columns that have been carved from the sandstone. The rock has fallen away above these front two columns and has been replaced with a small man-made wall between the top of the capitals and the cave ceiling.

On the right-hand column there is a depiction of Christ's descent into Hell and his Raising of Adam and Eve (see Fig. 25, p. 42). Jesus has with him the flag of the Resurrection which is to be seen behind his right shoulder. He is lifting the naked and limp Adam and Eve, who gaze inquiringly at him, and is trampling the Devil, portrayed as a two-headed black dragon lying vanquished on its back.

Jesus wears striped trousers and several layers of striped tunics which are tied at his waist with a striped cummerbund, the bow of which extends down the skirt ending in a checked pattern. Striped lines have been used to differentiate the different layers of his clothing. His two small hands protrude from the ends of his raglan-style sleeves. He is either wearing a turban or has a halo, painted with

segments of two colours: brown and yellow ochres. His face is framed by a full beard and moustache, and he has a wide nose, the line of which continues uninterrupted to form his eyebrows. The colours used are all ochres — shades of brown and earthy yellow — and grey, and black. A crude attempt at modelling is evident in the colouring of his cheeks and the lines across his neck. The similarity between this depiction of Jesus and that to be found in the next church of Petros and Paulos is so strong that I am sure they were both painted by the same artist.

To the right of this column, and painted on the wall, is a scene of the Virgin and Child. The Child is holding a fly-whisk. On the right is an archangel holding a sword. The colours are restricted to white and brown with outlines in black; the robes are striped in brown lines. The fresco is much damaged.

Petros and Paulos

The very small church of Petros and Paulos is an easy thirty-minute walk south of Mikael Biet Mahar. You can also drive from the main road right up to it in a four-wheel-drive vehicle. It is in a spectacular location, halfway up the escarpment, and is built on a narrow ledge under a cliff overhang. It is reached by a short climb of some 15 metres up the steep cliff face, using holes carved into the rock for your hands and feet. Plenty of help will be available from the priest and other locals in guiding you during your ascent; however, if you are a vertigo-sufferer, you should not even attempt it.

Entry to the church is through its comparatively large narthex and then back out on to the ledge that runs alongside the church's west wall, to an open entrance at its northern end. Only the sanctuary

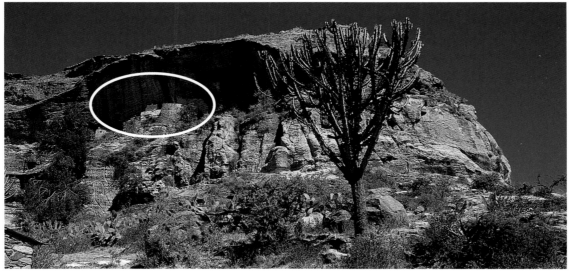

Fig. 107. Petros and Paulos under its cliff overhang

Petros and Paulos

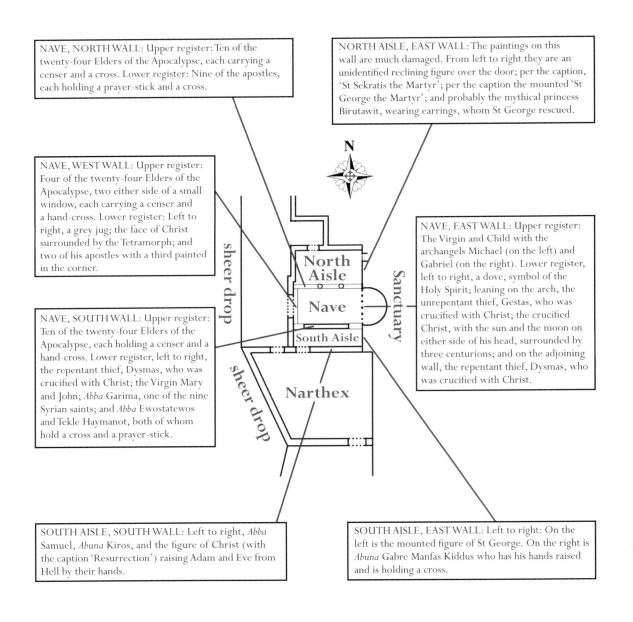

NAVE, NORTH WALL: Upper register: Ten of the twenty-four Elders of the Apocalypse, each carrying a censer and a cross. Lower register: Nine of the apostles, each holding a prayer-stick and a cross.

NORTH AISLE, EAST WALL: The paintings on this wall are much damaged. From left to right they are an unidentified reclining figure over the door; per the caption, 'St Sekratis the Martyr'; per the caption the mounted 'St George the Martyr'; and probably the mythical princess Birutawit, wearing earrings, whom St George rescued.

NAVE, WEST WALL: Upper register: Four of the twenty-four Elders of the Apocalypse, two either side of a small window, each carrying a censer and a hand-cross. Lower register: Left to right, a grey jug; the face of Christ surrounded by the Tetramorph; and two of his apostles with a third painted in the corner.

NAVE, EAST WALL: Upper register: The Virgin and Child with the archangels Michael (on the left) and Gabriel (on the right). Lower register, left to right, a dove, symbol of the Holy Spirit; leaning on the arch, the unrepentant thief, Gestas, who was crucified with Christ; the crucified Christ, with the sun and the moon on either side of his head, surrounded by three centurions; and on the adjoining wall, the repentant thief, Dysmas, who was crucified with Christ.

NAVE, SOUTH WALL: Upper register: Ten of the twenty-four Elders of the Apocalypse, each holding a censer and a hand-cross. Lower register, left to right, the repentant thief, Dysmas, who was crucified with Christ; the Virgin Mary and John; *Abba* Garima, one of the nine Syrian saints; and *Abba* Ewostatewos and Tekle Haymanot, both of whom hold a cross and a prayer-stick.

SOUTH AISLE, SOUTH WALL: Left to right, *Abba* Samuel, *Abuna* Kiros, and the figure of Christ (with the caption 'Resurrection') raising Adam and Eve from Hell by their hands.

SOUTH AISLE, EAST WALL: Left to right: On the left is the mounted figure of St George. On the right is *Abuna* Gabre Manfas Kiddus who has his hands raised and is holding a cross.

is rock-hewn, the rest being a built-up structure of wood beams, stones and mortar. The wall and entrance (no longer used) directly in front of the sanctuary are very much in the Aksumite style, with stones sandwiched between wood beams. Architecturally, Petros and Paulos is not of much interest, but its paintings definitely are. Paul Henze, in his book *Ethiopian Journeys* (1997), says:

> The paintings are amongst the most interesting early paintings I saw anywhere in Ethiopia, done in rich earth colours – browns, brownish reds, tans, creamy yellows and olive green. Though crudely executed with broad brush strokes, they have an originality and liveliness often missing in Ethiopian paintings of this early period.

The church has a small nave and two aisles and measures some 6 metres north to south and 3 metres east to west. The roof of the nave is approximately 1.5 metres higher than the rest of the church, and it is on the walls of this raised section that the most striking frescoes have been painted. On the south side of the nave a wall has been built recently, presumably to prevent the raised roof structure from collapse. Consequently, the south aisle has now become a small room.

Nave, East Wall

As you enter the tiny church, your eyes are immediately drawn to the delightful scene of the Virgin and Child in the top register above the arched entrance to the sanctuary. It is a painting of much warmth

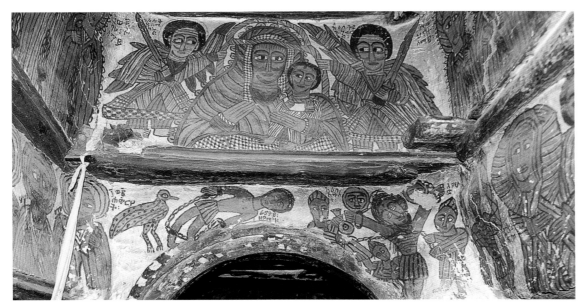

Fig. 108. Nave, east wall

and serenity, conveyed by the earthly colours and the Virgin's expression. The archangels Michael, on the left, and Gabriel, on the right, stand full-length on either side of the Virgin and Child. Their wings are arched above her head, and they hold a rope-like canopy over both Mary and Jesus, defining the sacred space. The eyes of the archangels and of the Child are all focused on Mary; clearly it is she who is being honoured here.

The Virgin is robed in a checked gingham cloak of red ochre on a white background, which also partly covers her head; there is no traditional blue *maphorion* in this painting. Her hands are inert; Jesus holds a dove in his. An effort has been made to render volume by the stripes in the Virgin's shawl, which covers her head and torso, the lines of the folds being complementary to her form. The edge of her shawl is decorated with small bells.

The archangels wear striped trousers and tunics tied with cummerbunds. A network of parallel stripes at varying angles through their bodies and wings has been used to give them a sense of volume. Their tunics are edged with a wide band of black and white checks resembling a hoop skirt. With one hand they hold the canopy over the Virgin, and with the other they hold swords held away from the Virgin and Child. They have striking black hair. This scene is separated from the Crucifixion below it by a wooden beam.

In the depiction of the Crucifixion, the artist has placed the bodies in such a manner as to cover the entire triangular space of the spandrel; thus, the unrepentant thief, Gestas, who was crucified with Christ, has been placed on his left side, leaning against the arch. He is recognised by the thick chain attached to his wrists and dangling over his legs. To the left of him, is an oversized dove, symbol of the Holy Spirit.

On the right is Christ on the Cross with the sun and moon on either side of his head. He is surrounded by three centurions. Jesus' arms are extended upwards forming a 'V' to allow room for the rest of the composition. His head rests on his right arm. On his right and leaning over the archway are the heads and torsos of two of the centurions, one of whom is Stephaton. He holds a bottle, which, I assume, was intended to represent the wine mixed with gall that was offered to Jesus to help reduce his pain on the way to Golgotha (Matthew 27:34). On the right is the centurion, Longinus, spearing Christ's side. To the right of Longinus, and mostly painted on the adjoining wall, is the standing figure of the other convicted thief, Dysmas, crucified with Christ, who repented and said, 'Jesus, remember me when you come into your kingdom' (Luke 23:42).

The arch itself is decorated in a black-and-white chequerboard pattern.

Nave, South Wall

In the lower register and next to the repentant thief is a distraught Mary, her arms raised above and around her head, with John who has his arms around her; his hands have long, tapering fingers. Both are crying, their tears rendered by long, vertical, black lines. Despite the awkwardness of their figures they convey real sorrow. The caption reads, 'She was standing beneath the cross during Jesus' crucifixion.'

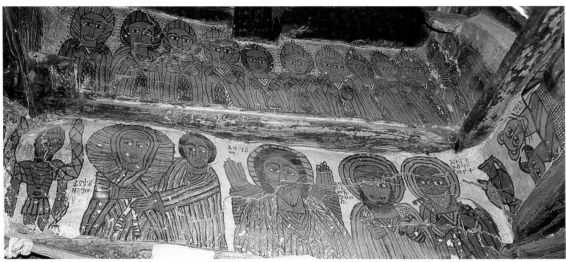

Fig. 109. **Nave, south wall**

They are followed by *Abba* Garima, one of the nine Syrian saints, standing on his own, wearing a herringbone, voluminous gown in brown, his raised arms displaying long, tapering fingers edged in white. Next to him are *Abba* Ewostatewos and Tekle Haymanot, both renowned founders of monasteries. They each hold a cross and a prayer-stick and wear turbans. Their striped cloaks merge into one another but are in contrasting colours. A jug painted in grey is placed in the corner of the south and west walls.

In the upper register, above the wood beam separating it from the fresco below, is a frieze of ten of the twenty-four Elders of the Apocalypse (John 4:4). All hold a censer and a hand-cross and are robed in long striped cloaks and what appears to be a turban, edged with small bells. A striking detail is that all have a triangle in white and black between the neck and the garment.

Nave, West Wall

In the lower register is a painting of the face of Christ surrounded by the Tetramorph (see Fig. 27, p. 45). The caption below his neck reads 'Egziobiher', or God. Unlike many of the other faces, there is no attempt to model his. He is depicted in the style of Ethiopian paintings dating back to the Middle Ages: frontal, hieratic and with deeply set, large, black eyes which place the viewer under their spell. He has a neat pointed beard, beautifully delineated in grey and black.

He is surrounded by a *mandorla* that is quite unique. Instead of being rounded, as it usually is, here the space is described by a twisted rope in grey, orange and light brown and the space within is painted in black and white checks. The overall effect is quite stunning.

The Tetramorph, symbols of the four evangelists, are placed parallel to the beam, two on each side of the square *mandorla*. On the left, at the bottom, is the bull of St Luke, with, above, the lion of

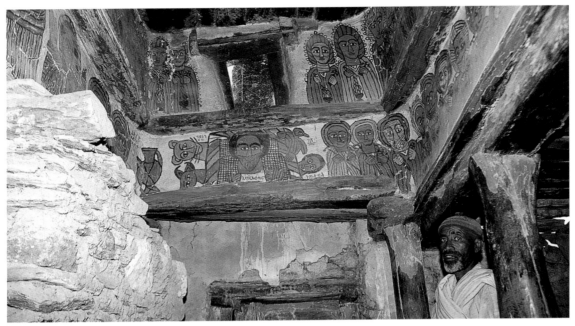

Fig. 110. Nave, west wall

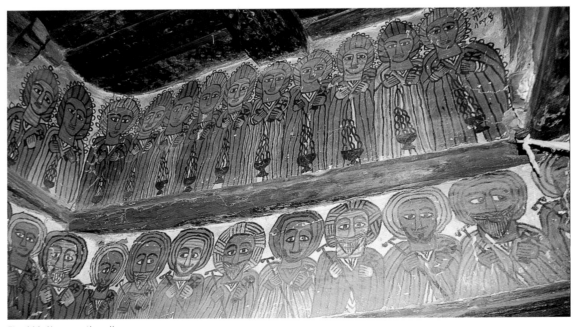

Fig. 111. Nave, north wall

St Mark. On the right, at the bottom, is the face of a man symbolising St Matthew with, above, the eagle of St John gripping on to the rope of the *mandorla* with its talons.

To the left of Christ is the previously mentioned grey jug. To the right are two of his apostles with a third painted in the corner of this wall and the north wall. Above the wood beam, in the upper register are four of the twenty-four Elders of the Apocalypse, two either side of a small window.

Nave, North Wall

The upper register of this wall comprises the remaining ten of the twenty-four Elders of the Apocalypse with their censers and crosses and, in the lower register, the remaining nine apostles who carry a prayer-stick and a cross. The apostles wear striped cloaks over a tunic that is only just visible. Around their necks is a square bib in a solid colour.

South Aisle, East Wall

The lower part of the fresco has fallen away leaving only the upper part visible. On the left is the mounted figure of St George with his elaborately plaited hair. On the right, with his hands raised and holding a cross, is Gabre Manfas Kiddus, also known as Abbo, the hermit whose sanctity tamed wild beasts and the founder of the monastery of Zeqwala, south of Addis Ababa.

South Aisle, South Wall

Painted on this wall are *Abba* Samuel, *Abuna* Kiros and the figure of Christ with the caption 'Tensae', meaning 'Resurrection'. Christ is portrayed raising Adam and Eve by their hands from Hell. It is this painting that is almost identical to that found on the column in Mikael Biet Mahar.

North Aisle, East Wall

The paintings on this wall are much damaged. Over the door there is an unidentified reclining figure. The caption above the next figure to the right states that he is 'St Sekratis the Martyr'. The inscription above the mounted figure identifies him as 'St George the Martyr', and, consequently, it is probable that the woman with large earrings at the far right of the wall is the mythical princess Birutawit (of Beirut) whom St George rescued.

The style of the painting in Petros and Paulos is distinctive. The palette is limited to ochre shades – of brown and pale yellow – and greys and black. The manner in which some of the figures are drawn combines simplicity with a suggestion of three-dimensionality. Some examples of this are: the archangels' hands holding the *mandorla* over the Virgin and Child; the palm of Adam's raised hand in the scene with Christ raising Adam and Eve; and the raised hands of Gabre Manfas Kiddus.

Most of the figures appear to be wearing turbans. Their faces are framed by full beards and moustaches beautifully delineated in black and grey or white. A distinctive feature of all the figures is their

pronounced neck and their wide nose, the line of which continues uninterrupted to form eyebrows. They are all robed in striped garments. The crude attempt to model most of the faces and necks with brown, parallel lines is very un-Ethiopian and indicates an interest in imported visual models.

In attempting to date the frescoes, the following points are noted: (a) the painting of Christ lifting Adam and Eve by the hand is a subject which started being depicted only from the second half of the sixteenth century; and (b) the little bells on the Virgin's cloak are the same kind we see around that of Tekle Haymanot in the church of Debre Sina Maryam at Gorgora, which dates from the 1630s. For these reasons, I would date the paintings to no earlier than the mid-seventeenth century.

After making your descent, which will be a test of your nerve, ask to see the very recently rock-hewn, small church at the base of the cliff. A farmer by the name of 'Haleka' Halefom Retta from the neighbouring village excavated it all on his own! He started in 1982 and completed it twelve years later, something worth noting when conjecturing how long it took to create Tigray's rock-hewn churches.

Mikael Melehayzenghi

Another easy walk of some thirty minutes from Petros and Paulos brings you to the small, primitive cave church of Mikael Melehayzenghi. It is only a few metres above the plain and is reached via wide stone steps which lead you up to the two small, 2.5-metre-high holes in the rock face which serve as its entrances. The church is completely rock-hewn and measures approximately 8.5 metres east to west and 7 metres north to south. The most striking feature of Mikael Melehayzenghi is to be found in the recessed ceiling just after entering the left-hand doorway. An Aksumite frieze, approximately half a metre in height, runs around three sides of the recess. Forming the dome of the recess is a beautiful, circular, shallow relief carved from the sandstone rock. Many bands of intricate circular patterns radiate out from an enclosed Greek cross at the centre of the relief, the whole design resembling the decorated Tigrayan circular bread loaf, the *himbasha*.

Medhane Alem of Adi Kasho

The walk across the fields from Mikael Melehayzenghi to Medhane Alem (Saviour of the World) will take between forty-five minutes and an hour. As you near the church, you will have to climb up a slope of exposed sandstone. It is covered with potholes, which the local people believe to be the hoofprints of St George's horse. The church is set in a walled compound with an imposing entrance (the Deje-Selam or Gate of Peace), surrounded by olive trees. When I was there, vervet monkeys were playing with one another along the walls. The space between the Deje-Selam and the church is strewn with stone graves.

The church's façade is striking. It has been carved from a 15-metre-high cliff to create four massive pilasters some four metres apart. The rock above the façade has been carved in such a way that

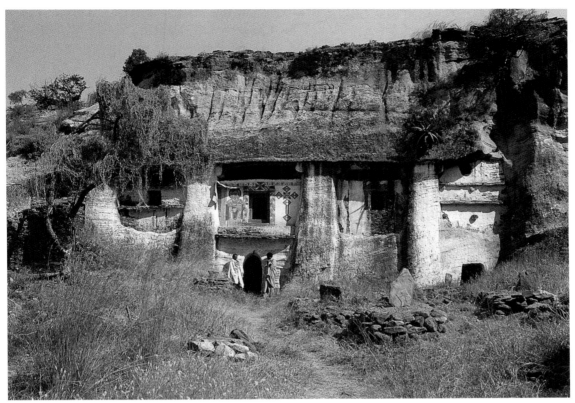

Fig. 112. The west façade of Medhane Alem

it resembles a thatched roof. The overall effect is that this west façade has the appearance of a conventional building.

The entrance is between the second and third columns from the left. This section has been completely excavated from between the two columns and then refilled with a man-made wall having the door in its lower half, with a heavy lintel above, and a window above the lintel with two relatively recent paintings on either side of it: Christ making a blessing on the left and an elaborate cross on the right. The other three sections between the columns have been excavated out only in their top half, which has then been filled in with a man-made wall. It is probable that these walls between the columns are a recent modification to provide the church interior with some protection from the weather. Without these walls, the ambulatory that runs behind the façade would have been partially open.

The church has a nave and two aisles and is three bays deep with the sanctuary at its eastern end. The nave is wider than its two aisles. The nave and aisles are separated by four large, freestanding, cruciform columns. Sadly, Medhane Alem has no frescoes. However, its architecture makes it one of

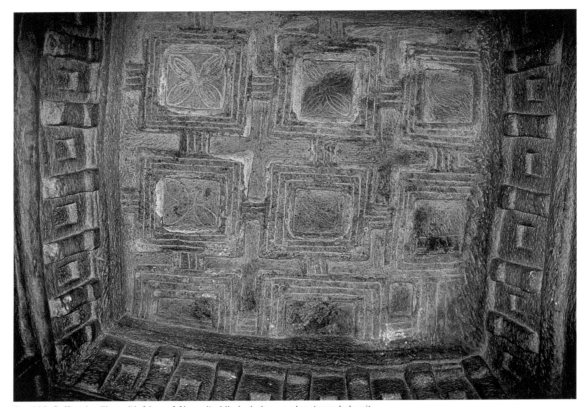

Fig. 113. Coffered ceiling with frieze of Aksumite blind windows and metopes below it

Tigray's greatest rock-hewn churches. Its coffered ceilings carved from the rock are outstanding. The two wooden doors leading from the ambulatory into the church, with windows above them, are inspired by ancient Aksumite buildings. They have a resemblance to the built-up churches of Yemrahane Krestos and Makina Medhane Alem outside Lalibela. The flat, coffered ceilings have various designs within the panels. The nave and the ambulatory have a carved frieze of Aksumite blind windows and metopes immediately below the ceiling.

David Buxton sees these ceilings as 'copied from wooden prototypes and the one in the vestibule is exactly the type of the narthex at Debre Damo' (quoted in Gerster, p. 58). He is of the opinion that this church dates from the eleventh or twelfth century.

I found a beautiful Sarcelly cross high up on a column in the nave, just below the Aksumite frieze, carved in shallow relief in the identical manner to those in the church of Bet Maryam in Lalibela.

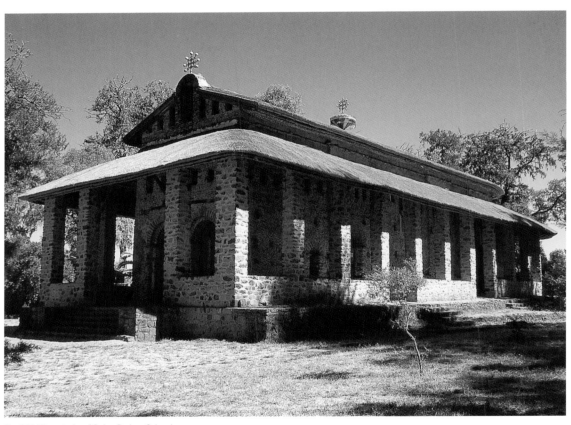

Fig. 114. The exterior of Debre Berhan Selassie

Chapter 5

The Gondarine Churches

From the seventeenth century on, those Gondarine churches that were decorated with paintings followed the same iconographic formula:

- The east side of the *maqdas* was reserved for Old Testament scenes.
- The west and south sides of the *maqdas* depicted scenes from the life of Christ.
- The north side of the *maqdas*, where the male congregation stands during services, included paintings of the equestrian saints.

Three Gondarine churches are included in this chapter. Two of them are round churches with a central *maqdas* – Debre Sina Maryam and Narga Selassie – and one of them is rectangular: Debre Berhan Selassie. Even though the latter is rectangular, and so does not have a central *maqdas*, it still follows the same convention for its wall paintings.

Debre Berhan Selassie at Gondar

Debre Berhan Selassie is situated on the outskirts of Gondar on a hill called Debre Berhan (Mountain of Light). The church is dedicated to the Trinity (*Selassie*) and so Debre Berhan Selassie means the 'Trinity Church of the Mountain of Light'. Like many churches in Ethiopia, it is encircled by a high fortified wall with towers in which the monks live. It is entered through an impressive gate incorporating a two-storey tower. The church itself is a rectangular structure with a rounded apse and is covered by a double pitched, thatched roof, on top of which are three elaborate Gondarine crosses with seven ostrich eggs at the ends of the arms. The church is surrounded by an open ambulatory with rectangular columns.

Debre Berhan Selassie

North Wall

1	Joachim and Anne praying for a child.
2	Anne breast-feeding Mary with Joachim looking on.
3	The presentation of Mary to the Temple.
4	Left, the Annunciation. Right, Mary drinking the Waters of Correction.
5	Massacre of the Innocents and the Flight into Egypt.
6	St George killing the dragon and saving Birutawit.
7	The Virgin Mary seated on a throne holding Jesus.
8	Domitianus' hunter is turned to salt-stone.
9	Story of Gigar. Herod watches the execution of Gigar.
10	Story of Gigar. Herod's horse shies away and throws him.
11	Flight into Egypt.
12	The Holy Family's encounter with Tamar.
13	Death of Mary, surrounded by the apostles.
14	Assumption of the Virgin Mary.
15	The Covenant of Mercy.
16	The Virgin Mary and St Michael weighing the deeds of Belai Kemer.
17	Story of Gabre Kristos being recognised by his dogs.
18-22	Mercurius (and in a small frame, St Basil and St Gregory), Eusebius, Claudius, Theodore the Oriental, George as King of Martyrs.
23-27	Victor, Theodore of Rome, Sebastianos, Philoteus (and beside him Marmehnam), Basilides the Martyr.
28	Decapitation of John the Baptist.
29	Cherkos and Julitta being burned to death.
30	Gabre Manfas Kiddus surrounded by lions and leopards.
31	Tekle Haymanot with, below him, Emperor Egwala Seyon (1801–18) holding his withered leg.
32	God the Father portrayed as one of the Trinity.
33	Adam and Eve.
34	St Michael.
35	King Iyasu I (1682–1706) with the nine Syrian saints below him.
36	Two saints. Above: *Abba* Samuel. Below: *Abba* Bula (known as Abib), a contemporary of Tekle Haymanot.

West Wall

1	Appearance of the Virgin Mary at Debre Metmaq.
2	Archangel Gabriel with his drawn sword.
3	Archangel Michael with his drawn sword.
4	A group of virgins praising Mary.
5	*Dabtaras* with sistra and prayer-sticks.
6	Three priests, a group of men, and the three equestrian saints – Mercurius, Theodore the Oriental, and George – praising Mary.
7	King David of Judah playing the lyre.
8	Mohammed (one-eyed) on horseback being led from Hell by the Devil.

The main entrance is in the west façade and has two large, wooden doors. The north and south façades have a door and three windows.

The original church was built by Emperor Iyasu I (1682–1706) and was consecrated in about 1694. It was probably a round church similar to Debre Sina Maryam at Gorgora. It was later destroyed and replaced by the present one. There have been many controversies and opinions about the date of the present church, but they have all been quelled by the research carried out by Guy Annequin (1976), who has established that it was built and decorated by Emperor Egwala Seyon, who reigned from 1801 to 1818. There is a portrait of this emperor in the church on the north wall. He is shown lying down below the figure of Tekle Haymanot (**31**). The caption above reads, 'How the ruler of the universe, Egwala Seyon, calls on His help.' In 1881, the dervishes attempted to burn the present church, but, according to local legend, they were attacked by bees and driven off.

The interior is a large nave with the sanctuary located at its eastern end through two double-arched doorways covered by curtains. The ceiling is supported by transverse beams, and between the beams the whole ceiling is decorated with the faces of archangels. Half of the rows have the archangels' heads placed so that they face east, and half are placed so that they face west. The idea is that they symbolise the omnipresence of God and that they see us wherever we are. This is Debre Berhan Selassie's most stunning feature and appears on many Ethiopian postcards. It is aptly described by Jules Leroy (1967, p. 35):

> Even the joisted ceiling is filled with a series of cherubs' heads made fashionable by the Italian Renaissance. Their large eyes stare down on the worshipper and enhance the intensely religious atmosphere engendered by this little Abyssinian version of the Sistine Chapel.

The Paintings

Debre Berhan Selassie's paintings cover the whole of the interior. Because of the open plan of the church, on entering, you are immediately enveloped in colour, and the effect is breathtaking. It is as though you had walked into a bejewelled cave.

The paintings have been executed on cloth which has then been glued on to the walls. They are not frescoes. They are typical of the Second Gondarine style and are characterised by shaded backgrounds, changing from yellow to red or green; modelling of the flesh, though there is no indication of light source or shadow; realistic details of costumes, hairstyles and accessories; and the depiction of cohesive narrative and genre scenes (Heldman, *African Zion*, p. 195). On the east wall, below the Nativity, there is a scene showing children playing a game of *ganna* (**10**), which means 'birth' and is therefore connected with the birth of Jesus. On the north wall, there is a painting (**3**) with a group of *dabtaras* holding long prayer-sticks and dressed in the same way as they are to this day. On the west wall (**5**) there is another group of *dabtaras*, again holding their prayer-sticks and with some holding sistra. Their

leader is playing a *qabaro* (church drum). It is also a characteristic of this church that all evil-doers are portrayed as 'one-eyed', their faces being depicted in profile.

Some of the paintings tell the story of the life of Jesus and of the Virgin which come from books that we do not have in Western Christianity: the *One Hundred and Ten Miracles of Our Lady Mary*, the *Pseudo-Matthew Gospel* (which deals with the early life of Jesus) and the *Synaxarium* (the book of the Saints of the Ethiopian Church).

North Wall

The north wall is divided into five registers with the two upper ones dedicated to the life of the Virgin Mary and some of her miracles. The sequence, left to right, in the top register is as follows:

1. Joachim and Anne, praying for a child.

2. Anne breastfeeding Mary with Joachim looking on.

3. Mary taken to the Temple at the age of three and received by the High Priest who takes over her education. Behind the High Priest is a group of *dabtaras*.

4. This next scene comprises two stories. On the left is the Annunciation. Mary is seated, spinning, in the Temple when Gabriel says to her:

> Do not be afraid, Mary, you have found favour with God. You will be with child and give birth to a son, and you are to give him the name Jesus. He will be great and will be called the Son of the Most High. The Lord God will give him the throne of his father David, and he will reign over the house of Jacob for ever; his kingdom will never end. (Luke 1:30–3)

On the right, she is drinking the Waters of Correction which she was forced to do in front of a court of priests to prove her innocence when she was found to be with child.

5. The Massacre of the Innocents and the Flight into Egypt. The profile of the 'one-eyed' King Herod can be seen in the window of the keep of his castle with the massacre of the small boys taking place below. On the right are Mary carrying the baby Jesus on her back in the same way that Ethiopian women carry their babies to this day; Joseph, depicted as an old man; and Mary's cousin Salome with an *injira* basket on her head.

The register ends with two large panels:

6. St George killing the dragon and thus saving the mythical princess Birutawit, the King of Beirut's daughter.

7. The Virgin and Child. Mary is seated on a typically Ethiopian throne, a day-bed covered with sumptuous brocade. She holds the child in her left arm. Jesus holds a book in his left hand and makes a blessing with his right. He is wearing black shoes. Mary is dressed in a red garment and is covered with a blue *maphorion* which falls over her throne forming a cascade. On her right shoulder she has a gold star and crown. Both Mother and Child have elaborate haloes typical of this period, giving the impression they were made of filigree. Behind are two archangels with their swords drawn; they are holding an embroidered drape which covers the lower half of their bodies. Their wings are extended and arched over Mother and Child, defining the sacred space.

The second register includes several different stories which are not in sequential order. They are as follows:

8. Domitianus' hunter is turned into salt-stone. The legend is that he was turned into a block of salt-stone when, after finding the Holy Family, he disobeyed Mary's command to keep their presence secret. Domitianus then visited the Holy Family and begged the Virgin Mary for the release of his hunter, and she complied with his request.

9. The story of Gigar. Gigar was the first Christian martyr slain by Herod according to the Ethiopian Church. On the spot where he was executed a large, flowering tree, which could not be felled, nor burned, nor smothered, sprung up. This part of the story is told in the scene to the right of the Flight into Egypt. We see the wicked 'one-eyed' Herod watching the execution of Gigar. Gigar's head has been cut off with such force that it bends the trunk of the large, flowering tree mentioned in the story.

10. The continuation of the story of Gigar. Herod's horse shied away and threw him when Gigar's soul appeared to threaten the wicked King. Herod is lying on the ground, his frightened horse rearing above him and the figure on the cloud symbolises the soul of Gigar. Below the cloud are two men carrying away the corpse of Gigar.

11. The Flight into Egypt is encapsulated between two trees. Mary is breastfeeding Jesus in the same way as her mother Anne breastfed her in the scene above. Salome, Mary's cousin, accompanied them to Egypt and helped take care of Jesus when Mary was tired.

12. The story of Tamar, which is told in the *Nagere Maryam*. When the Holy Family and Salome fled to Egypt, they arrived in a town and went to the house of a woman called Tamar. Joseph asked her for some food and drink for his family but, instead of being hospitable, Tamar struck Joseph's face and then wrenched Jesus from Salome's back and threw him to the ground. As a result of this act, Tamar was swallowed up by the earth and all her family were turned into monkeys and fled to the desert. At the right of the scene is Tamar's house; she can be seen seated on an upper floor. In the very bottom right of the panel she is shown being swallowed up by the earth while her family, portrayed as monkeys, are having their tails bitten by dogs on the steps of her house.

13. The Marian cycle ends with a large scene which begins at the bottom with the Dormition, the death of Mary. She is lying on a couch with her head resting on Jesus' lap, and she is surrounded by the weeping disciples.

14. Above the Dormition is the Assumption of the Virgin in which she is being lifted up to Heaven in a white cloud, the base of which is in the shape of a crescent moon, the symbol of the Virgin. The crescent moon and her star-studded halo are described in St John's vision:

> Next appeared a great portent in heaven, a woman robed with the sun, beneath her feet
> the moon, and on her head a crown of twelve stars. (Revelation 12:1)

The cloud is being raised by five angels with the sixth figure at the top right being that of St Thomas (the 'doubting Thomas'), the apostle who arrived late to witness the event. According to the *Synaxarium*, Thomas was not present at the time of her death but arrived on a cloud. He saw her body with angels and he saluted her. When he came to the other apostles they told him that Our Lady was dead. He said to them, 'I did not know it until I saw her body, even as you made me know when I doubted the Resurrection of Jesus Christ.'

15. To the left of the Assumption is the Covenant of Mercy or *Kidana Mehrat*. The images of Mary and Christ seated together with joined hands symbolically signifies the promise of Christ to answer the prayers of those who make supplications in the name of his mother, Our Lady Mary. The granting of the covenant is celebrated as a major Marian feast on the 16th of Yakatit.

16. Below this scene, just above the doorway, is a painting to illustrate the Covenant of Mercy above it. It is of the Virgin and St Michael weighing up the deeds of Belai Kemer, the cannibal who had committed horrendous crimes throughout his life but had once given water to a thirsty man 'for Mary's sake'. And for this good deed Mary tilts the balance and Belai is admitted to Heaven.

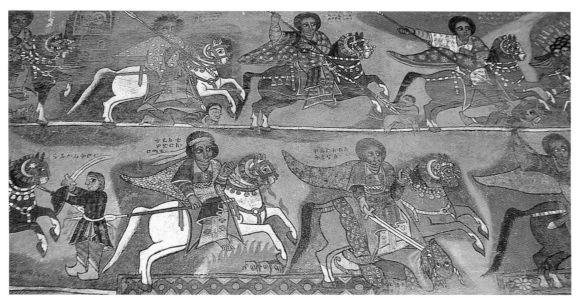

Fig. 115. **North wall.** Some of the equestrian saints

17. Just above the doorway is a small scene which shows a seated figure being licked by two dogs. This is Gabre Krestos, son of Emperor Theodosius (see p. 155), who, on returning to his father's city after having lived as an ascetic, was recognised only by his father's dogs.

The third and fourth registers are of equestrian saints, all galloping to the right, towards the sanctuary in the east of the church. Both the saints and their horses are wonderfully portrayed, especially in the cases of St George and St Basilides who are at the far right of both registers. Their horses are covered with magnificently embroidered blankets which reach down to their hooves. In the third register, the saints are, from left to right:

18–22. Mercurius, with, in a small frame above his horse's head, St Basil and St Gregory; Eusebius (son of St Basilides the Martyr); Claudius (Gelawdewos) killing the *seba'at*; Theodore the Oriental (Banadlewos); and George as King of Martyrs.

And in the fourth register they are:

23–7. Victor (Fikitor); Theodore the Roman (Tewodros Romawi) with his horse breathing spiritual fire and setting alight the evil ones; Sebastianos killing a snake with horns; Philoteus killing the bull Maragd and beside him, St Marmehnam on a white horse; and, finally, Basilides the Martyr.

In the fifth and lowest register, from left to right, the scenes depict:

28. The decapitation of John the Baptist.

29. Between the two windows are Cherkos and Julitta, being burned to death (they were actually beheaded). Cherkos (Cyriacus), a Christian martyr who was burned in AD 200, and his mother, Julitta, are said to have suffered death by fire because of their Christian faith when Cyriacus was only three years old. Though the literature about this saint was forbidden by Pope Gelasius at his Council of seventy-two bishops in Rome in AD 494, the story of his martyrdom has remained very much alive in Ethiopia.

30. In the scene between the window and the door is Gabre Manfas Kiddus, the famous hermit whose sanctity tamed wild beasts. He is typically portrayed clad in furs, girded with a hemp rope, and surrounded by lions and leopards.

31. To the right of the door is Tekle Haymanot with, below him, Emperor Egwala Seyon (1801–18), who is holding the saint's withered leg. The caption reads, 'How the ruler of the universe, Egwala Seyon, calls on His help.' Tekle Haymanot is depicted as the legendary saint who remained praying

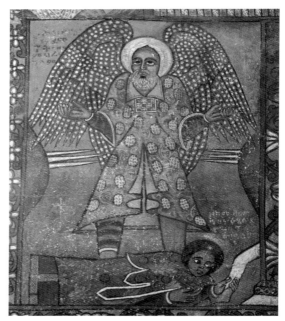

for twenty-two years, standing on one leg with his body balanced precariously between spears. His other leg eventually withered and fell off. Here, that leg is portrayed very differently from the other: it is painted in a dull brown. He has wings, which he was given by God when the rope he was using to descend from Debre Damo snapped. The saint's gown is covered in many small faces representing the many people he has helped and by whom he is considered a father.

32. Above Tekle Haymanot is a panel showing God the Father portrayed as one of the Trinity.

33. Below God the Father are Adam and Eve.

34. St Michael.

Fig. 116. North wall. Tekle Haymanot and Emperor Egwala Seyon

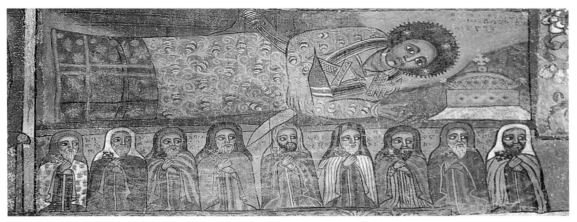

Fig. 117. North wall. The prostrate figure of Emperor Iyasu I and, below him, the nine Syrian saints

35. Above the right-hand window and below the Virgin and Child is Emperor Iyasu I (1682–1706) who built the first church of Debre Berhan Selassie. Below him are the nine Syrian saints.

36. In the space between the window and the wall, two saints are depicted: *Abba* Samuel riding his lion and, below him, *Abba* Bula, known as Abib, who came from Rome.

West Wall

This wall is dedicated to the appearance of the Virgin Mary in the church of Deir al-Magtas (the Monastery of the Baptistery) in the Nile Delta. This miracle, the Miracle at Metmaq, which occurred every year for five days and which is celebrated on the 21st of Genbot, is described in the collections of the *One Hundred and Ten Miracles of Our Lady Mary*. She was seated, surrounded by light, in the cupola of the church when the archangels and martyrs appeared. The three equestrian saints – Mercurius, Theodore the Oriental (Banadlewos), and George – descended from their horses and all three bowed before her.

In 1437/8, the church of Deir al-Magtas in Egypt was destroyed by a group of Muslim holy men who had become angered by the large crowds of Christian pilgrims visiting the church. This occurred at exactly the same time that the feast of Debre Metmaq had been introduced into the Ethiopian Church calendar. The Ethiopian emperor, Zara Yakob, had a church built to Our Lady Mary at a site he named Debre Metmaq in the province of Shoa. Unfortunately this church was destroyed by the Muslim conqueror Ahmad Gragn early in the sixteenth century. The feast of Debre Metmaq remains a major festival, celebrated with great solemnity, especially by women.

In the depictions of the miracle on this wall, Mary is seated on a large throne, wearing a crown, and with a dark blue cloak spread around her. Her right hand is raised, blessing those who praise her, while in her left hand she holds a white handkerchief. According to the story of the miracle, it was the

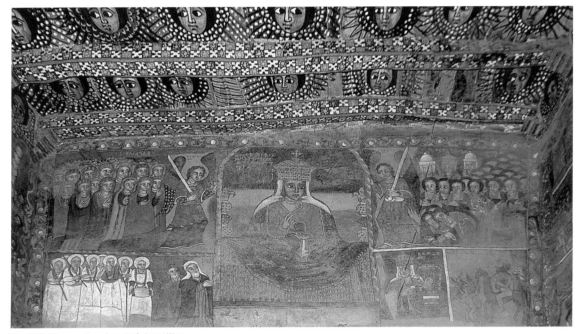

Fig. 118. West wall and part of the ceiling

custom of the faithful at the moment the vision appeared to remove their hats and head-scarves and throw them high up into the cupola. One year, a servant threw up her handkerchief and Mary caught it in her hands to prove the reality of the miracle.

1. The Virgin is surrounded by:

2. The archangel Gabriel with drawn sword.

3. The archangel Michael with drawn sword.

4. On the left, a group of virgins praising her.

5. Also on the left, a group of *dabtaras* with sistra, prayer-sticks and *qabaros* or ceremonial church drums, singing hymns to Mary.

6. On the right, three priests, a group of men and the three equestrian saints, already dismounted and bowing before her with their horses behind them.

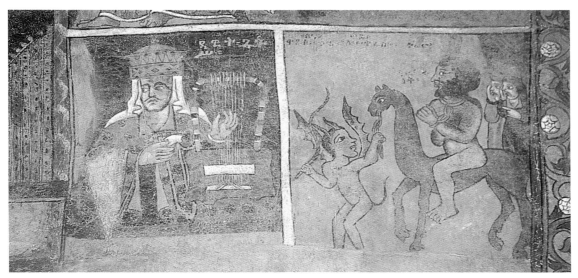

Fig. 119. West wall. King David playing the lyre and a devil leading Mohammed away on a camel

7. Also on the right, King David of Judah, who plays the lyre in her honour.

8. To the right of David is the fettered, naked and 'one-eyed' Mohammed, on the back of a camel, being led from Hell by the Devil. The Virgin had ordered that the Prophet should be brought from Hell in order to show his fate to his followers. The figure of the prophet Mohammed in connection with the Apparition at Metmaq does not appear in the *Synaxarium* or the *One Hundred and Ten Miracles of Our Lady Mary*. He has been depicted because of the great bitterness towards Islam by the Christians of Ethiopia in general and the people of Gondar in particular. During the nineteenth century, Gondar was burned and looted by the Mahdists of Sudan. Since then it became customary to depict the Prophet riding on a camel, naked, rendered in a particularly obscene manner.

South Wall

This is dedicated to the life of Jesus. Each episode is contained within a panel, all of which vary in size.

1. It begins on the top left with the Baptism. Jesus is shown immersed in a river full of fish.

2. Depicted in a small panel within that of the Baptism is the Virgin Mary.

3. Below is the Temptation of Jesus by the Devil in the desert. The Devil is shown dressed as a contemporary priest, unlike in other paintings of the same scene.

Debre Berhan Selassie

South Wall

East Wall

1	The Baptism: Jesus immersed in a river full of fish.
2	Virgin Mary.
3	The Temptation of Jesus by the Devil in the desert.
4	The Transfiguration, with Moses and Elijah on each side.
5	Jesus sends out the twelve disciples.
6	Entry into Jerusalem.
7	Jesus washing the feet of Peter.
8	The Last Supper. Judas, third from the right, is portrayed as 'one-eyed'.
9	Jesus prays on the Mount of Olives.
10	Jesus is betrayed.
11	Jesus is arrested.
12	The Flagellation.
13	Jesus with the Crown of Thorns.
14	Jesus carrying the Cross.
15	Jesus being nailed the Cross.
16	The Descent from the Cross.
17	The Lamentation.
18	The Virgin Mary holding the dead body of Jesus.
19	The Burial.
20	Mary Magdalene visits Christ's tomb.
21	The Raising of Adam and Eve.
22	The Ascension.
23	The Last Judgement.
24	Death of St Andrew.
25	Satan with a girl between his teeth.
26	Death of Judas (son of James) and of Matthias.
27	Death of St Peter.
28	Decapitation of St Paul with Nero looking on.
29	An unknown martyr.
30	The martyr *Abba* Abiy Egzie.

1	The Trinity, surrounded by the Tetramorph.
2–3	Twenty-four Elders of the Apocalypse.
4	The Crucifixion.
5	The recumbent figure of Emperor Iyasu I (r. 1682–1706).
6	The Descent into Hell.
7	The Annunciation.
8	The Nativity.
9	The Virgin Mary.
10	Children playing *ganna*.
11	The archangel Raphael.
12	The archangel Gabriel.
13	Meshach, Shadrach and Abednego in the fiery furnace.
14	The archangel Fanuel.
15	The archangel Sakuel.

The devil said to him, 'If you are the Son of God, tell this stone to become bread.' Jesus answered, 'It is written: "Man does not live on bread alone."' (Luke 4:3–4)

4. The Transfiguration with Moses and Elijah on each side. The Transfiguration took place on Mount Tabor. Jesus is resplendent in white robes against a vivid orange background. Like the Father above him and Moses and Elijah on either side, he is contained within white clouds that resemble cotton wool. In the Gospel, the three apostles fell face down, and this is how they are usually portrayed in Western art. Here they are depicted tumbling down the mountain.

After six days Jesus took with him Peter, James and John the brother of James, and led them up a high mountain by themselves. There he was transfigured before them. His face shone like the sun, and his clothes became as white as the light. Just then there appeared before them Moses and Elijah, talking with Jesus. Peter said to Jesus, 'Lord, it is good for us to be here. If you wish, I will put up three shelters – one for you, one for Moses and one for Elijah.' While he was still speaking, a bright cloud enveloped them, and a voice from the cloud said, 'This is my Son, whom I love; with him I am well pleased.

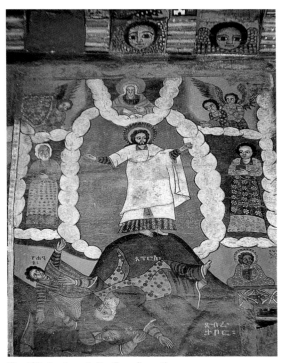

Listen to him!' When the disciples heard this, they fell face down to the ground, terrified. But Jesus came and touched them. 'Get up', he said. 'Don't be afraid.' When they looked up, they saw no one except Jesus. (Matthew 17:1–8)

5. Jesus sends out the twelve disciples. He is seated and covered by a red cloak embroidered with yellow rosettes. His head is surrounded by a golden halo. The twelve are to the right, seated in a close-knit group.

He called his twelve disciples to him and gave them authority to drive out evil spirits and to heal every disease and sickness. These are the names of the twelve apostles: first, Simon (who is called Peter) and his brother Andrew; James son of Zebedee, and his brother,

Fig. 120. South wall. The Transfiguration

John; Philip and Bartholomew; Thomas and Matthew the tax collector; James son of Alphaeus, and Thaddeus; Simon the Zealot and Judas Iscariot, who betrayed him. (Matthew 10:1–2)

6. The Entry into Jerusalem. The left-hand side of the composition shows Christ riding a donkey with his disciples following behind. Christ's golden halo is accentuated by being set against a dark green background whereas the rest of the scene is against a yellow background. In front of Christ are the welcoming citizens of Jerusalem, some of whom are laying out their cloaks on the ground in front of Christ while others, shown in a smaller scale, stand in a group holding palm fronds. At the far right is a representation of a temple with two arched doorways. Above these doorways, two 'one-eyed' men watch the welcoming scene below them from a window; one is pointing towards Jesus. They are, no doubt, the chief priests of the temple, which explains why they are portrayed as 'one-eyed'.

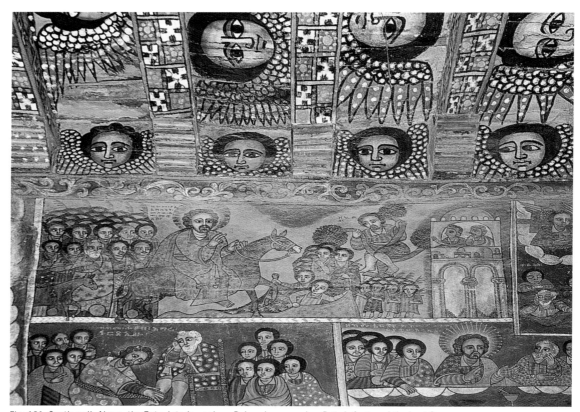

Fig. 121. South wall. Above: the Entry into Jerusalem. Below: Jesus washes Peter's feet, and the Last Supper

The disciples went and did as Jesus had instructed them. They brought the donkey and the colt, placed their cloaks on them, and Jesus sat on them. A very large crowd spread their cloaks on the road, while others cut branches from the trees and spread them on the road. The crowds that went ahead of him and those that followed shouted, 'Hosanna to the Son of David!' 'Blessed is he who comes in the name of the Lord!' 'Hosanna in the highest!' When Jesus entered Jerusalem, the whole city was stirred and asked, 'Who is this?' The crowds answered, 'This is Jesus, the prophet from Nazareth in Galilee.' (Matthew 21:6–11)

Shown above the citizens with their palm fronds is Zacchaeus, seated in the branches of a tree. He is mentioned in the Bible as being in Jericho, but Ethiopian iconographical tradition introduces him into the Palm Sunday scene:

Jesus entered Jericho and was passing through. A man was there by the name of Zacchaeus; he was a chief tax collector and was wealthy. He wanted to see who Jesus was, but being a short man he could not, because of the crowd. So he ran ahead and climbed a sycamore-fig tree to see him, since Jesus was coming that way. (Luke 19:1–4)

7. Jesus washing the feet of Peter. The scene is depicted against a dark green background. On the left is Jesus, kneeling and washing Peter's feet over a large bowl. Jesus is clothed in an orange robe embroidered with grey rosettes. His head is surrounded by a very light, almost transparent halo. Behind him some of the apostles look on. Peter is shown in the centre of the painting, seated in a high-backed chair. He is portrayed as an old man with white hair and a white beard. His right hand is cupped over his ear in a gesture to show that he is listening intently to the words of Jesus. Behind Peter are five of the apostles, seated on the ground. The one in the front has his bare legs showing which would indicate that he is next in line to have his feet washed.

After that, he poured water into a basin and began to wash his disciples' feet, drying them with the towel that was wrapped around him. He came to Simon Peter, who said to him, 'Lord, are you going to wash my feet?' Jesus replied, 'You do not realise now what I am doing, but later you will understand.' 'No,' said Peter, 'you shall never wash my feet.' Jesus answered, 'Unless I wash you, you have no part with me.' 'Then, Lord,' Simon Peter replied, 'not just my feet but my hands and my head as well!' (John 13:5–9)

8. The scene of the Last Supper shows Jesus with the twelve apostles. Judas, third from the right, is portrayed as 'one-eyed'. Below the table is a genre scene; two people are preparing the food and drink for the Last Supper; an *injira* basket is depicted on the right. This is where Ethiopians keep their staple flat bread to this day.

When evening came, Jesus was reclining at the table with the Twelve. And while they were eating, he said, 'I tell you the truth, one of you will betray me.' They were very sad and began to say to him one after the other, 'Surely not I, Lord?' Jesus replied, 'The one who has dipped his hand into the bowl with me will betray me. The Son of Man will go just as it is written about him. But woe to that man who betrays the Son of Man! It would be better for him if he had not been born.' Then Judas, the one that would betray him, said, 'Surely not I, Rabbi?' Jesus answered, 'Yes, it is you.' (Matthew 26:20–5)

9. Jesus prays on the Mount of Olives. The scene is painted against a dark green background. Jesus is kneeling under a tree with his hands held high in prayer while three of his disciples are asleep at his feet. The one in front, with white hair and a white beard, is Peter. The other two are clean-shaven and have a full head of black hair. Jesus is wearing a red robe, the folds of which are indicated by a lighter shade of red. The angel who appears to him while he prays can be seen in the upper left of the scene, contained within a white fluffy border to indicate that he is a heavenly body.

Jesus went out as usual to the Mount of Olives, and his disciples followed him. On reaching the place, he said to them, 'Pray that you will not fall into temptation.' He withdrew about a stone's throw beyond them, knelt down and prayed, 'Father, if you are willing, take this cup from me; yet not my will, but yours be done.' An angel from heaven appeared to him and strengthened him. And being in anguish, he prayed more earnestly, and his sweat was like drops of blood falling to the ground. When he rose from prayer and went back to the disciples, he found them asleep, exhausted from sorrow. 'Why are you sleeping?' he asked them. 'Get up and pray so that you will not fall into temptation.' (Luke 22:39–46)

10. Jesus is betrayed. The scene, which is painted against a yellow background, depicts the moment when Judas leads a crowd to Jesus. On the left, Jesus and his disciples stand, facing the crowd. One of the disciples, standing immediately behind Jesus, is holding a sword ready to defend him. At the front of the crowd, who are armed with spears, is a man mounted on a white horse which he has reigned in so forcefully that the animal has sat back on its rear legs.

While he was still speaking a crowd came up, and the man who was called Judas, one of the Twelve, was leading them. He approached Jesus to kiss him, but Jesus asked him, 'Judas, are you betraying the Son of Man with a kiss?' When Jesus' followers saw what was going to happen, they said, 'Lord, should we strike with our swords?' And one of them struck the servant of the high priest, cutting off his right ear. But Jesus answered, 'No more of this!' And he touched the man's ear and healed him. (Luke 22:47–51)

11. Jesus is arrested. He is standing at the centre of the scene and is surrounded by the crowd, who are armed with spears rather than with swords and clubs as stated in the Bible. Some of them have already laid hands on Jesus and, on the ground, between their legs, can be seen the head of Judas.

> Then Jesus said to the chief priests, the officers of the temple guard, and the elders, who had come for him, 'Am I leading a rebellion, that you have come with swords and clubs? Every day I was with you in the temple courts, and you did not lay a hand on me. But this is your hour – when darkness reigns.' Then seizing him, they led him away and took him into the house of the high priest. Peter followed at a distance. (Luke 22:52–4)

12. The Flagellation. On the right of the picture is Jesus, naked except for a red loincloth. He is tied to a stake by his hands, which are bound behind him, and also by his right leg. He looks away from his tormentors, who stand to the left of the scene and who are flogging him with branches. Jesus' naked body, which is streaked with blood, is ashen and contrasts with the healthy colour of his tormentors. 'Then he (Pilate) released Barabbas to them. But he had Jesus flogged, and handed him over to be crucified' (Matthew 27:26).

13. Jesus with the Crown of Thorns. Here again is the ashen figure of Christ, now partially covered by a red robe, wearing the crown of thorns. His hands are tied, but he is holding a staff in his right hand. One of the figures kneels behind him while the rest are taunting him. On the left, a soldier leans against his spear and jeers at Jesus.

> Then the governor's soldiers took Jesus into the Praetorium and gathered the whole company of soldiers round him. They stripped him and put a scarlet robe on him, and then twisted together a crown of thorns and set it on his head. They put a staff in his right hand and knelt in front of him. 'Hail, king of the Jews!' they said. (Matthew 27:27–9)

14. Jesus carries the Cross. In this scene Jesus has fallen to the ground with the weight of the Cross he is bearing. On the right, a soldier has grabbed the lower part of the Cross in order to give it to Simon, who is portrayed on the left, behind Jesus, already carrying the Cross.

> As they led him away, they seized Simon from Cyrene, who was on his way in from the country, and put the cross on him and made him carry it behind Jesus. (Luke 23:26)

15. Jesus is nailed to the Cross. This is a bird's eye view of the ashen figure of Christ being nailed to the Cross by six people who are positioned at its foot and at the ends of its arms. This is an unusual

representation of this scene with the Cross lying on the ground in an 'east–west' direction. Pilate, who is shown in profile, 'one-eyed' and seated on a throne, is washing his hands in a bowl brought to him by a woman.

16. The Descent from the Cross. The Cross, which is in the centre of the composition, has two ladders leaning against it with a disciple on each. The disciple on the ladder which is leaning against the right arm of the Cross holds the white cloth which was used to lower the body of Jesus while the other disciple, on the left, supports his shoulder. In the lower right of the painting, Joseph of Arimathea, who is wearing loose, red trousers and a pink cloak, holds Christ's feet. On the left, John clasps Christ's hand, while below stands the Virgin Mary, enveloped in a blue *maphorion*, her arms crossed in a gesture of piety, gazing with sorrow at the dead body of her son.

> Later, Joseph of Arimathea asked Pilate for the body of Jesus. Now Joseph was a disciple of Jesus, but secretly because he feared the Jews. With Pilate's permission, he came and took the body away. (John 19:38)

17. The Lamentation. The body of Christ is spread out on a white shroud but has not yet been wrapped. Joseph and Nicodemus are at either side of Christ, while, in the centre, the Virgin Mary, who is covered by a blue *maphorion* and with her head surrounded by a golden halo, holds her son's hand. There are two women standing behind Nicodemus:

> The women who had come with Jesus from Galilee followed Joseph and saw the tomb and how his body was laid in it. (Luke 23:55)

18. The Virgin Mary holds the dead body of Jesus while John sits with his head resting on his hand, his face full of sorrow.

19. The Burial shows Joseph and Nicodemus holding the body of Christ, which is shrouded in white linen:

> Later, Joseph of Arimathea asked Pilate for the body of Jesus … With Pilate's permission, he came and took the body away. He was accompanied by Nicodemus, the man who brought a mixture of myrrh and aloes, about seventy-five pounds. Taking Jesus' body, the two of them wrapped it, with the spices, in strips of linen. This was in accordance with Jewish burial customs. (John 19:38–40)

20. Mary Magdalene visits Christ's tomb. Soldiers are guarding the entrance to the tomb and of the three women mentioned in the Gospel according to St Mark only Mary Magdalene is shown to the lower left of the scene holding a jar of ointment. The young man dressed in white is depicted as an angel engaged in conversation with Mary Magdalene.

> When the Sabbath was over, Mary Magdalene, Mary the mother of James, and Salome brought spices so that they might go to anoint Jesus' body. Very early on the first day of the week, just after sunrise, they were on their way to the tomb and they asked each other, 'Who will roll the stone away from the entrance to the tomb?' But when they looked up, they saw that the stone, which was very large, had been rolled away. As they entered the tomb, they saw a young man dressed in a white robe sitting on the right side, and they were alarmed. 'Don't be alarmed,' he said. 'You are looking for Jesus the Nazarene, who was crucified. He has risen! He is not here. See the place where they laid him. But go, tell his disciples and Peter, "He is going ahead of you into Galilee. There you will see him, just as he told you."' Trembling and bewildered, the women went out and fled from the tomb. They said nothing to anyone, because they were afraid. (Mark 16:1–8)

21. The Raising of Adam and Eve. Though this is a scene frequently painted in churches after the sixteenth century, this one is a very unusual portrayal because it lacks any depiction of Hell or the Devil. Here, Jesus is standing on the ground and, in his left hand, holds a long-handled cross with a banner attached to it. His right hand is raised pointing towards Heaven. He wears a green cloak, which is draped over only one shoulder allowing his white tunic to be partially visible. On each side there is a row of angels' heads placed in amongst white clouds. Adam and Eve are seated cross-legged at Jesus' feet, enveloped in a light brown cloak. They look inquiringly towards him. The scene is imbued with a sense of calmness, in great contrast to its normal representation which is full of movement and agitation. (See Chapter 2 for a full description of the Raising of Adam and Eve.)

22. The Ascension. The scene is painted against a green background and is dominated by the figure of the risen Christ who, after his crucifixion, appeared to his disciples as proof that he was still alive. Jesus is wearing a green tunic speckled with golden motifs and an orange cloak embroidered with large white rosettes. This painting is unusual on three counts. First, the Virgin Mary is present. She is shown at the bottom left, in front of her son's disciples. She is leaning backwards and looking up at Jesus. She is recognisable by her blue *maphorion* and her large golden halo. Second, the presence of a banner across the lower part of Jesus' robe. Even though the banner is a symbol of the Resurrection, it is usually only depicted in scenes of the Harrowing of Hell. Third, only one angel, shown immediately below Jesus, is present, whereas the Bible refers to two angels (men dressed in white):

After he said this, he was taken up before their very eyes, and a cloud hid him from their sight. They were looking intently up into the sky as he was going, when suddenly two men dressed in white stood beside them. 'Men of Galilee,' they said, 'why do you stand here looking into the sky? This same Jesus, who has been taken from you into heaven, will come back in the same way you have seen him go into heaven.' (Acts 1:9–11)

The angel in this painting is dressed in a white, half-length garment with a green tunic and, although he is facing the viewer, his arms are outstretched pointing to Jesus above him.

23. The Last Judgement. Christ sits on a throne in the centre of the composition, his arms outstretched. He wears a richly embroidered red garment tied around his waist; it then comes over his left shoulder ending in meticulously arranged zigzag pleats. His head is surrounded by a golden halo made up of rays of different lengths – the longer, alternating rays ending in a cross shape. His figure is depicted against a screen embroidered with orange rosettes. At top right there are three angels brandishing swords. Below them are another two angels. The upper one holds the Book of Life, mentioned in Revelation, and the lower one sounds a trumpet, announcing the Last Judgement. A second angel holding the Book of Life is at the top left. To the left of Christ is Mary with her hands together in prayer. She is interceding on behalf of the souls. Christ's head is turned slightly towards her.

Though it is unusual for the Virgin to be present in a scene of the Last Judgement, the Ethiopians' fervent belief in the Covenant of Mercy makes her presence understandable. Below the Virgin are the pious souls looking up at Christ. To the right of Christ lie the condemned souls – naked and in a heap with skulls and bones, symbols of decay, scattered all around them.

Then I saw a great white throne and him who was seated on it. Earth and sky fled from his presence, and there was no place for them. And I saw the dead, great and small, standing before the throne, and books were opened. Another book was opened, which is the book of life. The dead were judged according to what they had done as recorded in the books. The sea gave up the dead that were in them, and each person was judged according to what he had done. Then death and Hades were thrown into the lake of fire. The lake of fire is the second death. If anyone's name was not found written in the book of life, he was thrown into the lake of fire. (Revelation 20:11–5)

24. The death of St Andrew, hanging upside-down from a tree.

25. This is a wonderful depiction of an enchained, black Satan in the middle of the fire of Hell. The orange flames engulf him with the condemned above him. He has a girl in his mouth. Ethiopian

legend has it that once, when Satan was roaming the earth, as he is allowed to do every one thousand years, a girl saw him and fell in love with him. When she died, young and innocent, she went to Heaven. After some time, she begged God that he forgive Satan and bring him to Heaven, as she was longing so much for him. God sent the girl to Hell, where Satan, on hearing that she had dared approach God for his sake, put her between his teeth, from which position she was forced to see the horrors of Hell for an eternity.

26. The death of Judas (the son of James) and Matthias.

27. The death of St Peter who was crucified upside-down. One of his executioners is pulling a rope around his feet. Peter, the leader of the apostles, the rock of the church, was put to death by Nero in AD 64, and he was crucified upside-down at his own request.

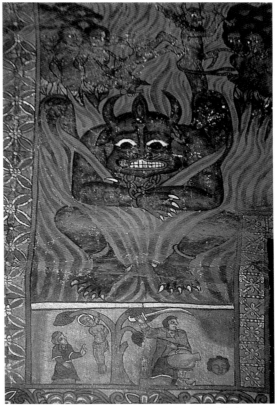

Fig. 122. South wall. Satan and, below, the death of Judas (son of James) and Matthias

28. The decapitation of St Paul with Nero looking on. Paul was one of the most influential of the early church leaders. He was imprisoned in Rome in about AD 67 and eventually was executed by Nero.

29. An unknown martyr.

30. The martyr *Abba* Abiy Egzie, one of the monastic saints.

East Wall
The Trinity and the Crucifixion take up most of the wall.

1. The Trinity surrounded by the Tetramorph (symbols of the four gospel writers). The theme of the Trinity is of European origin and was introduced to Ethiopia by the Italian painter, Nicolo

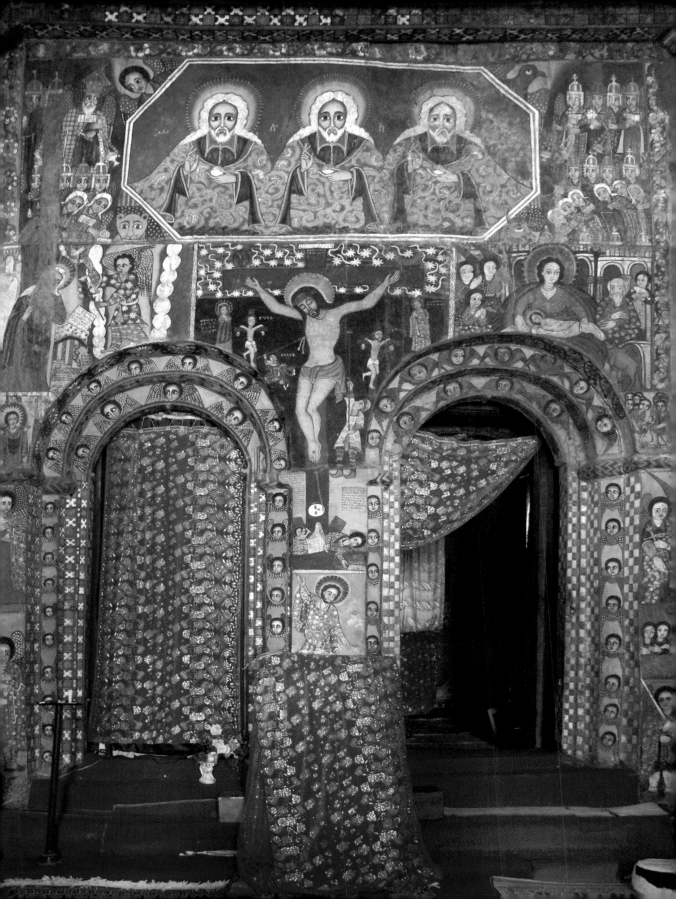

Fig. 123 (right). East wall

Brancaleone, in the late fifteenth and early sixteenth centuries. This may be the reason for the figures to be wearing large, pointed collars which are associated with European dress of the period. Each Person is surrounded by a halo. They have long wavy hair covering their shoulders, white beards and drooping moustaches. They have large open eyes. Each wears a black tunic with a red ochre, large, pointed collar. None of their necks are visible. Their cloaks are richly decorated in red, yellow and orange shades of ochre. Their right hands make a gesture of blessing: the thumb, index and middle finger are outstretched with the other two fingers folded back. Each holds an egg rendered in white and grey. The egg is the symbol of the Trinity because of its three parts: the yoke, the white and the shell.

2–3. The twenty-four Elders of the Apocalypse, some of whom are portrayed wearing crowns and others represented as priests. The Elders, together with the Trinity, are looking down on to the scene below them.

4. The Crucifixion, a magnificent scene portrayed against a black background which serves to highlight the pathos. Surrounding the horizontal arm of the Cross is a visual representation of the mourning of the cosmos: 'The sun will be turned to darkness and the moon to blood before the coming of the great and dreadful day of the Lord' (Joel 2:31). The stars are falling, the red crescent moon is on the right, and the sorrowful grey sun is on the left. At the base of the Cross is the skull of Adam receiving blood from the wounds of Christ, a reference to the belief that Christ was crucified upon the site where Adam was buried. It signifies the redemption of Adam and through him, of all humanity.

5. Below Christ is the recumbent figure of Emperor Iyasu I (1682–1706), here depicted for the second time in this church. His sword scabbard protrudes sideways from his body, encased by his diaphanous over-tunic.

6. The Descent into Hell. The theme of redemption is expanded by the scene below the prostrated king where a resplendent Christ is seen descending into Hell to raise Adam and Eve. These two scenes, the Crucifixion and the Descent into Hell, relate to the prayer of blessing of the bread and the wine in the anaphora of the apostles: 'He stretched out his hands in the passion, suffering to save the sufferers that trust in him. Who was delivered to the passion that He might destroy death, break the bonds of Satan, tread down hell, lead forth the saints, establish a covenant, and make known His Resurrection.'

7. The Annunciation. Mary is reading when the archangel Gabriel appears to her.

8. The Nativity. The scene is contained within arcaded walls meant to symbolise the manger. Mary is beautifully portrayed as a pretty young girl, completely in contrast with the poor old Joseph to the right of her with his bald head and beard. She has attractive wavy black hair and, surrounding her head, is an elaborate yellow, blue and white halo. She is wearing a richly brocaded red gown and is enveloped within a blue cape. The baby Jesus lies upon her lap. Mary looks more like an Italian *contessa* in a palace setting than any other Nativity scene you are likely to see in Ethiopia. To the left of Mary are: the angel who has told the shepherds of the birth of Jesus, two of the shepherds, and an ass. To the right of her, behind Joseph, is the third shepherd, who is carrying a lamb, and below Joseph is the ox. Above all of them some of the twenty-four Elders are leaning over the parapet to get a good view of the Nativity.

9. The Virgin Mary.
10. Children playing *ganna*.
11. The archangel Raphael.
12. The archangel Gabriel.

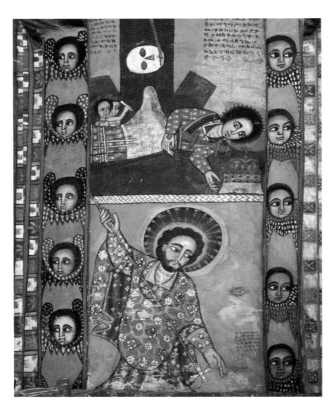

Fig. 124. East wall. The recumbent Emperor Iyasu and Christ's descent into Hell

13. The Jewish youths, Meshach, Shadrach and Abednego in the fiery furnace.

14. The archangel Fanuel who brought food and drink to Mary during the years she spent in the Temple as a child.

15. The archangel Sakuel.

Debre Sina Maryam at Gorgora

Gorgora is situated on the northern shore of Lake Tana. It is 60 kilometres south of Gondar from where the driving time is about two hours. Leaving Gondar, you head south on a tarmac road towards the town's airport. After passing the airport, the tarmac comes to an end, and it is then a dirt road all the way to Gorgora. The first time I visited Debre Sina Maryam I was not expecting to see much that would impress me. Much to my surprise, I was delighted, not only with the church itself but also its location, which is on a small headland right beside Lake Tana – a beautiful setting. The church has been built perhaps one metre above the level of the lake.

The Church

Debre Sina Maryam is said to have been erected by *Abuna* Thomas during the reign of Emperor Amda Seyon (1314–44). It has never been burned down or sacked, even by the dervishes, who seem to have

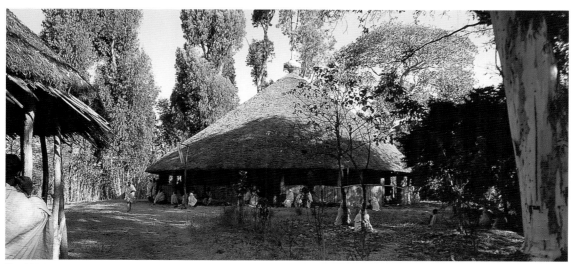

Fig. 125. The round church of Debre Sina Maryam

Debre Sina Maryam

West Wall

South Wall

1	Christ in Majesty and the Tetramorph.
2	Covenant of Mercy and twenty-four Elders of the Apocalypse.
3	St Raphael.
4	Harrowing of Hell (Adam and Eve rescued).
5	Crucifixion.
6	The Annunciation.
7	Virgin and Child surrounded by angels.
8	Inscription with the words of the donor.
9	*Waizero* Malakotawit, the donor of the paintings.
10	Inscription naming the donor as Waizero Malakotawit.
11	Tekle Haymanot.
12	*Abba* Ewostatewos.
13	Gabre Manfas Kiddus (very damaged).
14	*Abba* Samuel of Waldebba riding his lion.
15	Mary crowned as Queen of Heaven.
16	St George as King of Martyrs.
17	The life of Tekle Haymanot.
18	The crowned archangel Michael.
19	St Basilides.
20	Soldiers of St Basilides carrying weapons for him, the one on the left named as Irnis.
21	St George as dragon killer.
22	The Trinity – only one person remains.

1	Mary's Apparition in the Egyptian Monastery of Metmaq.
2	The Last Judgement.
3	Unknown – badly damaged.
4	The Nativity.
5	Adoration of the Magi.
6	Flight into Egypt.
7	Massacre of the Innocents.
8	Jesus sends out his disciples.
9	St Antony receiving the belt of a monk. Behind him are two saints, probably *Abba* Macarius and *Abba* Bula.
10	The Trinity – only one Person remains.
11	Emperor Theodosius (347–395 AD) and possibly his Spanish wife Aelia Flacilla.

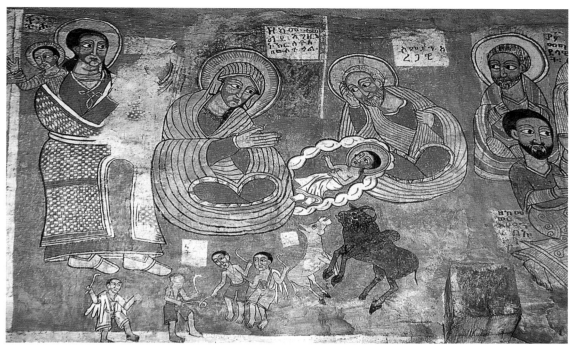

Fig. 126. South wall. The Nativity with children playing *ganna* below

missed all the churches in Gorgora, although they must have passed close by on their way to Gondar. The church is a round, centrally planned building. It stands on a podium, which is level with the surrounding ground. Its conical roof is supported on the exterior by tree trunks serving as columns. There is a low reed screen of one metre in height between each column thus forming the ambulatory.

The church is typical of Ethiopia's round churches with its three concentric parts: the *qene mahlet* or exterior ambulatory; the *qeddest*, which is the circular space between the church wall and the sanctuary; and the drum, which rests on the top of the square *maqdas*.

The inner surface of the circular wall has been plastered over in white and has no paintings. Surrounding the sanctuary are twelve large tree trunks serving as columns which carry a crown of trusses on which the roof rests. The number twelve represents the apostles.

The sanctuary has three doors and three windows, all in wood and following the Aksumite style, with recessed beams framed at the corners with protruding horizontal square beams called 'monkeyheads'. The windows are carved from a single piece of wood with lattice work of tendrils and leaves. All the wood frames were originally covered in white plaster and painted with leaves and geometrical patterns. This has only partially survived.

The conical thatched roof is surmounted by a cross with finials ending in five ostrich eggs.

The Paintings

The paintings are typical of the First Gondarine style of the seventeenth century. All the scenes are portrayed against a delicately shaded background of muted ochres from reds to yellows to greens. There has been an attempt to model the faces by inserting rouge below the cheekbone. The folds of the neck have also been highlighted in red ochre. The faces are long with narrow, pointed noses which continue uninterrupted to form the arch of one of the eyebrows. The other eyebrow is painted frequently as a wave rather than an arch. Some of the women have black hair falling over their shoulders, a conscious attempt to portray a more natural trait. The figures are imbued with calmness, even under the direst circumstances, such as the stoning of St Stephen where his tormentors appear to have been taken out of a slow-motion film.

They all have the typical large Ethiopian eyes with a very expressive intent gaze. It is a characteristic of this church that all evil-doers are portrayed as 'one-eyed'. Their clothes are depicted with lines that follow and accentuate the contour of the body and are filled with geometric patterns, parallel lines or checked gingham, such as the lady carrying a baby on her back in the Nativity scene (South wall, panel 4). Those figures who sit cross-legged in the paintings wear cloaks that envelope their whole body, including their legs, giving the impression that they are seated on a cushion.

There are some delightful realistic genre scenes such as the boys playing the game of *ganna* below the Nativity and, on the drum, the *dabtaras* playing their different instruments below the enthroned Virgin.

On the west wall of the sanctuary, beneath the Virgin, an inscription names the donor of the paintings, *Waizero* Malakotawit, who also enlarged the church (panel **10**). She was the eldest daughter of Susenyos (1607–32), who married the governor of Tigray and died soon after childbirth in 1627.

West Side

Drum

1. On the upper part, just below the thatched roof, is Christ in Majesty within a *mandorla* and surrounded by the Tetramorph.

2. Below is the Covenant of Mercy when Christ gave Mary the right to intercede on behalf of any sinner provided he or she had done at least one good deed in her name. Both scenes are surrounded by the twenty-four Elders of the Apocalypse: 'Surrounding the throne were twenty-four other thrones, and seated on them were twenty-four elders. They were dressed in white and had crowns of gold on their heads' (Revelation 4:4).

In this painting they have wings like angels, are lavishly and colourfully attired, and wear crowns and hold hand-crosses and censers, instead of golden bowls and harps: 'And when he had taken it, the

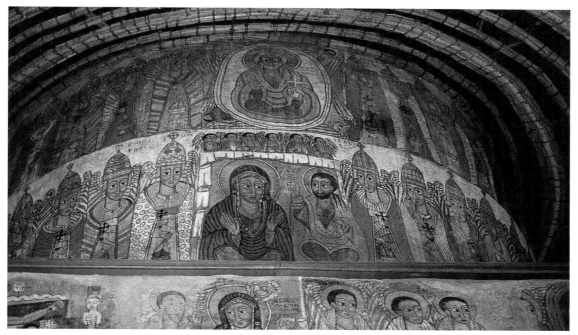

Fig. 127. West side, drum. Above: Christ in Majesty. Below: the Covenant of Mercy

four living creatures and the twenty-four elders fell down before the Lamb. Each one had a harp and they were holding golden bowls full of incense, which are the prayers of the saints' (Revelation 5:8).

Doorway

In the centre of the wall is a stunning Aksumite wooden doorway with 'monkey-heads'. Cable moulding runs between the doorway beams which are themselves elaborately painted. The outer beams are decorated with a running vine on which sunbirds are perched, sipping nectar from the flowers. The inner beam is patterned with red crosses set within roundels.

3. On the door itself St Raphael is portrayed guarding the entrance to the sanctuary. He brandishes his sword above his head with his right hand while his left holds the scabbard. His clothes are lavishly painted in orange, yellow and green ochre. The feathers of his wings have been meticulously depicted. He is wearing tight trousers, and his feet are pointing outwards. Both the decoration of the doorway and the stance and clothing of the saint are reminiscent of Indian art.

Sanctuary Wall

Looking at the top register, left to right, we have:

4. The Harrowing of Hell. 'Salutations to thy Resurrection, the day of which became the day of Adam's salvation' (*Synaxarium*). Christ is shown with Adam and Eve at his feet holding on to his robes, waiting to be rescued. Below is the delightful figure of the Devil, seated on a fire. He gives the impression that he is fuming because Christ has rescued his prey – his fists are clenched, his hair stands on end, and his tongue protrudes.

5. Next is the Crucifixion. The emaciated Christ has both legs resting on the Cross. The redemptive significance of the Crucifixion is emphasised by the angels who gather the blood of Christ in chalices. The centurion pierces Christ's chest with a spear: 'Instead, one of the soldiers pierced Jesus' side with a spear, bringing a sudden flow of blood and water' (John 19:34).

Unusually, the Cross is surrounded by a white cotton-like band, which is probably meant to depict Christ's aura. A distraught Mary holds her left arm up to her head, but her grief is subdued as she looks outward towards the viewer. Next to her is St John, crying and looking at Christ, his hands crossed over his chest. The two thieves appear to be kicking against their fate; both have one

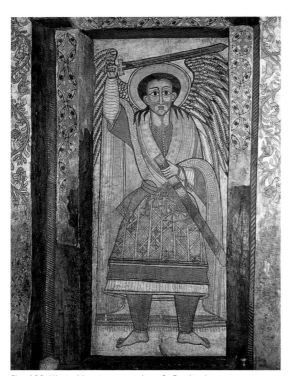

Fig. 128. West side, sanctuary door. St Raphael

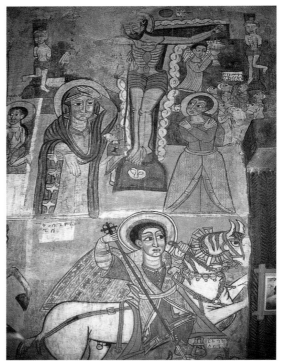

Fig. 129. West wall. Above: the Crucifixion. Below: St George killing the dragon

of their legs lifted in the air. Below one of the thieves is a realistic depiction of the guards dividing the clothes amongst themselves: 'When they had crucified him, they divided up his clothes by casting lots' (Matthew 27:35).

6. Next is the scene of the Annunciation which is over the door:

> In the sixth month, God sent the angel Gabriel to Nazareth, a town in Galilee, to a virgin pledged to be married to a man named Joseph, a descendant of David. The virgin's name was Mary. The angel went to her and said, 'Greetings, you who are highly favoured! The Lord is with you [...] You will be with child and give birth to a son, and you are to give him the name Jesus. He will be great and will be called the Son of the Most High.' (Luke 1:26–8 and 31–2)

The Virgin is seated, spinning, with the archangel Gabriel standing full-length behind her. Above Mary is a dove, symbol of the Holy Spirit.

7. Finally we have the Virgin and Child, surrounded by angels. Mary's face is full of sadness. Her hands are crossed over Jesus' gown, and she holds a handkerchief with her left hand. To the left of the Virgin, and above the door, are three standing angels.

8. Below them there is an inscription which reads, 'I have contributed to these pictures to give my services to Our Lord, not because I am looking for a reward or for praise, but to obtain salvation for my soul through the intercession of Our Lady Mary and by the mercy of Our Lord Jesus Christ'.

9. Just below and to the right of this inscription, under the door's top right 'monkey-head', is a painting of a lady seated cross-legged – she is this donor.

10. Below the Virgin on the far right, is another inscription that names the donor as *Waizero* Malakotawit.

On the other side of the door, below the Virgin and Child, are portrayed the four most popular Ethiopian saints:

11. Tekle Haymanot, whose cloak is surrounded by what appears to be bells but are the tips of sticks which he placed around his cell to prevent him from falling asleep as he prayed in a standing position for twenty-two years.

12. *Abba* Ewostatewos (see Fig. 10, p. 19).

13. A damaged painting of Gabre Manfas Kiddus, where only his arms and his pet beasts are now visible.

14. *Abba* Samuel riding his lion.

Below, on the plinth, the paintings are in a completely different style to the rest of the wall and, most probably, have been painted at a later date. Here we have:

15. Mary crowned as Queen of Heaven.

16. To the right of Mary, St George as King of Martyrs, wearing a crown and mounted on a horse covered with a richly embroidered saddle-cloth.

At the very bottom of the plinth are some damaged scenes; from left to right:

17. The life of Tekle Haymanot.

18. The crowned archangel Michael.

Returning to the left-hand side of the wall, in the second register, we have, left to right:

19. The mounted St Basilides.

20. An inset panel showing Basilides' soldiers carrying his weapons for him, the one on the left being named as Irnis.

21. In this next major scene, St George is killing the dragon. To the early Christians, a dragon symbolised evil and, in particular, paganism. The conversion of a country to Christianity by a saint would thus be depicted in symbolic form as the slaying of a dragon with a spear.

22. On the plinth below is a much damaged painting of the Trinity. All that remains is only one of the three Persons of the Trinity.

South Side

Drum

1. The south side of the drum is taken up by a symbolic illustration of Mary's Apparition in the Egyptian Monastery of Metmaq. She is seated cross-legged underneath a white canopy carried by two young servants, above whom are several angels. She is enveloped in a blue *maphorion* which goes underneath her and serves as a cushion. To left and right she is surrounded by the Elders of the Apocalypse wearing church robes and crowns and holding sistra. Below her is a delightful genre scene: *dabtaras* playing different instruments. Three of them play a *qabaro* (barrel-shaped church drum), others play smaller round drums, and two are blowing extremely long sinuous horns.

The feast of Debre Metmaq commemorates the annual appearance of Our Lady Mary for five days in the month of Genbot at the church of Deir al-Magtas in the Nile Delta. Mary appeared miraculously within a circle of light in the cupola of the church, surrounded by angels, prophets, martyrs and equestrian saints. The account of this miracle appears in the Ethiopian *Synaxarium* as well as in the *One Hundred and Ten Miracles of Our Lady Mary*.

Sanctuary Wall

2. Starting at the left of the top register is the Last Judgement, which occupies the full height of the wall down to the blank dado. The darkness of Hell is filled with light. Even though the painting has been damaged by rainwater, you can see that below Christ the colour was, and still is, white. His halo is depicted as radiant with its outer edge pierced with rays issuing from him. The scene is reminiscent of the vision in the Book of Daniel:

> A river of fire was flowing, coming out from before him. Thousands upon thousands attended him; ten thousand times ten thousand stood before him. The court was seated, and the books were opened. 'Then I continued to watch because of the boastful words the horn was speaking. I kept looking until the beast was slain and its body destroyed and thrown into the blazing fire.' (The other beasts had been stripped of their authority, but were allowed to live for a period of time.) (Daniel 7:10–2)

The 'beast', slain and thrown into the flames, is at the feet of Christ. The other beasts, two of the Devil's helpers, are standing by the fire, holding maces, their hair on end, looking up towards Christ. The river of fire is depicted as a thin red ribbon tied around the necks of the condemned. To Christ's right are five pairs of figures representing the souls who have been saved. Above them

we can see the archangel Michael who is guiding them to Paradise with, possibly, Enoch and Elijah who were already heavenly residents.

3. To the right of the Last Judgement, above the door is a badly damaged scene.

4. Next to it is the Nativity. Mary is admiring the baby Jesus, who is enclosed by his aura shown as a white cotton-like band. The man whom we would usually take to be Joseph is, in fact, Simeon as indicated by the inscription above him.

> Now there was a man in Jerusalem called Simeon, who was righteous and devout. He was waiting for the consolation of Israel, and the Holy Spirit was upon him. It had been revealed to him by the Holy Spirit that he would not die before he had seen the Lord's Christ. Moved by the Spirit, he went into the temple courts. When the parents brought in the child Jesus to do for him what the custom of the Law required, Simeon took him in his arms, and praised God […]. (Luke 2:25–8)

The inscription above Mary's head says, 'This picture shows us Our Lord Jesus Christ being born in a manger'. The Holy Family is surrounded by two delightful genre scenes: children (who are in fact the shepherds who have been guided to the Nativity by the angels) playing a game of *ganna* (a kind of hockey; *ganna* means birth and it is therefore connected with the Nativity); and, behind Mary, stands St Elizabeth carrying the baby John the Baptist within her shawl in just the same way as is done to this day in Ethiopia.

5. The Adoration of the Magi. Mary sits on an upright chair holding Jesus within her left arm. The three kings kneel before Jesus with their crowns and horses in front of him. Not only Mary and the three kings hold cups with their right hands to toast one another, but so does Jesus:

> After they had heard the king, they went on their way, and the star they had seen in the east went ahead of them until it stopped over the place where the child was. When they saw the star, they were overjoyed. On coming to the house, they saw the child with his mother Mary, and they bowed down and worshipped him. (Matthew 2:9–11)

The woman above the middle Magi is Mary Magdalene as indicated in the inscription by her head.

6. The last scene in the top register is the Flight into Egypt. This scene is partially damaged due to rainwater. One can see Salome in the background and Joseph by the head of the horse. Jesus is still

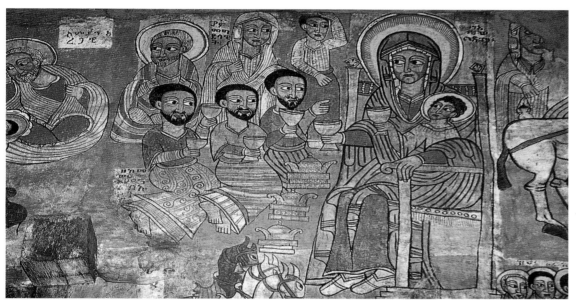

Fig. 130. South wall. The Adoration of the Magi

visible, but the body of Mary has disappeared. It is still possible to see that she was seated astride the horse, and her big toe is inside the stirrup leaving the rest of her foot free.

> So he got up, took the child and his mother during the night and left for Egypt, where he stayed until the death of Herod. And so was fulfilled what the Lord had said through the prophet: 'Out of Egypt I called my son.' (Matthew 2:14–5)

7. The Massacre of the Innocents is depicted between the door and the window. It is very realistically portrayed. One of the soldiers grabs a mother's hair as he reaches out for her baby. However, regardless of the chaos of the scene, there is a feeling of calmness about the figures, which is typical of the paintings in this church.

> When Herod realised that he had been outwitted by the Magi, he was furious, and he gave orders to kill all the boys in Bethlehem and its vicinity who were two years old and under, in accordance with the time he had learned from the Magi. Then what was said through the prophet Jeremiah was fulfilled. (Matthew 2:16–7)

8. Between the window and the end of the wall, below the Flight into Egypt, is a seated Jesus sending out the twelve disciples:

He called his twelve disciples to him and gave them authority to drive out evil spirits and to heal every disease and sickness. These are the names of the twelve apostles: first, Simon (who is called Peter) and his brother Andrew; James son of Zebedee, and his brother, John; Philip and Bartholomew; Thomas and Matthew the tax collector; James son of Alphaeus, and Thaddeus; Simon the Zealot and Judas Iscariot, who betrayed him. (Matthew 10:1–2)

9. Below is St Anthony, being given the belt of a monk by an angel. Behind him are two saints, probably *Abba* Macarius (his disciple who founded a monastery) and *Abba* Bula

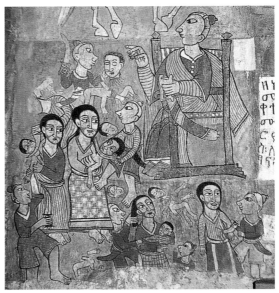

Fig. 131. South wall. The Massacre of the Innocents

(surname Abib) who helped *Abba* Macarius bury St Anthony in the garments of Athanasius of Alexandria. At this time it was the custom of holy men to retreat into the desert and live in seclusion, and St Anthony was to become one of the first Christian anchorites to establish a monastery. His feast is on the 22nd of Terr, and his life, as told in the *Synaxarium*, is summarised below.

St Anthony was born in the city of Keman in Egypt, south of Cairo, to Christian parents. Very early in his life he retreated into the desert to devote himself to God and where he was to be severely tempted by the Devil. After twenty years, God commanded Anthony to preach Christianity. And so he returned to the city, where many came to his side to be cured and to hear his doctrine.

After some time had passed, St Anthony resolved to go to Upper Egypt where no one knew him, and, while he was waiting for a ship to take him there, he heard a voice say, 'Where are you going Anthony? What do you lack here?' He replied, 'Many people come here and prevent me from living in solitude and that is why I want to go to Upper Egypt.' And the voice said, 'If you go to Upper Egypt, your annoyance will be doubled but if you really want to live alone, go for three days into the desert.' And Anthony joined an Arab caravan and returned to the desert and the solitude which he loved.

One day he heard a voice say, 'Go out and see what awaits you.' He went and saw an angel wearing a monastic garb with a girdle and a cord of the cross, and on his head

Debre Sina Maryam

East Side

North Side

1	The Forty Martyrs (the *Arbahara*) who were drowned in Lake Tana on the orders of Ahmad Gragn (1506–43).
2	King David playing his lyre.
3	King Solomon.
4	King Hezekiah.
5	King Josiah.
6	The Entry into Jerusalem.
7	Jonah, Daniel, and Manasseh.
8	Seven saints, left to right: Bakmis, Serabeon, Esderus, unidentified, Pumen, Busui and Sisoy.
9	Eight saints, left to right: Garima, Likanos, Abib, Latsun, *Abuna* Fer, Zelamon, Efrem and Thomas.
10	Eight saints, left to right: Alef, Zehema, Aftse, Za-Mikael Aragawi, Yemata, Guba, Pantaleon and an unidentified saint.
11	Virgin and Child.

1	Mary Queen of Heaven.
2	The Transfiguration.
3	St Justus (Yostos) on a black horse, killing the Berbers.
4	St Mercurius, on a brown horse, killing Julian the Apostate.
5	St Claudius spearing the *seba'at*.
6	St Philoteus killing the bull Maragd.
7	St Theodore the Oriental (Banadlewos) killing the King of Quz.
8	St Fasilidas on a bay horse.
9	The Ascension.
10	The Baptism of Jesus.
11	The Three Jews in the Fiery Furnace.
12	St Peter crucified upside-down.
13	The Stoning of St Stephen.
14	The Decapitation of John the Baptist.
15	St Cherkos and his mother, Julitta.
16	The Sacrifice of Isaac.

was a skull-cap like a helmet; he was seated, plaiting palm leaves. A voice said to him, 'Anthony, act wisely in this matter', and he took this to mean that he should become a monk and establish a monastery, which he did. *Abba* Macarius was to become one of his disciples and took over the running of the monastery after St Anthony's death.

Emperor Constantine (*c.* AD 274–337) heard about Anthony and sent him a letter asking that he be remembered in his prayers. Anthony answered him, and his reply was also read by the King of Barkinon, which was seven months' journey from Egypt. The King of Barkinon wrote to ask him to come to his country to bless its nation by the Passion of Our Lord Christ. Anthony said to God, 'If you wish me to go there, then give me a sign of your wishes.' While saying this, a cloud of light appeared and carried him away to Barkinon. The King rejoiced, and the sick were brought to him, and he healed them. He remained there for seven months, teaching the people, and many became monks. He was to become a commuter: each Sunday, the cloud of light brought him to his monastery in Egypt where he would comfort his people, and then the cloud would take him back to Barkinon the next day. Throughout his life, the Lord appeared to him many times and comforted him. And when he died, he went up into Heaven with great glory.

10. On the left-hand side of the plinth is another much damaged painting of the Trinity with only one of the three Persons of the Trinity remaining.

11. On the other side of the plinth, there is a very striking painting of Emperor Theodosius (AD 347–95) and possibly his Spanish wife, Aelia Flacilla. It was Theodosius who, in vigorous suppression of paganism and Arianism, established the creed of the Council of Nicaea (AD 325) as the universal norm for Christian orthodoxy and directed the convening of the Second General Council at Constantinople (AD 381).

East Side

Drum

1. These are the Forty Martyrs, the *Arbahara*, who, according to local tradition, were ordered to be drowned in Lake Tana by Ahmad Gragn (1506–43), the Muslim commander who raided much of the highlands of Ethiopia. They are shown here up to their waists in water, with bare torsos and haloes. This legend is most probably based on the Forty Martyrs of Sebaste.

In AD 320, Constantine was Emperor of the western segment of the Roman Empire and Licinius of the east. Under pressure from Constantine, Licinius had agreed to legalise Christianity in his territory,

and the two made an alliance. But Licinius later revoked the agreement and made a new attempt to suppress Christianity. He ordered his soldiers to repudiate it on pain of death.

In the 'Thundering Legion', stationed near Sebaste in Armenia (now Sivas in Turkey), forty soldiers refused. They were stripped naked one evening and herded onto the middle of a frozen lake and told that they could come ashore only when they were ready to deny their faith. To tempt them, fires were built on shore, with warm baths, blankets, clothing and hot food and drink close by. As night deepened, thirty-nine men stood firm, but one eventually broke and left for the shore. However, one of the soldiers standing guard was so moved by the fortitude of the Christians that he took off his clothes and ran out to join them. And so the number of the martyrs remained at forty. By morning, all were dead of exposure.

Sanctuary Wall

The top register is taken up with four seated kings from the Old Testament starting with:

2. David, who is playing the lyre.

3. Solomon, his hand on the pommel of his sword ready to administer justice.

4. Hezekiah (715–686 BC), son of Ahaz, and the thirteenth successor of David as King of Judah at Jerusalem. In preparing for the inevitable Assyrian campaign to retake Palestine, Hezekiah strength-ened the defences of his capital, Jerusalem, and dug out the famous Siloam tunnel which brought the water of the Gihon springs to a reservoir inside the city walls:

> As for the other events of Hezekiah's reign, all his achievements and how he made the pool and the tunnel by which he brought water into the city, are they not written in the book of the annals of the kings of Judah? Hezekiah rested with his fathers. And Manasseh his son succeeded him as king. (2 Kings 20:20)

5. After Hezekiah is Josiah, King of Judah (*c.* 640–609 BC) and grandson of Manasseh, who set in motion a reformation that bears his name and that left an indelible mark on Israel's religious traditions.

In the lower register, from left to right, are:

6. Jesus' Entry into Jerusalem. Jesus is riding a black and white striped horse which resembles a zebra. Perched in the tree separating this scene from the next is Zacchaeus. He is mentioned in the Bible as being in Jericho but Ethiopian iconographical tradition introduces him into the Palm Sunday scene:

Jesus entered Jericho and was passing through. A man was there by the name of Zacchaeus; he was a chief tax collector and was wealthy. He wanted to see who Jesus was, but being a short man he could not, because of the crowd. So he ran ahead and climbed a sycamore-fig tree to see him, since Jesus was coming that way. (Luke 19:1–4)

7. Three characters from the Old Testament. The first is Jonah, whose torso is shown emerging from the mouth of the whale: 'But the Lord provided a great fish to swallow Jonah, and Jonah was inside the fish three days and three nights' (Jonah 1:17). The second is Daniel who is lying enclosed within a tub with, behind it, a lion looking down on him: 'So the king gave the order, and they brought Daniel and threw him into the lions' den. The king said to Daniel, "May your God, whom you serve continually, rescue you!"' (Daniel 6:16). The third is Manasseh, who was the King of Judah, son of King Hezekiah. His story is told in 2 Chronicles 33. He was a great sinner who repented when, because of his action, he was taken prisoner to Babylon. These three men are grouped together perhaps because, in their distress, they called on the Lord to deliver them, and God saved them, as illustrated in the following biblical quotations:

From inside the fish Jonah prayed to the Lord his God. He said: 'In my distress I called to the Lord, and he answered me. From the depths of the grave I called for help, and you listened to my cry.' (Jonah 2:1–2)

The king was overjoyed and gave orders to lift Daniel out of the den. And when Daniel was lifted from the den, no wound was found on him, because he had trusted in his God. (Daniel 6:23)

And when he prayed to him, the Lord was moved by his entreaty and listened to his plea; so he brought him back to Jerusalem and to his kingdom. Then Manasseh knew that the Lord is God. (2 Chronicles 33:13)

8. In the bottom register, to the left of the window, are seven saints. From left to right, they are Bakmis, Serabeon, Esderus, unidentified, Pumen, Busui and Sisoy.

9. Also in the bottom register, but to the right of the window, are two rows of saints, eight in each row. In the top row from left to right are Garima, Likanos, Abib, Latsun, *Abuna* Fer, Zelamon, Efrem and Thomas.

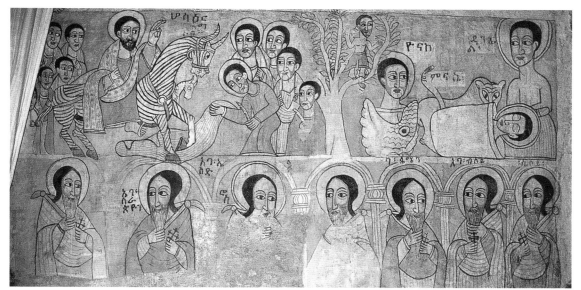

Fig. 132. East wall, left side. Above, left to right: the Entry into Jerusalem; Jonah, Daniel and Manasseh. Below: seven saints

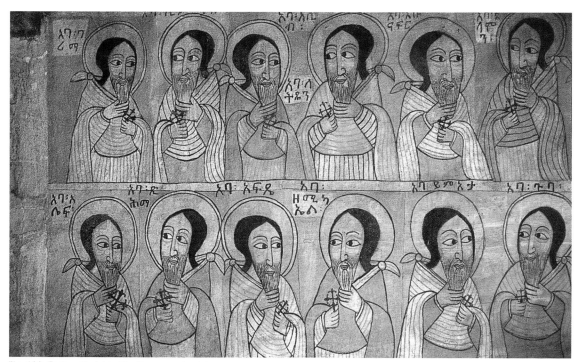

Fig. 133. East wall, right side. Two rows of saints

10. In the bottom row, left to right are Alef, Zehema, Aftse, Za-Mikael Aragawi, Yemata, Guba, Pantaleon and an unidentified saint. They are portrayed in pairs, gazing at one another, as if in conversation. In one hand they hold a hand-cross and with the other they are tenderly stroking their beards.

11. On the plinth is a painting of the Virgin and Child.

North Side

Drum

1. On the left is Mary as Queen of Heaven, standing within a rectangular *mandorla* supported by angels. She is dressed in a blue *maphorion* which covers her head and her red dress. She wears no crown but has a halo.

2. On the right is the Transfiguration. Jesus is in the centre of the scene with his hands out-stretched. To the right of him is Moses and, at his feet, is the prostrate figure of Elijah. Below Jesus the apostles John, James and Peter are asleep on the ground.

Sanctuary Wall

The top register has a series of six paintings of equestrian saints (**3–8**).

3. St Justus (Yostos), Basilides' nephew, on a black horse, killing the Berbers.

4. St Mercurius on a brown horse, killing Julian the Apostate. Amongst the numerous miracles attributed to the saint, a famous one is the murder of Julian the Apostate. Julian, after renouncing Christ, imprisoned St Basil of Caesarea, who, together with his followers, invoked St Mercurius' intervention against the Apostate. God listened to him and sent Mercurius the martyr, who ran his spear through Julian's head.

5. St Claudius (Gelawdewos) spearing a *seba'at*, a sort of centaur, except that it has a lion's body. The head of the *seba'at's* torso, which is that of a man, is much deteriorated.

6. St Philoteus killing the bull Maragd which his parents worshipped as an idol.

7. St Theodore the Oriental (Banadlewos) on a black horse killing the King of Quz.

8. St Fasilidas on a bay horse.

9. The panel at the far right is of the Ascension. Christ is depicted within a *mandorla* which is outlined by a white, cotton-like band. Surrounding Christ are his disciples.

> So when they met together, they asked him, 'Lord, are you at this time going to restore the kingdom to Israel?' He said to them: 'It is not for you to know the times or dates the Father has set by his own authority. But you will receive power when the Holy Spirit comes on you; and you will be my witnesses in Jerusalem, and in all Judea and Samaria, and to the ends of the earth.' After he said this, he was taken up before their very eyes, and a cloud hid him from their sight. (Acts 1:6–9)

In the second register, from left to right, are:

10. The Baptism of Jesus. Both John and Jesus are in the water which comes up to their waists. Fish are shown swimming around them. Christ's head is surrounded by a halo, having red rays within it, and he appears to be blessing John.

> Then Jesus came from Galilee to the Jordan to be baptised by John. But John tried to stop him, saying, 'I need to be baptised by you, and are you coming to me?' But Jesus answered him, 'Let it be this way for now, for this is the proper way for us to fulfil all righteousness.' Then John let him. When Jesus had been baptised, he immediately came up out of the water. Suddenly the heavens opened up for him, and he saw the Spirit of God descending like a dove and coming to rest on him. Then a voice from heaven said, 'This is my Son, whom I love. I am pleased with him!' (Matthew 3:13–7)

11. The three Jews in the Fiery Furnace. This event is celebrated by the Ethiopian Church on the 19th of Tahsas. Their story comes from Daniel 3 and it is retold in an abbreviated form in the *Synaxarium*, Tahsas 2:

> On this day God performed an act of power for the three children, that is to say, Ananias, Azarias and Misael [the Greek names for Shadrach, Meshach and Abednego], sons of Eliakim, the King of Judah, whom Nebuchadnezzar carried off into captivity with their father and he reared them in his home and sold them in the country of Babylon. When Nebuchadnezzar had made an image of gold he commanded his officers and the people of his kingdom to worship it. When certain men informed him that the saints had refused to worship it, he commanded his soldiers to cast them into the fiery furnace which had been heated seven times hotter than usual, and they prayed for a long time with their hands stretched out. Then the angel of the Lord went down and made the fire to become like a cool wind, and

he brought them out and the fire had neither touched them nor singed the hair of their heads. When Nebuchadnezzar saw this he bowed down and worshipped God and he honoured the three children exceedingly. Salutation to Shadrach, Meshach and Abednego who were preserved by God in a fiery furnace which was heated with pitch and asphaltum.

12. St Peter crucified upside-down. One of his executioners is pulling a rope around his feet. Peter, the leader of the apostles, the rock of the church, was put to death by Nero in AD 64, and he was crucified upside-down at his own request.

13. The Stoning of Stephen. Stephen was one of the seven disciples chosen by the twelve apostles to take on the job of the daily distribution of food so that they could be free to pray and preach the life of Jesus as told in Acts 7:8–60. Here, his martyrdom is depicted after he has rebuked the Jews: 'You stubborn people with uncircumcised hearts and ears! You are always opposing the Holy Spirit, just as your ancestors used to do' (Acts 7:51). When they heard this they were furious and:

> They raised a loud shout, held their ears shut, and together they all rushed at him. They threw him out of the city and began to stone him to death. Meanwhile, the witnesses laid their coats at the feet of a young man named Saul. As they continued to stone Stephen, he kept praying, 'Lord Jesus, receive my spirit!' (Acts 7:57–9)

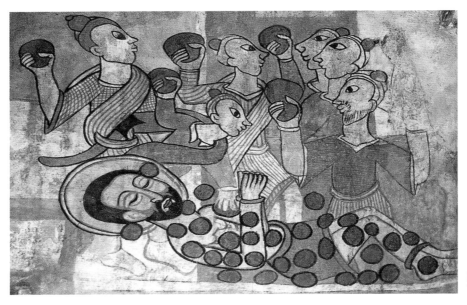

Fig. 134. North wall.
The stoning of Stephen

As I have said previously, this terrible event is depicted with absolute calmness on the faces of those involved. Stephen's tormentors are shown in exactly the same manner – their faces in profile, 'one-eyed' and chinless – as the many torturers in the church of Abuna Gabre Mikael at Koraro. It seems as though, for Ethiopian church-painters of this period, this was the accepted way in which to portray evil-doers.

14. On the left-hand side of the third register is the Decapitation of John the Baptist:

> For Herod himself had sent men who arrested John, bound him with chains, and put him in prison on account of Herodias, his brother Philip's wife. For Herod had married her. John had been telling Herod, 'It's not lawful for you to have your brother's wife.' So Herodias bore a grudge against John and wanted to kill him. But she couldn't do it because Herod was afraid of John. He knew that John was a righteous and holy man, and so he protected him. Whenever he listened to John, he did much of what he said. In fact, he liked listening to him.
>
> An opportunity came during Herod's birthday celebration, when he gave a banquet for his top officials, military officers, and the most important people of Galilee. When the daughter of Herodias came in and danced, she pleased Herod and his guests. So the king told the girl, 'Ask me for anything you want, and I'll give it to you.' He swore with an oath to her, 'I'll give you anything you ask for, up to half of my kingdom.' So she went

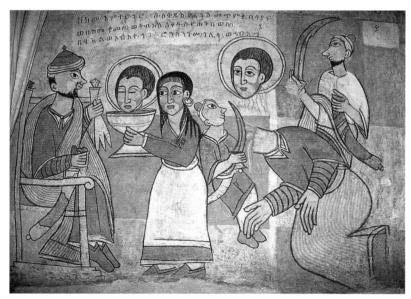

Fig. 135. **North wall.** The decapitation of John the Baptist

out and said to her mother, 'What should I ask for?' Her mother replied, 'The head of John the Baptist.' Immediately the girl hurried back to the king with her request, 'I want you to give me right now the head of John the Baptist on a platter.'

The king was deeply saddened, yet because of his oaths and his guests he was reluctant to refuse her. So without delay the king sent a soldier and ordered him to bring John's head. The soldier went and beheaded him in prison. Then he brought John's head on a platter and gave it to the girl, and the girl gave it to her mother. When John's disciples heard about this, they came and carried off his body and laid it in a tomb. (Mark 6:17–29)

John is depicted on the right, kneeling, his head already cut off and floating above his body. We see the 'one-eyed' guard above him, before the event and, in front of him, after the event. Salome presents his head in a bowl to the seated, 'one-eyed' Herod. Again, the scene is depicted without any trace of agitation on the part of any of those portrayed.

15. The next scene is of saints Cherkos and Julitta. Cherkos (Cyriacus), a Christian martyr at the age of three, and his mother Julitta are said to have been beheaded in AD 200 because of their Christian faith. Though the literature about this saint was forbidden by Pope Gelasius at his Council of seventy-two bishops in Rome in AD 494, the story of his martyrdom has remained very much alive in Ethiopia. Their story is told in the *Synaxarium*:

On the 15th of Terr, when Alexander was the governor, St Cherkos and his mother Julitta became martyrs. The governor asked Julitta to sacrifice to the gods, unless she wanted to die suffering cruel torments. She replied, 'If you want to do so, send someone in to the town to look for a three-year-old boy; he will tell us whom we must worship.'

The governor dispatched someone to look for him, and they found the boy, whose name was Cherkos. The governor asked him, 'What is your name?' The boy answered, 'I am a Christian and my baptismal name is Cherkos.' The governor told him, 'Sacrifice to the gods, so that I may honour you and give you some money.' The boy answered, 'Get away from me, you servant of Satan and enemy of justice.'

When he heard this the governor became furious and ordered that the boy be taken away and given fifty lashes, until his blood ran like water. When Julitta saw her son's constancy, she thanked God. The governor then ordered that a boiling cauldron be brought and that the two be thrown into it. When Julitta saw the cauldron she was filled with fear. Her son prayed, and God Almighty conferred on her a divine power so that when she entered into the cauldron with her son, nothing happened and they came out unburnt. The governor then ordered that they were put into a torture machine, to pull them with ropes, so that

their bodies were lacerated until the angel of God came and saved them. Since he could do nothing against them, the governor ordered that their necks be cut with a sword.

16. The Sacrifice of Isaac. Here we see Sarah, seated cross-legged, surrounded by two maids holding fly-whisks. Sarah wears a red ochre tunic and is enveloped by her off-white cloak which has a geometrical design, also in red ochre. She holds a flower in her left hand. Her luscious black hair is carefully arranged over her shoulders, as is the hair of one of her maids. She seems to be listening to what God says to Abraham:

> Some time later God tested Abraham. He said to him, 'Abraham!' 'Here I am,' he replied. Then God said, 'Take your son, your only son, Isaac, whom you love, and go to the region of Moriah. Sacrifice him there as a burnt offering on one of the mountains I will tell you about.' (Genesis 22:1–2)

What happened next is shown in the scene below Sarah:

> Abraham took the wood for the burnt offering and placed it on his son Isaac, and he himself carried the fire and the knife. As the two of them went on together, Isaac spoke up and said to his father Abraham, 'Father?' 'Yes, my son?' Abraham replied. 'The fire and wood are here,' Isaac said, 'but where is the lamb for the burnt offering?' Abraham answered, 'God himself will provide the lamb for the burnt offering, my son.'
>
> And the two of them went on together. When they reached the place God had told him about, Abraham built an altar there and arranged the wood on it. He bound his son Isaac and laid him on the altar, on top of the wood. Then he reached out his hand and took the knife to slay his son. But the angel of the Lord called out to him from heaven, 'Abraham! Abraham!' 'Here I am,' he replied. 'Do not lay a hand on the boy,' he said. 'Do not do anything to him. Now I know that you fear your God, because you have not withheld from me your son, your only son.' Abraham looked up and there in a thicket he saw a ram caught by its horns. He went over and took the ram and sacrificed it as a burnt offering instead of his son. (Genesis 22:6–13)

Isaac is seen on the right, carrying the wood for the offering. He wears only a tunic around his waist. In the next scene Isaac is lying down, his feet bound, his father about to kill him with an enormous curved knife. The Lord appears to him over the thicket, seated cross-legged and enveloped in his cloak which serves as a cushion, so typical of the paintings in this church. The poor ram can be seen with a rope around its neck, hanging from the flowering thicket.

Narga Selassie

West Side

1	The Trinity surrounded by the Tetramorph.
2	Adam and Eve, clothed, in the Garden of Eden.
3	The Annunciation.
4	The Nativity.
5	John baptising Jesus in the river Jordan.
6	Jesus agonising in the Garden of Gethsemane.
7	Jesus just before his capture.
8	The arrested Jesus being taken to Caiaphas, the high priest.
9	The Flagellation.
10	Jesus with the Crown of Thorns.
11	The Virgin and Child surrounded by two archangels. Queen Mentewab is below her.
12	The Covenant of Mercy (damaged).
13	St Raphael and the whale with a church on its back.
14	Moses bringing the Jews out of Egypt.
15	Pharoah and his drowning army.
16	Miriam beating a drum.
17	Aaron, the high priest and brother of Moses, holding a sistrum and a prayer-stick.
18	St Michael brandishing his sword.
19	The Devil tempting Euphemia.
20	The Crucifixion.
21	The prostrate Emperor Iyasu II (r. 1730–55).
22	St George killing the dragon and rescuing the princess Birutawit.
23	The Resurrection (very damaged).

North Side

1	Christ's Transfiguration on Mount Tabor.
2	St Aboli riding a light brown horse.
3	St Philoteus spearing the bull, Maragd.
4	Theodore of Rome riding a white horse, breathing spiritual fire and setting alight the evil ones.
5	St Claudius (Gelawdewos) riding a red horse and spearing a seba'at.
6	St Sissinios riding a brown horse.
7	St Marmehnam riding a white horse.
8	St Basilides.
9	St George represented as King of Martyrs.
10	The archangel Gabriel brandishing his sword.
11	Shadrach, Meshach, and Abednego in the fiery furnace.
12	The archangel Michael holding his sword.
13	Cherkos and Julitta in the flames of the fire (badly deteriorated).
14	Unidentified equestrian saint on a white horse.
15	St Mercurius riding a black horse which is trampling Julian the Apostate.
16	St George on a white horse, killing the dragon.
17	The Trinity surrounded by the Tetramorph.
18	The story of Adam and Eve.
19	The recumbent figure of Emperor Iyasu II.
20	Abraham and Sarah receiving three visitors.
21	Moses and the burning bush.
22	Moses receiving the tablets of stone.
23	God appears to Moses.
24	The Sacrifice of Isaac.
25	Jacob's ladder.
26	The Death of Jacob.
27	The Devil (as a black crow) tells Cain how to kill.
28	Cain kills Abel.
29	The Mourning of Abel.

Narga Selassie, Lake Tana

The first time I visited Lake Tana I went in a tour coach from Gondar to Bahar Dar via Gorgora and then around the eastern edge of the lake. It was a hot and dusty journey which I vowed I would not do again. When I did return, it was by boat, across the lake from Gorgora to Bahar Dar, stopping at several islands on the way – a far more pleasant and interesting way to travel. It was then that I first saw the church of Narga Selassie.

If you plan on visiting Narga Selassie, you can do it in a day from either Gorgora or Bahar Dar. I would strongly recommend that you depart from Bahar Dar because it is there that the only large and rapid boat is moored. On one occasion, my husband took a small launch, powered by a tired outboard motor, from Gorgora, visited Narga Selassie, and then went on to Bahar Dar. The journey, which ended in darkness on a boat with no lights, took eleven hours.

In 1747, Queen Mentewab, who had been baptised Walatta Giyorgis, the Regent to her son Iyasu II (1730–55), left the capital, Gondar, looking for a place to build a monastery. She sailed on Lake Tana in a fragile *tankwa* (the narrow papyrus craft used to this day by the locals), arriving at the largest of the islands, Dek, in the centre of the lake. She chose Narga, one of several islets of Dek that is linked to the main island by an isthmus which becomes submerged during the rainy season. Here she decided to build the monastery, which she dedicated to the Holy Trinity, together with a house for herself. Before departing on 21 April 1747 she ordered the construction to begin.

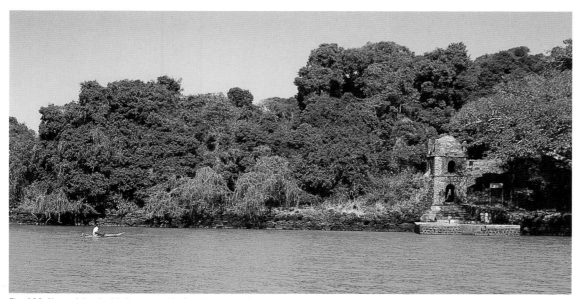

Fig. 136. Narga Island with its quay-side Gondarine turret

The history of the foundation and the first decoration of the monastery are recorded on a few pages which are bound together with a codex kept in Berlin. The report begins with a tribute in which she is compared to Empress Helena, the mother of Emperor Constantine:

'We want to write down the report on the piety of our king Iyasu and our queen Walatta Giyorgis, as their piety has given us great delight; because there is no king like Iyasu, except for Constantine, and there is no queen like Walatta Giyorgis, except for Helena; because they are like one another: their love is the same, their shrewdness is the same and their piety is the same.' The writer goes on to explain the largesse of Queen Mentewab. Once again she is compared to Helena. Just as the latter had cleaned Mount Calvary in order to able to dig for Christ's Cross, so Mentewab cleaned the place on which the future church was to be erected. She exhorted the smiths and builders whom she had commissioned with the construction: 'Be grieved if I shall no longer experience the completion of the construction works; but you will not be able to complain of a shortage of material. I shall not allow there to be a lack thereof.' (Hein and Kleidt, 1999, p. 179)

Two processional crosses given to the church bear incised portraits of Mentewab and Iyasu II thus suggesting that both the construction and the paintings were completed, and the church dedicated to the Holy Trinity, before Iyasu's death in 1755. (Di Salvo, 1999, p. 23)

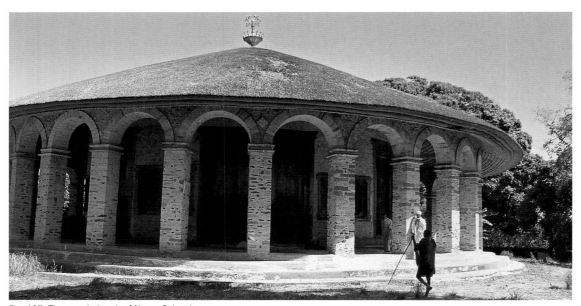

Fig. 137. The round church of Narga Selassie

There are two entrance gates to the church compound: a very imposing, well-preserved, Gondarine two-tier turret, surmounted by a dome with four pinnacles, which is at the quayside, and a ruined round tower on the side of the isthmus linking Narga to Dek. Originally they were an integral part of the lower wall defending the islet and could have been used as observation and signalling posts. Also, in part of this wall is the small structure of the 'Bethlehem' where bread and wine for mass are prepared.

A wide and long quay built in 1993 makes for easy disembarkation. From the turret at the quayside you make your way up some 60 metres to the circular wall of the church compound with the church at its centre. The entrance gate to the sacred enclosure is another Gondarine two-tier tower with four pinnacles similar to the one at the water's edge. On its exterior a cornice marks the first-floor level and the ceiling of the second.

The Church

The church is a round, centrally planned building which used to have a conical thatched roof, recently replaced by one of corrugated iron. It has three circular concentric parts and rests on a podium. An exterior portico comprises twenty-nine rectangular columns and round-headed arches made up of perfectly fitted voussoirs with an ensuing ring supporting the roof. The columns, as well as the wall inside the church, are made from irregularly hewn stones, set in mortar, whereas the corners are constructed with squared-off stones. This is the *qene mahlet* or exterior ambulatory (see Fig. 1, p. xxiv).

Next there is the circular wall of the church which has eight doorways, allowing an unusual amount of light into the interior. The west doorway, which is the widest, has triple leaves; the north, east and south doorways have double leaves. Between each of these entrances there are four single-leaf doors. The space between the walls and the sanctuary forms the *qeddest*. The wall is covered in white plaster. In the centre is the sanctuary, the *maqdas*, and towering above it can be seen the circular drum. Both the sanctuary and drum are covered in paintings.

Wooden windows and door frames recede into the sanctuary wall and are constructed with three recessed beams. Instead of having Aksumite 'monkey-heads', they have a corrugated rectangular wooden piece which bridges the gap between the angles. The outer frames of some of the doors and windows are covered with plaster and are painted with a double line of small squares with flower patterns on a red or green background, alternating with landscapes and naturalistic details, such as a bird catching a fish, sketched with quick brushwork of marine blue on a white background. Mario Di Salvo, who has studied this church in detail, has seen them as imitating 'azulejo' tiles which are widely used in the Iberian Peninsula. The interior recessed frames are covered with rows of angels' faces, similar to those in Gondar's Debre Berhan Selassie.

From the drum spring twelve rafters, which rest on the exterior wall of the church, and which in turn support a double crown of trusses on which the roof rests. All are richly painted and decorated.

On a plaque placed in 1951 on one of the pilasters is written, in the beautiful characters of the Ethiopian alphabet: 'The building of this church of Narga Selassie started at the beginning of the eighteenth century by Empress Mentewab. Since the roof, the *qeddest*, the *qene mahlet* and six pilasters were damaged, in 1944, in the 23rd year of his reign, Emperor Haile Selassie I had them completely restored. The paintings, many of the doors and the windows belong to the ancient time' (Di Salvo, 1999).

The Paintings

The paintings have been executed on canvas, by different artists; they are not frescoes. Some have deteriorated due to water seepage from the old thatched roof, and some, the lower ones, have been damaged by contact with human bodies. Restoration work has been performed on several, and others have been substituted with later paintings. They are easily removed from the walls and replaced.

Chojnacki, in his recent study of these paintings, has classified them as belonging to the Qwara style, named after the region of Queen Mentewab's origin, and considers them the pearl of this style. The Qwara School belongs to the mainstream of the Second Gondarine style but has its own characteristics. The colours are intense but clear, in a variety of hues of red, orange, brown and a distinctive green which has a bluish shade. The faces are rounded, even those of the Holy Trinity on the north wall who are portrayed as old men with grey hair, moustaches and beards (Di Salvo, 1999, p. 131). As in all the paintings of the Second Gondarine style, the clothes are meticulously depicted.

Until the eighteenth century, the figures of the church donors seldom appeared. Ethiopian rulers started being depicted below the figures of the Virgin or Christ or a favourite saint as the century wore on, and in this church we have the figure of Queen Mentewab prostrated below the Virgin and Child (see Fig. 30, p. 47). Queen Mentewab was not only beautiful – her name means 'How beautiful she is' – but was a remarkable woman who ruled both during the reign of her son, Iyasu II (1730–55) and also during the reign of her grandson, Iyoas (1755–69).

West Side

1. The west side of the drum has a painting of the Trinity surrounded by the Tetramorph. The Trinity is depicted as three identical figures represented in the Ethiopian manner as old men with white hair, holding an orb in their left hand, symbol of their power on earth.

2. A clothed Adam and Eve in the Garden of Eden, are symbolised by a flowering tree.

The west wall of the sanctuary is devoted to the theme of redemption from the Annunciation to the Crucifixion and the Covenant of Mercy. The paintings in the top register, from left to right, are as follows:

3. The Annunciation. A startled Mary, her left hand drawn to her chest, was reading when the archangel Gabriel dressed in a sumptuous courtly manner, appeared on a cloud offering her a flower. The event is described in the *Synaxarium*, Magabit 29:

> In the sixth months after the conception of Elizabeth, Gabriel was sent from God to Nazareth to a virgin, named Mary, who was betrothed to Joseph of the house of David. The angel said to Mary, 'Rejoice, Oh full of grace, God is with thee.' She was troubled at his voice but she had confidence in him. Gabriel said, 'Fear not, thou hast found grace with God. Thou shalt conceive and bear a son, His name shall be Jesus and He shall be great and shall be called the 'Son of the Highest' and the Lord shall give Him the throne of his father David and He shall reign over the House of Jacob for ever, and to His kingdom there shall be no end.' The Virgin answered, 'How can this happen to me? How can I conceive since I have never known a man?' The angel answered, 'The Holy Spirit shall come unto thee, and the power of the Most High shall overshadow thee and He who shall be born of thee is holy, and shall be called the Son of God.' And then he gave her the sign of the truth of his annunciation to her. He said, 'Behold Elizabeth, thy kins-woman, who was barren, hath conceived in her old age, for nothing is impossible with God.' Mary answered, 'Behold, I am hand-maiden of the Lord – let him deal with me as you have said.'

4. The Nativity. The baby Jesus is surrounded by Mary and a diminutive Joseph. Unusually, at the head of the crib, a large-sized angel is praying over the child. One of the shepherds carries a lamb over his shoulders.

5. John baptising Jesus in the river Jordan. Jesus is immersed up to his chest in the river with fish swimming around him. The dove of the Holy Spirit hovers over him and, exceptionally, God the Father is also depicted emerging from a cloud above the Holy Spirit.

> Then Jesus came from Galilee to the Jordan to be baptised by John. But John tried to stop him, saying, 'I need to be baptised by you, and are you coming to me?' But Jesus answered him, 'Let it be this way for now, for this is the proper way for us to fulfill all righteousness.' Then John let him. When Jesus had been baptised, he immediately came up out of the water. Suddenly the heavens opened up for him, and he saw the Spirit of God descending like a dove and coming to rest on him. Then a voice from heaven said, 'This is my Son, whom I love. I am pleased with him!' (Matthew 3:13–7)

6. Jesus agonising in the Garden of Gethsemane. The painting shows the disciples asleep while Jesus is praying. He has a vision of himself carrying the Cross which is depicted in front of him on the left of the panel.

> Then Jesus went with his disciples to a place called Gethsemane, and he said to them, 'Sit here while I go over there and pray.' He took Peter and the two sons of Zebedee along with him, and he began to be sorrowful and troubled. Then he said to them, 'My soul is overwhelmed with sorrow to the point of death. Stay here and keep watch with me.' Going a little farther, he fell with his face to the ground and prayed, 'My Father, if it is possible, may this cup be taken from me. Yet not as I will, but as you will.' Then he returned to his disciples and found them sleeping. (Matthew 26:36–40)

7. The next episode of Jesus just before his capture is shown in a panel divided into two by a set of arrows pointing downwards. On the left side of the panel Jesus is shown walking, followed by his disciples. On the right side is Judas with the armed crowd. At the feet of Jesus, below the tips of the arrows separating the two sides, one of his disciples is depicted cutting off the ear of the high priest's servant.

> 'Rise, let us go! Here comes my betrayer!' While he was still speaking, Judas, one of the Twelve, arrived. With him was a large crowd armed with swords and clubs, sent from the chief priests and the elders of the people. (Matthew 26:46–7)

> With that, one of Jesus' companions reached for his sword, drew it out and struck the servant of the high priest, cutting off his ear. (Matthew 26:51)

8. The last scene in this top register portrays Jesus arrested and being taken to Caiaphas, the high priest:

> Those who had arrested Jesus took him to Caiaphas, the high priest, where the teachers of the law and the elders had assembled. (Matthew 26:57)

The story of Jesus' life and death continues down the right-hand side of the wall as follows:

9. The Flagellation:

> They spat on him, and took the staff and struck him on the head again and again. (Matthew 27:30)

10. Jesus with the Crown of Thorns being mocked by soldiers.

The soldiers led Jesus away into the palace (that is, the Praetorium) and called together the whole company of soldiers. They put a purple robe on him, then twisted together a crown of thorns, and set it on him. And they began to call out to him, 'Hail, king of the Jews!' Again and again they struck him on the head with a staff and spat on him. Falling on their knees, they paid homage to him. And when they had mocked him, they took off the purple robe and put his own clothes on him. Then they led him out to crucify him. (Mark 15:16–20)

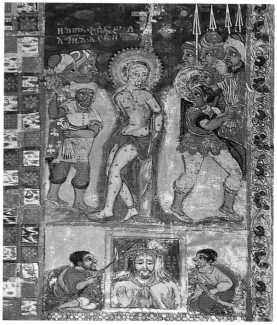

Fig. 138. West wall. Above: the Flagellation. Below: Jesus wears the Crown of Thorns

Here we have two soldiers on each side of a painting of Jesus wearing a crown of thorns, one of whom is striking it. This painting is a powerful copy of the imperial icon known as *Kwer'ata re'esu* (the striking of his head), a sixteenth-century European painting which the Gondarine kings adopted as their imperial standard. Loyalty to the Emperor was sworn upon this icon. It was carried into battle since it was said to have been painted by St Luke (but it was clearly of European origin) and was believed to have divine powers of intercession. It was to have a great influence on art and was copied both in manuscripts and in church paintings from the eighteenth century onwards.

The story of the painting, which was most probably taken to Ethiopia by the Jesuits, has been related by Richard Pankhurst. In 1744, in a campaign against the Sudan in which the Ethiopians were put to rout, the icon was captured by the Sudanese and later retrieved by diplomatic means. It arrived back in Gondar at the time when James Bruce, the Scottish explorer, happened to be there. Bruce recounted the jubilant processions which accompanied its return and, more importantly, he was the one to describe the painting for the first time. He related that it was transferred to an island in Lake Tana for safe-keeping.

It was at the Battle of Magdala in 1868 that the icon was to fall into British hands – the hands of Richard Holmes, an employee of the British Museum, who had accompanied the British forces as their archaeologist. His true role was to acquire as many treasures as possible for the Museum. However, this work of art was to return to England and remain in his hands. Emperor Yohannes IV wrote to

Queen Victoria and to Granville, the Foreign Secretary, requesting its restitution to Ethiopia and stressing its historical importance to the nation. The British Museum was requested to locate it but replied that it was not in their possession and that they did not know of its whereabouts. By this time, Richard Holmes had become the librarian at Windsor Castle and still he did not own up to its possession. It was eventually sold at Christies in 1917 by his widow for £420 to a gentleman from Wimbledon. In 1950, it was reoffered for sale and was bought for £315 by Luiz Reis Santos, a Portuguese art historian and a professor at Coimbra University. It is believed that it is still in Portugal, in the possession of Santos' widow.

11. The Virgin and Child surrounded by two archangels (see Fig. 30, p. 47). She wears a magnificent blue coat embroidered with flowers. Below her is the patron of this church – the Queen and Regent Mentewab – who is lying outstretched. This is one of the most delightful paintings in this church. Queen Mentewab wears a heavily embroidered skirt, in blues and reds, and a white blouse. Her hair is pulled back and pleated in such a way as to give the impression of a crown surrounding her serene and beautiful face.

12. The dado has a damaged painting of the Covenant of Mercy in which Jesus and Mary are sitting together with joined hands, symbolically signifying the promise of Christ to answer the prayers of those who make supplication in the name of his mother, Our Lady Mary. Below is a depiction of the prostrate Emperor Iyasu and his mother Queen Mentewab.

In the centre of the wall is a recessed doorway with three arched panels framed by a band of a double line of squares with yellow flowers against an alternating red and green background. In between are landscapes and naturalistic details sketched in marine blue against a white background. The interior recessed frames are covered with rows of angels' faces.

13. In the right-hand panel is St Raphael with the whale, which has a church on its back (see Fig. 13, p. 22). He is said to have saved a church in Egypt which was threatened by the thrashing about of a whale that had been washed ashore by a flood. Raphael is depicted killing the whale with his spear.

14. The centre panel which actually is the door into the sanctuary, depicts a scene from the story of Moses bringing the Jews out of Egypt. Here, Moses is touching the sea with his prayer-stick.

> Moses stretched out his hand over the sea, and at daybreak the sea went back to its place. The Egyptians were fleeing towards it, and the Lord swept them into the sea. The water flowed back and covered the chariots and horsemen – the entire army of Pharaoh that had followed the Israelites into the sea. Not one of them survived. (Exodus 14:27–8)

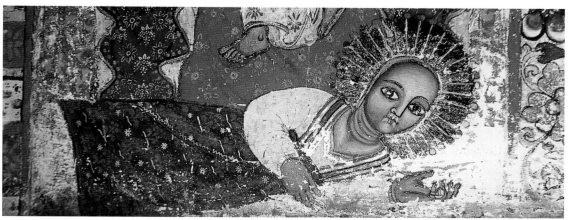

Fig. 139. West wall. Queen Mentewab

15. The Pharaoh is surrounded by his drowning army with only the tops of their heads, their spears, and their rifles, remaining visible.

16. On the right leaf is Miriam depicted as told in Exodus 15:20: 'Then Miriam the prophetess, Aaron's sister, took a tambourine in her hand, and all the women followed her, with tambourines and dancing'. Except that here she is beating a drum.

17. At the bottom is the figure of Aaron, the high priest, holding a sistrum and a prayer-stick. He was the elder brother of Moses, three years his senior.

18. On the left is St Michael wearing lavishly painted clothes and brandishing his sword.

19. Below St Michael is a small illustration of the Devil tempting Euphemia; she was to become a saint and is venerated on the 12th of Sene. This is a purely Ethiopian story and is described by Eustathius, who is said to have been a priest under Bishop Anthimus, in *St Michael the Archangel: Encomium of Eustathius* which I have summarised below:

> Euphemia was the wife of Aristarchus, a general in the service of Emperor Honorius (AD 395–423), by whom he had been appointed governor of Trake (Mesopotamia). Aristarchus was a Christian and had been baptised by St John Chrysostom (AD 347–407). He was devoted to St Michael and offered gifts in his name every month. When he was nearing his death, he entreated his wife Euphemia not to neglect the offering to St Michael and to continue to make gifts to the poor and to the Church after his death.

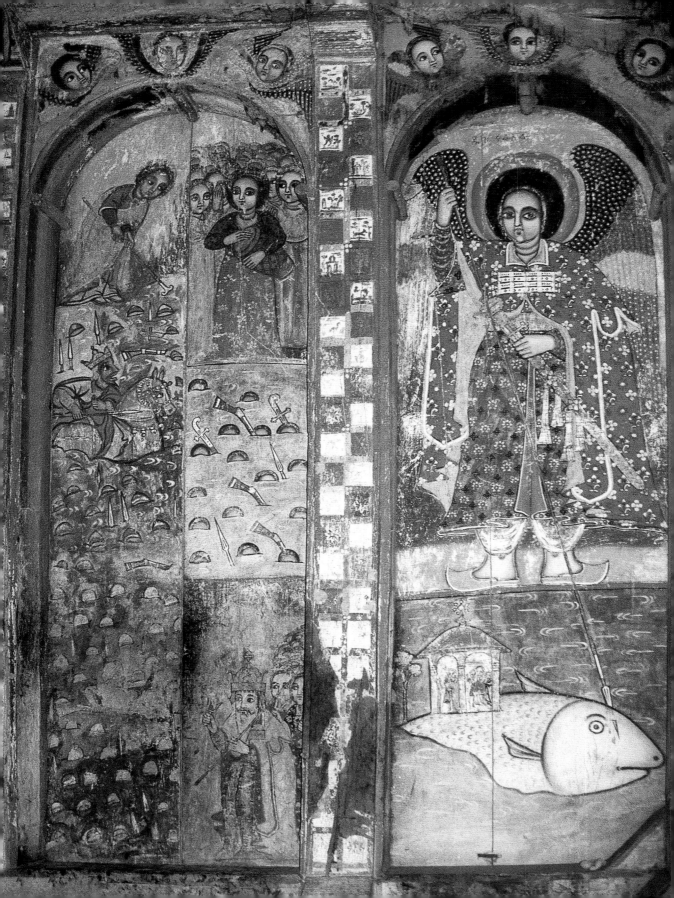

Fig. 140 (left). West wall door. Centre panel: Moses bringing the Jews out of Egypt. Right panel: St Raphael and the whale

She replied that she would do so and, indeed, that she would increase them. She begged her husband to have a portrait of archangel Michael painted on a wooden tablet so that she may hang it in her bedroom to induce the saint to protect her and be her guardian after her husband's death. After the painting was completed and Aristarchus had committed his wife to the care of St Michael, he died.

The envy of the Devil was roused, and he tempted Euphemia constantly because he wanted her to marry Hilarichus, the Chief Prefect of Emperor Honorius, whose wife had recently died. The Devil disguised himself as a nun and thus gained admittance to her presence. He offered her many gold and silver ornaments to persuade her, but she said she would only remarry if her guardian gave her permission. She crossed herself and asked St Michael for his help and the Devil departed.

But the Devil appeared to her a second time, now disguised as a goat carrying a sharp two-edged sword in his hands. Euphemia fled to her painting of St Michael and asked for his help. And yet again the Devil came to her, this time in the form of St Michael holding a golden sceptre but lacking his cross. And so Euphemia recognised that he was the Devil and asked him to salute her picture of St Michael, whereupon the Devil turned himself into a lion and attacked her. Euphemia cried out to St Michael, who immediately appeared in all his glory and chastised the Devil and drove him away in disgrace.

When Euphemia was nearing death, she went to the bishop of the city and he administered the sacraments. He then came to her house where she donated everything she owned to him to give to

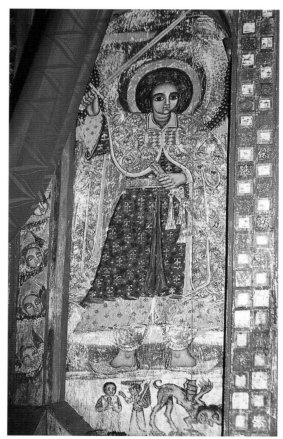

Fig. 141. West wall door. Left panel: St Michael and, below, the Devil tempting Euphemia

the poor. She then went to her bed holding the sacred painting of St Michael and prayed to the archangel to be with her in her dying hours. Suddenly there was a sound like the roar of a waterfall, and all present saw the archangel appear in great glory and take the soul of Euphemia up to Heaven.

The painting, which had been lying on Euphemia's face when she died, disappeared miraculously. No one knew where it had gone. But when they had buried her and had gone back to the church to celebrate the sacrament, it was seen hanging in the centre of the apse without any support whatsoever. The news of this miracle reached Constantinople and the Emperor and Empress came to Trake to see it.

In this small painting, we see Euphemia protecting herself by clasping the painting of the archangel Michael to her breast. In front of her is the Devil in the form of St Michael with archangel's wings but having the horns of the Devil. The horrifying, oversized beast to the right is the Devil disguised as a goat.

To the left of the doorway are the following scenes:

20. The Crucifixion. On a background which is now white but used to be painted in yellow, orange and blue, we see Christ depicted as an older, bearded man with a rather emaciated torso. His mother Mary is kneeling with her arms around his Cross, while John is praying on the right. A centurion stands below the Cross and gives Christ a sponge filled with vinegar.

> Immediately one of them ran and got a sponge. He filled it with wine vinegar, put it on a stick, and offered it to Jesus to drink. (Matthew 27:48)

Below John's feet there are three faces which represent the event that took place after the death of Christ.

> At that moment the curtain of the temple was torn in two from top to bottom. The earth shook and the rocks split. The tombs broke open and the bodies of many holy people who had died were raised to life. (Matthew 27:51–2)

The man on horseback to the left of the picture is the centurion, Longinus, who is spearing Christ's side.

21. Below the above scene, and separated from it by a red line, is the young Emperor Iyasu II lying prostrated in the way donors are usually depicted in Ethiopian churches. To the left are a

group of Iyasu's soldiers, holding spears and maces – the implied message is that the Emperor's soldiers are ready to fight the enemies of Christ.

22. Below this is St George, riding a white horse and killing the dragon (see Fig. 16, p. 27). Birutawit, the mythical princess, daughter of the King of Beirut, is shown perched in a tree.

23. On the dado is a much damaged painting of the Resurrection.

North Wall

1. The north side of the drum is taken up with Christ's Transfiguration which took place on Mount Tabor. The scene follows the New Testament description:

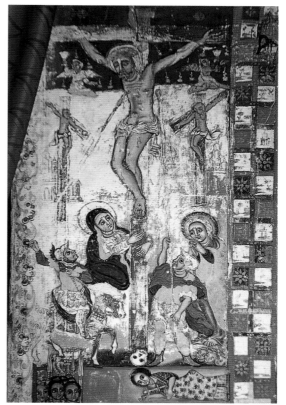

Fig. 142. West wall. The Crucifixion with King Iyasu II below

> After six days Jesus took with him Peter, James and John the brother of James, and led them up a high mountain by themselves. There he was transfigured before them. His face shone like the sun, and his clothes became as white as the light. Just then there appeared before them Moses and Elijah, talking with Jesus. Peter said to Jesus, 'Lord, it is good for us to be here. If you wish, I will put up three shelters – one for you, one for Moses and one for Elijah.' While he was still speaking, a bright cloud enveloped them, and a voice from the cloud said, 'This is my Son, whom I love; with him I am well pleased. Listen to him!' When the disciples heard this, they fell face down to the ground, terrified. But Jesus came and touched them. 'Get up,' he said. 'Don't be afraid.' When they looked up, they saw no one except Jesus. (Matthew 17:1–8)

Christ is depicted resplendently robed in a white garment embroidered with red flowers and surrounded by an orange aura, all against a vivid yellow background. A bright white cloud envelops and isolates Christ from the rest of the group. Moses and Elijah and two angels are at either side while

God the Father appears in a cloud above Jesus. The three apostles – Peter, James and John – are shown seated below. Peter appears to be overcome by the vision; his arms are outstretched, and he appears to be falling backwards.

The north wall is dedicated to equestrian saints and scenes from the Old Testament. It is pierced by a recessed door, and the entire wall is framed by a band of flowers. The top register is a continuous cycle of equestrian saints. Their horses are trotting towards the right and are shown in profile. The saints are shown in three-quarter stance with their capes blowing out behind them; they each hold a spear and have only their big toe in the stirrup. Each is identified with his name written below his horse or by their symbol. Saint and horse are enveloped in a green or red aura against a mustard-yellow background.

Starting at the top left corner:

2. St Aboli riding a light brown horse. Below his horse is a prostrate man who has been speared twice.

3. St Philoteus is spearing the bull, Maragd, which was the subject of idol-worship by his parents.

4. Theodore of Rome riding a white horse, breathing spiritual fire and setting alight the evil ones.

5. St Claudius (Gelawdewos) is riding a red horse and spearing a *seba'at*, a sort of centaur with a lion's body and a human torso (see Fig. 19, p. 32).

6. St Susenyos riding a brown horse.

7. St Marmehnam riding his white horse. The top part of the painting has gone but the symbols of a church and a woman offering food to a person are still visible. In *Churches of Ethiopia* (p. 204), Raineri has described the life of this saint as follows:

> On the 14th of Tahsas Saint Marmehnam, his sister Sarah and their forty servants were martyred. His father was King Ator, a pagan, while his mother was a Christian. The monk Matthew miraculously cured Marmehnam of leprosy and later baptised the saint, his sister and their servants. When he found out that they had embraced Christianity, Ator, who could not dissuade them from their faith, had them beheaded and ordered their bodies to be burnt. The Lord, however, hid their mortal spoils. Due to the intervention of Marmehnam's mother, the monk Matthew first freed the King from Satan and later baptised him and all the city population and ordered that a church dedicated to the Virgin was built and their wealth was distributed amongst the poor. The mother of the martyred brother and sister then had tombs built where her children and their servants could receive a worthy burial.

8. St Basilides.

9. St George represented as King of Martyrs. Both figures are seated on stationary, majestic horses covered with richly embroidered saddle-cloths that reach down to their hocks.

The recessed door has an outer frame that consists of a double line of squares with yellow flowers against a red background, alternating with landscapes and naturalistic details sketched in marine blue on a white background. The interior recessed frames are covered with rows of angels' faces.

10. On the right leaf is Gabriel as the guardian archangel brandishing his sword in his right hand with a long-handled cross in his left which is pointing down towards:

11. The three Jewish youths – Shadrach, Meshach, and Abednego – in the fiery furnace. They are about to be rescued by Gabriel. This event is mentioned in Daniel 3:25–7 but is also described in the following quotation from the Old Testament Apocrypha:

> He (Nebuchadnezzar) said, 'Look! I see four men walking around in the fire, unbound and unharmed, and the fourth looks like a son of the gods.' Nebuchadnezzar then approached the opening of the blazing furnace and shouted, 'Shadrach, Meshach and Abednego, servants of the Most High God, come out! Come here!' Shadrach, Meshach and Abednego came out of the fire and the satraps, prefects, governors and royal advisers crowded around them. They saw that the fire had not harmed their bodies, nor was a hair of their heads singed; their robes were not scorched, and there was no smell of fire on them. (Daniel 3:25–7)

12. On the left leaf is Michael as the guardian archangel holding a sword, which is pointing downwards, in his left hand. This painting is much deteriorated.

13. It appears that St Michael is rescuing Cherkos and Julitta, but only one of the two, and the flames of the fire, remains visible. Cherkos (Cyriacus), a Christian martyr who was burned in AD 200, and his mother, Julitta, are said to have suffered death by fire because of their Christian faith when Cyriacus was only three years old. Though the literature about this saint was forbidden by Pope Gelasius at his Council of seventy-two bishops in Rome in AD 494, the story of his martyrdom has remained very much alive in Ethiopia.

The second register to the left of the door is taken up by three more equestrian saints.

14. The first equestrian saint (unidentified) is riding a white horse.

15. In the centre is St Mercurius riding a black horse which is trampling Julian the Apostate. To the right, in a small panel level with the horse's head, are St Basil, Bishop of Caesarea in Cappadocia, and St Gregory, his friend; both are praying to St Mercurius.

16. St George riding a white horse and killing the dragon.

17. On the left-hand side, below the equestrian saints, is the Trinity surrounded by the Tetra-morph, symbols of the four evangelists: the man, Matthew, top left; the lion, Mark, bottom left; the ox, Luke, bottom right; and the eagle, John, top right. As mentioned in the 'Iconography' section of Chapter 2, the theme of the Trinity is of European origin, and that seems to be the reason for the figures to be wearing European dress. Here, each is clothed in a light green tunic with a small pointed collar forming a square around the neck. Their red ochre cloaks are richly decorated with flowers in greens and whites with grapes depicted in black. Each Person is sur-rounded by a halo in the same green as their tunic. They have short grey, wavy hair and neatly trimmed white beards and drooping moustaches. They have large, open eyes. Their right hands make a gesture of blessing while their left holds a white egg.

18. Below is the story of Adam and Eve. It starts with the bust of Adam. Next is Adam lying down with Eve emerging from his side followed by the two of them enjoying Paradise, the Garden of Eden, symbolised by flowering trees. They are fully clothed. Below this we see them naked on either side of a tree with God shown behind Eve, banishing them from Paradise. On the right-hand side of the painting they are shown sitting together, crying.

19. Below is the recumbent figure of Emperor Iyasu II, here depicted for the second time in this church. His sword scabbard protrudes from his body and is clearly visible.

To the right of the Trinity we have scenes from the Old Testament stretching all the way to the sanctuary door.

20. They start with Abraham and Sarah receiving three visitors. The three men are envoys of God who come to forewarn them of the birth of a son. They could be mistaken for the Trinity, but a closer look reveals that they have their hands folded. They are messengers of God, and that is why they have haloes.

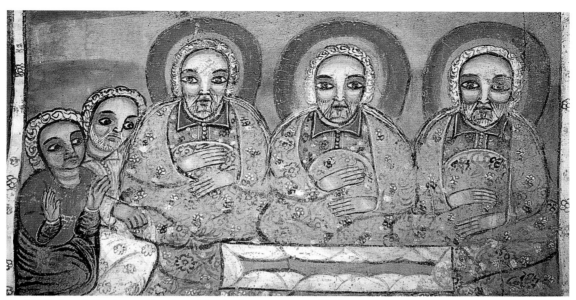

Fig. 143. North wall. Abraham and Sarah receiving the three messengers of God

The Lord appeared to Abraham near the great trees of Mamre while he was sitting at the entrance to his tent in the heat of the day. Abraham looked up and saw three men standing nearby. When he saw them, he hurried from the entrance of his tent to meet them and bowed low to the ground. He said, 'If I have found favour in your eyes, my lord, do not pass your servant by. Let a little water be brought, and then you may all wash your feet and rest under this tree. Let me get you something to eat, so you can be refreshed and then go on your way – now that you have come to your servant.' 'Very well,' they answered, 'do as you say.' So Abraham hurried into the tent to Sarah. 'Quick,' he said, 'get three seahs of fine flour and knead it and bake some bread.' Then he ran to the herd and selected a choice, tender calf and gave it to a servant, who hurried to prepare it. He then brought some curds and milk and the calf that had been prepared, and set these before them. While they ate, he stood near them under a tree. 'Where is your wife Sarah?' they asked him. 'There, in the tent,' he said. Then the Lord said, 'I will surely return to you about this time next year, and Sarah your wife will have a son.' (Genesis 18:1–10)

21. Moses and the burning bush. Moses kneels in front of the burning bush. In his right hand he holds his prayer-stick over his shoulder, while his left hand is cupped over his ear giving the appearance that he is trying to hear better the voice coming from the burning bush.

There the angel of the Lord appeared to him in flames of fire from within a bush. Moses saw that though the bush was on fire it did not burn up. So Moses thought, 'I will go over and see this strange sight – why the bush does not burn up.' When the Lord saw that he had gone over to look, God called to him from within the bush, 'Moses! Moses!' And Moses said, 'Here I am.' (Exodus 3:2–4)

22. Moses receiving the tablets of stone. He is standing while he receives the tablets from God. The presence of God is implied by a hand emerging from a white cloud handing over the tablets.

The Lord said to Moses, 'Come up to me on the mountain and stay here, and I will give you the tablets of stone, with the law and commands I have written for their instruction.' (Exodus 24:12)

23. God appears to Moses.

24. The Sacrifice of Isaac. A continuous narrative shows, first, Isaac carrying a bundle of wood and following behind his father. To the right, a half-naked Isaac kneels over an altar. Abraham is brandishing a knife ready to sacrifice his son. A full-size angel stands over Isaac, his hand extended to stop Abraham using the knife.

Some time later God tested Abraham. He said to him, 'Abraham!' 'Here I am,' he replied. Then God said, 'Take your son, your only son, Isaac, whom you love, and go to the region of Moriah. Sacrifice him there as a burnt offering on one of the mountains I will tell you about.' (Genesis 22:1–2)

Abraham took the wood for the burnt offering and placed it on his son Isaac, and he himself carried the fire and the knife. As the two of them went on together, Isaac spoke up and said to his father Abraham, 'Father?' 'Yes, my son?' Abraham replied. 'The fire and wood are here,' Isaac said, 'but where is the lamb for the burnt offering?' Abraham answered, 'God himself will provide the lamb for the burnt offering, my son.' And the two of them went on together. When they reached the place God had told him about, Abraham built an altar there and arranged the wood on it. He bound his son Isaac and laid him on the altar, on top of the wood. Then he reached out his hand and took the knife to slay his son. (Genesis 22:6–10)

25. Jacob's ladder. Jacob, dressed in red, is shown asleep on the ground with the ladder in front of him reaching up to Heaven with one angel ascending it and one descending.

Jacob left Beersheba and set out for Haran. When he reached a certain place, he stopped for the night because the sun had set. Taking one of the stones there, he put it under his head and lay down to sleep. He had a dream in which he saw a stairway resting on the earth, with its top reaching to heaven, and the angels of God were ascending and descending on it. There above it stood the Lord, and he said: 'I am the Lord, the God of your father Abraham and the God of Isaac. I will give you and your descendants the land on which you are lying.' (Genesis 28:10–3)

26. The Death of Jacob. The scene depicts Jacob, who is covered by a loincloth, surrounded by his fully clothed sons. Joseph kneels over his father's body and another son, shown to the right and behind Joseph, is tearing out his hair in a gesture of mourning.

Then he gave them these instructions: 'I am about to be gathered to my people. Bury me with my fathers in the cave in the field of Ephron the Hittite, the cave in the field of Machpelah, near Mamre in Canaan, which Abraham bought as a burial place from Ephron the Hittite, along with the field. There Abraham and his wife Sarah were buried, there Isaac and his wife Rebekah were buried, and there I buried Leah. The field and the cave in it were bought from the Hittites.' When Jacob had finished giving instructions to his sons, he drew his feet up into bed, breathed his last and was gathered to his people. (Genesis 49:29–33)

27. The Devil, in the form of a black crow, tells Cain how to kill. Here Cain is shown seated in a field, his head resting in his hand. He is envious of his brother, Abel, and is pondering on how he can harm him. A black crow swoops down to him. According to one of the priests at Narga Selassie, this crow is the Devil in disguise and has come to instruct Cain as to how he can kill his brother. From this moment on, the Devil having disclosed the secrets of homicide, mankind was to be plagued for ever more with murderous intentions.

28. Cain kills Abel. In this scene Cain holds a wooden club with two hands, and Abel has fallen over after receiving the fatal blow.

Now Cain said to his brother Abel, 'Let's go out to the field.' And while they were in the field, Cain attacked his brother Abel and killed him. Then the Lord said to Cain, 'Where is your brother Abel?' 'I don't know,' he replied. 'Am I my brother's keeper?' The Lord said, 'What have you done? Listen! Your brother's blood cries out to me from the ground. Now you are under a curse and driven from the ground, which opened its mouth

Narga Selassie

East Side

South Side

1	The Ascension of Christ with angels blowing trumpets and beating drums.
2	The Holy Family and Salome hiding from Herod's soldiers in a tree trunk.
3	The Virgin Mary praying on the way to Egypt and an angel brings drink and food.
4	The Flight into Egypt.
5	The Virgin Mary suckling Jesus on their journey to Egypt.
6	The return of the Holy Family from Egypt.
7	Jesus has supper at Bethany.
8	Jesus walks on water and holds Peter's hand.
9	The Entry into Jerusalem.
10	The Virgin Mary suckling the infant Jesus.
11	The archangel Gabriel holding a sword.
12	The Virgin Mary.
13	The archangel Michael holding a sword.
14	Doubting Thomas inserts his hand into Jesus' wound.
15	The Raising of Jairus' Daughter.
16	Jesus gives the apostles the power to heal.
17	Christ tempted by the Devil.
18	The Crucifixion.
19	The Harrowing of Hell.
20	Emperor Constantine listening to Arius.

1	The Apparition of the Virgin Mary at Metmaq.
2	Joachim and Anne with the baby Mary.
3	Anne and Joachim taking Mary to the Temple.
4	Mary seated outside the Temple in Jersualem.
5	Zechariah, the high priest, addressing a group of priests with his back to Mary.
6	The Circumcision of Jesus.
7	The Adoration of the Magi.
8	The Presentation of Jesus in the Temple.
9	Joseph's Dream. Salome and the Virgin and Child are fast asleep.
10	King Herod seated on his throne and surrounded by his henchmen.
11	The Proclamation of the Town Crier.
12	The Massacre of the Innocents.
13	The Waters of Correction.
14	Herod in pursuit of the Holy Family when they fled to Egypt.
15	The Holy Family fleeing while Gigar and his followers protect them.
16	The Dormition.
17	The Funeral of the Virgin.
18	The Assumption of the Virgin.
19	The Coronation of the Virgin.
20	St Michael weighing the deeds of Belai Kemer.
21	The Virgin Mary interceding on behalf of Belai Kemer.
22	Two prostrated donors, a man and a woman, both unidentified.
23	The prostrated Queen Mentewab.
24	The story of the cannibal Belai Kemer.
25	The Flight into Egypt.
26	The Covenant of Mercy.
27	Two prostrated donors, probably Queen Mentewab and her son Iyasu II.

to receive your brother's blood from your hand. When you work the ground, it will no longer yield its crops for you. You will be a restless wanderer on the earth.' (Genesis 4:8–12)

29. The Mourning of Abel. A naked Cain is shown seated on the ground, tearing his hair out. To the right is an angel who is probably telling him what he will suffer as a consequence of his evil act.

East Side

1. The east side of the drum depicts the Ascension of Jesus. After his crucifixion, he appeared to his disciples as proof that he was still alive. He promised them that after forty days the Holy Spirit would come to each of them and that they would then witness his ascension. In the centre of the composition is Jesus, surrounded by a wide aura and encircled by the faces of angels. On either side, angels are blowing trumpets and beating drums. Below this scene, and separated from it by white clouds, two angels are talking to the startled apostles.

After he said this, he was taken up before their very eyes, and a cloud hid him from their sight. They were looking intently up into the sky as he was going, when suddenly two men dressed in white stood beside them. 'Men of Galilee,' they said, 'why do you stand here looking into the sky? This same Jesus, who has been taken from you into heaven, will come back in the same way you have seen him go into heaven.' (Acts 1:9–11)

The sanctuary wall is framed by a wide band of decorative flowers and pierced by a large window. The scenes depicted on the wall are episodes from the life and miracles of Jesus. The top register tells the stories connected with the Flight into Egypt. The Holy Family is accompanied by Salome, the Virgin's cousin, who, according to the *One Hundred and Ten Miracles of Our Lady Mary*, helped to look after Jesus because Mary was not a strong woman. Each scene is set within a panel separated from its neighbours by a narrow red band.

2. The Holy Family. They are being pursued by a group of Herod's soldiers and find shelter within a tree trunk which miraculously opens up to allow them to hide inside. The soldiers, depicted in profile and 'one-eyed', appear on the left listening to their leader while, through an opening in the tree, we can see the Holy Family. Mary, bare-breasted, is about to nurse the Child, and behind her are the head of a donkey and Joseph and Salome.

3. Mary prays when, on their way to Egypt, the Holy Family had nothing to eat. In this scene, Joseph and Salome are asleep on the ground, and Jesus is looking up while his mother prays. In

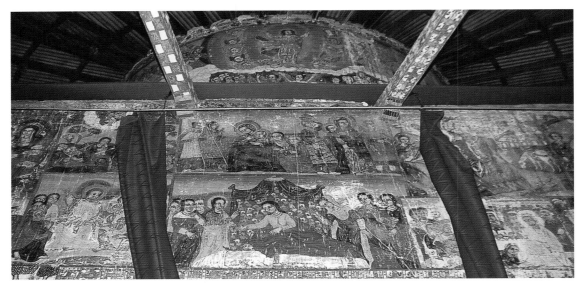

Fig. 144. East drum and wall. The Raising of Jairus' Daughter

response to her prayers, an angel, depicted within a white cloud, brings drink in a cup together with food in an *injira* basket, where, to this day Ethiopians keep their *injira* (unleavened bread).

4. The Flight into Egypt. This panel has two scenes. In the one on the left, which took place outside a town called Kuesya, the Holy Family is shown seated, worriedly looking at two standing men, holding spears, who clearly have evil intentions as can be surmised by the way they are depicted – 'one-eyed' with their faces in profile. The story is told by Mary to Theophilus in the *One Hundred and Ten Miracles of Our Lady Mary*, which is summarised below.

> When we were in Egypt and going along the side of a mountain at sunset, we noticed two thieves, one a Jew and one an Egyptian, whom we had met before. As soon as we were seen by the thieves they rushed upon us. I thought we were going to be killed; they had stripped us of our clothing. We had escaped from Jerusalem to avoid the massacre of the children and now we were going to perish here. And I cried and cried.
>
> When the Egyptian thief saw me crying, he asked the Jewish thief to return our clothing because he could see that my child was 'like the son of a king' but the Jew refused. The Egyptian then said, 'Last night we obtained much booty, and the portion that is my share shall be yours, only let me keep the clothes of these wayfarers as my own possession, so I may give it back to them, for it is hard for me to see this child standing more naked than any other child of man.' And the Jew gave him their apparel and he returned it to me.

Jesus then said to me, 'Do you see those two thieves? They shall be crucified with me, one on my right hand and one on my left, in Jerusalem by the Jews. And the thief, who has shown us mercy, shall believe in me on the cross, and he shall enter the Paradise. As for this place where they stripped me naked and where you have wept so much, it shall be a healing of every person who is sick or ill.'

In Coptic times, Kuesya had several churches: two dedicated to Mary, one to St George, and one to St Michael.

In the scene on the right, Mary, Salome and Joseph are walking away with Jesus being carried on his mother's back.

5. The Virgin suckling Jesus on their journey to Egypt. While Joseph and Salome look on, a beautifully depicted donkey grazes on the right. In the background appear the buildings of a town.

6. The return of the Holy Family from Egypt. Jesus is portrayed as a young boy who is walking between his parents and holding Mary's hand. Salome follows on behind Joseph.

After Herod died, an angel of the Lord appeared in a dream to Joseph in Egypt and said, 'Get up, take the child and his mother and go to the land of Israel, for those who were trying to take the child's life are dead.' (Matthew 2:19–20)

7. Over the window is the Supper at Bethany. Christ is seated at the end of the table looking down at Mary who is putting ointment on his feet. Her prostrated figure takes up most of the foreground. Mary's brother Lazarus sits on the opposite side of the table from Jesus.

Six days before the Passover, Jesus arrived at Bethany, where Lazarus lived, whom Jesus had raised from the dead. Here a dinner was given in Jesus' honour. Martha served, while Lazarus was among those reclining at the table with him. Then Mary took about a pint of pure nard, an expensive perfume; she poured it on Jesus' feet and wiped his feet with her hair. And the house was filled with the fragrance of her perfume. But one of the disciples, Judas Iscariot, who was later to betray him, objected, 'Why wasn't this perfume sold and the money given to the poor? It was worth a year's wages.' He did not say this because he cared about the poor but because he was a thief; as keeper of the money bag, he used to help himself to what was put into it. 'Leave her alone,' Jesus replied. 'It was intended that she should save this perfume for the day of my burial. You will always have the poor among you, but you will not always have me.' (John 12:1–8)

8. Jesus walks on water. On the left of the picture Jesus is standing on the water while Peter kneels in front of him. Jesus is holding his hand to prevent him from sinking into the lake while the rest of the apostles look on eagerly within their boat.

> During the fourth watch of the night Jesus went out to them, walking on the lake. When the disciples saw him walking on the lake, they were terrified. 'It's a ghost,' they said, and cried out in fear. But Jesus immediately said to them: 'Take courage! It is I. Don't be afraid.' 'Lord, if it's you,' Peter replied, 'tell me to come to you on the water.' 'Come,' he said. Then Peter got down out of the boat, walked on the water and came towards Jesus. But when he saw the wind, he was afraid and, beginning to sink, cried out, 'Lord, save me!' Immediately Jesus reached out his hand and caught him. 'You of little faith,' he said, 'why did you doubt?' And when they climbed into the boat, the wind had died down. Then those who were in the boat worshipped him, saying, 'Truly you are the Son of God.' (Matthew 14:25–33)

9. The Entry of Jesus into Jerusalem. Jesus is riding a small, white, female donkey with her young offspring trailing along behind her. To the left are the apostles following on foot while on the right people bow down and spread out a carpet in front of the donkey. Perched up in a tree is Zacchaeus. He is mentioned in the Bible as being in Jericho, but Ethiopian iconographical tradition introduces him into the Palm Sunday scene:

> Jesus entered Jericho and was passing through. A man was there by the name of Zacchaeus; he was a chief tax collector and was wealthy. He wanted to see who Jesus was, but being a short man he could not, because of the crowd. So he ran ahead and climbed a sycamore-fig tree to see him, since Jesus was coming that way. (Luke 19:1–4)

10. This scene of Mary suckling the infant Jesus and surrounded by monks, angels and King David playing the lyre, is related to the iconography of Our Lady at Mount Qwesqwam where the Holy Family lived while exiled in Egypt. (The story is related in 'Iconography of the Virgin Mary' in Chapter 2.) Here, archangels Gabriel and Michael carry flowers instead of swords.

A magnificent series of four recessed blind windows takes up half the space in the lower part of the wall. They are framed by a wide band made up of crosses in alternating red and blue. Between the arms of the crosses there are motifs drawn in blue in quick brushstrokes. An inner band of angels' faces surrounds the four arched window panels.

11. The archangel Gabriel holding a sword together with some believers below him. All are turned towards:

12. Mary, who is lavishly attired in a blue *maphorion* embroidered with a gold motif. On her right shoulder there is a gold star following the style made fashionable by Queen Mentewab's painting of the Virgin and Child. She holds a white handkerchief in her left hand and is making a blessing with her right, which shows two elongated fingers.

13. The archangel Michael holding a sword with, below him, a group of faithful women turned towards the Virgin Mary.

14. Doubting Thomas. This is a delightful scene, rarely depicted. Jesus is standing on a white cloud with his right arm lifted and his torso bare. The diminutive Thomas, standing at Jesus' side, inserts his fingers into the wound.

> Now Thomas (called Didymus), one of the Twelve, was not with the disciples when Jesus came. So the other disciples told him, 'We have seen the Lord!' But he said to them, 'Unless I see the nail marks in his hands and put my finger where the nails were,

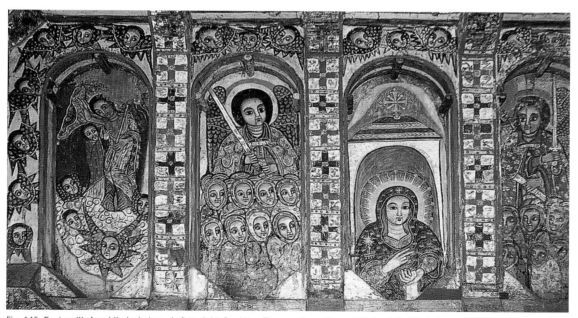

Fig. 145. East wall's four blind windows. Left to right: Doubting Thomas, the archangel Michael, the Virgin Mary, and the archangel Gabriel

and put my hand into his side, I will not believe it.' A week later his disciples were in the house again, and Thomas was with them. Though the doors were locked, Jesus came and stood among them and said, 'Peace be with you!' Then he said to Thomas, 'Put your finger here; see my hands. Reach out your hand and put it into my side. Stop doubting and believe.' Thomas said to him, 'My Lord and my God!' Then Jesus told him, 'Because you have seen me, you have believed; blessed are those who have not seen and yet have believed.' (John 20:24–9)

15. Over the blind windows is a large panel depicting the Raising of Jairus' Daughter. Jairus, a priest of the synagogue, had a sick daughter. He asked Jesus to come to his house and cure her by the laying on of hands. Jesus holds the hand of the little girl, who is already sitting up on a large canopied bed, and is blessing her. Her parents are on the right of the picture, and the disciples Peter, James and John are shown on the left behind Jesus.

> While Jesus was speaking, some men came from the house of Jairus, the synagogue ruler. 'Your daughter is dead,' they said. 'Why bother the teacher any more?' Ignoring what they said, Jesus told the synagogue ruler, 'Don't be afraid; just believe.' He did not let anyone follow him except Peter, James and John the brother of James. When they came to the house of the synagogue ruler, Jesus saw a commotion, with people crying and wailing loudly. He went in and said to them, 'Why all this commotion and wailing? The child is not dead but asleep.' But they laughed at him. After he put them all out, he took the child's father and mother and the disciples who were with him, and went in where the child was. He took her by the hand and said to her, 'Talitha koum!' (which means, 'Little girl, I say to you, get up!'). Immediately the girl stood up and walked around (she was twelve years old). At this they were completely astonished. (Mark 5:35–42)

16. Jesus gives the apostles the power to heal. Jesus is seated in the midst of the twelve apostles, talking to them and blessing them while they look in awe towards him. Some are portrayed as mature men with white beards while others are clean-shaven and young.

> He called his twelve disciples to him and gave them authority to drive out evil spirits and to heal every disease and sickness. (Matthew 10:1)

17. Christ tempted by the Devil. Jesus is seated on the left against a mountainous background, wearing a mustard-coloured tunic and a turquoise cloak embroidered with a white motif. The Devil, portrayed by a dark-skinned man, is offering Jesus a stone, which he holds in his right hand

while Jesus' left hand is making a gesture of protest. A black-winged, horned beast – another representation of the Devil – hovers in mid-air between the two. This creature is looking at Jesus with its red tongue clearly visible.

> The devil said to him, 'If you are the Son of God, tell this stone to become bread.' Jesus answered, 'It is written: "Man does not live on bread alone."' (Luke 4:3–4)

18. The Crucifixion. This is a very powerful depiction of the event. The scene is set against a black background and is imbued with much pathos. The emaciated face of Christ is covered with drops of blood represented by straight lines. His eyes are closed, his head leans against his right arm, and his legs are crossed. His whole body is surrounded by his aura, unusually shown as undulating white lines issuing from his body. The centurion, Longinus, on the left, is piercing the body of Christ, while, on the right, another centurion holds the pole with the sponge soaked in vinegar for Christ to drink. On either side of Jesus are the two thieves, Dysmas and Gestas, shown as diminutive men, their legs tied up with rope. They seem to be almost an afterthought; the one on the left has actually been painted on the frame of the wall. Below, Mary touches the Cross while she is held around her waist by another person. She looks up at her son in a calm manner while John, on the opposite side, is clearly agitated, with his hands raised towards Christ. The lower part of the painting is damaged – one can only see the round shape of what was once a skull or the head of a prostrated donor.

19. The Harrowing of Hell. A resplendent, resurrected Christ is robed in white with a red cloak and holding a long-handled cross. He is surrounded by a yellow aura which is set against a dark blue background. Directly below Christ is the Devil, represented by the face of a huge black, horned monster with bright red lips. To the left is Adam and to the right, Eve. Behind them is the multitude of souls waiting to be taken up to Heaven.

20. Emperor Constantine listening to Arius. Most of the paintings on the dado have disappeared; the only one that is still visible is this one which is directly below the Harrowing of Hell. On the left, Constantine is seated on a throne with only his head and crown still visible; they are painted against a red background. Facing him is Arius, seen in profile, standing behind a red lectern and holding a white book. It is an Ethiopian convention to portray evil people in profile. Arius (*c.* AD 250–336) was a Libyan theologian and founder of the heresy known as 'Arianism' which caused so much controversy within the Christian Church that Constantine had to convoke the Council of Nicaea in AD 325 to settle the matter. Behind Arius we can see a multitude of men wearing cowls over their heads; they represent the 380 bishops who attended the Council and who excommunicated Arius.

The paintings on the plinth are much damaged and difficult to distinguish. They are:

21. *Abba* Samuel.
22. Gabre Manfas Kiddus.
23. Tekle Haymanot.
24. Several saints.

South Side

1. The drum is taken up by the Apparition of the Virgin Mary at Metmaq. The miracle commemorates her appearance in the church of Deir al-Magtas (the Monastery of the Baptistery) in the Nile Delta. This miracle occurred every year for five days and is described in the *One Hundred and Ten Miracles of Our Lady Mary*. She appeared seated, surrounded by light, in the cupola of the church together with archangels and martyrs. The three equestrian saints – Mercurius, Theodore the Oriental (Banadlewos) and George – descended from their horses and all three bowed before her.

Here we have a very graphic depiction of the miracle. Mary is sumptuously dressed in a red tunic richly embroidered around the neck. Over her tunic she wears a blue cloak embellished with red and white flowers. She is depicted within a red and yellow arch and is seated on a throne with high arms ending in the form of a lotus flower. The throne is covered with a patterned carpet upon which her cloak is spread out. In her left hand she holds a white handkerchief and with her right she makes a blessing. She wears a bejewelled crown from which hangs a red veil.

Two angels stand on either side of her throne with their hands crossed over their chests in a sign of respect. Over her head is the brilliant light described in the miracle. In this case it has been painted in white, red, orange and touches of blue. Angels and noblemen appear in the top row while, below her throne and to the right, are a group of elders and *dabtaras*, some holding musical instruments and some with their right arms across their chests; all wear white turbans. At the very centre stands the high priest with his arms outstretched and holding two white handkerchiefs. On the extreme right is the 'one-eyed' and naked Mohammed riding a camel. The Virgin had ordered that the Prophet should be brought from Hell so that his followers should be aware of his fate.

In this painting the only equestrian saint who is shown is St George – St Mercurius and St Theodore are not present. St George's white horse is in the lower part of the composition, on the left, while the saint himself is shown kneeling just above it. St George appears in many paintings of the Virgin Mary who, as written in the *Synaxarium*, once explained to a young man whom she had cured of an illness, 'St George follows me always. He never parts from me wherever I go. I send him everywhere

for help.' The south wall is dedicated to the life of the Virgin Mary. The entire wall is framed by a wide band of flowers. The wall is pierced by a recessed door leading into the sanctuary. The narrative starts in the top register, at the left-hand side.

2. Joachim and Anne, the Virgin's parents, are seated within an arch. Anne is holding the baby Mary.

3. Anne is walking towards the Temple, seen in the next panel, carrying Mary on her back in the same way that Ethiopian women carry their babies to this day. Behind them is Joachim. The *Synaxarium* says that Anne was childless and Joachim was already an old man. They prayed to the Lord and made a vow to dedicate their child to God should they be blessed with one. Mary was born and reared by Anne until she was three years old at which time they took her to the Temple.

4. Mary is seated in front of an Ethiopian round church which symbolises the Temple in Jerusalem. In front of her is the archangel Fanuel who is bringing food and drink for her. The food is brought in an *injira* basket where the Ethiopians keep their staple bread – *injira* – which is eaten at every meal. A second angel is seen above, in a cloud.

5. Zechariah, the high priest of the Temple, is addressing a group of priests with his back to Mary. They all hold prayer-sticks. According to the *Synaxarium*, Mary remained in the Temple for twelve years.

6. The Circumcision of Jesus. This is a rarely depicted scene – of all the Ethiopian churches I have visited, only Selassie Chelekot near Mekele has a similar painting. Mary, shaking and visibly upset at the thought of the pain Jesus is going to suffer, is at the centre of the composition. Behind her are a group of priests holding prayer-sticks. In front of her, shown in smaller scale, are Salome and Joseph looking towards Jesus, who is portrayed as an older boy, not the eight-day-old baby he was meant to have been. Jesus is held by several priests, one of whom is holding a knife menacingly.

> On the eighth day, when it was time to circumcise him, he was named Jesus, the name the angel had given him before he had been conceived. (Luke 2:21)

7. The Adoration of the Magi. On the left-hand side is Mary, seated within an arch and holding the child. She wears a white tunic, a royal blue cloak edged in gold and a light blue veil. Jesus is half naked except for a light blue mantle draped around his waist, touching the hand of one of the three magi and blessing them with his right hand. The first two magi are kneeling; their crowns are on the ground with their servants between them, holding the gifts. The third stands behind the other two and is wearing his crown. Above them, and separated by a rough landscape, are their three horses and two grooms.

8. The Presentation of Jesus in the Temple. This event is described in the *One Hundred and Ten Miracles of Our Lady Mary*, summarised as follows:

> I brought Jesus to the Temple and there we found a priest whose name was Simeon and he was waiting to see the Saviour before he died. And I gave him the child and he carried him in his arms and blessed him and bore him around the Temple. Now, he was a blind man and my Beloved Son opened Simeon's eyes and, when he saw him, Simeon said, 'Now let your servant depart in peace for my eyes have seen your salvation which you have prepared before all people.'

Simeon died that day.

9. Joseph's Dream. In the foreground, Salome and the Virgin and Child are fast asleep. Salome is wearing rich, elegant robes and has her head resting on her left arm. Below her head is a colourful *injira* basket together with a gourd of water. The Virgin and Child are wrapped up in Mary's blue *maphorion*. Behind them is a courtly dressed angel holding a sword and pointing at Joseph who is shown, wide awake, behind Mary.

> When they had gone, an angel of the Lord appeared to Joseph in a dream. 'Get up,' he said, 'take the child and his mother and escape to Egypt. Stay there until I tell you, for Herod is going to search for the child to kill him.' (Matthew 2:13)

10. Set within an archway is King Herod, seated on his throne and surrounded by his henchmen, all of whom are depicted as 'one-eyed'.

11. The Proclamation of the Town Crier, who is standing in the middle of the composition facing a group of terrified fathers, announcing that every male child under the age of two years was to be slain.

12. The Massacre of the Innocents. This is one of the most vividly depicted scenes in this church. It shows the horrified mothers clutching their baby boys while Herod's men are beheading them. One of the soldiers is grabbing a woman by her hair.

13. The Waters of Correction (see Fig. 28, p. 46). This is the story of Joseph and Mary being asked to go before the high priest because the scribe, Annas, denounced Mary as being pregnant before her marriage, and of Mary being made to drink the waters of correction in front of the elders of

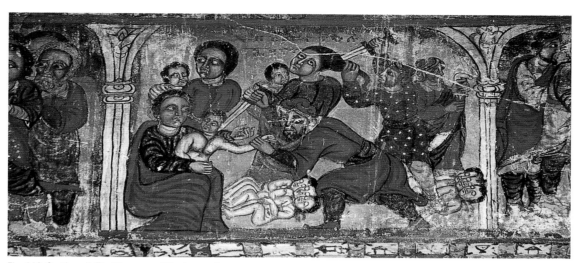

Fig. 146. South wall. The Massacre of the Innocents

the synagogue. Mary is seated, covered by a blue *maphorion*, in the centre of the composition. Because of her hierarchical importance, she is depicted larger than any of the other figures, even though she is seated cross-legged. Her head is surrounded by a gold halo made up of rays of unequal length which sparkle against a red background. Joseph is seated behind her, his cheek resting on one hand, worriedly awaiting the verdict. Behind them stands Annas, Mary's accuser. In the background is the Temple depicted by two superimposed arcades. In front of Mary and Joseph are four 'one-eyed' wicked-looking elders.

14. Herod in pursuit of the Holy Family when they fled to Egypt. This small panel shows the 'one-eyed' Herod, on horseback, with an angel in a cloud above him, threateningly brandishing a sword.

15. The Holy Family fleeing while Gigar and his followers protect them. This legend is told in the *One Hundred and Ten Miracles of Our Lady Mary*. This is an unusual depiction of the story. On the right-hand-side of the picture, the Holy Family, together with Salome, is seen walking. In the centre is Gigar, riding a white horse, and behind him are his soldiers confronting Herod's men. Below them appear the walls of a city.

16. The Dormition. The Virgin Mary is lying on a couch with Jesus supporting the pillow under her head. Behind him are the faces of angels. In the centre is Peter, depicted as a bald, old man, bending over while reading the last rites. King David is at the feet of Mary, playing his lyre, with the apostles behind him.

17. The Funeral of the Virgin. The apostles are carrying the Virgin's bier which is covered by a cloth. As described in the *Synaxarium*, Jesus told Peter to take Mary's body and leave by the east side of the city where they would find a new sepulchre on which they should lay the body down and guard it. And Peter, together with the other disciples and the three virgins, prepared Mary's body and laid it on a bed.

18. The Assumption of the Virgin. This painting is much damaged, the only discernible parts being that of the Virgin's head, which is surrounded by a very large halo, and the figures of three angels. Below, in the left-hand corner, just visible, is the face of a man which probably belongs to Thomas, the only disciple not present at her burial but who saw her being lifted up to Heaven by angels when he arrived on a cloud.

19. The Coronation of the Virgin. She is seated on a throne, her arms crossed over her chest. She was sumptuously robed in a blue *maphorion*, but the colour has now faded. She was originally attired in the same luxurious manner as was made fashionable by Queen Mentewab's own painting of the Virgin. Behind her throne stand two figures of the Trinity – Father and Son – holding a bejewelled crown over her halo.

The recessed doorway is framed on both sides by a wide band of red crosses on a white background. The two interior beams are covered by angels' faces. On the doors, beginning at the right-hand side, we have:

20. St Michael weighing the deeds of Belai Kemer, whose story is told at the very bottom of the door; sadly St Michael's weigh-scales have disappeared.

21. On the left-hand leaf, at the top, is the Virgin Mary (again badly damaged) interceding on behalf of Belai Kemer, whose soul is represented as a small child holding the Virgin's skirt.

22. Below the Virgin are the figures of two prostrated donors, a man and a woman, both unidentified.

23. Below St Michael is the prostrated Queen Mentewab.

24. At the bottom of both door leaves is the story of the cannibal Belai Kemer.

To the right of the doorway are two scenes:

25. The Flight into Egypt (see Fig. 29, p. 47). After an angel had warned Joseph in a dream, he took Mary and Jesus and departed with them to Egypt. Mary and Jesus are shown riding on a white horse followed behind by Salome who holds an *injira* basket on her head with one hand and carries a water pitcher in the other.

26. The Covenant of Mercy. This is an unusual representation of this event in which Mary intercedes with her son on behalf of those sinners who have asked for forgiveness in her name. Mary is shown on the left, crying and pointing towards the sinners who are all huddled beneath her. Jesus is seated on his throne in the middle of the composition, his arms outstretched, clothed in richly embroidered robes which are now very faded.

27. Below Christ's feet are two prostrated donors, a man and a woman, unidentified but who probably are Queen Mentewab and her son Iyasu II.

28. The paintings on the plinth are much damaged, but the one on the left of the plinth is clearly the face of the Devil.

The Processional Crosses

Narga Selassie owns several eighteenth-century crosses and manuscripts donated by Queen Mentewab and her son Emperor Iyasu II, whose images are depicted on them. One of them is a magnificent, large, silver, portable cross; the figures that appear on it are in gold leaf. At the top is the crucified Christ, and at the bottom are the two thieves who were crucified with him, Dysmas and Gestas. To the right of the Crucifixion is Christ being apprehended by a soldier and, below that, is the scourging of Christ by another soldier. Below again is Christ laid out, symbolising his burial. To the left of the Crucifixion is Christ standing and, below, is Christ seated, wearing the Crown of Thorns.

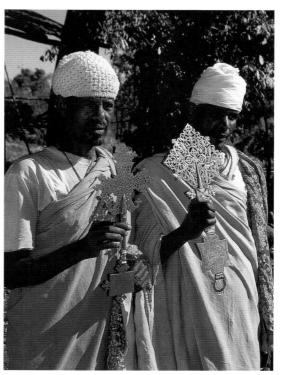

Fig. 147. Two priests, each holding a processional cross

Below that again are the three Marys around Christ's tomb. In the centre there is a four-leaf motif – Mary and John appear in the bottom leaf.

On the scroll is the Trinity surrounded by the Tetramorph. Below, on the right, is the prostrated Queen Mentewab and, on the left, is the prostrated King Iyasu II, his sword scabbard protruding sideways from his body, covered by his diaphanous over-tunic. On the reverse side is the Holy Family fleeing to Egypt. Joseph is leading a donkey on which Mary is seated with the Child; Salome is walking behind them, carrying an *injira* basket on her head. Joseph carries a long pole over his shoulder and a gourd of water is hanging at the end of the pole.

Another processional cross in bronze was also donated by the royal family. At the top centre is the resurrected Christ carrying a banner, symbol of his triumph over death. Below, and on the right, is Emperor Iyasu II and on the left, Queen Walatta Giyorgis, daughter of St George, the title by which Queen Mentewab was addressed.

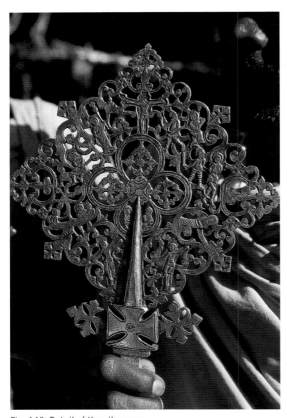

Fig. 148. Detail of the silver cross

Fig. 149. The scroll of the silver cross

The Manuscripts

One of the several manuscripts belonging to this church is dedicated to the miracles of St Michael and was donated by Queen Mentewab who appears in one of the illustrations, prostrated below the figure of God depicted as one Person of the Trinity and surrounded by the Tetramorph.

Another double-page illustration shows the story, as told in the *Synaxarium* for the 12th of Hedar, of St Michael and Dorotheus and his wife, Theopista, a couple who commemorated every festival dedicated to the saint until they ran out of money. They then sold all their belongings to be able to afford one last festival. St Michael appeared to Dorotheus and told him to buy a sheep and a fish but not to gut the fish until he was told to. He did as St Michael had instructed and called everyone to join him in this last feast he was hosting to honour the saint. When he went to the cellar to find his last jug of wine, he was amazed to see that the whole cellar was filled with wine and much flour. After all his guests had feasted and left, St Michael appeared again to Dorotheus and commanded that he slit the belly of the fish, and there he found 300 gold dinars, which St Michael had given him for his good deeds.

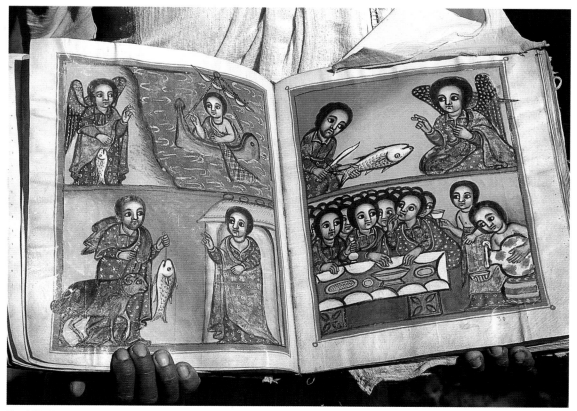

Fig. 150. Manuscript. The story of St Michael and Dorotheus

Fig. 151. The cave location of the church of Yemrahane Krestos

Chapter 6
The Churches near Lalibela

A visit to Lalibela (altitude 2,600 metres) is a 'must' for anyone going to Ethiopia. Its many rock-hewn monolithic churches are one of the wonders of the world. However, when you are there, do not miss out on visiting three churches in the vicinity of Lalibela – not many tourists make the journey to see them nor are they aware of their existence. Two of them – Yemrahane Krestos and Makina Medhane Alem – are built-up churches, in the Aksumite style, located within a cave. They are both situated on different spurs of the same mountain ridge whose peak is Abuna Joseph (4,190 metres). The third, Ghenate Maryam, is a monolithic rock-hewn church, well worth seeing because of its frescoes.

Yemrahane Krestos

Yemrahane Krestos dates to the mid-twelfth century and is perhaps the most impressive built-up church that you are likely to visit. It is located some 45 kilometres from Lalibela, on a dirt road, which takes one and a half hours to drive. It is then only a short walk of fifteen minutes up a slight gradient.

It is said that the church was built during the Zagwe dynasty, which lasted from 1137 to 1270, by Yemrahane Krestos, the first of the great Zagwe church-builders and grandson of the founder of the dynasty, Marara. His *gadl* says that he ruled for forty years, and it is tempting to suggest that he could be the legendary Prester John who is thought to have ruled from 1140 to 1180. No written evidence associated with the Zagwe dynasty survives because any existing chronicles were destroyed by the Solomonic dynasty that followed it. As stated by Pankhurst in *The Ethiopians* (2001, p. 45), 'Unlike their Aksumite predecessors, they did not mint coins, or produce inscriptions, and, living much further from the coast, made far less use of imported, datable, articles. No known foreign traveller moreover described the country at this time.'

Yemrahane Krestos

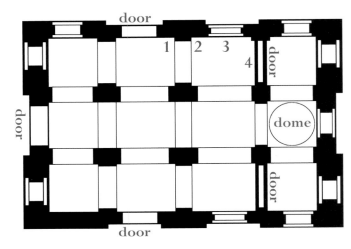

1	Above and to right of entrance door: the Return from Egypt.
2	Between the arch and upper window: above, the Baptism of Christ; below, the Washing of the Feet.
3	Below upper window: the Crucifixion and scenes from the Resurrection.
4	Above door, left to right: the Entry into Jerusalem, Christ in Majesty, and the Pentecost. Below: four equestrian saints; two unknown in the centre, *Abba* Minas on the left and St Philoteus on the right.

Legend has it that Emperor Yemrahane Krestos was transported, in a dream, to Jerusalem where he was shown the layout of the church. The church has been built in a cave, beneath a massive spur of rock below a high cliff. It has been well protected from the elements and is in near-perfect condition. The first foreigner to have seen and described it was the Portuguese chaplain, Francisco Alvares, in August 1520. He was told by the priests that the reddish stones used in the church's construction had been brought by angels from Jerusalem; however, he found a nearby quarry from where these stones had been taken. No other European is recorded to have seen it again until 1939 when it was visited by the Italian archaeologist, Monti della Corte. In the 1940s, David Buxton of the British Council published a report, together with photographs, on Yemrahane Krestos in which he says that he believed it to be the precursor of the Lalibela rock-hewn churches.

Yemrahane Krestos is a prime example of Aksumite construction. It is built on a red-stone plinth. Its walls are made up of alternating layers of white plastered rubble and inset horizontal wooden timbers. The façade is pierced by many windows in two rows, all of which have wooden frames with projecting corner posts, or 'monkey-heads'. They are filled with interesting and attractive interlaced designs in either wood or stone. There are three doors, again, all having wooden frames and 'monkey-heads'. At the four corners of the church there are what appear to be small towers which project slightly from the façade and rise slightly above its roof line; this feature is typical of the architecture of Aksumite palaces. In between the towers, the truncated saddleback roof over the second and third bays of the nave can be seen. The sanctuary dome rises between the two eastern towers. The main entrance is not in the west façade, opposite the sanctuary, but is set two-thirds of the distance along the north façade, near the north-west tower.

The church has a basilical-type plan with a nave and two aisles. It is four bays deep and has a sanctuary, surmounted by a dome, at its eastern end, which is separated from the nave by a triumphal arch. Two rooms flank the sanctuary; each can be entered through an Aksumite wooden door at the eastern end of the two aisles. Three pairs of stone columns are connected by arches with each other and their corresponding pilasters on the side walls. The columns have horizontal bands that imitate the recessed timbers of the exterior; however, in this case it is the narrow bands that protrude. All the columns and pilasters have wooden bracket capitals that are elaborately carved and brightly painted.

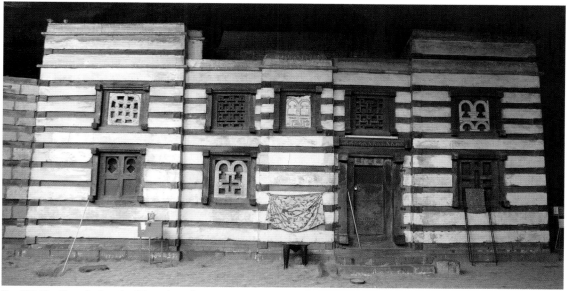

Fig. 152. The Aksumite façade of Yemrahane Krestos

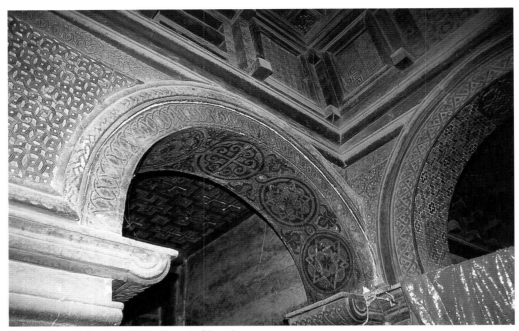

Fig. 153. Decorated arches with the Aksumite frieze above

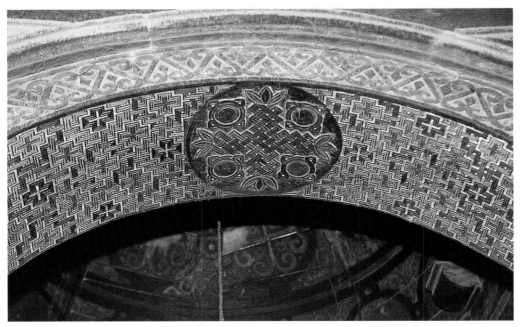

Fig. 154. Detail of the decoration of the arch in front of the *maqdas*

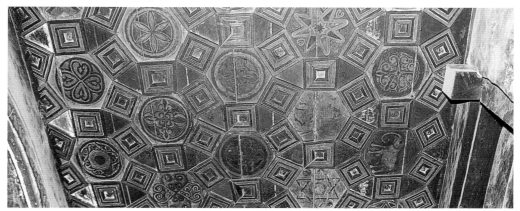

Fig. 155. Ceiling decoration

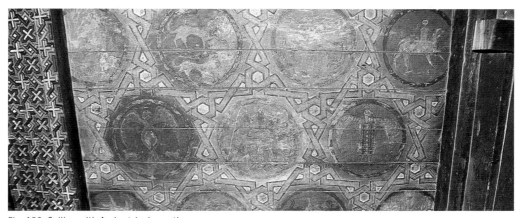

Fig. 156. Ceiling with Arab-style decoration

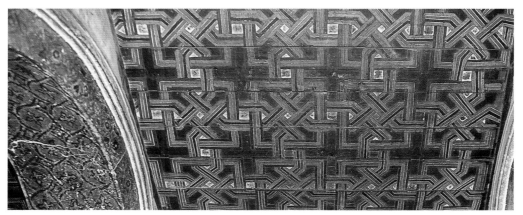

Fig. 157. Ceiling decoration

The whole interior has a red flagstone floor. The soffits have entwined roundels within which are floriated and geometrical crosses; the triangular space between the roundels is covered with a *fleur-de-lis* decoration. The spandrels between the arches are filled with interlaced roundels which have been carved and painted. Above the arches of the nave there is a wooden Aksumite frieze with two true windows on each side; all the others are blind windows including the three over the entrance to the sanctuary. The windows have been decorated with a variety of incised geometrical patterns, most of which form crosses.

The wooden, truncated saddleback roof (see Fig. 5, p. 6), which is completely coffered, rests on this frieze. At its centre there is a tie-beam with two vertical 'queen-posts', both of which have intricate, protruding bosses. Each aisle also has an Aksumite frieze, but smaller than that of the nave, with a flat, wooden ceiling resting on it. The ceilings are divided into several sections, some of which are decorated with inlaid double crosses, others with squares and one other with painted medallions having interlocking, geometrical designs around them. Depicted within the medallions are several scenes including men in a square-rigged sailing vessel; lions; an elephant with its mahout and two other riders on its back; a man on horseback; a chimera (a fire-breathing monster with a lion's head, a goat's body and a serpent's tail); a winged figure with a peacock and a scorpion under its wings; and a vulture with its wings outstretched but with the body of a human. Ewa Balicka-Witakowska and Michael Gervers, who have made a very detailed study of this church (2001), state that these patterns are all to be found in Coptic art dating back to at least the seventh century. They point out that, in Yemrahane Krestos's *gadl*, the Ethiopian King requested that the Sultan of Egypt send panels of the doors of his palace to Ethiopia in exchange for gold. It would seem that Egyptian material and perhaps workmen were indeed sent and this would explain why a Coptic influence is so apparent in the decoration of the whole church.

There are three sections of wall that have paintings on them. They are easily missed because all of them are located high up on the north side of the church and so are behind you after you have entered. Also, their colours are dull, and they are very dusty, making them difficult to see in the dark church. Ewa Balicka-Witakowska has dated them to the end of the twelfth century, and she and Michael Gervers indicate (2001) that the accumulated evidence suggests that the paintings are not an offshoot of Coptic art but the product of a genuine Coptic workshop, and that this supposition receives additional support from the fact that no Ethiopian inscription accompanies the paintings.

Above and to the right of the north entrance door is a scene depicting not the Holy Family's Flight into Egypt but rather the Return from Egypt (**1**). This is apparent because Joseph is carrying on his shoulders Jesus as a young boy, not a baby. The Virgin is shown riding a donkey, side-saddle; she holds the reigns in her left hand while the index finger of her right hand points upwards. An angel stands to the right of the scene with one wing raised protectively above the Virgin.

In the first bay to the east of the north entrance door, between the arch and the upper window, there are two scenes: the Baptism of Christ above and the Washing of the Feet below (**2**). At the centre

Fig. 158. Painting in the first bay to the east of the north entrance door

of the Baptism scene, Christ is shown submerged in water up to his neck; above his head is a dove, symbol of the Holy Ghost; and above the dove is a star. On the left is John the Baptist, standing on the bank and holding his clothes above his left knee to prevent them getting wet. On the right, two angels witness the event, each with one raised wing.

In the Washing of the Feet Christ is depicted seated on the right of the scene; his importance is emphasised by him being shown larger in size than his disciples and by being separated from them by a narrow, white, winding towel. The way in which he has been painted is unusual in that he is not kneeling at the disciples' feet but rather is shown seated majestically on a stool. The disciples are gathered to the left of him in two rows with five in the front and seven at the back.

To the right of the Washing of the Feet, on a narrow strip of wall below the upper window, is a fascinating series of scenes concerning the Crucifixion and the Resurrection (3). On the left is the Cross, which is shown empty; below it are five nails and the two thieves with their hands tied behind their crosses. Next is shown the visit of the two Marys to the tomb, which is represented as a large domed structure with the angel seated in front of it, holding a long-handled cross in his left hand and pointing upwards with his right index finger. To the right of this are two figures depicting the appearance of Christ to Mary Magdalene; Christ is on the right with his head turned over his right shoulder towards Mary Magdalene, who is on the left. On the far right is the last scene in this series, that of Doubting Thomas with Christ shown holding Thomas's hand and guiding it towards his wounds.

Above the entrance to the north room flanking the sanctuary is a panel depicting several scenes (4). On the left side of the upper register is the Entry into Jerusalem. The city is represented as a large red-brick building surmounted by domes, each with a cross. In front of the city there are two haloed figures welcoming Christ who is at the centre of the composition, a figure larger than the rest and riding a white mule. His right hand is raised in blessing, the left holds a book decorated with a large cross on its cover. Zacchaeus is shown in a tree to the left of the city. The twelve apostles are behind Christ, in two rows, one of five and one of seven as in the Washing of the Feet painting.

Next is Christ in Majesty. Christ is enthroned within a *mandorla* held by the four figures of the Tetramorph; he has a cross nimbus around his head; he holds a book in his left hand and his right hand is raised in blessing. Below is the Virgin Mary with her hands in the *orans* position. She is larger in size and surrounded by the apostles, who are in two rows of six each. To the right is the Pentecost. The apostles are shown in two rows of six, under an arch. Their raised hands and contorted stance reflect the significance of the event. The Holy Ghost is shown in the form of a dove; twelve rays radiate downwards from its beak onto the apostles. There is a large face above the dove, probably that of God the Father.

In the lower register are four equestrian saints riding towards the right, towards the sanctuary. Each is within a rectangular frame. On the left is *Abba* Minas, recognisable because of the two camels resting between his horse's legs. *Abba* Minas was a very popular Coptic saint (and still is) who suffered martyrdom under Diocletian. His relics were taken to Alexandria, and, when the accompanying soldiers decided to leave Egypt, the camels refused to move. In the middle are two unknown saints and on the right is St Philoteus spearing the bull Maragd.

The church shares its cave with a second building, also in the Aksumite style, which is the only extant example of secular architecture of the Zagwe period. It is rectangular and has two doors and two rooms. Today, it is used as a treasury and a storeroom.

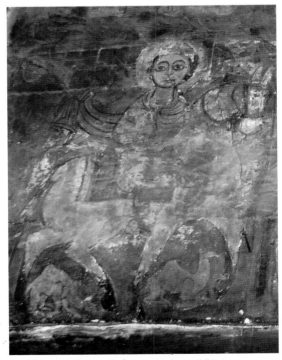

Fig. 159. *Abba* Minas with two camels beneath his horse

Ghenate Maryam

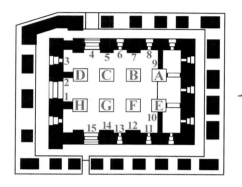

Walls & Pillars

1	Above: the five wise virgins. Below: the mounted Kwelsewon and his seated mother Tahrayanna Maryam. Unidentified standing figure on the right.
2	Above: the five foolish virgins. Below: Adam and Eve and the serpent.
3	Above: St Mary the Egyptian receiving communion from Zosimos. Below: Christ as Lord of All with the Virgin Mary to the left.
4	The wedding at Cana. Above and to the right, Anba Marina with small boy.
5	The mounted St George and Bifan's son.
6	Above: *Abba* Hor (left) and *Abba* Minas with his spear (right). Below: Bifan's wife (left) and St Sophia and her three daughters (right).
7	*Abba* Samuel of Kalamun.
8	Above: Abraham's wife, Sarah (left) and an ass (right). Below: *Abba* Daniel (left) and an unidentified figure (right).
9	Above: the Sacrifice of Isaac (left) and Dinah and Jacob (right). Below: the Entry into Jerusalem.
10	Above: Jonah and the whale (left) and three birds and unknown figure (right). Below: the Presentation in the Temple – Simeon, Joseph with the Child, Mary, and Salome.
11	Above: St Mercurius spearing Julian the Apostate. Below: Moses and unknown figure.
12	St Paul the Hermit.
13	The story of St Mamas.
14	St Mamas riding a lion.
15	Elephants above the door. Right: unknown figure.

Columns

A	WEST SIDE: the Cleansing of the Temple.
B	EAST SIDE: the Transfiguration with, left to right, Moses, Christ, and Elijah. NORTH SIDE: St Barbara and St Juliana. SOUTH SIDE: King David playing his lyre. WEST SIDE: Blank.
C	EAST SIDE: Emperor Yekuno Amlak on his throne. On either side of him, also seated, are Nehyo Bakrestos and Mahari Amlak. SOUTH SIDE: the three Jews in the Fiery Furnace. NORTH SIDE: the Annunciation with Elizabeth, Mary's cousin, seated on the right. WEST SIDE: Unknown scene.
D	SOUTH SIDE: the archangel Michael. EAST SIDE: The patriarchs Giyorgis and Markos.
E	WEST SIDE: Archangel Michael.
F	SOUTH SIDE: the Presentation of Mary in the Temple. St Anne holds Mary in front of her. To the right is the high priest and to the left are three more figures. NORTH SIDE: the Baptism of Jesus. EAST & WEST SIDES: Blank.
G	EAST SIDE: Jesus appears to Mary Magdalene. SOUTH SIDE: Jesus teaching in the Temple. WEST SIDE: the Annunciation. NORTH SIDE: Jesus washing the feet of the disciples.
H	EAST SIDE: three prophets. SOUTH SIDE: the mounted St Cherkos. NORTH SIDE: St Gabriel.

Arch Soffits

A-B	*Abbas* Pantaleon (west) and Sinoda (east).
B-C	*Abbas* Arsenius (east) and Bame (west).
C-D	*Abbas* Yawahani (east) and Alef (west).
E-F	Unknown figures.
F-G	St Onuphrius (possibly) and an unknown figure.
G-H	*Abbas* Yemata (east) and Garima (west).

Fig. 160 (left). Ghenate Maryam protruding above its rock trench walls

Ghenate Maryam

Ghenate Maryam, the 'Paradise of Mary', is to the south-east of Lalibela, a 35-kilometre (one-hour) drive mainly on dirt roads, and is at an altitude of 2,650 metres. Your car will be able to drive right up to the church compound. It is a monolithic rock-hewn church, but, unlike those in Lalibela, the red tufa of its roof projects sufficiently above its surrounding trench walls so that it is visible at a distance. A false roof, funded by UNESCO, has been erected over the whole church; hopefully this eyesore of bamboo scaffolding will be replaced with a more aesthetically acceptable, permanent structure.

Entry to the church courtyard is through a breach in the south wall of the trench, which has a gatehouse. In the trench west wall, two open rooms have been excavated, the larger having a central rock-hewn column. If you visit the church fairly early in the morning, you will be able to see, and hear, the *dabtaras* beating their drums and shaking their sistra in these rooms.

The approximate exterior dimensions of the church are: 20 metres long by 16 metres wide by 11 metres high. It has a slightly truncated saddleback roof and a colonnade of rectangular, rock-hewn pillars, which runs around all four walls, evocative of a Greek temple. Each slope of the roof has been

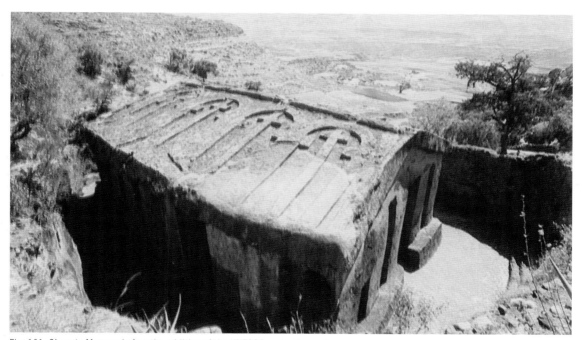

Fig. 161. Ghenate Maryam before the addition of the UNESCO protective roof

carved with four arches resting on corbelled capitals at the top of pillars; within each arch there are carved crosses. The whole church stands on a substantial plinth which is breached where the three doors give access to the interior. However, the gap in the west is displaced relative to the line of the main entrance.

The interior is of the basilical-type with a nave and two aisles separated by two rows of four rectangular columns. It is four bays deep and has a sanctuary at its eastern end. On either side of the entrance there is a full-height wall joining the exterior wall to the first pair of columns, thus creating a vestibule. The columns have no base but do have pseudo-capitals of carved corbels and imposts of the type that are prolific in Lalibela's monolithic churches. The columns are connected to one other by arches.

The founder of the church was Yekuno Amlak (1270–83), the first ruler of the Solomonic dynasty that succeeded the Zagwes. Ghenate Maryam is named as the monastery of Yekuno Amlak in Dersana Urael, which indicates that Yekuno Amlak had endowed a monastery with the church – but no monastery exists today. An inscription in Ghenate Maryam says, 'by the Grace of God I, King Yekuno Amlak, after I had come to the throne by the will of God, built this church'. As Gerster surmises: 'The church … was probably an attempt by the new ruler to demonstrate his legitimacy, in the heart of the area of Zagwe power, with a characteristic building which would still have been regarded by his contemporaries as a current Zagwe achievement.'

Yekuno Amlak was related to all the rulers of central Ethiopia on his mother's side: Emmena Seyon, daughter of the ruler of Wagda and Katata (Matewos) and sister of Madhanina Egzi, ruler of Fatagar. She married Gelawdewos, ruler of Dawwaro, and they had four children. He left her to become a monk. She then married Tasfa Iyyasus, the presumed descendant of the Solomonic dynasty, by whom she had twins: Yekuno Amlak and Dibbora, mother of *Abuna* Zena Mareqos and Maryam Kebra. However, Yekuno Amlak's claim to the throne was based on royal blood through his father. Tekle Haymanot, grandfather of Madhanina Egzi, was the brother of Yekuno Amlak's mother. The church of Ghenate Maryam was dedicated to *Abba* Matta, an Egyptian monk from the Monastery of St Pachomius who first brought monasticism to Ethiopia. A portrait of him appears on the east wall of the sanctuary. An inscription above him reads, 'St *Abba* Matta! Intercede and pray for us and for those who adorned for us your house with the images of the saints' (translated by Ewa Balicka-Witakowska).

The Paintings

The whole church has been lavishly painted on plaster – the pictures are true frescoes and date to the late thirteenth century. Unfortunately the colours have faded, and the plaster has peeled in many parts of the church. The figures in the frescoes are very distinctive. They all have round heads, and, when they are surrounded by haloes, the halo has an outer edge of a pearl motif. The eyes have large black

pupils painted in the upper part leaving a great portion of white iris visible. The figures are frontally depicted, flat, with no attempt to give the illusion of volume or perspective; the drawing is linear. The saintly figures wear a characteristic monastic cape, which covers most of the upper torso and comes down to their feet but opens up in the front revealing a tunic and an apron which is draped diagonally across the tunic. They wear pointed caps or cowls and have pointed beards.

The colour range is limited to ochre shades of brown and red, green and a striking aquamarine. The latter was probably a copper-based green which, over time, has oxidised into this wonderful blue. Many of the figures are set within an architectural framework. Some of the aprons and cloaks have bold curvilinear designs reminiscent of Art Nouveau arabesques.

There is a distinct similarity between the style of depicting the standing saintly figures in Ghenate Maryam with the saints painted by the Coptic master Theodore (1232–3) in the church of St Antony at the Red Sea. At both churches the figures are enclosed within an arch and with their hands clasped in supplication in front of their chest, a gesture commonly found in Coptic art.

West Entrance Bay (Plan 1 and 2)

Represented on the walls of this bay are the five wise and five foolish virgins, a scene closely related to the Last Judgement since it teaches personal responsibility for our spiritual condition. The five foolish virgins are on the northern side with the five wise ones on the southern side. In the Bible, Jesus relates the Parable of the Ten Bridesmaids:

> At that time the kingdom of heaven will be like ten virgins who took their lamps and went out to meet the bridegroom. Five of them were foolish and five were wise. The foolish ones took their lamps but did not take any oil with them. The wise, however, took oil in jars along with their lamps. The bridegroom was a long time in coming, and they all became drowsy and fell asleep. At midnight the cry rang out: 'Here's the bridegroom! Come out to meet him!' Then all the virgins woke up and trimmed their lamps. The foolish ones said to the wise, 'Give us some of your oil; our lamps are going out.' 'No,' they replied, 'there may not be enough for both us and you. Instead, go to those who sell oil and buy some for yourselves.' But while they were on their way to buy the oil, the bridegroom arrived. The virgins who were ready went in with him to the wedding banquet. And the door was shut. (Matthew 25:1–10)

Four of the foolish virgins are painted on the north wall of the entrance with the fifth on the west wall. They all have haloes, and each holds a lamp in her left hand. They wear the same capes as the monastic saints, which open up at the front to reveal their tunics and aprons. All of their aprons have different designs and colouring, and some are diagonally draped across the tunic. All are barefooted.

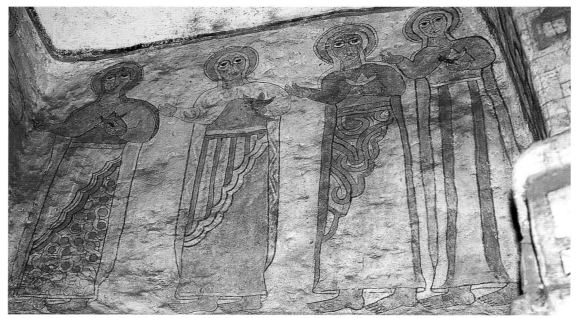

Fig. 162. West entrance bay, north side. Four of the five wise virgins

Below the wise virgins are the mounted Kwelsewon and his seated mother Tahrayanna Maryam. To the right is a standing figure holding a cross who cannot be identified because the name above him has been deleted. Below the foolish virgins is a painting of Adam and Eve with the serpent depicted almost as though it was a vertical pole next to Eve. Both Adam and Eve have their arms held in such a manner as to create an oval. All the colour has disappeared except for a patch of aquamarine following the contour of Adam's arms.

Fourth Bay, North Aisle (Plan 3)
At the top is a painting of St Mary the Egyptian receiving communion from Zosimos. To the right of this painting is an aperture within which is a beehive. Bees are considered sacred within Ethiopia and so they are left undisturbed. Below is a depiction of Christ as Lord of All, seated on a throne which forms an architectural frame, with the Virgin Mary to the left.

Third Bay, North Aisle (Plan 4)
On the north wall, above the door, is a frieze depicting the Wedding at Cana. At first glance it appears uninteresting, being colourless and smothered in dust; however, it deserves a much closer look. To the left, on the adjacent wall, one can see the large water jars with a figure looking inside them. To the right is a table covered with plates and cups at which Jesus is seated with one of his disciples opposite

him; both have haloes and beards. The guests are seated on chairs with X-shaped legs whereas Christ sits on a dais. To the right of Christ is the inscription 'Governor of the feast'. Above Christ, the inscription reads, 'Jesus Christ, as he made the water wine.' The standing figure on his left is identified as 'St Mary'. This portrayal of Christ is both unusual and fascinating; he is shown with his back towards us but with his inclined head looking directly at us. He has a neatly trimmed black beard, and his features are meticulously depicted with an aquiline nose and beautifully expressive eyes. The remainder of the frieze shows a number of wedding guests clearly having a good time, feasting and drinking.

On the third day a wedding took place at Cana in Galilee. Jesus' mother was there, and Jesus and his disciples had also been invited to the wedding. When the wine was gone, Jesus' mother said to him, 'They have no more wine.' 'Dear woman, why do you involve me?' Jesus replied. 'My time has not yet come.' His mother said to the servants, 'Do whatever he tells you.' Nearby stood six stone water jars, the kind used by the Jews for ceremonial washing, each holding from twenty to thirty gallons. Jesus said to the servants, 'Fill the jars with water'; so they filled them to the brim. Then he told them, 'Now draw some out and take it to the master of the banquet.' They did so, and the master of the banquet tasted the water that had been turned into wine. He did not realise where it had come from, though the servants who had drawn the water knew. Then he called the bridegroom aside and said, 'Everyone brings out the choice wine first and then the cheaper wine after the guests have had too much to drink; but you have saved the best till now.' (John 2:1–10)

On the right and above the wedding feast is a portrayal of St Anba Marina with a small boy beside her. She had entered a monastery posing as a monk and was later accused of seducing a woman and fathering her son. She never revealed her sex and, as a sinner, was expelled from the monastery. She brought up the boy, who had been abandoned by his mother, as her own and later, when the child was old enough to decide to become a monk, she returned with him to the monastery.

Pilaster between Bays 3 and 2, North Aisle (Plan 5)
The fresco shows St George on horseback having rescued Bifan's son (see Chapter 3 for the story).

Second Bay, North Aisle (Plan 6)
Below, on the left, is Bifan's wife welcoming the safe return by St George of her son. To the right are St Sophia (symbol of the personification of the wisdom of God) and her three daughters Pistis, Elpis and Agapis (Faith, Hope and Charity). Sophia is depicted within an arch on either side of which are her two grown-up daughters. She holds the youngest one on her knees. The inscription reads, 'St Sophia with her children, may her prayers lead them to Heaven.'

At the top of the wall are *Abba* Minas with his spear on the right, and *Abba* Hor on the left. Separating them is a Teutonic cross and an opening in the wall. All the colours have deteriorated except for the vivid aquamarine. *Abba* Hor, the son of a blacksmith, went to Pelusium (near the coast

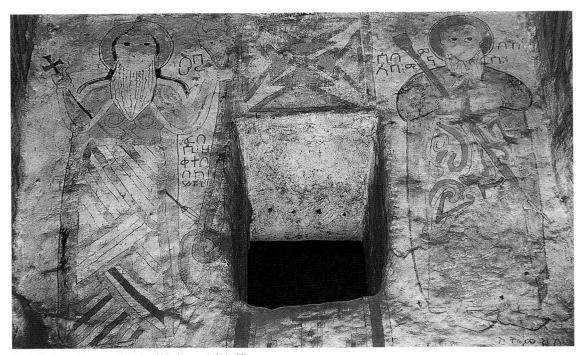

Fig. 163. Second bay, north aisle. *Abba* Hor and *Abba* Minas

south-east of Port Said) in the late third century and confessed his Christianity. After being tortured, he converted the governor and his family. The next governor executed his predecessor and sent *Abba* Hor back to Antinoe for execution. Here he is depicted as a dragon-slayer. With his right hand he grasps a trident with a cross at its handle and with his left he throttles a serpent with a wide-open mouth from which the horned head of the Devil appears. This image refers to an incident in his legend which relates that, while he was in the desert, the Devil challenged him to retain his saintliness by visiting Alexandria, one of the most sinful of cities. *Abba* Hor was also renowned for the many pilgrimages he made to holy places, and the inscription above him in this painting reflects this: '*Abba* Hor, the pilgrim, when he killed the serpent.'

According to the *Synaxarium*, *Abba* Minas was one of the most popular Coptic saints, and according to his legend he died under Emperor Diocletian and his body was brought to Alexandria. His father was governor of Phrygia in Turkey, and his mother was barren, until, through the intercession of the Virgin Mary, she had a son, Minas. She taught him the Scriptures, and, when he was eleven years old, his father died. Three years later, his mother also died. Because of the affection he was shown by the governor of Phrygia, he abandoned Christianity. But when Diocletian started persecuting Christians, Minas went into the desert and prayed. He saw heavens open and martyrs crowned and a voice said,

'He who toils for the name of Our Lord Jesus Christ shall receive this crown.' And he returned to the city and became a Christian, and many men, knowing he came from a noble family, tried to dissuade him from this. The governor had him severely tortured and finally had him beheaded. He became a martyr. The governor had his body thrown into a fire but his followers collected the remains and swathed them in beautiful cloth and hid them till the persecutions were ended.

St Minas' body was taken to Libya and eventually was put on board a ship bound for Alexandria. During the voyage, beasts came out of the sea with faces like serpents and necks like those of camels, and stretched out their necks towards the saint's body, which they licked. After arriving in Alexandria, his followers put Minas' body on a camel, but the camel refused to get up and so they lifted the body onto a second camel, and it would not rise either, regardless of how hard they beat it. Thus they knew that this was God's will, and they buried him there and built a shrine over him, and then departed.

Now, there was a shepherd whose sheep was very sick and he brought it to St Minas' shrine, and, having rolled it in the water nearby, the sheep was cured. The shepherd took some dust from the shrine, and, whenever sheep or people were ill, he would mix the dust with water and smear it on them, and they would be cured.

Emperor Constantine heard of this, and he had an only daughter who was sick with running sores. He sent her to St Minas' shrine, and she smeared her body with water from the shrine and slept there that night. St Minas appeared to her and said, 'When you rise in the morning, dig, and you shall find my body,' and she was healed straight away. When she rose, she had her people dig, and they found Minas' body, and her father built a church over it, and Emperor Arcadius and Emperor Honorius built a city there.

Pilaster between Bays 2 and 1, North Aisle (Plan 7)

Here is a full-length fresco of *Abba* Samuel of Kalamun set within an architectural frame. He was an Egyptian monk who founded a monastery at Kalamun in the southern part of the Fayoum oasis. He participated in the Council of Chalcedon (AD 451). He was persecuted and tortured by Emperor Leon.

First Bay, North Aisle (Plan 8 and 9)

On the lower left-hand side of the north wall (8) is *Abba* Daniel. The inscription reads, '*Abba* Daniel, we salute you, intercede and pray for us.' He was the abbot of the famous Egyptian monastery of Scete in the sixth century. The figure to the right of *Abba* Daniel is unidentified.

On the left, at the top, is Sarah. Her feet are placed as if walking towards the right. The inscription reads 'Sarah, wife of Abraham.' Her left arm points towards Abraham and Isaac who are depicted on the adjacent wall. To the right of Sarah is an ass. The text above it says, 'Here is the ass laden with wood', although the painter has omitted to include any wood in this fresco. The text is a reference to Genesis 22:3: 'Early the next morning Abraham got up and saddled his donkey. He took with him two

of his servants and his son Isaac. When he had cut enough wood for the burnt offering, he set out for the place God had told him about.'

The east wall of this bay (**9**) has an oculus. At the top left is the Sacrifice of Isaac. The text reads, 'Abraham and Isaac: here is the lamb.' Abraham is depicted wearing the same monastic clothes as the saints in this church. With his left hand he holds his son Isaac by his hair and in his right he holds the knife. Above them, hanging from a tree, is the lamb. Both father and son are barefoot; Abraham's feet, like those depicted in Egyptian art, are both shown as a right foot.

To the right of the Sacrifice of Isaac is a painting of a small seated woman and, within an architectural frame, a standing, bearded male figure. The text between their heads reads, 'Dinah consoling her father Jacob.' Dinah was the daughter of Jacob and his wife Lea, and her story

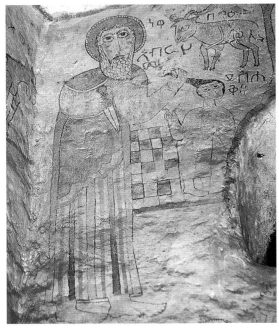

Fig. 164. First bay, north aisle. The Sacrifice of Isaac

is told in Genesis 34, which relates how she was raped by Shechem, the Hivite, and how her brothers took revenge and cunningly exterminated all the men of that tribe and took all their women and wealth.

On this same wall, the link is made between the Sacrifice of Isaac in the Old Testament and the impending Sacrifice of Christ in the New Testament – a much damaged painting of the Entry into Jerusalem appears below the oculus. Jesus is riding an ass and is framed by a linear, aquamarine baldachin. On the far right, suspended from a tree, is Zacchaeus. He is mentioned in the Bible as being in Jericho, but Ethiopian iconographical tradition introduces him into the Palm Sunday scene:

> Jesus entered Jericho and was passing through. A man was there by the name of Zacchaeus; he was a chief tax collector and was wealthy. He wanted to see who Jesus was, but being a short man he could not, because of the crowd. So he ran ahead and climbed a sycamore-fig tree to see him, since Jesus was coming that way. (Luke 19:1–4)

First Bay, South Aisle (Plan 10 and 11)

The east wall of this bay (**10**) also has an oculus below, which is a scene of the Presentation depicting Simeon and the Holy Family at the Temple. Simeon was the righteous and devout old man who was promised by the Holy Spirit that he would not die before he saw the Christ Child. Here we have Joseph

presenting Jesus to Simeon, who is on the left. Behind Joseph are the Virgin Mary and Salome.

At top left of this bay is a depiction of Jonah and a somewhat diminutive whale resting on a table. Jonah appears to be feeding the whale; however, he does hold a dagger menacingly in his right hand. Above the oculus are paintings of three birds, the larger one being an extraordinary portrayal of a bird in human guise and wearing what appears to be a striped cloak. To the right is an unidentified figure – a human form with an animal's head and tail and the talons of a raptor.

To the left of the window at the top of the south wall (**11**) is the mounted St Mercurius spearing Julian the Apostate who is prostrate below the saint's horse. Both St Mercurius and Julian the Apostate have halos, which would suggest that in this church the halo is a decorative

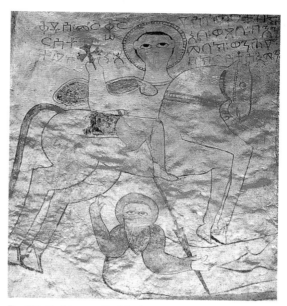

Fig. 165. First bay, south aisle. St Mercurius spearing Julian the Apostate

motif rather than a symbol of sanctity. The inscription above St Mercurius is a prayer: 'St Mercurius, martyr of Christ; supplicate and pray for Yekuno Amlak and Nehyo Bakrestos. Amen.'

Below St Mercurius are two figures, each within an architectural frame: Moses on the left and an unidentified figure on the right.

Pilaster between Bays 1 and 2, South Aisle (Plan 12)

St Paul is bearded and wears a long tunic. He could be St Paul the Hermit. The inscription reads, 'St Paul, the fountain of wisdom, intercede and pray for us.' He is depicted within an architectural frame.

Second Bay, South Aisle (Plan 13)

On the south wall of this bay and on the next pilaster is the story of St Mamas. St Mamas was tortured for his faith by the governor of Caesarea and was then sent before Emperor Aurelian (AD 270–5) who tortured him again. An angel liberated him and ordered Mamas to hide himself on a mountain near Caesarea. He was later thrown to the lions but managed to make the beasts docile. He preached to animals in the fields, and a lion always remained with him as his companion. The legend of St Mamas occupies three paintings. All portray the events preceding his death. The scenes have been shortened so much that it is impossible to understand them without reference to the inscriptions.

To the left of a cruciform window are several does with their young. This refers to a fragment of the text. The story is that St Mamas made cheese with the milk of does and gave it to the poor. To the right of the window are two men, their arms entwined. They represent Aurelian soldiers sent to capture the saint but who, on listening to St Mamas preach amongst the wild beasts, became converted to Christianity. Above the window is a Teutonic cross.

Pilaster between Bays 2 and 3 (Plan 14)
On this pilaster, St Mamas is portrayed riding a lion on his way to Caesarea (now Kayseri in Turkey) to appear before his judges.

Third Bay, South Aisle (Plan 15)
Immediately above the door and below the window are a couple of amusing little elephants, the one on the left painted in a terracotta colour and the one on the right depicted in outline. On the right is a figure with a swirling, tendril-like design on his clothes in browns and white. He has two left feet but otherwise is very realistically portrayed.

Column A
On the west side of this column is the Cleansing of the Temple (9). The temple is on the right with doves perched on its roof. On the left two merchants in orange robes flee before Jesus.

Column B
On the east side of this column is an unusual depiction of the Transfiguration. Jesus is seated on a throne with his legs folded beneath him in an oriental fashion. Moses stands wearing a white tunic and a coat in brown with tendril-like patterns in a very light tan; his hand holds his beard. On the right is Elijah wearing a striped tunic in brown and white.

On the north side are St Barbara and St Juliana, painted within an architectural frame. The inscription between them reads, 'St Barbara and her sister Juliana, intercede and pray for us.' According to the Ethiopian texts, before they were decapitated, Juliana stated that she was the spiritual sister of Barbara.

On the south side is King David playing his lyre. The west side is blank.

Column C
On the east side of this column is Emperor Yekuno Amlak seated cross-legged on a raised throne with double S-shaped legs, typical of the Islamic style of the eleventh and twelfth centuries. On either side of him are Nehyo Bakrestos and Mahari Amlak who are seated on folding chairs with X-shaped legs. The inscription above the figures reads, 'In giving thanks to God it is I who has built this church,

Yekuno Amlak, whom God made king by his will. My father, Nehyo Bakrestos, was an agent for me to have this church built in the name of Mata. May God have mercy on me in the Kingdom of Heaven with my fathers, Mahari Amlak and Nehyo Bakrestos. Amen.'

Abba Matta (3rd Terr) was one of the twelve monks who came to Aksum from the Hellenistic world through Egypt in the early days of the Ethiopian Church. The church of Ghenate Maryam was originally dedicated to him and later rededicated to Mary.

Nehyo Bakrestos would appear to have been the more important of the two clerics in this painting since he is the only one mentioned in the prayer that appears above the depiction of St Mercurius on the south wall (**11**). It seems probable that he was the head of a monastery associated with the church.

This portrait of the donor attended by the two abbots of the monastery associated with this church bears witness to the close relationship between the crown and monastic leaders. One of the abbots oversaw the excavation and decoration of Ghenate Maryam. In 1270, according to tradition, it was Tekle Haymanot who was instrumental in obtaining the abdication of the last Zagwe ruler in favour of the Solomonic Yekuno Amlak, an accomplishment that was financially very beneficial to the Ethiopian Church. Tekle Haymanot was the founder of the monastery of Debre Libanos and became the *Echege* (the leader) of the Ethiopian Church.

On the south side of this column is a depiction of the three Jews in the Fiery Furnace – Shadrach, Meshach, and Abednego – being rescued by an angel. On the north side is the Annunciation with Elizabeth, Mary's cousin, seated on the right. Elizabeth was in the sixth month of her pregnancy (Luke 1:24–31). The west side is blank.

Column D

On the south side is the winged archangel Michael and on the east side are the patriarchs Giyorgis II (1215–*c.* 1225) and Markos.

Column E

An angel is painted on the west side of this column.

Column F

On the south side is a fresco of the Presentation of Mary in the Temple. According to apocryphal

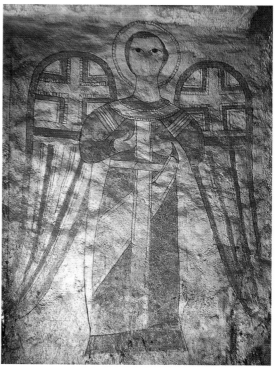

Fig. 166. Column D, south side. The archangel Michael

tradition and an account in the *Synaxarium*, Mary's parents took her to live in the Temple of Jerusalem when she was three years old, to fulfil a vow they had made to the Lord when they were childless. Mary remained in the Temple for twelve years and was cared for by an angel who brought her food and clothing.

St Anne, her mother, stands holding Mary in front of her. To the right is the high priest, and to the left are three more figures. The placement of Mary in relation to her mother is reminiscent of early Byzantine icons, which are called 'The Source of Life', where the Virgin Mary holds Jesus in front of her. No colour remains in this painting, only the figures outlined in black. An inscription at the lower left of St Anne shows that it functioned as a devotional image; it reads, 'Anne, mother of Mary: may her prayer be upon us.'

On the north side is the Baptism. The river water is depicted as a drape that is held up in front of Jesus and John by an archangel on the left. The east and west sides are blank.

Column G

On the east side is the scene of Jesus appearing to Mary Magdalene: 'Noli me tangere' (John 20:17):

> Jesus said, 'Do not hold on to me, for I have not yet returned to the Father. Go instead to my brothers and tell them, 'I am returning to my Father and your Father, to my God and your God.'

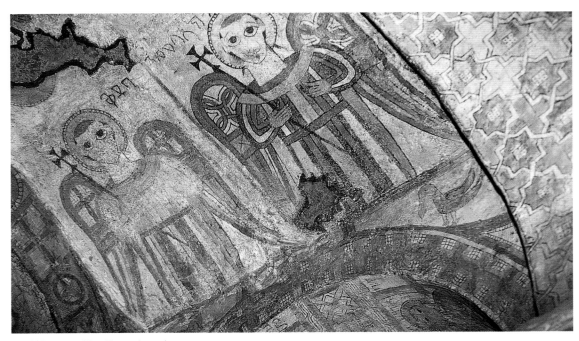

Fig. 167. Nave ceiling. Two archangels

On the south side is Jesus teaching in the Temple. He is seated on a raised, framed throne, holding a book in his left hand and with his right hand pointed upwards as if emphasising his words. He is surrounded by a multitude of people. The three on the right are probably Mary, Joseph, and Salome.

On the west side is the Annunciation which is now hardly visible, and, on the north side, Jesus washes the feet of his disciples.

Column H

On the south side is the mounted St Cherkos; on the north side is St Gabriel; and on the east side are three prophets.

The Arch Soffits

The most striking characteristic of Ghenate Maryam's frescoes is the stunning geometrical decorations that surround the arches, spandrels, soffits and those parts of the ceiling that have not been damaged. All of the decorations include crosses; even the multitude of angels portrayed throughout the church have crosses within the upper parts of their wings. In addition there are two anthropomorphic representations of the sun. One is on an arch in the nave and is surrounded by two Teutonic crosses. The face of the sun, encircled by a halo of rays, has the same beautiful white eyes and aquiline nose as those of the figures in the church. From an early time the solar disc was considered to be a symbol of Christ, and in Ethiopian churches it is often depicted directly above the main entrance or on the sanctuary arch, or both. Christ is regarded as 'the Sun of Righteousness': 'But for you who revere my name, the sun of righteousness will rise with healing in its wings' (Malachi 4:2).

Arch A–B Soffit: *Abbas* Pantaleon (west) and Sinoda (east), standing within an architectural frame. At the head of the arch is another representation of the sun, whose face is surrounded by an eight-pointed star and contained within a roundel. On either side of the sun are two additional roundels, both of which contain a Greek cross. Both saints are wearing hoods and have haloes; both wear aprons, and both have long, white, pointed beards. *Abba* Pantaleon, one of the nine Syrian saints, holds a hand-cross emphasising his missionary role. The script over Sinoda on the east side of the soffit reads, 'Hail, *Abba* Sinoda.' He was abbot of the White Monastery in Upper Egypt, and reformer of Coptic monasticism; he drew up canons for monks, nuns and the laity; and he attended the Council of Ephesus (AD 431) which excommunicated Nestorius. He is wearing a light brown coat and a darker brown tunic. His hands hold his robe. His half apron, decorated with kidney-shaped patterns in aquamarine, white and light brown, has indented edging cutting diagonally across his tunic. The shapes are outlined in black or dark brown, as are the folds of the garment appearing below his apron.

Arch B–C Soffit: *Abbas* Arsenius (east) and Bame (west). Arsenius was a high dignitary in the Byzantine court of Theodore the Great. In 385 he left Constantinople and became a monk in the desert of Scete. Bame was also an Egyptian monk who allowed Hilaire, daughter of Emperor Zenon, to become a nun in the desert.

Arch C–D Soffit: *Abbas* Yawahani (east) and Alef (west). Yawahani was a sixth-century Egyptian monk who went to Ethiopia, where he founded a monastery. Alef was one of the nine Syrian saints.

Arch E–F Soffit: Unidentified saints.

Arch F–G Soffit: Two unknown saints. However, the legs of one of them are covered by a long white beard – hence he could be St Onuphrius, who is usually depicted naked except for his beard. He was a hermit for seventy years in the desert near Thebes in Upper Egypt.

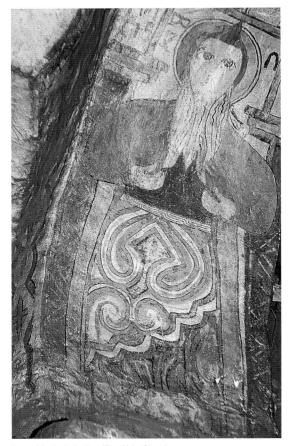

Fig. 168. Arch A–B soffit. *Abba* Sinoda

Arch G–H Soffit: *Abbas* Yemata (east) and Garima (west), two of the nine Syrian saints. The caption above the two saints reads, 'Peace to you *Abba* Yemata and peace to you *Abba* Garima.'

The frescoes of this church are quite remarkable not only for the boldness of their designs but also because of the ancient Christian iconography used in some of the biblical scenes as well as the number of Egyptian desert fathers portrayed both on the walls and on the soffits of the numerous arches. It is for these reasons that Ewa Balicka-Witakowska, who some years ago researched this church, has pointed out that the artist was either an Egyptian or an Ethiopian trained in Egypt who was strongly influenced by Coptic monastic paintings.

Makina Medhane Alem

Red numbers	Lower level paintings
Blue numbers	Upper level paintings

West Side

1	Hunting scene.
2	Birds.
3	Teutonic cross with sun and moon.
4	St Honorius.
5	St Marmehnam.

South Side

6	St Mamas riding a lion.
7	Messenger of the governor.
8	Daniel within a geometrical arch.
9	St Anbakom, also known as Habakkuk.
10	Unidentified figure.
11	St Honorius.
12	*Abba* Daniel, disciple of St Honorius.
13	St Archilides.
14	Gabre Krestos.
15	St Onuphrius.
16	Paphnutius, biographer of St Onuphrius.
17	Samson's parents sacrificing a goat.

North Side

18	Teutonic cross with sun and moon.
19	Five wise virgins.
20	Scene from the life of St George.
21	St Pachomius (disciple of St Anthony).
22	St Macarius (disciple of St Anthony).
23	St Anthony.
24	*Abba* Mataa.
25	*Abba* Yohanni.
26	St Victor riding a leopard.
27	Sacrifice of Isaac.

Wall Dividing Nave From Sanctuary

28	St George spearing Euchios.
29	St Theodore the Oriental spearing a snake.
30	Archangel Gabriel.
31	Archangel Michael.
32	Journey to Bethlehem.
33	The Transfiguration.

Dome Over Sanctuary

34	Christ in Majesty.

North Column

South side: St Matthew and St Mark.
West side: Baptism of Christ, and St Barbara.
North side: unidentified figure and St Juliana.

South Column

North side: St Luke, St John, and Giyorgis II.
West side: David and the archangel Fanuel.
South side: Kwelsewon and Tahrayanna Maryam.

Makina Medhane Alem

Makina Medhane Alem, the 'Redeemer of the World', is a small, built-up church set in a huge cave on the east side of the peak of Abuna Joseph. To reach it involves a three-hour walk from the church of Ghenate Maryam, which is at an altitude of 2,650 metres. Makina Medhane Alem is at 3,280 metres, so you will have a steep climb of 630 metres to get up to it – but it is well worth it.

According to the priest, the church was built in the sixth century by the King of Aksum, Gabre Maskal. However, David Phillipson, in his book *Ancient Churches of Ethiopia* (2009), dates it to between 1100 and 1300. The construction of the church is Aksumite, but, instead of having horizontal wooden beams, it has layers of dressed red tufa blocks set slightly back from the alternating layers of rubble, which have been smoothed over. The building has been finished off by a cornice of thin blocks of tufa surmounted by the same masonry as the walls below it.

The nave has a wooden gabled roof, raised to a higher level than the rest of the church by the clerestory. The exterior has been plastered over with a thin layer of lime. The sanctuary has a wooden dome, also plastered on its exterior; it is much lower in height than the roof of the nave. The windows in the upper wall of the nave and the single, west-facing window of the dome are plain. The remaining windows in the lower part of the walls, and the west door, are framed in the typical Aksumite manner, with wooden timbers and 'monkey-heads'. The ground-level 'monkey-heads' of the other two entrances are missing.

The interior is spectacular, but you do need a strong torch to appreciate it. It has a nave and two aisles with a sanctuary at the eastern end. The nave is surrounded by a wooden Aksumite frieze above which there is an upper wall pierced by three plain windows on each side. The wooden ceiling is richly decorated, and your eyes are immediately drawn to it because of its shape and colour. It is similar in design to that of Yemrahane Krestos. It has two tie-beams, each with a 'King-post' that has a boss made up of three squares of diminishing size. The ceiling consists of wooden coffers painted with a variety of geometrical designs, mainly squares, swastikas and roundels in red ochre, yellow and green, and the occasional aquamarine. The same designs have been duplicated in the wooden frieze and the beams.

The aisles have flat, wooden ceilings which are much lower than that of the nave. These ceilings are supported by a series of criss-crossing beams creating coffers, also decorated with swastikas and geometrical designs but without roundels. Here the colours are in pristine condition and are still sufficiently vibrant to appreciate their original pigment; they are reminiscent of the Arts and Crafts colours so esteemed by William Morris.

The Paintings

I believe that the paintings date from the end of the thirteenth century because of their close resemblance to the style of those in Ghenate Maryam, which date from this time. There is a strong similarity

Fig. 169. Makina Medhane Alem is situated on the ridge just below the peak of Abuna Joseph

in the robes of some of the saints. This is especially true of the diagonal band that runs across the lower part of their tunics, and also the architectural setting in which many of them are placed, comprising a squared-off arch supported by columns. Another similarity is in the way that some of the figures have their tiny rounded hands placed in front of their chests in a gesture of prayer with their thumbs uppermost, a pose that is similar to that found in Coptic art and, more specifically, in the paintings in the Monastery of St Antony at the Red Sea (1232–3). The figures are outlined by black lines, and most are frontally depicted; the colours are white, blue and brown and yellow ochres. Their faces have large eyes with pupils shown close to the upper eyelash, and their eyebrows connect with the lines forming their noses. Most of the haloes depicted are delineated with a string of pearls.

Ewa Balicka-Witakowska, who has made a very detailed study of this church, believes that it was painted by a Coptic workshop because (1) some of the iconography belongs to Coptic rather than Ethiopian tradition, and (2) the inscriptions, even though carefully written, have many characters reversed and numerous words incorrectly spelt indicating that the scribe had a very poor knowledge of Ge'ez. Furthermore, Marilyn Heldman points out that the knotted tail of St George's horse is typical of the horses depicted in both the monasteries of St Antony and St Paul at the Red Sea, which were painted by Theodore and his workshop. Also, St George wears what appears to be chain mail, which was typical of the body armour shown on Crusader icons but was unknown in Ethiopia.

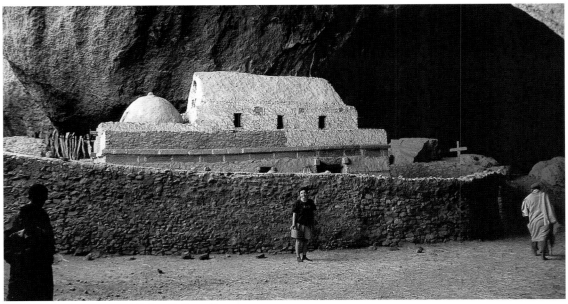

Fig. 170. María-José in front of Makina Medhane Alem

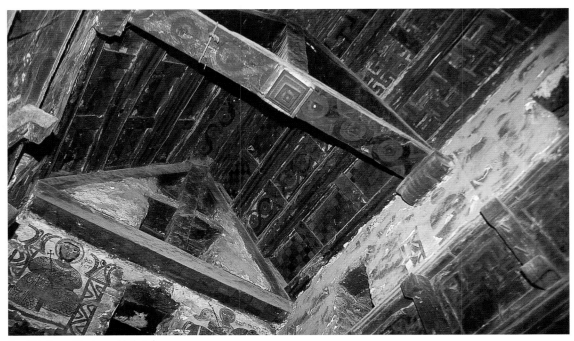

Fig. 171. Nave. Wooden gabled roof

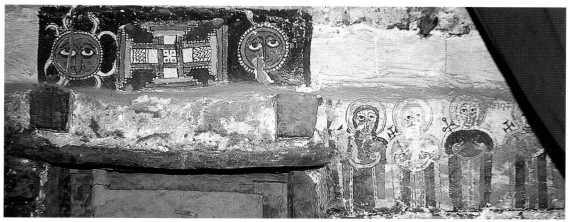

Fig. 172. West side. Anthropomorphic sun and moon and the wise virgins

Fig. 173. West side. St Honorius (left) and St Marmehnam (right)

West Side

To the left of the doorway is a hunting scene (**1**) with two hunters armed with bows and arrows and a third holding a mace while dragging a deer behind him. This scene probably relates to the life of St Mamas. On either side of the door are birds (**2**) and, directly above the door, is a Teutonic cross (**3**), painted on a black background with an anthropomorphic sun on the left and moon on the right, both of which have a somewhat sad expression.

On the clerestory, above the Aksumite frieze and on either side of a window, there are two figures painted against a white background in a style very similar to that of Ghenate Maryam's frescoes. On the left is St Honorius (**4**), seated on a throne in an oriental fashion with his legs folded beneath him. The sides of the throne resemble totem poles, decorated with zigzags in alternating brown ochre and charcoal grey and ending in finials resembling a stylised bird. On the right, St Marmehnam (**5**) is riding a brown horse with his light brown cloak billowing out behind him. Both saints hold long-handled crosses.

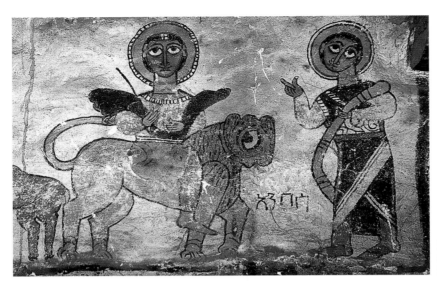

Fig. 174. South side. St Mamas riding a lion and, in front of him, the messenger of the governor

South Side

On the aisle wall, to the left of the door, is St Mamas (**6**) riding a lion with a goat and a deer behind him; the saint was known to have nourished himself on the milk of wild goats and deer. A lion always remained with him as his companion. St Mamas' torso and head are turned towards us. The script beneath the lion's head reads, 'The True Lion.' The lion is depicted in profile with its eye gazing coyly at the viewer and with its red tongue protruding. In front of St Mamas is the messenger of the governor (**7**) who came to arrest him but who became a Christian.

To the right is the prophet Daniel (**8**), standing within a geometrical arch. He is dressed in the same way as the five virgins – in a red ochre cloak that covers his upper torso and reveals a striped tunic beneath. He is also holding a sash in both hands. On either side of Daniel's protective arch are two lions, illustrating the biblical story of when he was thrown into the lions' den.

The next figure along is St Anbakom (**9**), also known as Habakkuk, who is standing by a pillar looking towards Daniel. According to legend, St Anbakom was transported to Babylon by an angel so that he could give food to Daniel while he was with the lions. In this painting, the angel's hand can be seen holding a lock of St Anbakom's hair. His story, as related in the *Synaxarium*, is summarised as follows:

One day this prophet cooked some lentils in a pot. He was carrying the pot and some bread to the men, who were reaping in the fields outside the city when the angel of God appeared to him and said, 'Take this food to Daniel, the prophet, in the den of lions in the city of Babylon.' He replied, 'I have never been to Babylon, and I do not know where the den of lions is.' And the angel took him by his hair as he was carrying the food and brought him to the pit in

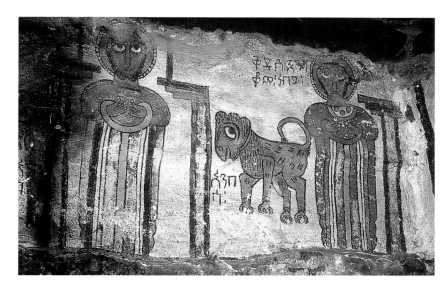

Fig. 175. South side. Daniel on the left with St Anbakom on the right

Babylon and Habakkuk gave the food to Daniel. Daniel ate it, and immediately the angel took Habakkuk back to Judah.

On the south clerestory there is a series of saints. On the right is an unidentified figure (**10**). To the left of him is the prostrated St Honorius (**11**) with his disciple *Abba* Daniel standing behind him (**12**). The next figure to the left, within an architectural frame, is St Archilides (**13**). He wears a charcoal-grey cloak, a brown ochre tunic and the same kind of diagonal band on his skirt as found in the figures in the paintings of Ghenate Maryam. He is standing within a square arch which rests on columns and is decorated with a zigzag design in brown. Archilides' story, as told in the *Synaxarium*, is summarised below:

He was of a patrician family from Rome. His father was John and his mother, Sandakika; both good souls who kept the commandments. His father died when he was twelve, and, later on, when his mother wanted him to marry, he declined. The Emperor appointed him to his father's office, across the seas. While they were at sea there was a great storm, and the ship broke up, but Archilides managed to cling to a piece of wood and so made it to dry land.

When ashore, he found the dead bodies of those who had perished and he realised the transience of this world and wondered, 'Why bother about the goods of this fleeting world if, when I die, I will return to dust?' He gave up his appointment and walked all the way to Syria, to the monastery built by St Romanus. He gave the abbot the 200 dinars in gold that he still had left and asked to become a monk. He became a devout monk who prayed and

fasted regularly, and God gave him the gift of healing the sick. He made a covenant with Our Lord that he would never look upon the face of a woman again.

After twelve years had gone by, his mother decided that he must be dead since she had never heard from him. But one day she overheard some pilgrims describing the miracles and appearance of St Archilides, and she recognised that this must be her son. So she decided to travel to the monastery of St Romanus. Having sent a message to her son that she would soon arrive, she set off on her journey. 'I wish to see you once more', she had said in her message. But he replied that he had made a covenant with God not to see a woman again and so he would not be able to receive her. She replied, 'If I cannot see you, I will go into the desert and allow the wild beasts to devour me.' He could not break his covenant with God so he prayed that he would die, which he did, and he went to Heaven. In Heaven, he said to the gatekeeper, 'Go to my mother and let her come in with me.'

When his mother arrived at the monastery and heard that her son was dead, she asked God to take her soul as well, and God obliged. When the monks tried to separate their bodies for burial, a voice came from the body of Archilides, 'Bury my body with that of my mother in one grave because I did not give her her heart's desire. Let her see me.' And when they heard this voice, the monks marvelled exceedingly and glorified God and buried the two of them in one grave.

To the left of the window is the figure of Gabre Krestos (**14**) standing within an architectural frame, his hands tight to his chest in a gesture of prayer. To the left of Gabre Krestos is St Onuphrius (**15**), an Egyptian hermit who lived in the desert of Upper Egypt for seventy years, recognisable by his distinctive long beard that covers virtually all of his body and his bare legs. In front of him is the small figure of the monk Paphnutius (**16**) who was his biographer.

Fig. 176. South side. St Archilides (left), the prostrated St Honorius, and his disciple *Abba* Daniel (right)

The final two figures (**17**) on the left of the wall – a woman seated on a raised platform holding a knife in one hand and an animal in the other, and a man behind her holding an open sack – have been interpreted by Ewa Balicka-Witakowska to be Samson's parents sacrificing a goat in thanksgiving for the birth of their only son.

North Side

On the aisle wall, directly above the north door, is a Teutonic cross with sun and moon (**18**) similar to that above the west door. To the right of the doorway are five female figures (**19**); the caption reads, 'The Wise Women'. They illustrate Christ's parable of the five wise and five foolish virgins. Here they are shown carrying long-handled crosses and not lamps and bottles of oil because they have already entered the Kingdom of Heaven. Their hands are held close to their chest in a pious gesture. A sash is held in their hands forming a loop which, together with their rounded shoulders, creates an oval. They all wear a cloak covering their upper torso which opens at the waist to reveal a colourful striped tunic.

To the right of the five wise virgins is one of two scenes from the life of St George (**20**); the second scene is on the wall dividing the nave from the sanctuary. It is an inscribed painting of a haloed widow for whom St George performed two miracles. She is holding a hand-cross and is placed within an architectural frame from which leaves are sprouting. The inscription reads, 'The widow, the column of whose house St George caused to put forth leaves' (Heldman, 2000). St George also cured her blind and lame son.

On the north clerestory, at its west end, are two of the disciples of St Anthony, St Pachomius (d. AD 346) and St Macarius (**21, 22**), one standing and one seated. Next is St Anthony (**23**), the great hermit of the desert, standing within an architectural frame, holding a cross and with a similar diagonal band on his skirt as St Archilides on the opposite clerestory. Then, either side of the window, are *Abba* Mataa (**24**), also known as Libanos, who received his monastic habit from St Pachomius, who advised Mataa to go to Ethiopia, and *Abba* Yohanni (**25**). Both are standing within an architectural frame. To the right is St Victor (**26**), riding what appears to be a leopard. The last painting on this clerestory is that of the Sacrifice of Isaac (**27**). Abraham holds a long pointed knife in one hand and holds a kneeling Isaac by his hair with the other. The lamb is shown hanging from a tree.

Wall Dividing the Nave from the Sanctuary

Continued from the north aisle wall is the second scene in the life of St George (**28**) which shows the mounted saint, wearing what appears to be chain mail, spearing Euchios, the general sent by Diocletian to destroy the saint's shrine in Lydda. St George's white horse has a knotted tail. To the right is St Theodore the Oriental (**29**), spearing a distinctively knotted anthropomorphic snake which bears a strong resemblance to the one the saint is shown killing in the church of St Antony at the Red Sea.

On the north side of the entrance to the sanctuary is the archangel Gabriel (**30**), and on the south is St Michael (**31**).

At the southern end of the wall dividing nave and sanctuary is a painting of the Journey to Bethlehem (**32**). The Virgin Mary is seated side-saddle within an architectural frame which is topped by one of the extended wings of the two angels on either side of her.

Over the entrance to the sanctuary is the Transfiguration (**33**) with Moses and Elijah and two other figures. The sanctuary dome is painted with Christ in Majesty (**34**) surrounded by the Tetramorph and with one angel on either side.

North Column

On the south side of this column, one above the other, are St Matthew and St Mark; on the west side, the Baptism of Christ and St Barbara; and on the north side, an unidentified figure and St Juliana, St Barbara's servant who was martyred with her.

South Column

On the north side of the column are St Luke, St John and Giyorgis II, *abuna* of Ethiopia between 1215 and 1225; on the west side, David playing the lyre and the archangel Fanuel; and on the south side, Kwelsewon (above) and his mother, Tahrayanna Maryam (below).

Chronology of Kings, Queens, Emperors and Empresses

1559–63	Minas Wanag Sagad II or Admas Sagad I, son of Lebna Dengel Dawit.
1563–97	Sarsa Dengel Malak Sagad I, son of Minas.
1597–1603	Yakob Malak Sagad II, son of Malak Sagad.
1603–4	Za Dengel Asnaf Sagad II, son of Abeto Lesana Krestos, brother of Malak Sagad I.
1607–32	Susenyos Malak Sagad III or Seltan Sagad I, son of Fasilidas, grandson of Yakob.
1632–67	Fasilidas or Fasil, Alam Sagad or Seltan Sagad, son of Susenyos.
1667–82	Yohannes (John) or Alaf Sagad, son of Fasilidas.
1682–1706	Iyasu (Jesus) I or Adyam Sagad II, son of John I.
1706–8	Tekle Haymanot I (Leul Sagad, Gerum Sagad, Abtak Sagad), son of Iyasu I.
1708–11	Tewoflos (Theophilus) Asrar Sagad, son of John I.
1711–16	Yostos (Justus) Tahai Sagad, great-grandson of King John I.
1716–21	Dawit III (David), Adbar Sagad I, son of Iyasu I.
1721–30	Bakaffa (Asma Giyorgis, Masih Sagad, Adbar Sagad), son of Iyasu I.
1730–55	Iyasu (Jesus) II (Adyam Sagad II, Berhan Sagad), son of Bakaffa.
1755–69	Iyoas (Joas) I or Adyam Sagad III, son of Iyasu II.
1769	Yohannes (John) II – he reigned for six months, son of Iyasu II.
1769–77	Tekle Haymanot II (Admas Sagad II, Tebab Sagad, Hayl Sagad), son of John II.
1777–9	Salomon (Solomon), son of Abeto Adahie.
1779–84	Tekle Giyorgis or Fekr Sagad, brother of Tekle Haymanot II.
1777–1855	Twenty-three kings sat on the throne – a period of anarchy; no important historical events occurred.
1855–68	Tewodros (Theodore) II, Kasa, son of Dejazmach Khaylu Maryam or Walda Giyorgis.
1868–89	Yohannes (John) IV, Kasa, killed in a battle against the Mahdi army at Gallabat.
1889–1913	Menelik II.
1913–6	Ledj Iyasu, grandson of Menelik, died 1935.
1916–30	Zawditu, daughter of Menelik; Ras Tafari Makonnen recognised as official heir in 1916.
1930–74	Haile Selassie, son of Ras Makonnen, deposed September 1974, murdered in Addis, 27 August 1975.

Ethiopian Calendar

Ethiopia has its own ancient calendar, which is based on the old Egyptian system of dividing the year into twelve thirty-day months with an extra month of five days (six in a leap year) at the end of the Ethiopian year, which occurs during the Gregorian month of September. Each year is dedicated to one of the four evangelists – Matthew, Mark, Luke and John – with every leap year being that of Luke. Even though the Ethiopian months do not correspond to those of the Gregorian calendar, the days of the Ethiopian week do.

	Ethiopian Calendar		Gregorian Calendar	
#	Month	#	Start Date	Start Date, Leap Year
1	Meskerem	9	11 September	12 September
2	Teqemt	10	11 October	12 October
3	Hedar	11	10 November	11 November
4	Tahsas	12	10 December	11 December
5	Terr	1	9 January	10 January
6	Yakatit	2	8 February	9 February
7	Magabit	3	10 March	—
8	Miyazya	4	9 April	—
9	Genbot	5	9 May	—
10	Sene	6	8 June	—
11	Hamle	7	8 July	—
12	Nehase	8	7 August	—
13	Pagwemen	9	6 September	—

The Ethiopian hours of the day are also different to those with which we are familiar. The day begins at dawn, at 6:00 a.m., and is counted as hour 'zero', which, it can be argued, is much more logical than our system. The end of the day and beginning of the night is at hour '12'. In making appointments with drivers, guides, etc., it is vitally important that you ensure all parties know which system they are using. Your intended 6:00 a.m. start from the hotel could be delayed till 12 noon!

Bibliography

Annequin, Guy (1976) 'De quand datent l'église actuelle de Dabra Berhan Sellasé de Gondar et son ensemble de peintures?', *Annales d'Éthiopie*, 10: 215–26.

Balicka-Witakowska, Ewa (1998–9) 'Les Peintures murales de l'église rupestre éthiopienne Gannata Maryam près Lalibela', *Arte medievale*, 12–3: 193–209.

—— (2004) 'The Wall-Paintings of the Church of Madhane Alam near Lalibela', *Africana Bulletin*, 52: 9–29.

Balicka-Witakowska, Ewa and Michael Gervers (2001) 'The Church of Yemrehane Krestos and its Wall-Paintings: A Preliminary Report', *Africana Bulletin*, 49: 9–47.

Beckwith, John (1970) *Early Christian and Byzantine Art* (Harmondsworth).

Belaynesh, Michael, S. Chojnacki and R. Pankhurst (eds) (1975) *The Dictionary of Ethiopian Biography* (Addis Ababa).

Brooks, Miguel F. (1894) *St Michael the Archangel: Encomium of Eustathius* (London).

—— (1906) *The Life of Takla Haymanot* (London).

—— (1996) *Kebra Negast* (Lawrenceville, NJ).

Budge, Sir E. A. Wallis (1922) *Legends of Our Lady Mary the Perpetual Virgin and Her Mother Hanna* (London).

—— (1933) *One Hundred and Ten Miracles of Our Lady Mary* (London).

Caraman, Philip (1985) *The Lost Empire: The Story of the Jesuits in Ethiopia* (London).

Chojnacki, Stanislaw (1983) *Major Themes in Ethiopian Painting* (Wiesbaden).

Di Salvo, Mario with texts by Stanislaw Chojnacki and Osvaldo Raineri (1999) *Churches of Ethiopia: The Monastery of Narga Sellasie* (Milan).

Elias, Girma (1997) *Aksum* (Addis Ababa).

Gabre-Sellasie, Zewde (1975) *Yohannes IV, Emperor of Ethiopia* (Oxford).

Gerster, Georg (1970) *Churches in Rock: Early Christian Art in Ethiopia* (London).

Gozálbez, Javier and Dulce Cebrián (2007), *Etiopía: un rostro con tres miradas* (Barcelona).

Haggai, Erlich (1996) *Ras Alula and the Scramble for Africa* (Lawrenceville, NJ).

Hein, Ewald and Brigitte Kleidt (1994) *The Marian Icons of the Painter Fere Seyon: A Study of Fifteenth Century Ethiopian Art, Patronage and Spirituality* (Wiesbaden).

—— (1999), *Ethiopia: Christian Africa* (Ratingen).

—— (2000) 'Wise Virgins in the Kingdom of Heaven: A Gathering of Saints in a Medieval Ethiopian Church', *Source: Notes in the History of Art*, 19 (2): 6–12.

Heldman, Marilyn (1994) *The Marian Icons of the Painter Fere Seyon: A Study of 15th Century Ethiopian Art, Patronage and Spirituality* (Wiesbaden).

—— (2000) 'Wise Virgins in the Kingdom of Heaven: A Gathering of Saints in a Medieval Ethiopian Church', *Notes in the History of Art*, xix/2: 6–12 (New York).

—— (2007) 'Metropolitan Bishops as Agents of Artistic Interaction between Egypt and Ethiopia during the Thirteenth and Fourteenth Centuries', in C. Hourihane (ed.), *Interactions: Artistic Interchange between the Eastern and Western Worlds in the Medieval Period* (Princeton, NJ), 84–105.

Heldman, Marilyn and Munro-Hay, Stuart (1993) *African Zion, the Sacred Art of Ethiopia*, Grierson, Roderick (ed.) (New Haven and London).

Henze, Paul (1994), *Aspects of Ethiopian Art from Axum to the 20th Century* (London). Essays based on the *Proceedings of the 2nd International Conference on the History of Ethiopian Art*, September 1990, Poland.

—— (1997) *Ethiopian Journeys* (London).

—— (2000) *Layers of Time: A History of Ethiopia* (London).

Jäger, Otto (1974) *Antiquities of North Ethiopia* (London).

Kaplan, S. (1992) *The Beta Israel (Falasha) in Ethiopia* (New York).

Lepage, Claude and Jacques Mercier (2005) *The Ancient Churches of Tigrai* (Paris).

Leroy, Jules (1967) *Ethiopian Painting in the late Middle Ages and under the Gondar Dynasty* (London).

Merahi, Kefyalow (1997) *The Covenant of Holy Mary Zion with Ethiopia* (Addis Ababa).

Mercier, Jacques (2004) Vierges d'Ethiopie (Montpellier).

Pankhurst, Richard (1982) 'The History of an Ethiopian Icon', *African Affairs Journal*, 81.

—— (2001) *The Ethiopians* (Oxford).

Phillipson, David (2009) *Ancient Churches of Ethiopia* (New Haven, CT).

Plant, Ruth (1985) *Architecture of the Tigray, Ethiopia* (Worcester).

Playne, Beatrice (1986) 'History of Ethiopian Art' (*Proceedings of the 1st International Conference on the History of Ethiopian Art*) (London).

Ramos, Manuel João with Isabel Boavida (1999) *The Indigenous and the Foreign in Christian Ethiopian Art* (Papers from the Fifth International Conference on Ethiopian Art, November).

Reverte, Javier (2001), *Dios, El Diablo y La Aventura* (Barcelona).

Trimingham, J. S. (1952) *Islam in Ethiopia* (Oxford).

Ullendorff, Edward (1968) *Ethiopia and the Bible* (Oxford).

—— (1973) *The Ethiopians: An Introduction to Country and People* (London).

Glossary

Abba	Title, meaning 'My Father', given to Church dignitaries, monks, holy men and highly respected individuals.
Abuna	Ecclesiastical title for the head of Ethiopian Church as well as for the head of a monastic order.
alga	A traditional Ethiopian bed and, by extension, a throne.
amba	A flat-topped, vertical cliff.
Amharic	The Semitic language of Amhara, the principal language of modern Ethiopia.
begena	A large harp.
berelle	A special vessel for drinking *tej*.
caftan	An Indian-style, long-sleeved cloak, tied at the waist with a wide cummerbund.
croix pattée	A cross having limbs which are nearly triangular, being very narrow where they meet and widening towards the extremities.
dabtara	A cantor, a deacon, a church official who performs liturgical music and dances. Also a learned man of the Church.
debre	A mountain or monastery.
Dejazmach	The highest military-cum-political title after *Ras*, literally 'Commander of the Door' (Rear Guard). This title was usually given to provincial governors. It has recently become an honorary title.
Echege	The highest ranking Ethiopian cleric after the *Abuna* in the Ethiopian Church.
Equestrian Saint	Warrior saint depicted on horseback, bearing arms, and shown victorious in combat with representations of evil; also applies to named martyrs because of their trials and death in the name of Christ.
Falashas	A Semitic people who had settled in the country before the arrival of Christianity.
gadl (pl: *gadlat*)	Life of a saint.
ganna	A kind of hockey game. Its name means birth and hence it stands as a symbol for the Nativity.
Ge'ez	The ancient Semitic language of Ethiopia, now used only as a liturgical language.
harag	A geometrical design inspired by Islamic ornamentation; *harag* means the tendril of a climbing plant. This design was sometimes used to frame the pages of Ethiopian manuscripts.
himbasha	Circular bread loaf of the province of Tigray.
injira	Ethiopian staple bread.
inzira	A large flute.
Kebra Negast	The history of the Ark of the Covenant's journey to Ethiopia and of the Solomonic line of Ethiopian kings.

Kidana Mehrat Covenant of Mercy.

Kwer'ata re'esu It means 'The striking of his [Christ's] head' and was the name originally given to a European painting of Christ wearing the Crown of Thorns.

lamd A ceremonial cape for which the original model was a lion skin with the paws hanging over the shoulder.

Ledj Title of a young nobleman.

makwamiya See under 'prayer-stick'.

mandorla An almond-shaped halo placed around a figure to indicate the presence of God.

maphorion The kind of veil worn by the Virgin Mary.

maqdas The sanctuary where the *tabot* rests and to which only senior priests and the king are admitted.

masingquo A one-stringed violin.

monastic 'house' A group of monasteries whose affiliation was based upon their mutual allegiance to a particular monastic leader.

Nagere Maryam It means 'History of Mary' and is a collection of stories about her life, organised and read for the twelve months of the year.

Nebura'ed An ecclesiastical title given by the emperor to the senior administrator of the church of St Mary of Zion in Aksum and the church of St Mary in Addis Alem, Shoa Province. This title originated in the fourteenth century when *Abuna* Yakob sent twelve missionaries to southern Ethiopia to proselytise and found new monasteries. Since he had no power to consecrate them as bishops, he placed his hands on them and made them each a *nebura'ed* in charge of both ecclesiastical and lay matters.

negarit A military drum.

Negus A title meaning 'king', but also 'ruler, chief, head, commander'. It was the traditional title of the Ethiopian monarch.

one-eyed Evil-doers are often portrayed in profile with only one eye visible.

orans (pl: *orantes*) Early Christian posture of prayer, standing with arms outstretched. Scenes such as the Three Youths in the Fiery Furnace adopt this posture. The Virgin Mary is also often represented *orans*.

prayer-stick In Ge'ez, a *makwamiya*. A stick ending in a T-shape at the top which is used to lean on during the lengthy church services; it is also a type of baton in liturgical dances.

qabaro A church drum.

qene mahlet Outside ambulatory of a round church or the narthex of a rectangular one.

qeddest Inner ambulatory of a church surrounding the sanctuary or *maqdas*.

Ras The 'head', or commander; the highest title of the official who was the supreme military commander and governor of the largest and most important provinces.

scapular Worn by monks and consisting of leather straps around the shoulders and across the breasts.

seba'at A monster possibly imagined by Ethiopian artists. It vaguely resembles a Greek centaur; it has the body of a lion and head, chest, and hands of

human. Its three-pronged tail is snake-like, ending in three heads. The creature is armed with a bow and almost always appears with St Claudius.

Selassie The Trinity.

shamma Draped one-piece white cotton outer garment worn by Ethiopians. Although it is usually draped over either shoulder, other ways of draping it are an essential part of traditional Ethiopian etiquette. In the past, *shammas* twisted around the waist was an expression of submission. The sixteenth- and seventeenth-century artists often represented St John at the crucifixion in this way.

Synaxarium A Church calendar describing the saints celebrated for each day of the year.

tabot The Ark of the Covenant in which the tablets of the law were placed. According to Ethiopian legend, the Ark of the Covenant was brought by Menelik, the son of Solomon and the Queen of Sheba, and finally placed in Maryam Seyon, the church of Mary of Zion in Aksum.

A *tabot*, generally made of wood, is an essential part of a church – it is the *tabot* that is consecrated rather than the church.

tankwa A papyrus reed boat bound together by strips of the fig tree bark, a craft still used to this day.

teff The principal cereal grass of Ethiopia (*Eragrostis tef*), grown elsewhere as a fodder plant.

tej A kind of mead, the national drink of Ethiopia.

Tensae The Resurrection.

Tetramorph Symbol of the four evangelists.

tsenatsil A type of sistrum.

tucul Traditional indigenous house.

Waizero Lady, a title originally pertaining to the women of the royal family and subsequently applied to noble women in general.

zema Religious chants.

List of Illustrations

Index